THE PERSISTENCE
OF THE
CLASSICAL

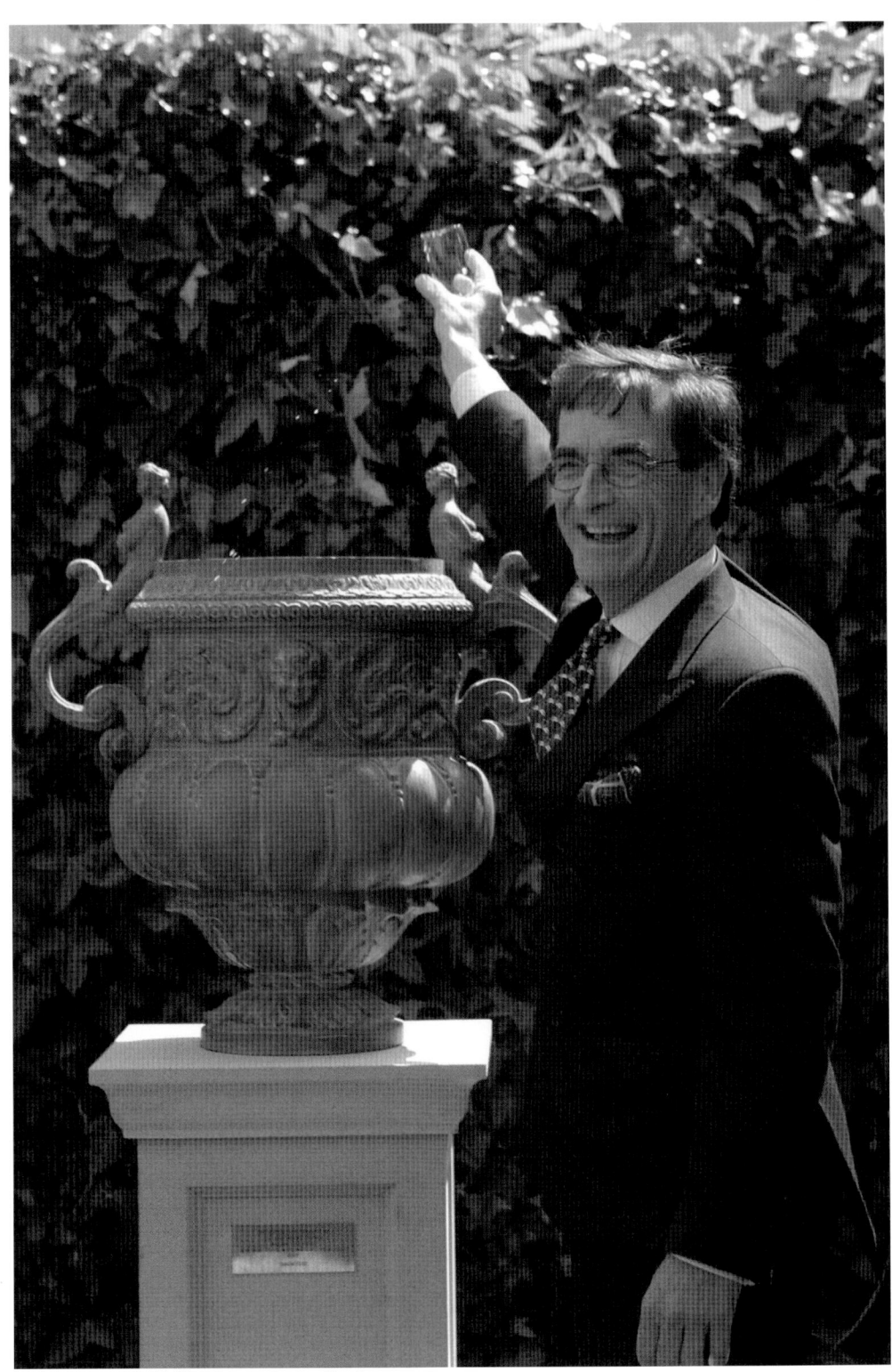

THE PERSISTENCE OF THE CLASSICAL

ESSAYS ON ARCHITECTURE
PRESENTED TO
DAVID WATKIN

EDITED BY FRANK SALMON

PHILIP WILSON PUBLISHERS

Published on the occasion 30 September 2008
by Philip Wilson Publishers

© Copyright 2008 F. E. Salmon on behalf of the Friends of David Watkin.
The copyright in all the articles belongs to the respective authors.

All rights reserved
No parts of the contents of this book may be reproduced without the written permission of
the publisher and the individual authors.

Published in 2008 by Philip Wilson Publishers Ltd., 109 Drysdale Street, The Timber Yard, London N1 6ND
www.philip-wilson.co.uk

Designed in Monotype Centaur by
Geoff Green, Geoff Green Book Design, Cambridge, UK

Printed and bound in Everbest

ISBN 978-0-85667-661-1

Frontispiece: Professor David Watkin, inaugurating an urn by libation in the gardens of Peterhouse,
Cambridge, 21 May 2007 (Photo: John Thompson, JET Photographic)

Subventions and Subscriptions

SUBVENTIONS TO SUPPORT PUBLICATION OF THIS BOOK
HAVE BEEN RECEIVED FROM

The Bard Graduate Center for Studies in the Decorative Arts, Design, and Culture; The Trustees of The Georgian Group; IPC Media; Anthony Mould Ltd.; Porphyrios Associates; John Simpson & Partners; Sotheby's; Quinlan and Francis Terry Architects

SUBSCRIPTIONS TO SUPPORT PUBLICATION OF THIS BOOK
HAVE BEEN RECEIVED FROM

The Master and Fellows of Peterhouse, Cambridge; Robert Adam; Nigel Anderson; Sophie Andreae; The Marquess of Anglesey; Dr James Campbell; Charles Cator; Lord Crathorne; Lord Dalmeny; Paul Doyle; Justin Fenwick; Lord Charles Fitzroy; Christopher Gibbs; Craig Hamilton; William Hanbury-Tenison; Paul Hanvey; John Hardy; Mr and Mrs John Hess; Michael Hoare; Dominic Houlder; Professor Deborah Howard; Della Howard; Miranda, Countess of Iveagh; Lady Jenkins; Tim Knox; Sir Mark Lennox-Boyd; Todd Longstaffe-Gowan; Dr Alyce Mahon; Jonathan Marsden; Charles Marsden-Smedley; Lady Nutting; Hugh Petter; Giles Quarme; Sir Hugh Roberts; Nick Robinson; Lord Rothschild; Dr Charles Saumarez Smith; George Saumarez Smith; Hon. James Stourton; Michael Wade; Dr Susan Weber; Sir Marcus Worsley, Bt.; Dr James Yorke

Contents

Subventions and Subscriptions	v
Contents	vii
Notes on Contributors	ix
Preface and Acknowledgements	xii

I: THEORIES, HISTORIES AND WRITERS

RICHARD JOHN — 1
Vitruvian Symmetriae: The Debate about Method

RODERICK O'DONNELL — 12
Classical Sanctuaries for Catholic London: Three and a Quarter Centuries of Continuity

ANTHONY GERAGHTY — 26
The "dissociation of sensibility" and the "tyranny of intellect": T.S. Eliot, John Summerson and Christopher Wren

ALAN POWERS — 40
The Classical Theory of Hope Bagenal

ROGER SCRUTON — 56
David Watkin and the Classical Idea

II: NEO-CLASSICAL AND NINETEENTH-CENTURY STUDIES

ROBIN MIDDLETON — 73
Some Pages from Marie-Joseph Peyre's Roman Album

JOHN HARRIS — 98
Fratri Optimo: The Tale of a Brotherly Gift

FRANK SALMON — 106
C.R. Cockerell and the Discovery of Entasis in the Columns of the Parthenon

CHARLES SAUMAREZ SMITH — 124
The Design and Construction of the National Gallery

MANOLO GUERCI — 136
Charles Barry's Designs for Northumberland House, 1852-55

III: CLASSICISM AND THE PICTURESQUE IN THE TWENTIETH CENTURY

JOHN MARTIN ROBINSON — 153
Neo-Georgian: The De-Gothicizing of Wilton House

JOHN WILTON-ELY — 164
"A Vindication of Classical Principles": Sir Albert Richardson (1880-1964)

GAVIN STAMP — 183
Classicism without Columns

BARRY BERGDOLL — 202
Complexities and Contradictions of Post-Modernist Classicism: Notes on the Museum of Modern Art's 1975 Exhibition *The Architecture of the Ecole des Beaux-Arts*

CHRISTOPHER WOODWARD — 218
The English Vision: The Picturesque Revisited

Bibliography of David John Watkin, 1961–2008 — 229

Notes on Contributors

BARRY BERGDOLL studied for a BA at King's College, Cambridge, from 1977 to 1979, working under David Watkin and Robin Middleton. His doctoral dissertation was completed at Columbia University in 1986 and published in 1994 as *Léon Vaudoyer: Historicism in the Age of Industry*. Since 1985 he has been a member of the faculty of Art History at Columbia University and since 2006 the Philip Johnson Chief Curator of Architecture and Design at the Museum of Modern Art.

ANTHONY GERAGHTY was supervised for his doctoral dissertation on Sir Christopher Wren by David Watkin in the mid-1990s. He is Lecturer in the History of Art at the University of York, UK, and the author of *The Architectural Drawings of Sir Christopher Wren at All Souls College, Oxford* (2007).

MANOLO GUERCI, architectural historian and architect, is the Jeremy Haworth Research Fellow in architectural history and a graduate tutor of St Catharine's College, Cambridge. His current research concentrates on comparative studies of palaces in Early Modern Europe, with particular attention to seventeenth-century Rome, Paris and London. David Watkin supervised his doctorate on the Strand palaces of the early seventeenth century from 2003.

JOHN HARRIS is Curator Emeritus of the Drawings Collection of the Royal Institute of British Architects. One of his roles when teaching at Cambridge in the 1960s was to explain how archives are the fodder for research and writing. He

found David Watkin an attentive listener, borne out by the publication in 1968 of a monograph on Thomas Hope.

RICHARD JOHN is a scholar of Peterhouse, Cambridge, where he was a pupil of David Watkin, and a former fellow of Merton College, Oxford. Since 1999 Prof. John has taught on the faculty of the School of Architecture at the University of Miami. He was recently appointed Editor of *The Classicist*, the journal of the Institute of Classical Architecture & Classical America, and is currently the 2008 Harrison Design Associates Visiting Scholar at the Georgia Institute of Technology.

ROBIN MIDDLETON wrote a dissertation on Viollet-le-Duc at Cambridge under Nikolaus Pevsner and was, from 1972 to 1987, head of General Studies at the Architectural Association School of Architecture and also Librarian and lecturer at the Faculty of Architecture and History of Art at Cambridge, where he focussed, together with David Watkin, on eighteenth-century architectural studies. In 1977 they published *Architettura Moderna*, issued in 1980 as *Neo-Classical and 19th Century Architecture*. From 1987 to his retirement in 2005 Robin Middleton taught at Columbia University in New York.

RORY O'DONNELL was an undergraduate pupil of David Watkin's from 1975 to 1977, and a camp follower while a Bye-Fellow of Magdalene College, Cambridge from 1979 to 1981. Since 1982 he has been an Inspector at English Heritage (from 2003 in Government Historic Estates, formerly Crown Buildings). He is a much published authority on the Catholic Revival and the Pugin family.

ALAN POWERS is Professor of Architecture and Cultural History at the University of Greenwich. He was an undergraduate at Clare College, Cambridge, from 1973 to 1977 and studied the History of Art Tripos, with a specialism in architectural history.

JOHN MARTIN ROBINSON is Maltravers Herald Extraordinary and an independent scholar. He has written many books on architectural history and is a trustee of Wilton House.

FRANK SALMON is Lecturer in the History of Art at the University of Cambridge. He teaches post-medieval British architectural history in succession to David Watkin, under whose guidance he carried out doctoral research work from 1986 to 1989. He is also a Fellow of St John's College, Cambridge.

NOTES ON CONTRIBUTORS

CHARLES SAUMAREZ SMITH was an undergraduate at King's College, Cambridge and a pupil of David Watkin from 1974 to 1976. He wrote his undergraduate dissertation on the Neo-classical Mausoleum and his doctorate on Castle Howard – published as *The Building of Castle Howard* – won the Alice Davis Hitchcock Medallion. He was Director of the National Portrait Gallery from 1994 to 2002, Director of the National Gallery from 2002 to 2007 and is now Secretary and Chief Executive of the Royal Academy.

ROGER SCRUTON is Research Professor at the Institute for the Psychological Sciences in Arlington, Virginia, and a writer and philosopher. He is author of a number of books, including *The Aesthetics of Architecture* (1979), *The Classical Vernacular* (1993), and *England: an Elegy* (2001).

GAVIN STAMP was born in 1948 and read first History and then, inspired by David Watkin, Fine Art at Cambridge. He has written about the architecture of the Gilbert Scott dynasty, Alexander "Greek" Thomson and Edwin Lutyens, amongst others, as well as about power stations and telephone boxes. Having taught the history of architecture at the Mackintosh School of Architecture in Glasgow, where the University made him an honorary professor, he has reverted to being an independent scholar. For many years he was chairman of the Twentieth Century Society.

JOHN WILTON-ELY, Emeritus Professor in the History of Art at the University of Hull, read History at Jesus College, Cambridge, from 1958 to 1961, enhanced by lectures at the School of Architecture in Scroope Terrace. After postgraduate study at the Courtauld Institute, London (with a short spell of training under Sir Albert Richardson in his London office), he taught at the Universities of Nottingham and Hull before directing educational studies at Sotheby's. He has published widely on European Neo-classicism, as well as on varied aspects of the classical tradition in British architecture, and is a leading authority on Giovanni Battista Piranesi.

CHRISTOPHER WOODWARD studied at Peterhouse, Cambridge, from 1987 to 1990 and was taught History of Art by David Watkin. By the time of the publication of *Sir John Soane: Enlightenment Thought and the Royal Academy Lectures* he was Assistant Curator at Sir John Soane's Museum, where, in 1999, he collaborated with David Watkin on the exhibition "Visions of Ruin". He has recently begun work as Director of the Museum of Garden History, and his contribution to this volume reflects that new interest.

Preface and Acknowledgements

IN THIS VOLUME, fifteen friends and former pupils of David Watkin offer him essays of tribute on the occasion of his retirement from the Personal Chair conferred upon him by the University of Cambridge. Looked at from virtually every viewpoint, David's academic achievements have been immense. His scholarly studies of British and European architects and architecture – from his first book on Thomas Hope of 1968 to his most recent contribution on the same figure in the volume that accompanies the Hope exhibition of 2008 in London and New York – have been no less than cornerstones in the still relatively young discipline of academic architectural history in this country. His wide-ranging and widely translated surveys of international and of English architecture are to be found on school and university reading lists as well as on the bookshelves of interested amateurs across the world. His critique of the dogmas of the Modern Movement and of the historiographical tradition that supported them in the 1960s and 1970s was a necessary corrective and has arguably had a lasting effect, in that young architectural students today take a more pluralistic view of their task and profession. His own pupils fill posts in major universities, in national and royal institutions and in auction houses; they are, in short, at the heart of the establishment of architectural and art history in Great Britain.

The essays presented here have been written to range over many areas – though inevitably not all – of David's interest and expertise. They are grouped into three sections, the central one dealing with aspects of eighteenth- and nineteenth-century

Neo-classicism, the field at the heart of much of his most scholarly work. Framing that section are two others. The first illustrates some of David's beliefs and principles, placing him alongside other historians and writers on architecture. Moreover, Roderick O'Donnell's essay, dealing in large part with the Brompton Oratory, notes David's quarter-century service on that great church's Art and Architecture Committee, and thereby points to the often overlooked practical roles he has played in the public service of architecture, both in this country and overseas (notably in the United States, where he has judged the Driehaus Prize in Chicago and supported the classical architecture programme at the University of Notre Dame). He has been a willing member of English Heritage's advisory committees and even more so of The Georgian Group, which he has served as Vice-Chairman since 1991. While David has supported that organisation in its conservation aims, it is arguable that he has made a still more important contribution in promoting the interests of contemporary designers working in the classical tradition. The third section of the book is therefore devoted to studies of classicism and the Picturesque in the twentieth century. David sees the classical tradition as a living and relevant, indeed as a "radical" architecture – one that is persistent in the positive sense of its being enduring and constantly repeated. The title of this book was chosen independently but it is satisfying to note that it effectively coincides with that of an unpublished lecture given at the Art Workers Guild in 1955 on "The Persistence of the Classic" by Hope Bagenal, the subject of Alan Powers' essay here.

The manner of the writing in this volume varies, from the academic with its scholarly apparatus to the populist and the polemical. We make no apology about this, for, whilst David's entire career has been at the University of Cambridge, he has influenced the way architecture is studied and written about in this country much more broadly. In evidence of this, one need only turn to the widely ranging types of writing and types of publication that appear in his own bibliography, which is also presented in this book for the years from 1961 to 2008. David has written over 175 articles, to add to the 27 books with which he has been involved as author or editor. In addition he has produced an extraordinary number of book reviews – over 200 of them – effectively forming a unique critical overview of almost every major publication in the entire field of British architectural history from the time of Inigo Jones to the close of the nineteenth century.

What cannot be recorded here – but will be acknowledged by anyone who has experienced it – is the penetrating argument and eloquent rhetoric of David Watkin's lecturing and other teaching over a forty-year period, during which he never appeared

less than well-prepared on the subject in hand, not to mention impeccably dressed in seemingly limitless shirt, tie and handkerchief combinations to his many elegant suits or jackets. Those who have worked or studied with David will also be aware of the great solicitousness and kindness he has shown over the years to colleagues and pupils, certainly within the University and colleges of Cambridge but doubtless elsewhere too. The essays published here have been offered by their authors (who range from David's own *de facto* research advisor, John Harris, and his near contemporary, Roger Scruton, to his most recently graduated doctoral student, Manolo Guerci) in a spirit not just of admiration but also of warm affection.

Editing this volume has, in consequence, not been an onerous task although there are, of course, individuals whom I should like to thank for their assistance. Foremost amongst these stands Paul Doyle, who has acted as my sounding-board and advisor throughout. I am very grateful to the institutions that have supported publication of this book by providing subventions. They are listed at the front of this book, as are the names of those friends of David's who have provided support as subscribers. All have my thanks, as do the following for particular assistance given: Robert Bargery, Justin Fenwick, Charles Hind, Dominic Houlder, Sheila O'Connell, Philip Pattenden, Nick Robinson, Nicholas Savage, Gavin Stamp, Hon. James Stourton.

I owe Scott Wilcox, Melissa Fournier and Neil Smith of the Yale Center for British Art a great debt for providing all the drawings that we have used as headpieces in this book. These are by the Welsh architect James Lewis (1751–1820) and are taken from an album entitled "Ornaments and Sketches Done in the Years 1771–72 at Rome and Sundries Collected Since" (Yale Center for British Art, Paul Mellon Collection, B1975.2.781). Geoff Green has incorporated these images into his beautiful design for the book. The texts have been scrupulously copy-edited by David Hawkins, and I am grateful to Philip Wilson, publisher of David's recent monograph on Carl Laubin, for producing this volume as well.

Finally I must thank Francis Terry for the new drawing of the pineapple encircled by an *ourouboros* – the Egyptian image of a serpent swallowing its own tail – that appears embossed on the cover of the subscribers' edition and on the title page of all copies. It was David Watkin himself who, in 1996, explained Sir John Soane's understanding (drawn from the Baron d'Hancarville's 1785 *Recherches*) and usage – perhaps for the first time since Antiquity in the case of the *ourouboros* – of these emblems, which stand for the regenerative Creator and for eternity.

FRANK SALMON
St John's College, Cambridge, June 2008

PART I

THEORIES, HISTORIES AND WRITERS

Vitruvian *Symmetriae*:
The Debate about Method

RICHARD JOHN

Numerous problems faced early Renaissance architects engaged in the revival of an *all'antica* classicism, not the least of which was interpreting Vitruvius' confused account of how to set out the different *genera* of columns. In the third book of the *De Architectura*, the Roman architect began his systematic description of the Ionic *symmetriae*, the proportional relationships between the elements of the order, as follows: "If the base is to be in the attic mode, let its height be divided so that the upper part is one-third the thickness of the column and the rest left for the plinth. Then, excluding the plinth, let the rest be divided into four parts. Of these, let one-fourth constitute the upper torus. Let the other three be divided equally, one part composing the lower torus and the other, with its fillets, the scotia, in Greek *trochilus* (fig. 1)."[1] This account of series of divisions into equal parts implied a corresponding sequence of geometrical manoeuvres at the drafting table or in the mason's yard; an implication made explicit when later, in his description of the Ionic capital, Vitruvius instructed the reader to "place one leg of a pair of compasses in the centre of the capital and open out the other to the edge of the cymatium and bring this leg around and it will touch the outer edge of the bands."[2]

In the fourth book, Vitruvius approached the setting out of the Doric order with a different method based on a sequence of arithmetical calculations rather than the geometrical constructions he had used for the Ionic: "Let the front of a Doric temple at the place where the columns are put up be divided, if it is to be four-columned, into twenty-seven parts; if six-columned, into forty-two. One of these parts will be

the module, which the Greeks call *embater*. The arrangements of the rest of the work will be brought about through calculations based upon it."[3] Vitruvius continued his account of the orders using this system, giving the proportions of the remaining parts in terms of modules and fractions of modules.[4]

An architect who was concerned with how to set out the *genera* of columns in a drawing might deduce from these passages that there were two different ways of determining the proportional relationships when making a specific design: one was by a geometrical process of repeated partition while the other involved arithmetical calculation, using whole and fractional modules. The distinction seems quite clear in Vitruvius' mind because he does not refer once to the use of a module while describing the Ionic *symmetriae* in chapters four and five of book three, while conversely he uses it constantly when explaining the Doric *symmetriae* in chapter three of book four. His use of different methods for setting out each of the two *genera* may well reflect the distinct regional traditions of Ionic and Doric architecture as he perceived them from the Greek treatises to which he had access. However, because he does not give any explanation for why he uses the two different systems in his text, a Renaissance designer might just as easily assume that they were simply two interchangeable ways of approaching the setting out of the orders, and that, therefore, the choice between them was more a matter of personal preference than anything else.

Modern studies of the post-medieval classical tradition in architecture have virtually ignored this basic methodological choice facing architects, perhaps because an appreciation of the *paideia* of classicism waned when it ceased to be taught and practiced in the middle of the twentieth century. Eileen Harris and Nicholas Savage drew attention to the two different systems in their essay on "Books on the Orders" in *British Architectural Books and Writers 1556–1785* (Cambridge 1990), claiming that "The system of equal part division devised by [Hans] Blum, though easier to apply than the modules, minutes and fractions of minutes used by Palladio, Scamozzi and Vignola, was nevertheless superseded by the latter in the second half of the seventeenth century."[5] As will become apparent, this equal part system did not in fact originate with Blum and it did not die out before 1700.

More recently, Mario Carpo has tackled the topic in much greater depth in a most stimulating article, though he unfortunately adhered to the same basic historical framework as Harris and Savage. He maintained that the graphical system for representing the geometrical partitioning of the orders only appeared for the first time in 1550 with Cosimo Bartoli and Hans Blum, and that with the publication of the "modern" modular systems of Vignola and Palladio, this "dead end" approach of

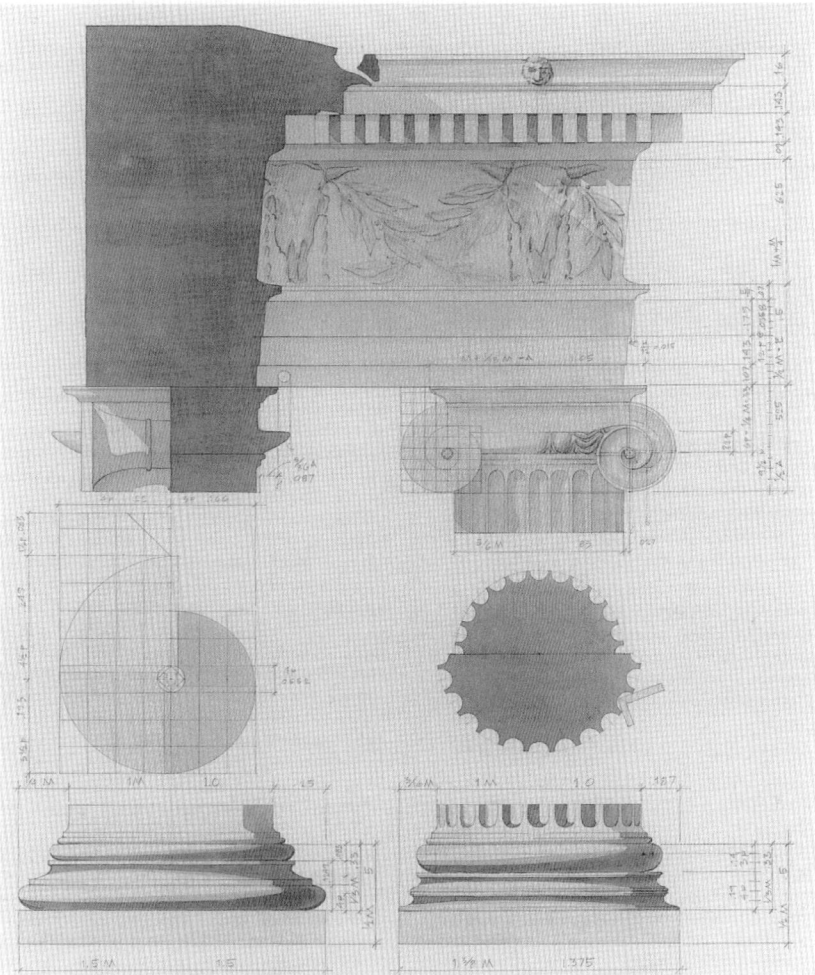

Fig. 1 Thomas Gordon Smith, Diagram of the Ionic *Symmetriae*, 2003

"visualizing geometry" was soon engaged in a "losing battle against numbers". He concluded that, by the end of the seventeenth century, "numeracy and arithmetic did gain the upper hand as the primary instrument for processing the modular proportions of the orders – a primacy that is still uncontested." [6] These claims are seriously undermined by the fact that in most illustrated architectural treatises predating 1550 geometrical partitioning diagrams are indeed used to describe the orders and also that, throughout the eighteenth, nineteenth and twentieth centuries, books which promoted geometrical rather than arithmetical methods for setting out the orders remained hugely popular. This essay attempts to correct the first of these misconceptions by tracing the increasing use of geometrical partitioning methods for graphically setting out the orders from the last decades of the cinquecento through to the middle of the seicento.[7]

Fig. 2 Fra Giocondo, *Vitruvius*, Venice 1511, fol. 29r

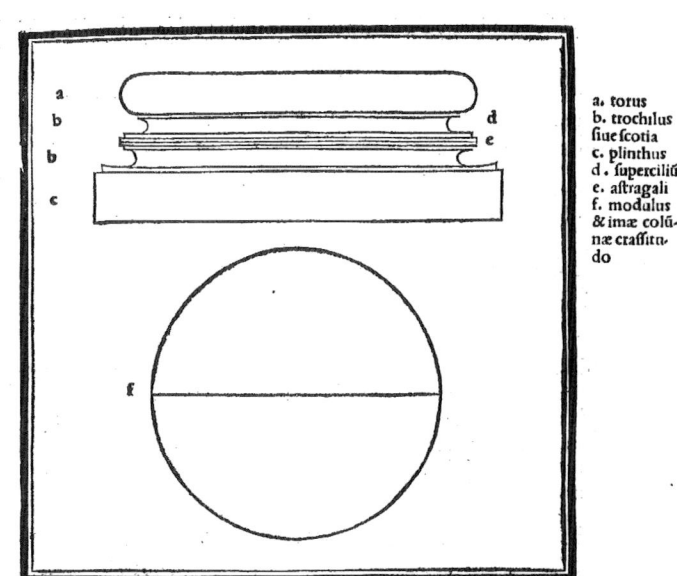

Leon Battista Alberti was keenly aware of the inadequacy of Vitruvius' description of *symmetriae* in his treatise *De re aedificatoria*, written in about 1450 and first printed in 1485. In book seven, Alberti expanded the account of setting out the *genera* to fill in those details which Vitruvius had omitted even though they were essential to completing the geometrical construction of the orders. For example, in his account of the attic base, he repeated the sequence of partitions given by Vitruvius, but when he comes to the final element, the scotia with its two flanking fillets he adds: "Nextrulo septimum spatii dedere: reliquum subexcauarunt." (give a seventh part to the fillet; the rest is hollowed out).[8]

Though Alberti's treatise remained unillustrated until 1550, his expanded account of the *symmetriae* proved influential to the graphic tradition as can be demonstrated

by noting whenever this extra stage is included in the sequence of the partitioning of the attic base. The earliest known attempt to illustrate Vitruvius comprehensively in the Renaissance is a late fifteenth-century manuscript preserved in the Biblioteca Ariostea in Ferrara.[9] The confident *all'antica* drawings, which are clearly contemporaneous with the text, are occasionally accompanied by dots, either individually or in rows and columns, laid out in such a way that there can be no doubt that they are marks or guides for the geometrical construction of the elements illustrated. The folio illustrating *De Architectura* III.v.4, clearly shows four separate columns of dots to the left of the mouldings of the attic base.[10] The first column, of four dots, indicates the division of the whole base into three equal parts to give the height of the plinth; the next column, beginning level with the top of the plinth, is of five dots indicating the division into four parts to obtain the height of the upper torus. Then three dots partition off the lower torus, and finally eight closely spaced dots indicate the division of the two fillets and the scotia.

The geometrical guide marks found in the illustrations to the Ferrara manuscript were surely intended to help an architect set out the orders. Yet, such markings are not to be found in the first illustrated edition of Vitruvius which was printed in Venice a few years later in 1511.[11] Here, the elegant images, perhaps drawn by the editor, Fra Giocondo, propose a different approach to assist in the proportioning of the orders. In the woodcuts illustrating the Attic base, the Ionic base, the volutes of the Ionic capital, and the Doric entablature and pediment, an extra feature was included in the woodcut in addition to the parts of the orders which were the subject of the illustration: a simple modular scale.[12] In the illustrations of the two bases (fig. 2), a line representing the module was circumscribed by a circle representing the lower diameter of the column; in the other two examples the one module-long line was shown in isolation (in the case of the ionic volutes, it was featured twice, on either side of the capital). The alphabetic key in the margin next to these woodcuts ensured that there would be no mistake about the identification of these lines, labeling them either as "module and lower column diameter" ("modulus & imae columnae crassitudo") or, as in the case of the Doric entablature, simply as "modulus".

In his illustrations Fra Giocondo was proposing that the *embater* or module which Vitruvius had used to describe the Doric *symmetriae* could be used to set out both the Ionic and Doric *genera* rather than the alternative method, the sequential process of partition favoured in the Ferrara manuscript. Unlike the later advocates of a modular system, such as Vignola and Palladio, Fra Giocondo did not use numbers to convey the size of the module but was instead dependent upon the dimensional accuracy of

Fig. 3 Giovan Battista Caporali, *Architettura*, Perugia 1536, fol. 82r

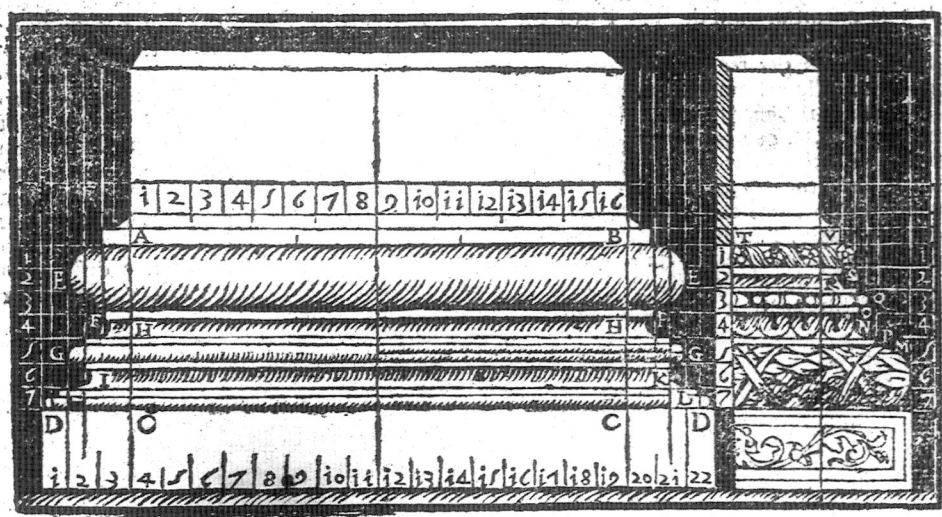

the woodcuts. In later versions of his edition, published in a cheaper and smaller format, the modular scale appears to have been generally left out of the illustration of the Doric entablature, perhaps suggesting that its usefulness was not generally appreciated or that an alternative graphical method based on geometry was beginning to gain acceptance.

Cesare Cesariano's translation of Vitruvius was printed with his extensive commentary and extravagant illustrations in Como in 1521 despite a notorious falling out between author and publisher. His woodcuts are generally cited as evidence of his almost complete reliance on contemporary Milanese architecture to illustrate the ancient text, though it is now acknowledged that he had also visited Rome, if only briefly.[13] His detailed diagrams of the orders are a little difficult to decipher, partly because of the overcrowding of details and partly because of the ill-considered idiom of using black outlines against a black background. Their reading is also hindered by the mass of grid lines, letter labels, and the rows and columns of sequential numbers all of which Cesariano employed in order to try to explain to the reader the system of geometrical partitioning one needed to use to set out the orders. He was clearly so proud of his success in developing this graphical notation that he drew attention to it in the title to the illustration of the Ionic capital and base where he pointed out that the *symmetriae* were given by "division into equal parts."[14]

Fifteen years after their first appearance, both Cesariano's woodcuts and his text were extensively plagiarized by Giovan Battista Caporali (a painter known as *il Bitte*

who had been a follower of Perugino) for his own translation of the *De Architectura*.[15] Though he did not manage to get any further than the first five books, Caporali did at least succeed in improving the clarity of Cesariano's woodcuts of the orders by revising the labeling and ensuring that the numbers marking out the equal divisions were easier to read (fig. 3).[16] The care he took to clarify the graphic representation of the geometrical constructions shows the value that he, and probably others, attached to the system. The following year Sebastiano Serlio also endorsed the approach in the first instalment of his treatise, the *Regole generale* (Venice 1537).[17] At first glance it might seem as though Serlio was not very familiar with the system, because the only sign of the tell-tale rows of dots indicating the division of elements into equal parts are two woodcuts illustrating the Ionic capital. In the text, however, Serlio included in his description of the setting out of the attic base that extra step, found in Alberti but not in Vitruvius, of dividing the scotia and its flanking fillets into seven parts to establish the heights of the fillets.[18]

Even before the publications of Caporali and Serlio in the 1530s however, the influence of both Alberti and Cesariano had been spread far beyond the Italian peninsula by Diego de Sagredo, a Spanish priest from Burgos. Sagredo, who had probably visited Italy in the early 1520s before becoming the cathedral librarian in Toledo, drew heavily on both Alberti and Cesariano to produce a popularization of Vitruvius in the form of a dialogue, the *Medidas del Romano* (Toledo, 1526).[19] In both the early Spanish and French editions of the *Medidas*, a few of the woodcuts illustrating the orders featured construction marks indicating that Sagredo was, as one might expect from his sources, quite familiar with the method of division into equal parts. For example, in discussing the setting out of the three fascias of an architrave, Sagredo describes and illustrates the division of the whole height of the architrave into twelve equal parts, with three allocated to the lowest fascia, four to the middle and five to the uppermost.[20]

Between the publication of the first French edition of the *Medidas* in 1536 and the second in 1539, the printer, Simon de Colines, decided to add some illustrations in order to make it absolutely clear how this system could also be applied to the bases of columns (fig. 4). Five woodcuts were awkwardly squeezed into the margins, shifting the main body of the text and any existing illustrations towards the gutter. No attempt at artistry was made by the draughtsman of these crude geometrical diagrams, because their import very clearly lay not in their beauty, but rather in the columns of sequential numbers arranged on one side to indicate the order and number of subdivisions.[21] Within a decade these utilitarian diagrams had been rein-

Fig. 4 Diego da Sagredo, *Raison d'Architecture*, Paris 1539, fol. 25v

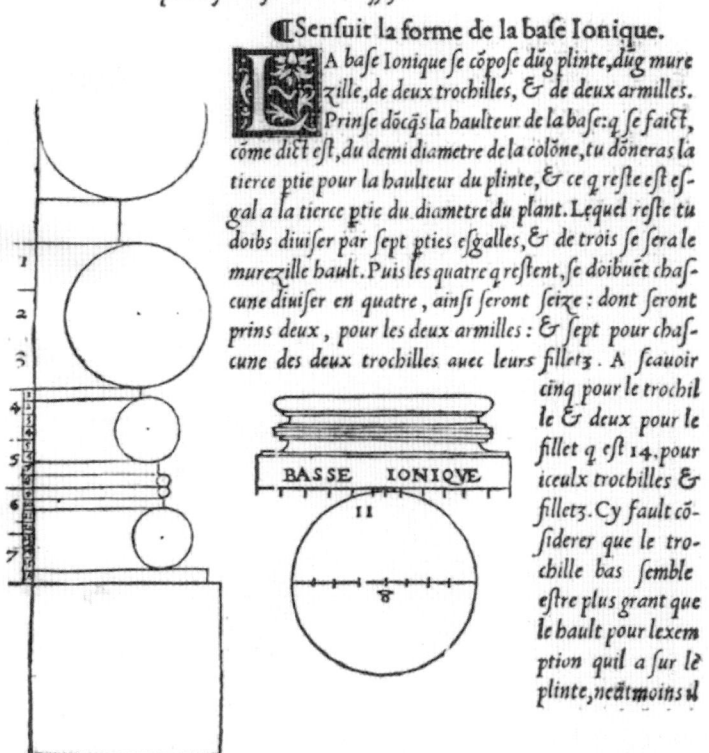

terpreted for their French audience by a far more talented hand: the sculptor Jean Goujon who provided the woodcuts for Jean Martin's translation of Vitruvius printed in 1547.[22] Here the same geometrical constructions featured as were shown in the five diagrams of column bases added by Colines to the later French editions of Sagredo, but now they were found in almost every detail of the orders. In addition to this fount of extra information, the images were made doubly compelling by Goujon's subtle shading which gave life and plasticity to the elements themselves.

In contrast to the handsome woodcuts of this French production, the first German translation of Vitruvius, which was issued the very next year from the Nuremberg presses of Johan Pitreius, was illustrated with images unashamedly recycled from Cesariano.[23] Walther Ryff, the editor, was not an architect but a physician, though he had been working on Vitruvius for most of the decade, having published

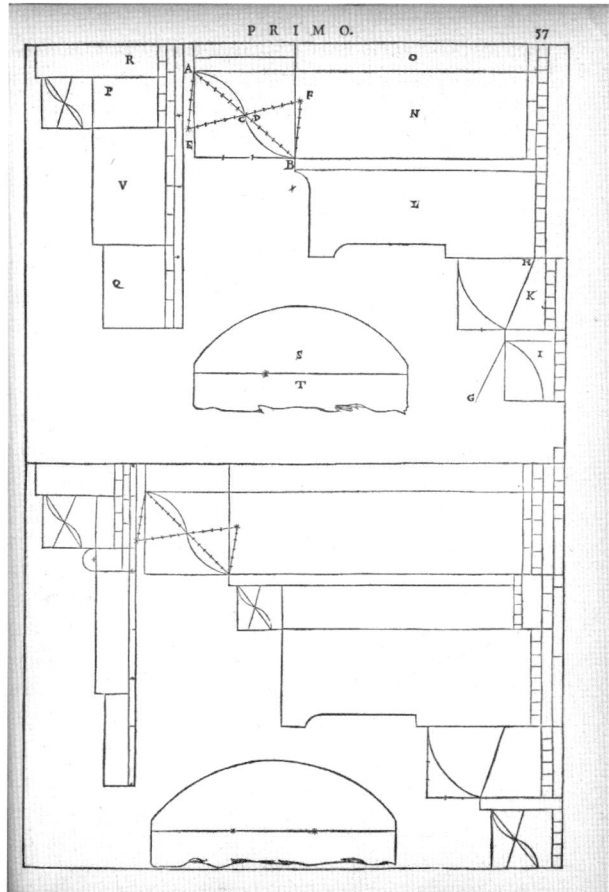

Fig. 5 Andrea Palladio, *I Quattro Libri* (Venice 1570): I, 57

a Latin edition in 1543.[24] The images in both publications were much more intelligible than the originals because the artists had thoughtfully substituted a white background for the black one of Cesariano, and the improvement in the illustrations of the orders in the Vitruvius Teutsch was particularly evident because the geometrical construction lines and their accompanying number sequences were rendered with great clarity.

By the middle of the sixteenth century the geometrical system had become ubiquitous. Hans Blum, an architect and engraver from Lohr who moved to Zurich in search of work, drew up an entirely fresh set of images — using the system to illustrate his *Quinque columnarum exacta descriptio atque delinaeatio cum symmetrica earum distributione*, in 1550. It was translated into French the following year,[25] and into English, as the *The booke of fiue collumnes of architecture*, in 1608.[26] It continued to enjoy a great popularity well into the seventeenth century, through a slew of new editions and plagiarisations.[27] Cosimo Bartoli's Italian translation of Alberti was also published in 1550 and its illustrations, the first to be supplied for the text, led the reader in a simple

stepwise fashion through the setting out of the orders using a sequence of division into equal parts.[28]

The almost universal acceptance of these methods for drawing and teaching the orders was only challenged for the first time by Vignola who adopted a purely arithmetical system based on the module in his *Regola delli cinque ordini d'architettura* of 1562.[29] Eight years later, Palladio gave a further impetus to this less familiar approach by using modules in his illustrations of the orders in the *Quattro Libri*. It should not be assumed, however, that he had rejected the geometrical method in the same way as Vignola because, in addition to describing the process of division into equal parts in the text which accompanied his plates of the orders, he also used it exclusively in two plates to demonstrate graphically how to set out the architraves and cornices of doors and windows (fig. 5).[30] To the modern scholar, Palladio's seemingly inconsistent use of these two different systems throughout his book on the orders might seem confused; it is worth bearing in mind, however, that in applying each of the two systems where he thought it was most appropriate he was following an excellent precedent: Vitruvius.

NOTES

1. *De Architectura*, III.v.2, translation by Thomas Gordon Smith from his *Vitruvius on Architecture* (New York: Monacelli Press, 2003): 100. For Vitruvius' sources on Ionic temples, see Rhys Carpenter, "Vitruvius and the Ionic Order," *American Journal of Archaeology*, 30.3 (July – September 1926): 259–69.
2. Smith, *Vitruvius on Architecture* (2003): 105.
3. *De Architectura*, IV.iii.3, Smith, *Vitruvius on Architecture* (2003): 123.
4. Mark Wilson Jones, "Doric Measure and Architectural Design 2: A Modular Reading of the Classical Temple," *American Journal of Archaeology*, 105.4 (Oct., 2001): 675–713.
5. Eileen Harris assisted by Nicholas Savage, *British Architectural Books and Writers 1556–1785* (Cambridge: Cambridge University Press, 1990): 23. It should be pointed out that the entry on Hans Blum in which his "invention" of the system of proportioning by using equal divisions is discussed, is acknowledged to be substantially the work of Rudolf Wittkower, so the mischaracterization of Blum's role may well have begun in the 1950s; Harris, *British Architectural Books* (1990): 121 n. 1.
6. Mario Carpo, "Drawing with Numbers: Geometry and Numeracy in Early Modern Architectural Design," *The Journal of the Society of Architectural Historians*, 62.4 (December 2003): 453, 458, 460.
7. I intend elsewhere to trace the later history of this method, from its use by Blondel at the end of the seventeenth century, through its great resurgence in the eighteenth century in the popular writings of Gibbs and others, to the twentieth-century revival of the method by William Ware in his *American Vignola*.
8. Leon Battista Alberti, *De re aedificatoria* (Florence: Nicolaus Laurentii, Alamanus, 1485): sig. q ii^v (author's translation).
9. Biblioteca Comunale Ariostea, Classe II, n. 176. This manuscript has recently been published in *Vitruvio Ferrarese: de Architectura*, ed. Claudio Sgarbi (Modena: Franco Cosimo Panini Editore, 2004).

10. Biblioteca Comunale Ariostea, Classe II, n. 176: fol. 40v.
11. On this edition see Lucia A. Ciapponi, "Fra Giocondo da Verona and His Edition of Vitruvius," *Journal of the Warburg and Courtauld Institutes*, 47 (1984): 72–90.
12. M.Vitruvius per Iocundum solito castigatior factus cum figuris et tabula ut iam legi et intellegi possit, [Venice: Johannes de Tacuino, 1511], fols 28v, 29r, 30r, and 37r.
13. See Ingrid Rowland, "Vitruvius in Print and in Vernacular Translation: Fra Giocondo, Bramante, Raphael and Cesare Cesariano," in Vaughan Hart and Peter Hicks, eds., *Paper Palaces* (New Haven and London: Yale University Press, 1998): 114.
14. "AEQUIS PARTIBUS DIVISIS" illustrating *De Arch.*, III.v, in Cesariano, *Di Lucio Vitruvio Pollione De Architectura* (Como: Gottardo da Ponte, 1521).
15. *Architettura, con il suo commento et figure. Vetruuio in volgar lingua raportato per m. Gianbatista Caporali* (Perugia: Bigazzini, 1536). On Caporali see Pietro Scarpellini: 'Giovan Battista Caporali e la cultura artistica perugina', *Atti del XII Convegno di studi Umbri: Perugia* (1981): 22–79.
16. *Architettura* (1536), fols 81v and 82r.
17. Sebastiano Serlio, *Regole generali di architettura. Sopra le cinque maniere degli edifici*, (Venice: Francesco Marcolini, 1537). See Vaughan Hart and Peter Hicks, trans. and ed., *Sebastiano Serlio on Architecture, Volume One* (New Haven and London: Yale University Press, 1996).
18. Serlio, *Regole generali* (1537), fol. XVIIr.
19. Diego de Sagredo, *Medidas del Romano: Necessarias a los officiales que quieren seguir las formaciones de las basas, colunas, capitales y otras pieças de los edificios antiguas* (Toledo: Remón de Petras, 1526); On Sagredo see, with earlier bibliography, Nigel Llewellyn, "'Hungry and desperate for knowledge': Diego de Sagredo's Spanish point-of-view" in Vaughan Hart and Peter Hicks, eds, *Paper Palaces* (New Haven and London: Yale University Press, 1998): 122–39.
20. Diego de Sagredo, *Raison d'architecture antique, extraicte de Victruue, et aultres anciens Architecteurs, nouuellement traduit Despaignol en Francoys* (Paris: Simon de Colines [1536]) fol. 35v.
21. On the French editions see Frédéric Lemerle, "La version française des Medidas del Romano" in F. Marías and F. Pereda, eds, *Diego de Sagredo, Medidas del Romano* (Toledo: Antonio Pareja Editor, 2000): Vol. 2: 93–106.
22. Frédéric Lemerle, "L'Architecture ou Art de bien bastir de Vitruve, traduit par Jean Martin à Paris chez Jacques Gazeau Françoys, en 1547," in S. Deswarte Rosa, ed., *Sebastiano Serlio à Lyon, Architecture et imprimerie* I (Lyons: Mémoire Active, 2004): 418–19.
23. *Vitruvius Teutsch … Marci Vitruvii Pollionis Zehen Bücher von der Architectur und künstlichem Bawen … erstmals verteutscht* (Nuremberg: Johan Pitreius, 1548).
24. *M. Vitrvvii … De architectvra libri decem* (Straßburg: Georgius Macheropeus, 1543).
25. *Les cinq coulomnes de l'architecture, ascavoir, la tuscane, dorique, ionicque, corinthie, & composite…* (Antwerp: Hans Liefferinck, 1551).
26. Hans Blum, *The booke of fiue collumnes of architecture called Tusca, Dorica, Ionica, Corinthia &Co[m]posita drawne and counterfeited after the tight semetry and cunning measors of free masons* (London: Simon Stafford, 1608).
27. See H. Günther, "Die Nachfolger Blums in Deutschland," in H. Günther, ed., *Deutsche Architekturtheorie zwischen Gotik und Renaissance*, (Darmstadt: Wissenschaftliche Buchgesellschaft, 1988): 146–48.
28. Leon Battista Alberti, *L'architettura di Leonbattista Alberti tradotta in lingua fiorentina da Cosimo Bartoli gentil'huomo & accademico fiorentino. Con la aggiunta de disegni* (Florence: Lorenzo Torrentino, 1550).
29. Giacomo Barozzi da Vignola, *Regola delli cinque ordini d'architettura* [Rome, 1562]
30. Andrea Palladio, *I Quattro Libri dell'architettura* (Venice: Domenico de'Franceschi, 1570): 22, 57, 59.

Classical Sanctuaries for Catholic London: Three and a Quarter Centuries of Continuity

RODERICK O'DONNELL

THE COMPLETION of the reredos at St Joseph's chapel, Brompton Oratory (fig. 1) took place on 19 March 2005.[1] The architect Russell Taylor's design included the addition of a concave screen of six baseless Doric columns supporting an entablature. The discussion of this design by the Oratory Art and Architecture Committee, set up in 1961, also marked more than twenty-five years of Professor Watkin's membership.

The use of the Doric order introduced a firmer, more masculine style to that great Italianate church, which demonstrates the continuities under discussion here. The wider role of the competition of the church (1878) in liberating Catholic church architecture from the Gothic Revival hegemony imposed by Pugin has been argued previously by this writer.[2] I have also suggested that its supposed "Roman Baroque" style is just as much a statement of the "Englishness" of English Catholicism, and can be seen as an homage to Wren and others.[3] The present paper considers new evidence on three classical Catholic sanctuaries in London: the Queen's Chapel at St James's Palace, as recorded in 1688; the Sardinian Embassy Chapel off Lincoln's Inn Fields, as photographed in 1905; and the high altar and sanctuary of Brompton Oratory as decorated (1888-90) by one James Cosgreave. It asks if the two former sanctuaries might have influenced the decoration of the latter. The question of the two angels at the Oratory, said to be the gift of the sculptor Edgar Boehm, is also discussed.

The Queen's Chapel at St James's Palace is the oldest surviving purpose-built

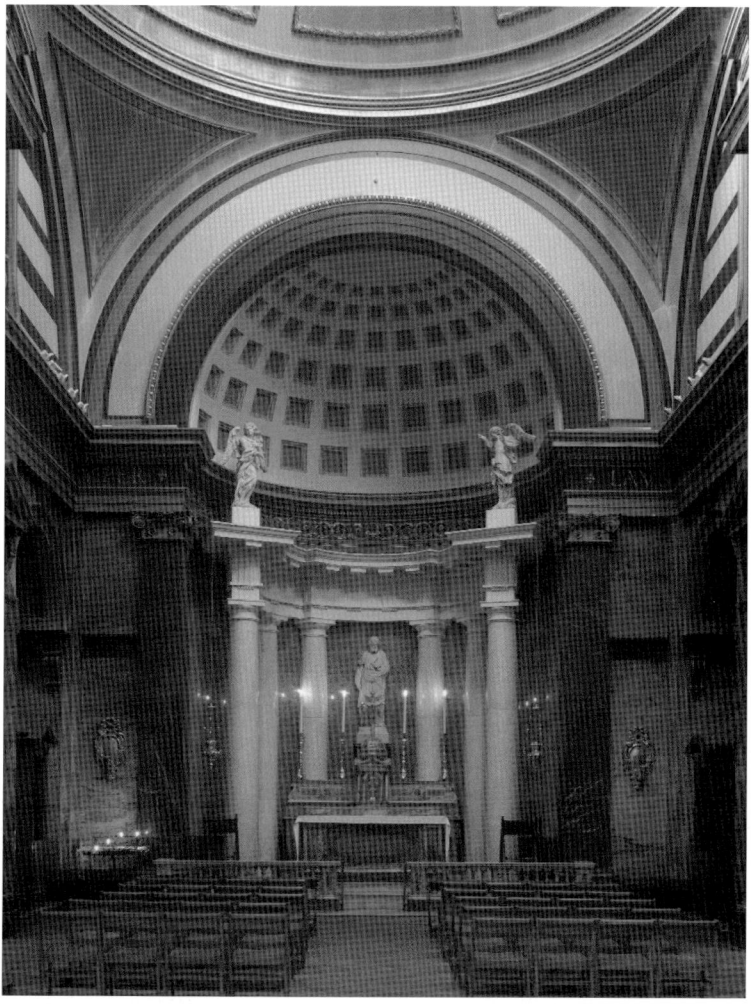

Fig. 1 St Joseph's chapel, Brompton Oratory: The concave screen of six baseless Doric columns by Russell Taylor architect, 2005 (Photo: Will Pryce, 2007)

post-Reformation place of Catholic worship in England. It was built 1623-5 for the Catholic consorts of the Stuart kings. Its attribution to Inigo Jones was only firmly recognised in the 1930s, and the importance of its east end most recently commented on by Giles Worsley.[4] Its complex history is given in the *History of the King's Works*[5] and a visual record of it as rearranged after the Restoration by Sir Christopher Wren is found in a rare print, best known from a copy in the Pepys Library, Magdalene College Cambridge.[6] This is the one invariably reproduced.[7] (There is no copy in Royal Library.) Pepys himself made the first of many visits to the Queen's Chapel on 21 September 1662, when it was first used by Queen Catherine of Braganza. He noted the Portuguese friars, the music and the sermon.[8] Since his copy of the print was cropped, with date and inscriptions missing, he gave it the title "Q.Mary's Popish Chapp.ll at S.t James's, 1688" on his manuscript table of contents of "my collection

THE PERSISTENCE OF THE CLASSICAL

Fig. 2 "Prospectus interior Sacelli Serenissima Mariae Magna[e] Britannia[e] Regina[e] Londini apud Sanctum Jacobum" and "J. Kip delin [avit] sculp[sit] et execudit" and, in manuscript, "to be sold at the Dutch glaziers house in Standhope [sic] street." (British Museum, register no. 00044567001)

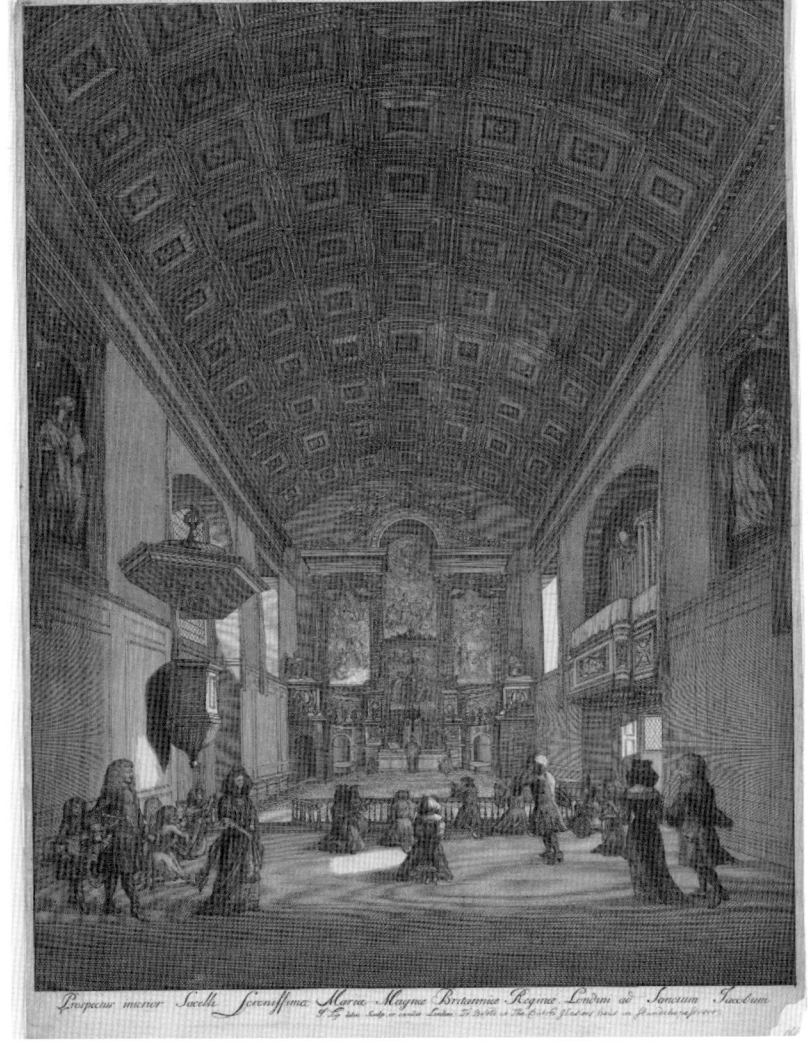

of Prints and drawings (as far extant...)."[9] The print was first reproduced in the *Wren Society* Vol. 7 (1930) with a different title.[10] Pepys's own title was that quoted by the Pepys Librarian to the Ancient Monuments Inspector G.H. Chettle[11] who used it in his seminal *Country Life* article.[12] However a copy in the Harley folios at the Society of Antiquaries has the full inscription "Prospectus interior Sacelli Serenissima Mariae Magna[e] Britannia[e] Regina[e] Londini apud Sanctum Jacobum" and "J. Kip delin (avit) sculp(sit) et execudit Londini" along with, in manuscript, "to be sold at the Dutch glaziers house in Standhope [sic] street". (fig. 2)[13] Jan Kip (or Kyp), previously thought to have arrived in London in 1689, would thus seem to have been in London earlier – in 1688 – here working alone before later collaborating with

Leonard Knyff on *Britannia Illustrata* (1707). The authorship of Kip, and the likely dating, is missed by Colvin and Thurley.[14] It was here that James Edward, Prince of Wales, was baptised on 15 October 1688.

The chapel as recorded by Kip shows Catholic ceremonies and fittings appropriate to the monastery or friary standing to the east. The scene is that of a low Mass with a priest with a two servers. Fashionable company is seen parading in the foreground; others bless themselves or tell their rosary beads and kneel at the altar rails following the Mass. The chapel has a prominent pulpit and tester on the left and organ gallery on the right (of which the gallery front survives) which was installed in the high summer of 1688, giving the most likely date of the print.[15] Preaching and music were important activities here. The niches house statues with labels of St Augustine of Canterbury with a primatial cross (right) – the first missionary from Rome to England – and St Benedict (left) – the founder of the Benedictine order. Charles II and James II also provided a staff of English Benedictines, and fourteen English Benedictine priests were here in 1685-8.[16] At the east end are the arms of Catherine of Braganza, flanked by flying angels carved by Grinling Gibbons, which survive today. Below this is the east window which seems to serve as a screen or *transparente*, since it is paintings, rather than an actual window, that are within its frame.[17] This astonishing sanctuary arrangement of 1682-4 is by Wren. The paintings can be identified as St Cecily (left), a central martyr with a palm ascending, and Angels (right), probably canvases changed according to the liturgical feast or season. (Lighting was also controlled by curtains to the windows.) In a separate frame immediately above the altar is a Holy Family rendered by the Dutch Catholic Jacob Huysmans. Two adoring angels kneel at the extremities of the reredos, their stance being in adoration of the hosts consecrated at Mass, and kept in the massive tabernacle on the altar (also decorated by Huysmans) similarly indicated by the hanging sanctuary lamp. The two quadrants with niches and their returns with roundels of SS Peter and Paul survive, as do the doors giving access behind the altar to a domed choir in which the Divine Office and Mass settings would be sung. Catholic services ceased with the Glorious Revolution, and some Benedictines were imprisoned; the choir was demolished in 1709. The Society of Antiquaries' Harley folios also have Jacques Rigaud's print of the interior as arranged by William Kent for the marriage of Princess Anne and Prince William of Orange, 17 March 1733.[18]

BROMPTON ORATORY: THE HIGH ALTAR

The London Oratory, set up in 1849, is a community of priests following the Rule of St Philip Neri, governing itself through two bodies: the three-man Congregation of Deputies, and the wider General Congregation, the minutes of which, with the collection of architectural drawings, form the research basis of this topic.[19] Their church, built 1880–84 by the architect Herbert Gribble, was opened with a decorative scheme for the sanctuary still to be decided on. The competition *Instructions* specified that the high altar from the previous church would be re-used.[20] Early photographic evidence suggests that this altar, clearly enlarged, survives in the present church, and this confirmed by the first guide (1884).[21] Although the *Survey of London* identified reused furnishings from the earlier church, such as the altar rails and floor in the sanctuary, it made no comment on the design or date of the high altar. The evidence which emerges from the Oratory archives is one of dithering over the decoration and reuse of existing furniture, suggesting both Oratorian conservatism and the low status of their architect, Gribble.

On 7 February 1883, in a cost-cutting mood, the decision was taken by the Congregation of Deputies for "replacing the High Altar and sanctuary floor ... each of these items to be subject to a vote of the General Congregation."[22] On 27 April 1883 the General Congregation voted for an "estimate and replacing in the New Church the old High Altar with the addition of two steps to the already existing three and increase the width of the super altare;"[23] and on 20 June 1883 it accepted "Mr Goad's estimate for replacing and making alterations to the old High altar...£300," that is the marble supplier Goad of Plymouth.[24] Significantly the architect is not mentioned, and the only related drawing surviving for this work is a tracing labelled "Design for laying out the sanctuary floor," which shows the current altar in position with extensions either side hatched in. Although there is an undated drawing by Gribble showing foundations to support four piers for his unexecuted baldachino (see below) there is nothing else for the actual high altar. By contrast, more detailed drawings survive showing his designs for the foundations of the Sacred Heart altar (and others which were to follow its details), and that for the fixing of the Lady altar from Brescia.

Then in April 1886 an Oratorian, Fr Kenelm Digby Best, offered to pay for the "renewal of the High Altar" as well as the decoration of the sanctuary and a "new high altar."[25] Could this have been a new structure? If so, no drawings survive for it. Despite the use of "replace" and "new," it would seem that the re-used altar was yet

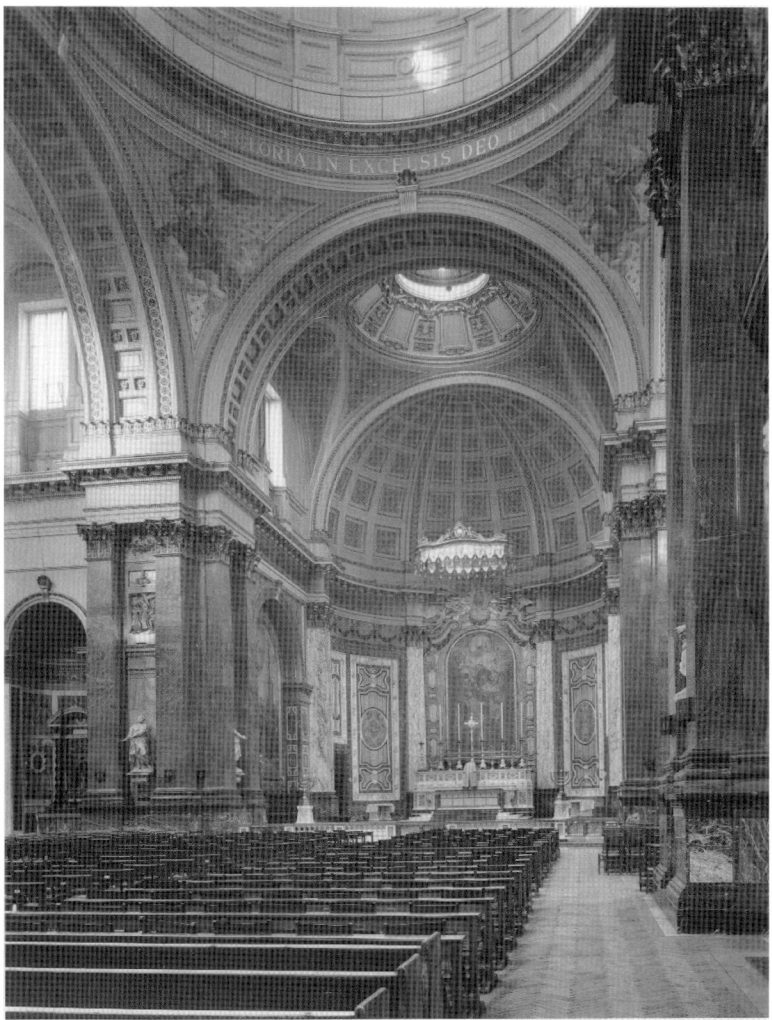

Fig. 3 Brompton Oratory (1878–84) by Herbert Gribble architect, the sanctuary incorporating the altar by J.J. Scoles, the wall revetments by J. Cosgreave and angels here attributed to Boehm (photograph RCMHE, 1948)

further adapted and ornamented piecemeal – as Fr Best's further gift design for a new tabernacle in December 1887 and the acceptance on 2 July 1890 of his gift of "additional gilt ornament" both suggest.[26]

Underlining its interim status, the high altar was not consecrated along with the church in April 1884, an omission rectified only in 1934.[27] But I argue that it is the altar from the earlier church which survives, and the reference to "the original altar as made of wood, and moved to the church at Chiswick," must refer to a further antecedent high altar to the one retained in 1884.[28] The existing altar is therefore identified as "the grand altar" from the previous church by the architect J.J. Scoles. (fig. 3)[29] Three other Scoles side altars from the previous church also survive, notably that of St Joseph for which there are drawings dated 1861. Given the maintenance of

THE PERSISTENCE OF THE CLASSICAL

tradition here through forty years of liturgical turmoil, this makes the high altar at the Oratory the oldest in daily use in the whole of Catholic London.

THE DECORATION OF THE SANCTUARY

The church was opened with a decorative scheme for the sanctuary still undecided, although a design of Gribble's with an altar under a baldacchino (fig. 4) was already known from his watercolour of the interior (1878),[30] provided for by his drawings made for foundations. Four further drawings of 1888, his most elaborate since the competition and contract sets, show him working towards the forms of the current sanctuary decoration but without the fluency of that ultimately achieved; Gribble fails to hit on the characteristic S-scroll broken pediment over the east end painting of the Assumption with St Philip after Concha, which had also been retained from the previous church.[31] The ambition of these drawings suggests him trying very hard to keep his name in competition, and

Fig. 4 H. Gribble's scheme for the sanctuary of the Oratory, from a watercolour of 1878, labelled "Interior view: The new church of the Oratory South Kensington," Herbert A. Gribble MRIBA architect (Photo: courtesy English Heritage, *Survey of London*)

unconvincingly point towards an overall marble cladding. His sanctuary scheme, rejected in January 1888, was reinstated for one week in June 1888 before a second and final rejection.[32] What he would have preferred to do can be seen in the St Philip altar (1890). Two Gribble drawings have a blank white overlay or outline to show the high altar reused. Instead, the decoration of the sanctuary was given to Cosgreave who is identified with only an initial and surname in the in the *Survey of London*.

James Patrick Cosgreave (1845-1901) was described by an obituarist as one who "devoted his services to the Oratory" and as "a journeyman decorator … who would never receive more than a journeyman's wage."[33] Both his names and piety remind us of the strong Irish presence in the nineteenth-century Oratory pews.[34] His name first appears in the General Congregation Minutes for 30 September 1884, when his scheme to decorate the apse of the St Wilfrid chapel, at the expense of the influential Fr Charles Bowden, was accepted unanimously by the Fathers (a very unusual thing).[35] After the first rejection of Gribble's ideas, Cosgreave's design for "the decoration of the small dome of the sanctuary and [to] veneer the four *inner* pilasters … with marble" was approved on 14 January 1888.[36] In June they agreed to "four pilasters

Fig. 5 LOA Drawings, unsigned, undated sketch c. 1888 of east end cartouche. (Photo: Roderick O'Donnell, 2008)

veneered in pavanozzo marble," and September saw them "accept Mr Cosgreave's design for the wall panels in the sanctuary apse"[37] — that is the two magnificent bays of onyx with a central jasper oval, all framed in statuary marble with black borders. These involved the removal of Gribble's door pediments and other details recorded in early photographs. Cosgreave also designed the "lower frieze" of putti and swags, and the lettering "Domus mea…" in the upper frieze.[38] Furthermore, he decorated the vault, although the references are confused: decoration of "the alternate coffers of the sanctuary apse" was approved 27 June 1888 (probably infilling of the coffers), and on 14 November another approval was given for the sanctuary roof.[39] Further approval was given in May 1890 for unspecified marbles, presumably for those in the right and left hand sanctuary.[40]

According to his obituarist, Cosgreave even made an Italian tour (like that of J.F. Bentley while designing Westminster Cathedral), as John Newman did to Paris for St Mary Moorfields.[41] The obituarist also claimed that Cosgreave took "the general scheme for the marbling of the apse [from that at] St John Lateran [Rome] and the vault decoration from that at the Certosa at Pavia."[42] His aedicule surround to the picture is of timber faced in scagliola with onyx panels in gilt wood frames, which the *Guide* (1901) says is based on the "Confession at St Peter's."[43] By contrast with the

Fig. 6 "The Catholic Chapel," A.C. Pugin and Rowlandson print (1808) (courtesy Charles Plante Fine Art)

many contemporary schemes for St Paul's Cathedral in painting or mosaic the use of such extensive marble revetment was remarkable in the 1880s, and anticipates the internal decoration of Westminster Cathedral from 1903. That this was the achievement of a "journeyman decorator," and evidently without the help of Gribble, seems extraordinary.

THE ROLE OF BOEHM

But was there another mind behind the design? The picture aedicule is topped by two scrolled brackets as a sort of broken pediment form with a central cartouche with an exposed heart – to suggest the Immaculate Heart of Mary, the dedicatory title of the church, luridly picked out in flaming red in the 1984 redecoration. It is crowned by a sunburst glory supported by two angels, which are said to be "Italian work of a good period the gift of the late sculptor Sir Edgar Boehm."[44] Fr Ralph Kerr's notes, however, refer to "Mr Boehm's gift of the two angels over the great door" as accepted in December 1884, well before the façade (1890-3) was begun.[45]

Gribble had drawn up the façade as part of the competition and the contact drawings. One of his pen and ink drawings is overlaid in pencil and wash with two

Fig. 7 The Sardinian Embassy Chapel dated May 1905, photo by the London County Council Architect's department, (English Heritage, London Region Historic Photograph Collection)

floating angels holding fronds, with the pencil inscription "Drawing showing the proportion of two figures proposed to be placed over the large western entrance December 2 1884."[46] This would seem to be consideration of such a gift, but presumably because of the delay in completing the façade, its actual destination would turn out to be the sanctuary. The key to all this may be an unsigned, undated and previously unpublished pencil sketch (fig. 5) in a hand unique in the collection, showing the angels, the sunburst, the cartouches and the picture frame almost exactly as in the completed sanctuary. Tellingly the S-scroll pediment is its trademark, and it also shows Cosgreave's swagged frieze and marble panel outline, as agreed in 1888-9. The angels are girlish and 'sweet' in a late Victorian taste, but those actually installed are

more androgynous and Baroque, perhaps inspired by the relationship with the martial seventeenth-century baroque angels by Thomas Ruez in the spandrels from the Lady altar from Brescia, installed in 1883-4, as well as the other Baroque statuary which Boehm, whose studio was nearby, must surely have studied.[47] In addition, their scale, materials, and the crucial positioning of the sanctuary surely establish them as the sculptor's work, rather than imports from Italy.[48] They are evidently of plaster, on armatures fixed into the wall, the beautiful limbs and wings defying gravity, their hands bearing fronds raised in awe of the Immaculate Heart. Cosgreave was authorised to make "certain alterations to the centre ornament over the picture" on 2 January 1889[49] and as Boehm was dead by December 1890, they must have been installed during those 22 months.

The Austrian Boehm is not noted for his churchwork, other than monuments, and his angels, such as those on a church reredos in Newmarket, are significantly feminised.[50] I posit that in the last decade of his life he was not only the unacknowledged, but also the crucial hand, in the evolution of the sanctuary of the Oratory's decoration, and the donor of these works of art otherwise so little recorded in the archive. Perhaps this was as *mea culpa* for abandoning the Catholic faith of his fathers on his marrying into an English family. Could the position of the Oratory angels – half-heraldic, half-iconographic – in fact be a reference to the angels and royal arms in the Queen's Chapel, by a sculptor intimate with the court and royal circle?

The indecision over the decoration of the sanctuary, and the reuse of existing furniture, suggest that the Fathers were still reacting to the tensions of the Pugin period, in which an Oratorian party was recognisable in the Rood Screen Controversy.[51] The "glare" of east windows had been specifically blamed on Pugin, and east-end reredoses, retables or paintings suggested. Windowless east ends had been recommended for the sanctuaries of new churches during the Rood Screen Controversy, specifically in G.J. Wigley's *St Charles Borromeo's Instructions on Ecclesiastical building* (1857), a translation of a crucial Counter-Reformation text.[52] In referring to such Latin and Counter-Reformation practice, the Oratorians were in fact reviving the pre-Pugin practice of a prominent 'painting' above the altar (usually a crucifixion), as found, indeed at the Queen's Chapel in 1688, and in the Catholic country house chapel or even the town chapel.

THE SARDINIAN CHAPEL

One of the most venerable of these chapels, as the Catholics called their places of worship before Pugin, survived in late Victorian London: the former Sardinian Embassy chapel. Built in 1762 by the Sardinian architect Jean-Baptiste Jacques, it survived the attack during the anti-Catholic Gordon Riots in 1780.[53] The east end "painting" of the Descent from the Cross by John Francis Rigaud was housed in a gilt frame set within an aedicule and crowned by paired consoles; was this a possible source for that adopted in the Oratory? This arrangement, known from the A.C. Pugin and Rowlandson print (1808) (fig. 6) was in 1884 a mere journey across town. It is this church that is recorded in photographs by the London County Council Architect's department, some dated May 1905, one of which is here published for the first time (fig. 7). The Sardinian Embassy chapel had fallen on hard times and was considered by few — except the L.C.C. Architect's department — and perhaps even an Oratory father, or Cosgreave, as of interest in a London beguiled by the exoticism of Westminster Cathedral. The parallels between the sanctuaries of the Queen's Chapel, the Sardinian Chapel and the Oratory show more than three and quarter centuries of continuity in the decoration and iconography of Catholic sanctuaries in London.

NOTES

1. *Church Building* 93 (May/June 2006): 18-19.
2. Roderick O'Donnell, "The Architecture of the London Oratory Churches" in *The London Oratory Centenary 1884–1984*, eds. Michael Napier & Alistair Laing (London: Trefoil, 1985): 21–47.
3. O'Donnell, "Catholic church architecture in England: 'Irish occupation' or 'the Italian mission'?" in *Architecture and Englishness, 1880–1914*, D. Crellin and Ian. Dungavell, eds., Papers from the Annual Symposium of the SAHGB, 2003 (2006): 59–71, ref.: 68–69.
4. Giles Worsley, *Inigo Jones and the European Classicist Tradition* (New Haven and London, 2007).
5. H.M. Colvin, ed., *History of the King's Works* (London: HMSO, 1975): 3, 130, 138, 163–64; 4 (1982): 248–49; 5 (1976): 244–54.
6. *The Catalogue of the Pepys Library at Magdalene College Cambridge* 3 (Robert Latham, General ed.), A.W. Aspitel, *Prints and Drawings*, Pt. 1: (London: Boydell & Brewer, 1980).
7. As in Simon Bradley, "The Queen's Chapel in the Twentieth Century" in *Architectural History* 44 (2001): 293–302, the most up to date account.
8. *The Diary of Samuel Pepys*, Robert Latham and William Matthews, eds.. 9 vols. (London: George Bell and Son, 1970–6) 3: 202.
9. *The Catalogue of the Pepys Library*, Pt 1: *General*, (Plate 2972/186: "Queen Mary's popish Chappell at St James's, 1688"): 15; identified by the editor as "Etching with engraving by J. Kip. The bottom margin with the lettering has been cut off."
10. *The Seventh Volume of the Wren Society 1930: the Royal Places of Winchester... and St James's ... 1660–1715*, A.T. Bolton

and Duncan Hendry, eds., (Oxford: for the Wren Society at the University Press, 1930): 207, 209, 254 and pl. 28, as "St James's Palace, Chapel of Mary of Modena, Queen of James II ... Pepys."

11. Francis McD. Turner, Pepys Librarian, to Chettle 20 October 1938, English Heritage, London, GHEU, CB/57/A/4/0. George Chettle (b.1886) who joined HM Office of Works on 28 October 1929, (Assistant Inspector on 5 May 1938, promoted Inspector by 1946), was largely responsible for the architectural-historical aspect of the restoration of the Queen's House (1934–6) and the Queen's Chapel (1938–9).

12. G.H. Chettle, "Marlborough House Chapel, St James's Palace," *Country Life* (5 November 1938): 450–53.

13. Society of Antiquaries (London), f. 61 of vol. 6 of the Edward Harley, 2nd Earl of Oxford, collection. The print is not listed in the ms index. (There is another copy in the British Museum, reproduced here: 00044567001.) The inscription and authorship were noted on p. 74, n. 17 in R. O'Donnell, "The interior of St Mary Moorfields [London]," *The Georgian Group Journal* 7 (1997): 71–74.

14. H.M. Colvin, ed., *History of the King's Works* 5, (London: HMSO, 1976): pl. 28, described as "a seventeenth-century engraving" (245), without attribution to an artist; Simon Thurley, "The Chapel Royal 1618–1685," in *Architectural History* 45 (2002): 238–74. Here it is described [fig. 10] as "by an unknown, probably continental, print maker."

15. Simon Thurley, *Whitehall Palace, an Architectural History of the Royal Apartments, 1240–1698* (New Haven and London, 1999): 135; the date on pl. 135 is therefore wrong.

16. [Dom] Geoffrey Scott [OSB], *Gothic Rage undone: the English Benedictines in Exile* (Stratton-on-Fosse: Downside Abbey Press, 1995): 13.

17. David Baldwin, *The Chapel Royal, ancient & modern* (London: Duckworth, 1990): 137–43. This gives the very confusing story of the paintings, and dates the Kip to "1687": 136.

18. Society of Antiquaries (London), f. 59 of vol. 6 of the Edward Harley collection. There is a pirated version at f. 60.

19. I wish to thank the Rev. Fr Rupert McHardy, Cong. Orat, archivist, for access to the London Oratory Archive (LOA), in particular to the uncatalogued collection of architectural drawings.

20. LOA, New Church file, "Instructions to Architects offering designs for the new Church of the Oratory."

21. LOA Photographs in an undated album show that the recessed outer pier and console bracket on both sides are additions; the plinth has been heightened. *The Description of the New Church of the Oratory* (London, B.F. Laslett, n.d. c 1884): 11, has the "altar, which originally stood in the old church, but has received further additions and embellishments."

22. LOA, Congregation of Deputies, 7 February 1883.

23. LOA. General Congregation, 27 April 1883. Only four steps (not five) were made. "Oratory in London chronology 1845–1947." typed ms c. 1947 of notes by Fr Ralph Kerr (died 1932) has "replace old High altar with additions. £300" under Feb. 1883.

24. LOA. Gen Cong, 21 June 1883. John and E. Goad, Phoenix Marble Works, Stonehouse, Plymouth signed contract drawings to supply the marble of the major and minor orders 20 January 1880. The capitals were omitted from this contract.

25. LOA, "Oratory in London chronology 1845–1947." An ms addition has "new high altar first used 19 September 1886."

26. "Oratory in London" under December 1887; and LOA, Gen. Cong. Minutes, 2 July 1890.

27. LOA, Oratory in London: 4.

28. LOA, "Various memoranda relating to the London Oratory history by FF Philip Gordon, RF Kerr…": 391–92. This may refer to the high altar from the Strand Oratory (1849–1953).

29. Scoles' temporary church (1853–4) was improved in 1858 (*Builder*, 1858: 500–01) where the "grand altar" is referred to; see also *Building News*, 1858: 690, 696. J.J. Scoles, architect, was the father of two priest-architects; for these Catholic dynasties, see R. O'Donnell "Pious bachelors, converts, fathers and sons: Catholic architectural practice 1791–1939" in Andrew Derrick, ed., "Catholic Architecture," special number of the *Ecclesiologist* 38 (May 2007): 25–36.

30. *Survey of London 41, Southern Kensington, Brompton* (London, Athalone Press, 1983): frontispiece.
31. LOA, Oratory in London, under March 1887. This replaced by the current copy by Pozzo 1928.
32. LOA, Congregation of Deputies Minutes, 14 January 1888; and then 11 June 1888, only to be rejected by the vote of the General Congregation, (Minutes 18 June 1888).
33. LOA, "Oratory notes 1845–1910," Cosgrave obit.: 108.
34. Sheridan W. Gilley, "Vulgar piety and the Brompton Oratory, 1850–60," in *Durham University Journal* (1981).
35. LOA, Gen. Cong., 30 September 1884.
36. LOA, Cong. of Deputies Minutes, 14 January 1888.
37. LOA, Gen. Cong. Minutes, 18 June 1888; 26 September 1888.
38. Ibid., 29 September 1888.
39. Ibid., 27 June 1888; 14 November 1888.
40. LOA, Cong. of Deputies Minutes, 7 May 1890. The marbles are identified in Henry Sebastian Bowden, *Guide to the Oratory South Kensington*, (London: Burns & Oates, 1901): 30–31.
41. O'Donnell, "St Mary Moorfields [London]," (1997): 71–74.
42. LOA, "Oratory notes 1845–1910": 108. The marbling is akin to that in the transepts of the Lateran, but the "Certosa at Pavia" reference does not agree with modern readings of this building.
43. Bowden, *Guide to the Oratory* (1901): 32. The marbling is similar to much in St Peter's, but hardly that in the Confession.
44. Ibid.
45. LOA, Oratory in London (Kerr, on Boehm's gift).
46. LOA, undated drawing in Gribble's hand c. 1880 with additions dated 2 December 1884.
47. *Survey of London 41, Southern Kensington, Brompton* identifies him as a resident at 34 Onslow Square nearby (103, 111), but does not mention him as involved at the Oratory.
48. Alistair Laing, "Baroque sculpture" in *The London Oratory Centenary 1884–1984* (1985): 65–83, does not notice the cartouche angels nor identify them as Boehm's gift.
49. LOA, Gen. Cong. Minutes, 2 January 1889. Denis Evinson, *Catholic churches of London*, (Sheffield Academic Press, 1998): 166, gives the cartouche but not the angels to Boehm.
50. Mark Stocker, *Edgar Boehm, Royalist and Realist: the life and work of Sir Joseph Edgar Boehm* (New York and London: Garland, 1988) does not mention this gift. However Prof. Stocker is content with my analysis of Boehm's role at the Oratory.
51. A. Welby, *Pugin: A Treatise on Chancel Screens And Rood Lofts, Their Antiquity, Use, and Symbolic Signification* (1851), (reprint, Gracewing, Leominster, 2005), R. O'Donnell, Introduction: vii–xviii.
52. J.G. Wigley, trans., *St Charles Borromeo's Instructions on Ecclesiastical building* (London, 1857). This view was repeated in the only English language *vademecum* on church architecture between Pugin and the Second Vatican Council, J.B. O'Connell's *Church building and furnishing: the Church's way* (London: Burns & Oates 1955).
53. R. O'Donnell, "The architectural setting of Challoner's episcopate," in *Challoner and his Church: a Catholic Bishop in Georgian England*, E. Duffy, ed., (London: Darton, Longman and Todd, 1981): 55–70.

The "dissociation of sensibility" and the "tyranny of intellect": T.S. Eliot, John Summerson and Christopher Wren

ANTHONY GERAGHTY

THE RECENT LITERATURE on Sir John Summerson has explored his attitudes to Modernism, conservation, and periodisation.[1] Much less is known, however, about his intellectual formation. This short article explores Summerson's engagement with the literary criticism of T.S. Eliot. More specifically, it argues that Summerson's celebrated essay on "The Mind of Wren", first published in 1937, was directly modelled on Eliot's interpretation of metaphysical poetry and on his theory of the "dissociation of sensibility". The methodological consequences of this borrowing will be explored: what happens when modes of enquiry devised in response to poetry are applied to architecture?

The "Mind of Wren" was awarded the Royal Institute of British Architects' Silver Medal for 1936 and published in February 1937 as "The Tyranny of Intellect: a study of the mind of Wren, in relation to the thought of his time".[2] It was reprinted, twelve years later, in *Heavenly Mansions*, a volume of collected essays.[3] As Summerson noted in the preface to that work, the Wren essay was "the longest and the oldest" in the book, and he undertook a number of minor alterations. Firstly, he shortened the title to "The Mind of Wren". Secondly, he rewrote the opening paragraphs. And thirdly, he omitted the bibliography appended to the 1937 version.

The 1937 version of the essay begins apologetically: "Much has been written on the subject of Christopher Wren, and to offer yet another study, and one which contains no factual contribution to knowledge, calls for an apology." Similarly, the reader is urged to "reflect that I am not trying to belittle my subject, nor to score off

previous writers."[4] The defensive tone is hardly surprising, for Summerson was writing against a background of Victorian and Edwardian Wren adulation. The cult of Wren had climaxed with the bicentenary celebrations of 1923, when the Royal Institute of British Architects published a commemorative volume of essays, at times hagiographical in tone.[5] 1923 also saw the founding of the Wren Society, which eventually issued twenty volumes of primary material,[6] later described by Summerson as "a treasury of knowledge ... the material on which any complete exposition will have to be based."[7] This scholarly vibrancy was bound up with what Lutyens termed the "Wrenaissance". "A whole generation of Architects", Summerson recalled in 1953, "enjoyed themselves in the sunshine of this Wren revival".[8] 1936 saw an exhibition on Wren at St Paul's Cathedral[9] — perhaps the immediate stimulus for the essay — together with the publication of Volume 13 of the Wren Society, which returned to the subject of St Paul's and announced the discovery of Wren's First Model design for the cathedral. The Model, as we shall see, plays a crucial role in Summerson's argument.

This, then, is the background to the appearance of "The Mind of Wren", a background that Summerson deliberately set himself against. As he explained at the outset of the essay, existing assessments of Wren — and architectural history more generally — were (in his view) ahistorical and uncritical: "the architecture of the past," he warned, "is in danger of being ignored because it is presented without relevance to the main issues of history." Summerson was therefore "attempting a new treatment" of Wren: one that was genuinely historical — "concentrating not on the life and work of the architect himself but on the relationship which these bore to the social, political and philosophical thought of his time;" and genuinely critical — bringing "definition to that too vague 'greatness' which, in Wren's achievement, we all acknowledge."[10] And to do so he looked outside the architectural profession, to the serious, high-minded world of literary criticism.

There was of course a generational aspect to this. As a young man, Summerson had (in his own words) "worked in offices which were still perfectly Edwardian, if not Victorian."[11] But by the early 1930s he was a committed Modernist, and in 1933 he became a founder member the MARS group. For such a person, the monumental classicism of the Wren Revival was a thing redundant. Yet Summerson remained fascinated by Wren, and he returned to him again and again in his published writings. Clearly he saw Wren as something of an alter ego. In particular, he identified with Wren's dual career, a career that echoed his own, albeit in reverse.

The scholarly ambition of "The Mind of Wren" is apparent from the bibliography

appended to the 1937 version. This lists an impressive array of sources — both primary: John Dryden's *Essay of Heroik Plays*, John Evelyn's *Parallel of Architecture*, Robert Hooke's *Diary*, John Locke's *Essay Concerning Human Understanding*, Samuel Sorbiere's *Voyage to England*, Thomas Sprat's *History of the Royal Society* — and secondary: T.S. Eliot's *Homage to John Dryden*, Allardyce Nicoll's *Restoration Drama*, G.M. Trevelyan's *England Under the Stuarts*, W.C.D. Whetham's *History of Science*, Basil Willey's *The Seventeenth Century Background*, and (in English) Heinrich Wölfflin's *Principles of Art History*. Most of these works are cited in the main text. The Eliot, however, is not, and with the silent omission of the bibliography, Eliot's influence on Summerson has dropped — possum-like — out of view.

Eliot's *Homage to John Dryden* was published by the Hogarth Press in 1924.[12] It contains three short essays on seventeenth-century English poetry (all three were originally published in *The Times Literary Supplement* in 1921): the one on Dryden, one on the Metaphysical Poets, and one on Andrew Marvell. Of the three, "The Metaphysical Poets" is the best known, for it contains Eliot's famous theory of the "dissociation of sensibility". Summerson's interest in Eliot should be set against his move to Bloomsbury in the early 1930s, when he fell in with a literary set that included, amongst others, Geoffrey Grigson and Herbert Read. Read was employed by Eliot on the *Criterion*, and there is every possibility that Eliot and Summerson met one another at this time.[13]

So what did Summerson take from Eliot? Arguably, an interest in the early modern period. By the mid-1930s, Eliot's literary criticism had made the seventeenth century intellectually fashionable. Summerson's interest in Wren needed no such sanction, but it may be significant that none of his earlier writings had dealt with seventeenth-century subjects. More significantly, in the *Homage to Dryden* Eliot provided a model of scholarship that was genuinely critical:

> To bring the poet back to life — the great, perennial, task of criticism — is in this case to squeeze the drops of the essence of two or three poems ... [so that] we may find some precious liquor unknown to the present age. Not to determine rank, but to isolate this quality, is the critical labour.[14]

Summerson, as we have seen, was likewise attempting a critical assessment of Wren's achievement. As we have seen, Summerson aimed to "bring some definition to that too vague 'greatness' which, in Wren's achievement, we all acknowledge." To enjoy St Paul's "as a work of architecture," he writes elsewhere in the essay, "requires a little more effort than to honour it as an object of sentimental regard."[15]

For Eliot and Summerson, this engagement with quality was bound up with a revisionist desire to resituate their subjects within the canon. In 1921, when Eliot was writing, the term "metaphysical poetry" was still "a term of abuse, or ... the label of a quaint and pleasant taste."[16] For Eliot, however, the metaphysical poets were the last true exponents of the English poetic tradition. They — together with the playwrights of the previous generation — represented "the main current" of the English tradition, a tradition interrupted, Eliot believed, in the middle years of the seventeenth century. Summerson begins his story at the other end of the seventeenth century, with Wren, but his evaluation of the century is essentially the same: the age of Wren (and Milton) represented a falling off from the age of Jones (and Donne).

Eliot's explanation as to why this was has become famous. "In the seventeenth century," he writes, "a dissociation of sensibility set in, from which we have never recovered."[17] The metaphysical poets, together with their immediate predecessors, displayed "a fidelity to thought and feeling."[18] They "incorporated their erudition into their sensibility: their mode of feeling was directly and freshly altered by their reading and thought ... there is a direct sensuous apprehension of thought into feeling."[19] This unity of "thought and feeling," however, was ruptured in the middle years of the century. To illustrate this point, Eliot contrasted Donne with Tennyson. "The difference," he concludes,

> is not a simple difference of degree between poets. It is something which happened to the mind of England between the time of Donne or Lord Herbert of Cherbury and the time of Tennyson and Browning; it is the difference between the intellectual poet and the reflective poet. Tennyson and Browning are poets, and they think; but they do not feel their thought as immediately as the odour of a rose.[20]

This dualistic notion of creativity is likewise central to Summerson's argument, which is unambiguously stated at the outset of "The Mind of Wren": "Both intellect and imagination, intuitively co-ordinated, are necessary to creative design, and the quality of a design depends on the measure of completeness in this co-ordination."[21] For Summerson, this was a universal truism that transcended time and place, and the same criteria are applied throughout his early writings. To cite just one example: his "Antitheses of the Quattrocento" essay, also published in *Heavenly Mansions*, applies the same conceptual framework to fifteenth-century Italy: Alberti's architectural theory is "a massive intellectual performance which at certain vital points fails to convince," his buildings are "thought rather than felt;" while Colonna represents "the reverse side of the Renaissance medal — the romantic, haunted, introverted side."[22]

The dissociation of thought and feeling was of course central to the existential

dilemmas of the early twentieth century. Benedetto Croce's *Aesthetic*, first translated into English in 1909, had popularised dualistic notions of the intellect and intuition, and irrationalist notions of creativity were much in the air in the 1920s and 1930s. Sigfried Giedion, for example, in his *Space, Time and Architecture* (originally delivered as lectures in 1938–9), refers to the split personality of modern man.[23] Eliot himself seems to have derived the concept (together with the phrase "dissociation of sensibility") from Remy de Gourmont's essay on "La Sensibilité de Jules Laforgue."[24]

Moving from effect to cause, Eliot blames Milton and Dryden for the dissociation of sensibility. Both, he argues, "performed certain poetic functions so magnificently well that the magnitude of the effect concealed the absence of others." The "language went on," but "the feeling became crude." They triumphed with "a dazzling disregard of the soul."[25] This thesis informs Summerson's negative assessment of Wren's early buildings, where the latter's delight in architectural style is similarly associated with the predominance of the intellect. Pembroke College Chapel, Cambridge, is "a strictly rational building … turned into Latin by the application of a Corinthian order … in conception it is totally unimaginative." (fig. 1). "Unimaginative", Summerson continues, "is perhaps too vague. 'Unpoetical' is more exact since it implies the absence of that deft, intuitive, co-ordination of thought and fancy which is exactly what is missing in Pembroke Chapel."[26] The Sheldonian Theatre in Oxford is

> a very highly wrought classical production … the idiom of the architecture must be placed on the totally unimaginative plane of an academic Latin essay, a production comparable, let us say, to Wren's elaborate inaugural lecture at Gresham College, or his long Biblical interpretation, in hexameters, of the signs of the Zodiac.[27]

Similarly, the Pre-Fire design for St Paul's Cathedral is "curiously artificial in character; we can imagine Wren piecing the classic elements together as he would piece together a hexameter and being mildly surprised at the happiness of the result."[28] In these passages, and others like them, Summerson associates Wren's handling of classical form with his "background of Latinity," a background that, Summerson argues, engendered a delight in linguistic ingenuity. Hence "the compact disposal of a return cornice" at the Sheldonian Theatre is likened to "a neat use of the ablative absolute."[29] By conceptualising Wren's classicism in this way – as language – Summerson could equate the manipulation of architectural style with Wren's intellectual ingenuity, just as, for Eliot, Milton's employment of certain "poetic functions … concealed the absence of others."[30] In both cases, the virtuoso play of technique was

Fig. 1 Christopher Wren, Pembroke College Chapel, Cambridge, 1663-65 (Photo: Myke Clifford)

itself symptomatic of a dissociated sensibility, for it concealed the absence of an imaginative capacity.

But poetry and architecture are not the same thing. Can the manipulation of architectural ornament really be symptomatic of artistic sensibility? Can we read the psychology of an architect in his façade? For Eliot, the genius of the metaphysical poets lay in their ability to communicate sensibility through language. The best poets, he argued, were "engaged in the task of trying to find the verbal equivalent for states of mind and feeling."[31] Summerson stops short of this, and his linguistic metaphor works on the level of syntax rather than meaning or expression. The metaphor,

however, was surely the genesis of that later work by which he perhaps remains best known, *The Classical Language of Architecture*.[32]

Eliot's explanation of the dissociation of sensibility is literary and technical, and, as such, in keeping with the professed aims of *The Sacred Wood* (1920), his first volume of literary criticism. In the preface to the second edition (1928) he stated that "when we are considering poetry we must consider it primarily as poetry and not another thing."[33] In part, this accounts for what Eliot later called the "truly embarrassing success" of his theory, for as Louis Menand has noted, the theory enjoyed "an extraordinary run precisely because its implications were largely uncontrolled."[34] Eliot himself described his exposition of the theory as cryptogrammic.[35] In the course of the 1920s, however, he rejected this commitment to the interpretation of "poetry ... as poetry," and in the preface to *Homage to John Dryden*, written three years after the essays themselves, he signalled this change of approach, arguing that a full treatment of metaphysical poetry would necessitate "considerations of politics, education, and theology."[36] For Eliot was increasingly interested, as the critic Timothy Materer has written, in "the relation of poetry to social and political conditions" and "the social conditions necessary for great art."[37] Where the metaphysical poets were concerned, Eliot never realised this programme, but several critics followed his cue. One such writer was Basil Willey, whose *The Seventeenth-Century Background: Studies in the Thought of the Age in Relation to Poetry and Religion*, first published in 1934, attributes the dissociation of sensibility to Descartes and the rise of science. This work is also listed in Summerson's bibliography, it may be recalled.

Summerson likewise followed Eliot's recommendation, and in the "Mind of Wren" he argues that the dissociation of sensibility – or, in a slogan of his own devising, "the tyranny of intellect" – was culturally determined. In the 1937 version of the essay he pleaded, as we have seen, for a "new treatment" of Wren, "concentrating not on the life and work of the architect himself but on the relationship which these bore to the social, political and philosophical thought of his time."[38] In the essay, Wren's psychology is therefore traced "back into the social and cultural growth from which his mind developed," and his artistic "failure" identified as "a historical phenomenon of the greatest importance, and one which can be detected in every aspect of English culture of the period."[39] Summerson's thesis is a classic case of what the critic Allon White has called "symptomatic reading," described by Louis Menand as "the method of treating literature as the record of a state of affairs which, by definition, the writer cannot manipulate – as the symptom of the writer's historical situation, or of his unconscious impulses, or of his neurological health."[40] Thus for

Summerson, "Wren's failure is as significant as his success, for both are the product of that tyranny of intellect which the seventeenth century established and from which almost every great artist of the eighteenth century was in conscious or unconscious revolt."[41]

For Summerson, then, the tyranny of the intellect was determined by the history of England, and most of the essay is given over to Wren's psychological formation in the midst of that history. His argument is broadly thus. Wren was born into "the sphere of Carolean churchmanship." His father and uncle, both royalist clergymen, formed "a lively intellectual nucleus" that pitted themselves against Protestantism on the one hand, Roman Catholicism on the other. "It was men like the Wrens," Summerson continues, "working in the tradition of Lancelot Andrewes and his disciple Laud, who fulfilled their function; and it was this atmosphere of intellectual conservatism that Christopher's inclinations towards learning were formed." It was in youth that Wren "received that rigorous schooling in Latinity without which no one could hope to cross the intellectual threshold of the seventeenth century."[42]

Then we reach the defining event of the age, the Civil War – what Summerson calls the "revolutionary movement." Taking his cue from G.M. Trevelyan's *England Under the Stuarts*, Summerson presents the Civil War not as "a battle between defined classes of people," but "a struggle within a closely integrated society." This resulted in "lines of conflict running in various and often surprising directions." Conflict and struggle are apparent "in the mental constitution of the time, and, consciously or unconsciously, in the mind of each individual." But the reflection of the conflict, he argues, is refracted, and "the conflict which is economic in origin is manifested as one of religious faith or scientific doubt."[43] This stage of the argument is peppered with language and ideas derived from Freud and Marx, though never systematically.[44]

Wren's "resolution of the conflict" lay within the academy, and specifically Oxford, where he fell in with the nascent Royal Society. Summerson quotes Thomas Sprat's *History of the Royal Society*, where Wren is associated with "a race of young men … invincibly arm'd against all the inchantments of enthusiasm."[45] In other words, the scepticism of the Royal Society was forged by the revolutionary crisis. Summerson then attempts a brief overview of Wren's scientific achievement, emphasising its diversity on the one hand and its tendency towards visual demonstration on the other. It was the latter tendency, he suggests, that "made the passage from science to architecture so easy" – a thesis Summerson was to develop in his later writings on Wren. With Wren's emergence as an architect in the 1660s, English architecture passed into "a quarter where tension was highest – namely, the Royal Society

group." The collective mindset of the Royal Society, Summerson claims, was "thoroughly anti-poetical. The imagination was regarded with the utmost suspicion, and consciously thrust aside as the enemy of truth." Hence the tyranny of intellect.[46]

Two short sections then follow, both intended to reveal the limitations of Wren's "non-imaginative approach to the arts." Firstly, Summerson explores Wren's engagement with literary culture and his attitude to wit, which, taking his cue from Croce and Eliot, Summerson calls "the imaginative descant of the age." We then follow in Wren's footsteps to Paris in 1665–6, where his English mind is "outlined against the French cultural scene." Wren, we are told, was "unconscious of the emotional colour, the latent romanticism, which is the glory of French art of the later seventeenth century."[47]

Summerson then turns his attention to the design history of St Paul's – the first of many such accounts – which he traces in the light of Wren's "intellectual development." More specifically, Summerson associates Wren's approach to design with the "empirical" methodology of the Royal Society. We begin with the Pre-Fire design, which reveals, like the earlier analyses of Pembroke College Chapel and the Sheldonian Theatre, "how little his sensibility to the use of architectural forms had developed." Then comes the Great Fire and an assessment of the First Model design, newly discovered in 1936, which triggers Summerson's attempt to translate "the concept of empiricism from philosophy to design." The argument is based on Wren's shifting ideas for the dome. In the thumbnail plans for the cathedral made in 1666 London (which exists in two versions), Wren envisaged "a domed east end with a nave running westward." In the First Model, however, "this arrangement was reversed." This reversal irritated Summerson, prompting the following observation: this "arbitrary reversal, implying a doubt that there could be any one inevitably right relationship for form and function in a cathedral, is characteristic of what we might call Wren's empirical method of design." This statement is predicated on a dubious definition of empiricism: "as a philosophic concept," Summerson writes, "empiricism implies the formation of judgements in the light of previous experience rather than established principles." His definition, however, enabled him to pit "empirical design" against established canons of taste. Wren ignores these canons of taste, we are informed, not only in the First Model design, but in his overall approach "to the cathedral problem" as a whole (because he does not know how to include a dome). To illustrate the point further, Summerson ingeniously quotes Roger Pratt's assessment of the First Model. For Summerson, Pratt stood in the Jonesian tradition of taste, and was therefore "assessing by standards of taste a design whose real standards

were purely intellectual. It was a case of intuitive criticism being applied to empirical design, a situation on which nothing but a critical stalemate could ensue."[48]

Summerson then quotes Wren's famous statement on the causes of beauty:

> There are two Causes of Beauty, natural and customary. Natural is from Geometry, consisting in Uniformity (that is Equality) and Proportion. Customary Beauty is begotten by the use of our Senses to those Objects which are usually pleasing to us for other Causes.[49]

Summerson interprets this statement very reductively, equating Wren's belief that "always the true Test is natural or geometrical beauty" with a conviction that "intellectual control could be established over the whole process of design."[50]

Summerson is now ready to conclude. While conceding the emergence of a late manner (which, citing Wölfflin, he styles baroque), he concludes that Wren never conquered the tyranny of intellect: a "vein of psychological inconsistency … runs through all Wren's work." Wren, however, was not to blame for this, for the mind of Wren was symptomatic of the age, for "it was in England that the tyranny [of intellect] reached its most formidable pitch."[51]

Summerson's essay, then, digs deep into the cultural history of the seventeenth century in a way that Eliot's *Homage to John Dryden* does not. As we have seen, however, Summerson took his cue from Eliot's preface, where a contextual approach to criticism was advocated. Eliot claimed not to have adopted such an approach in the *Homage to John Dryden*, and on the whole he did not. In "Andrew Marvell", however, he fleetingly attributes Milton's rejection of wit (and therefore feeling) to the "tendencies latent or the forces active in Puritanism."[52] This is as far as Eliot goes towards a cultural explanation of the dissociation of sensibility, but in this brief aside he hints at the conservative agenda underpinning his advocacy of contextual criticism. For the implication is that the Puritan revolution had a deleterious effect on English literature. Four years later, in 1927, Eliot was persuaded to "come out into the open," and in the preface to his next collection of essays, *For Lancelot Andrewes* (1928), he famously declared himself a "classicist in literature, royalist in politics, and anglo-catholic in religion."[53] It is not surprising, then, that he took a negative view of the English civil war, and in *After Strange Gods: A Primer of Modern Heresy* (1934) he argued that cultural orthodoxy was not only a good thing in itself but a necessary condition for artistic production.[54] This was his fundamental explanation for the dissociation of sensibility.

Did Summerson understand the conservative agenda underpinning Eliot's interpretation of the seventeenth century? His account of Wren's visit to Paris in 1665–6

implies a similar line of thought. "Had the Carolean monarchy and the Laudian Church been consolidated," Summerson conjectures,

> and the magisterial system been superseded by a privileged land-owning aristocracy … architecture, under such circumstances, would have developed in the direction which Inigo Jones and his school defined, and a tradition of taste would have been established too firmly to be deflected by any access of intellectualism. Instead of Wren, we might have had an English Mansart, and instead of the St Paul's we know, we might have had a structure more conservative, perhaps, in general form, but having the stylistic subtlety to which Jones's works were tending, but which English architecture never properly attained till the time of Chambers.[55]

Summerson stops short of directly attributing the Jonesian "tradition of taste" to the cultural orthodoxy of Carolean England. He does argue, however, that the civil unrest of the mid-seventeenth century interrupted this tradition.

This passage also reveals Summerson's assessment of the long-term consequences of the tyranny of intellect. The damage was not undone, he states, "till the time of Chambers." For Eliot, however, the dissociation of sensibility was "something from which we" — "we" being poets writing in English in the 1920s — "have never recovered." The metaphysical poets were the last exponents of true poetry and, as such, of relevance to the present. Modern poetry, Eliot writes, must be difficult, various and complex, for

> our civilization comprehends great variety and complexity, and the variety and complexity, playing upon a refined sensibility, must produce various and complex results. The poet must become more and more comprehensive, more allusive, more indirect, in order to force, to dislocate if necessary, language into his meaning … Hence we get something which looks very much like the conceit — we get, in fact, a method curiously similar to that of the "metaphysical poets."[56]

Summerson makes no such claims about the relevance of the past to the present. When "The Mind of Wren" is read in conjunction with other writings in *Heavenly Mansions*, however, a tacit argument about the present can be inferred. In "The Mischievous Analogy", his 1941 essay on modern British architecture, Summerson — as Alan Powers has noted — "comes closest to expressing his private misgivings about contemporary architecture."[57] Summerson accuses the architectural profession of being "obsessed with the importance not of architecture, but of the relation of architecture to other things." "Hard thinking," he states, has "distorted the architect's attitude to his art," for if "architects are more interested in the relationship of buildings

to a social and scientific context than in the buildings themselves, it is probable that the buildings will become dull, empty and unattractive to all except the architect." Contemporary architects were neglecting "the exposition and elaboration of purely architectural values."[58] In other words, the tenor of English Modernism was creating a new dissociation of sensibility. Summerson believed that contemporary architects, like Wren, were thinking too much.[59]

Summerson's remedy – "the exposition and elaboration of purely architectural values" – sounds suspiciously like the qualities he admired in Inigo Jones: "the values of mass, spacing, and linear texture which Inigo Jones had ... shown to be the essentials of classical design."[60] But this was as far as he could go, for Summerson was himself a Modernist, and as such had rejected the classicism of Wren and Jones (and its revival) for socio-political reasons. In "The Mischievous Analogy" he argues that classicism is inherently hierarchical and therefore irrelevant to "the social history of our times," with its "drastic flattening out of society" and "enhanced evaluation of the individual."[61] For Summerson, then, there could be no persistence of the classical – new circumstances needed new solutions.[62] It is thus ironic that he took so many of his ideas about the nature of artistic production from T.S. Eliot, a thinker who believed in *old* solutions to new circumstances.

NOTES

A version of this paper was read to the Oxford Architectural History Seminar in November 2007. I am grateful to the late Sir Howard Colvin, Louise Durning, Elizabeth McKellar, Mark Swenarton and William Whyte for their helpful comments on that occasion. Thanks also to Alan Powers, Frank Salmon and Gavin Stamp.

1. Frank Salmon, ed., *Summerson and Hitchcock: Centenary Essays on Architectural Historiography* (New Haven and London: Yale University Press, 2006); Elizabeth McKellar, "Popularism versus professionalism: John Summerson and the twentieth-century creation of the 'Georgian'," in Barbara Arciszewska and Elizabeth McKellar, eds., *Articulating British Classicism: New Approaches to eighteenth-century architecture* (Aldershot: Ashgate Publishing Ltd, 2004): 35–56; Alan Powers, "John Summerson and modernism," in Louise Campbell, ed., *Twentieth-Century Architecture and its Histories* (Society of Architectural Historians of Great Britain, 2000): 153–75; Howard Colvin, "John Newenham Summerson, 1904–1992," *Proceedings of the British Academy* 90 (1995): 467–95; Peter Mandler, "John Summerson 1904–1992: The architectural critic and the quest for the Modern," in Susan Pedersen and Peter Mandler, eds., *After the Victorians: Private conscience and public duty in modern Britain* (London and New York: Routledge, 1994): 229–45.
2. *The RIBA Journal* (February 20 1937): 373–90.
3. John Summerson, *Heavenly Mansions and Other Essays on Architecture* (London: The Cresset Press, 1949).
4. Summerson, "The Tyranny of Intellect" (1937): 373.
5. Rudolf Dircks, ed., *Sir Christopher Wren A.D. 1632–1723: Bicentenary memorial Volume published under the auspices of the Royal Institute of British Architects* (London: Hodder & Stoughton, 1923). For the cult of Wren, see Andrew Saint,

"The Mind of Wren," in David Crellin and Ian Dungavell, eds., *Architecture and Englishness 1880–1914* (Society of Architectural Historians of Great Britain, 2006): 37–59.

6. *The Wren Society*, A.T. Bolton and H.D. Hendry, eds., 20 vols (Oxford University Press, 1924–43).
7. John Summerson, "The Case of Sir Christoper Wren: A note on the Wren Society's evidence," *Country Life*, June 29 1945, 1130–31.
8. John Summerson, *Sir Christopher Wren* (London: Collins, 1953): 155–56.
9. Gordon Higgott, "The West End of St Paul's Cathedral: Design and Construction History" (Unpublished Report for the Dean and Chapter of St Paul's Cathedral, 2007): 145.
10. Summerson, "The Tyranny of Intellect" (1937): 373.
11. John Summerson, "The MARS Group in the Thirties," in John Bold and Edward Chaney, eds., *English Architecture Public and Private: Essays for Kerry Downes* (London and Rio Grande: The Hambledon Press, 1993): 303–09 (303).
12. *Homage to John Dryden: Three Essays on Poetry of the Seventeenth Century* (London: The Hogarth Press, 1927).
13. Alan Powers records that Summerson owned copies of the *Principles of Literary Criticism* by I.A. Richards (1930 edition) and *The Meaning of Meaning* by Richards and C.K. Ogden, "the key texts of the developing English Faculty at Cambridge" (Powers, "John Summerson and modernism" (2000): 157).
14. Eliot, *Homage to John Dryden* (1927): 34.
15. Summerson, "The Tyranny of Intellect" (1937): 373, 386.
16. Eliot, *Homage to John Dryden* (1927): 24.
17. Ibid., 30.
18. Ibid., 28.
19. Ibid., 29.
20. Ibid., 30.
21. Summerson, "The Tyranny of Intellect" (1937): 373.
22. Summerson, *Heavenly Mansions* (1949): 40, 46.
23. Sigfried Giedion, *Space, Time and Architecture*, 5th edition (Cambridge Massachusetts: Harvard University Press, 1973): 13.
24. Louis Menand, *Discovering Modernism: T.S. Eliot and His Context*, 2nd edition (Oxford University Press, 2007): 170.
25. Eliot, *Homage to John Dryden* (1927): 30, 32.
26. Summerson, "The Tyranny of Intellect" (1937): 378–79.
27. Ibid., 380.
28. Ibid., 384.
29. Ibid., 380.
30. Eliot, *Homage to John Dryden* (1927): 30.
31. Ibid., 31.
32. First published in 1963.
33. Cited in Menand, *Discovering Modernism* (2007): 133.
34. Menand, *Discovering Modernism* (2007): 148
35. Eliot, *Homage to John Dryden* (1927): 9.
36. Ibid.
37. Timothy Materer, "T.S. Eliot's critical program", in A. David Moody, ed., *The Cambridge Companion to T.S. Eliot* (Cambridge University Press, 2006): 48–59 (53–54).
38. Summerson, "The Tyranny of Intellect" (1937): 373.
39. Ibid.
40. Menand, *Discovering Modernism* (2007): 84.
41. Summerson, "The Tyranny of Intellect" (1937): 390.
42. Ibid., 374–75.

43. Ibid., 375.
44. For Summerson's early engagement with psychoanalysis, see Powers, "Summerson and modernism" (2000): 157. See also Christy Anderson, 'A Very Personal Renaissance', in Salmon (ed.), *Summerson and Hitchcock* (2006), 69–84 (75–76).
45. Quoted in Summerson, "The Tyranny of Intellect" (1937): 375. Summerson takes Sprat at face value, but as Michael Hunter observes, "Sprat's book is as much a confession of faith as a factual record" (Michael Hunter, *Science and Society in Restoration England* (Cambridge University Press, 1981): 29).
46. Summerson, "The Tyranny of Intellect" (1937): 375–79.
47. Ibid., 380–83.
48. Ibid., 383–86. For Wren's preliminary designs for St Paul's, see my catalogue of *The Architectural Drawings of Sir Christopher Wren at All Souls College, Oxford* (Aldershot: Lund Humphries, 2007): 44–84.
49. Lydia M. Soo, *Wren's "Tracts" on Architecture and Other Writings* (Cambridge University Press, 1998): 154.
50. Summerson, "The Tyranny of Intellect" (1937): 386–88.
51. Ibid., 388–90.
52. Eliot, *Homage to John Dryden* (1927): 36.
53. Eliot, *For Lancelot Andrewes: Essays in Style and Order* (London: Faber & Gwyer, 1928): ix.
54. Eliot, *After Strange Gods: A Primer of Modern Heresy* (London: Faber and Faber, 1934). For an unapologetic assessment of Eliot's conservatism, see Roger Scruton, *Arguments for Conservatism* (London and New York: Continuum, 2006): 191–208.
55. Summerson, "The Tyranny of Intellect" (1937): 382.
56. Eliot, *Homage to John Dryden* (1927): 30, 31–32.
57. Powers, "Summerson and modernism" (2000): 168.
58. Summerson, *Heavenly Mansions* (1949): 197, 199, 200.
59. Powers rightly identifies Summerson's dualistic interpretation of the Florentine Renaissance as "an analogy for modernism, with its personality split in a similar way" (Powers, "Summerson and modernism" (2000): 168).
60. Summerson, "The Tyranny of Intellect" (1937): 380.
61. Summerson, *Heavenly Mansions* (1949): 205–06. Summerson was less censorious in his architectural criticism: see, for example, his "Recent Work of Mr. E. Vincent Harris", *Country Life*, April 28 1934, 423–26.
62. David Watkin, *Morality and Architecture* (Oxford: Clarendon Press, 1977).

The Classical Theory of Hope Bagenal

ALAN POWERS

Architectural theory has seldom flourished in England in the familiar form of the treatise or manifesto, and on the occasions when the national tendency to pragmatism and pictorialism has undergone theoretical invigoration, it has come from abroad. The classical revival that began around 1900 left little discussion of lasting interest, apart from Geoffrey Scott's *The Architecture of Humanism*, 1914, a work that was rooted neither in practice nor in the professional culture of its time, but in the circle of Bernard Berenson in Florence.

Philip Hope Bagenal (1885–1979), always known by his second name, was one year younger than Scott and in almost every way his antithesis: a modest-living, high-minded man who wrote much more than Scott, but left his ideas mainly in the form of lectures and articles, apart from his collaboration with the Principal of the Architectural Association (AA), Robert Atkinson, on *Theory and Elements of Architecture*, 1926, the first of three projected volumes intended to encapsulate their joint pedagogy, but left incomplete. Scott's contribution to architectural theory was effective, especially after the First World War, but he played no active role in the architectural culture of his time, diverting to other scholarly interests. Bagenal by contrast operated in the centre of architectural discourse in London – as the Librarian and occasional history lecturer of the AA from 1919 to 1939 – but in a way that has meant that he is now a fading figure of folk memory (fig. 1). One student of the 1920s, Humphrey Carver, wrote, "I wondered if he was a reincarnation of some biblical or medieval saint;" while for John Brandon-Jones, he was "perhaps the greatest genius

ever connected with the AA."[1] Raymond Erith claimed that Bagenal "understood what classical architecture was about."[2] He also influenced many of the first generation of English Modernists, such as William Tatton Brown and David Medd, pillars of the social architecture of the post-war welfare state. After 1939, Bagenal worked for the Building Research Station, and continued his work as a freelance acoustic consultant, the skill for which he is chiefly remembered today, and which is justifiably emphasised in his entry in the *Oxford Dictionary of National Biography*. As the columnist "Astragal" in the *Architects' Journal* in 1935 put it, "his is a mixed sort of brain such as one rarely finds."[3] In addition to his architectural contacts, Bagenal and his wife Alison led a rich intellectual life with many friends, including contacts with Cambridge, where Hope's brother, Nicholas, was a King's contemporary and close friend of many Bloomsbury Group members. Hope himself was a friend of Mansfield Forbes, the Fellow of Clare who was not only a focus for modern ideas in the university in the 1920s and 1930s, but a catalytic figure of national importance.

Fig. 1 Hope Bagenal in the Architectural Association Library

This essay is an attempt at a brief summary of Bagenal's teaching on classicism, which was divided between an interest in the origin of its forms, their relationship to climate and geology, their manifestation in his own lifetime, and their claims to universality and timeless validity. In addition, I shall suggest that he has become more rather than less relevant in the early twenty-first century, and that many of his ideas have been developed, quite independently, by architectural theorists in the mainstream as well as some within the classical revival of the thirty years since his death.

THEORY AND ELEMENTS OF ARCHITECTURE

Bagenal began his career studying engineering at Leeds, before coming to London as an articled pupil to the architects David Niven and Herbert Wigglesworth in 1909. That year he joined the AA as a member, rather than as a student. In these years,

classicism was a subject of heated but largely undirected discussion. His first job was with Sir Edwin Cooper on the bombastic Corinthian Port of London Authority building and, after his war service in the Royal Army Medical Corps, he became assistant to A. Dunbar Smith and Cecil Brewer, enjoying extended discussions of architectural theory with Brewer, the designer of Heal's store in London and of the National Museum of Wales. Through Brewer, therefore, Bagenal's roots were partly in the progressive wing of the Arts and Crafts Movement, although he deprecated Brewer's attempts at original invention of column forms.[4] As AA Librarian and journal editor, he shared in the school community's enthusiasm for the revived classicism of Sweden that combined regional craftsmanship with a creative interpretation of primitive classicism. In England in the 1920s, craftsmanship was losing its force, while the use of classical forms was often confused on every level, so that his studies revolved around the intention of reforming architecture by precept and example. He had hardly begun to straighten out classicism before Modernism emerged, representing in his mind a further body of faulty doctrine.

Bagenal's collaborative book came near the beginning of his long writing life. So, while it is the most extended piece of his writing, it does not form a summary of his ideas, which continued to develop and crystallise. Opinion has differed on the respective roles of Atkinson and Bagenal as authors. Brandon-Jones believed the work to be largely by Bagenal and, given that Atkinson published little else, this seems credible. Bagenal, however, had the opportunity to write about the collaboration in an obituary tribute to Atkinson, and his modesty makes it seem as if the opposite were true. Atkinson's lectures to students seem to have provided a basis for the book's overall philosophy, summarised by Bagenal in the phrase "when in doubt, look deeper."[5] Atkinson became Principal of the AA in 1913, and was closely involved in discussions about the aims of architectural education, including the questioning of the suitability of methods adopted from the Ecole des Beaux-Arts. The book title corresponds to Julien Guadet's *Eléments et Théories de l'Architecture*, 1901, the summation of Beaux-Arts doctrine by its last major exponent. In fact, the problem perceived about Beaux-Arts work in England was not that it copied the French original too closely, but that by mimicking the forms without the underlying rationale, it missed the point – a complaint frequently made by Atkinson's friend, the AA President in 1926, H.S. Goodhart-Rendel. *Theories and Elements* could never be accused of superficiality, nor of being overtly French.

No book of this kind existed before in England, although Bagenal believed that Atkinson "no doubt got the first hint from Sir William Chambers' book on Civil

Architecture, but he made it his own."[6] Apart from Soane's Royal Academy lectures (unpublished until 1929), the nineteenth century bequeathed only dictionaries and histories, rather than comprehensive expository works. The Arts and Crafts movement had done little better, and Bagenal found W. R. Lethaby's attitude to architecture, which was present in parts of the education system before 1914, an over-reductive and ultimately anti-cultural one.

The definition of 'Theory' given early in the book, for English readers unfamiliar with the concept, shows metaphorical form as "a picture of relative factors, a recognition of the enemy chaos and of the fortress design."[7] To this extent, it is essentially a rationalist work, but there is no attempt to relate the book, for the reader's benefit, to previous architectural theories, even to Guadet, and it is based entirely on an accumulation of observed instances and speculations relating to them. In some respects it is closer to James Fergusson's search for material origins and universal principles; Atkinson and Bagenal, while not attempting history as such, introduced historical themes such as the development of plan and structure types from primitive sources — for example the aisled farmhouse representing the basilica type, and also the structural bay system in timber, which is related in turn to steel construction. The chapter on wall surface raises hopes that Gottfried Semper, Otto Wagner or Adolf Loos will appear in the footnotes to connect with European thought, but in vain. However, it serves a similar purpose in celebrating the decorative potential of the wall without over-emphasis on structural truth. In the two chapters on doors and windows, anthropology is implied, although no texts from this new discipline are cited. In fact, the emphasis on mythology and the belief systems implied by could be more closely related to the writings of Ananda Coomaraswamy, especially in the desire to relate the ordinary everyday object to lost sacred traditions, in the light of creeping materialism and loss of meaning. As the section on "Original Meanings" says, "[The] passage to and from between an inner and an outer world, this intercourse between man and his environment necessary to his health is at the root of all ancient symbolism attached to door and window. An architect when he designs a door is dealing with fundamental things in human nature so taken for granted that they have now almost passed out of the consciousness of the designer. But this is sheer loss."[8]

A review by the architect George Drysdale praised the book as "a new standard, type even, of book on architecture."[9] It differed from the rather disembodied works on architectural composition then in favour, one of which was produced by Howard Robertson, the Director of the AA and Atkinson's successor as Principal. While

students, including the young Denys Lasdun, read Geoffrey Scott while at the AA, *The Architecture of Humanism* remains largely on an abstract plane of argument, having eliminated the Arts and Crafts feeling for the physicality of building. It does not lead its readers to revel in the deeper meaning of stone cladding or brick bonding, or to speculate on the meaning of a door or window. While much preoccupied by construction, *Theory and Elements* was certainly not a construction manual, yet it succeeded in finding the points of contact between the material side of architecture and its cultural side. This accord was already threatened by Modernism, impatient of the past and of the accumulated experience that Bagenal believed to be the rationale for historical study by architects. *Theory and Elements* has the best claim to be the crown of an incomplete cycle in the development of architectural thought in Britain, superseding the Battle of the Styles and the eclectic confusion of the late nineteenth century, in all its fecundity.

In Britain in 1926, it was still credible to write "We must study modern buildings exactly in the same spirit as antique buildings, for we are ourselves in a historical period."[10] This approach corresponded to Auguste Perret's attempt to channel the classical heritage from antiquity onwards in France into concrete construction. Without knowing exactly why the second and third volumes failed to appear, we may imagine that the climate of opinion, already forming among students at the AA, was increasingly against it. Perhaps Bagenal's careful phrases and verbal constructions, which can be relished in retrospect, were unpalatable to a generation in a hurry, for whom Le Corbusier's aphorisms, half-understood, were more exciting. While Le Corbusier was not illustrated in *Theory and Elements*, Erich Mendelsohn got two pictures, from his drawings, and an acknowledgment of "the personality of a powerful artist," along with a warning that "a small mind will not become great by changing its mode from 'Classic' to 'Modern' or by using cantilevers instead of beams."[11]

Bagenal's mind is most clearly impressed on the book in the second chapter, "Climate and Building Material." This is not a discussion of weathering, even though the subject was one of Bagenal's preoccupations, but of the cultural conditions created by climate, mainly in terms of a dualism between northern and southern zones, and, in some respects, the divergence between Gothic and Classic. To the rapid variations of the English climate is attributed "a confusion of critical standards in architecture."[12] Yet the theory is not pushed to deterministic lengths, for while the discussion admits the possibility of a fusion, as in seventeenth-century French Renaissance, it states that "What is important is to avoid wasteful conflict between

the two when the problem at issue is fundamentally an artistic one."[13] To readers of Adrian Stokes' *The Quattro Cento*, 1932, the first of his mature writings that set the tone for all his pre-war thinking, these ideas sound familiar. Stokes quoted at some length from this part of *Theory and Elements* in his second chapter in order to define his 'Quattro Cento' as quintessentially southern, including Bagenal's references to Homer and his emphasis on the light-loving Dorians who were believed to have come into Greece from the north.

ANTIQUITY AND THE SOUTH

Theory and Elements predominantly contained material from the ancient world, including many of Bagenal's own photographs of Greek and Roman sites, and, typically, of later buildings that seemed to him to display the same principles (figs. 2 and 3). These were taken while he was Bernard Webb Student at the British School at Rome in 1925, and over the following years. In 1935, he was awarded the Athens Bursary and travelled with the architect Charles Holden, one of his particular friends in the architectural community and a fellow member of the Art Workers Guild. He clearly relished visiting sites such as Segesta in the company of a practitioner whose work he admired, and the account of the trip published the following year includes a drawing made on the site by Holden, and records remarks he made.[14] The British Schools at Rome and Athens encouraged an interchange between architects and archaeologists, and generated "new data of absorbing interest to teachers of architecture, would they but read them," as Bagenal lamented in 1929, although he worked at the AA with architect tutors such as S. Rowland Pierce who had made detailed surveys of classical sites while Rome Scholars.[15] He continued, "this new data can help us as teachers because a true study of origins is a study of design; the preoccupation of the British School at Athens with 'the archaic' concerns us because in structure, as in sculpture and the crafts, the archaic retains numberless links with design processes that are later lost."[16]

Bagenal's writings reveal his poetic side, encompassing his belief in the effect of climate, light and geology on architecture, supported by his overall understanding of the mystical quality of place, "the topographical instinct behind Greek architecture" as he called it, which in turn became a criterion for judging the appropriateness of architectural form.[17] Thus Bagenal's articles on "Antecedents of Greek Architecture" anticipate themes from the book published the same year, celebrating "the common Mediterranean gift of sheer brightness," and the lighting effects produced by

Fig. 2 The Parthenon, photographed by Hope Bagenal in 1935

reflected light on soffits, cast upwards from the stylobate, that rarely occurs under English skies.[18] In looking at the totality of the physical and cultural environment of the Greek temples, and finding the physical experience richer than the academic classical reduction of them, Bagenal used the word *amoenitas* in 1930 to describe the quality of place, not only the remote sites of antiquity, but the quality of a city as "a place not only for residence and business but also for sociability, peace and contemplation." These qualities he rightly saw as threatened in English towns and cities.[19]

Bagenal published relatively little on Roman architecture. While he felt that its mixture of the column and the arch offered very practical solutions to designers, he expressed a preference for the Greek "articulation of function of the building elements," especially in the eternal problem of the post and lintel.[20] Bagenal was critical of Lutyens for declaring, at an AA meeting in 1920, "Study the Romans rather than the Greeks. The Greeks were too subtle," commenting in 1953, "This might be read in a number of ways; but as a matter of history, his stereotyping of parts and

Fig. 3 Delphi, photographed by Hope Bagenal in 1935

mouldings made them, to modern eyes, appear meaningless, and contributed to the decline of the style."[21]

In his desire to learn applicable lessons from antiquity, Bagenal aimed to achieve function and beauty by the same means, as well as cultural resonance. He claimed that the work of the Building Research Station, in which he took a close interest before joining the staff during the Second World War, "reminded us of our own climate and that because some parts of a building had become decorative they have not necessarily ceased to be functional."[22] Thus modern science could be read back into history without threatening its integrity, but rather enhancing its applicability. Despite his preference for Greece, Bagenal published two articles on "The Lesson of Ostia" in 1927, concentrating on non-monumental buildings, opening with the statement "The lesson of Ostia is briefly that the Romans in a commercial age made bricks and used bricks much more intelligently than we do in the year of grace 1927."[23] In this he argued that bricks should be thought of as tiles (the Roman terminology being inter-

changeable), and that they looked best when set in wide joints, not, as with Victorian brickwork in Britain, made wider and set more closely. The penalties of modern practice were, as he found with so many things, aesthetic and practical at the same time.

From his studies of antiquity, Bagenal drew what he hoped would be a universal theory of monumental form. This was his theme in one of his major texts, "Architecture and the Contemplative Principle," a lecture given in Liverpool in 1940. "Let us take for a moment the idea of durability inherent in great buildings as such," he wrote, "the huge trilithon, the well-buttressed arch, the dome on square platform, convey at their grandest a sense of recognition. Whether we care to admit it or not, they express eternal things. I can speak here only for myself. In front of some of the great apparitions of the antique I have stooped my whole intellect and acknowledged changelessness – acknowledged the great 'I Am' of architecture."[24] In Bagenal's definition, the monumental was not simply the large or costly, but anything that displayed "the development out of process and towards contemplation," a duality explored at length in the text.[25]

VERNACULAR AND THE NORTH

For a generation raised at school on Greek and Latin texts, there was a temptation to find classicism concealed in unlikely places. Bagenal shared with other fanciful thinkers, such as the Welsh architect Dewi-Prys Thomas, the feeling that primitive herdsmen were alike in the motivation of their buildings, whether in Attica, Ryedale, Merionedd or County Galway, and that tumbledown barns could magically become temples or megarons in the mind (fig. 4). The associational impulse worked both ways, and contributed to a deeper understanding of antique architecture not only as 'high style' but as the refinement of vernacular practice.[26] Bagenal linked monumentality with primitive simplicity, and celebrated the open cart sheds seen in farm yards in several parts of England as well as in Ireland (the homeland of the Bagenals) "where monument and cottage are found side by side, built of the same material."[27] They satisfied him in their bearing on the origins of architectural form, "not because they are old, but because they have come about under widely applicable conditions without any style intention."[28] He claimed to see distinctive Doric and Ionic variants within these unconscious structures, and wrote "the orders used structurally have a beauty and 'necessity' of their own very different from the ordinary monumental."[29]

In devoting much time to the exploration of these matters, Bagenal shared his interests with other pioneers of vernacular research, including predecessors such as F.

C. Innocent, and contemporaries such as Lord Raglan and Iorwerth Peate. Bagenal was a close friend of W. G. Hoskins, author of *The Making of the English Landscape*, and they travelled together in the postwar years. To Hoskins' *festschrift* in 1975, Bagenal contributed his last published piece of writing, "The Rationale of Traditional Building." The attraction of travelling through England and observing the changing geology through building materials was a theme of Bagenal's echoed in the conversation of another AA pupil of the 1920s, Stephen Dykes Bower.

Fig. 4 Barn and Cowhouse at Cockington, Devon, photographed by Hope Bagenal

Among the more sophisticated buildings in Britain, Bagenal avoided the major monuments of country houses and preferred provincial Georgian, as seen in the towns near his home, Hertford and Ware. Bagenal's own practice as an architect consisted of one garden — at the King's School Worcester, where he was educated — and two buildings: the village hall at Wickhambrook, Suffolk, 1920, a rather undistinguished design, and, most relevant of the three, a garden temple at Elton Hall near Peterborough of 1957 for Sir Richard Proby (fig. 5). Described as a Temple of Silvanus and reflecting the patron's interest in forestry, this is an exercise in reconstructing a hypothetical English primitive Doric, complete with antefixae in the form of corn dollies, made by R. C. Lambeth, the Rural Industries Organiser for Cambridgeshire. Bagenal wrote to him, "I should like you to believe that the temple is not merely a piece of dilettante. The Doric and Ionic orders can be seen on Greek vases to be two distinct modes of primitive carpentry surviving all over Europe as in a field shed. The antefixae on eves and gable ends can be seen on the vases. In this country they survive only as straw cockerels and rick finials."[30]

It is possible, in addition, that Bagenal's exploration of the inherent classicism of vernacular buildings influenced the ideas of Raymond Erith, and provided some impulse for his adaptation of the *barchessa* of the Veneto villa as a convenient form of parking shelter for several of his country houses in the 1950s and 60s. Erith remained

a friend and, in 1955, sent Bagenal a long letter concurring with Lord Raglan's theory that houses were by origin temples, and elaborating on the theme with a charm only possible when the recipient is sympathetic.[31]

BAGENAL AND MODERNISM

With such convictions about architecture, Bagenal could never be wholly sympathetic to Modernism. He belongs with many of his generation who knew an architectural world predating the 1920s, and were concerned with finding their own solutions to the problems of energising and re-establishing architecture in their own time, rather than taking them ready-made from the images of European Modernism. To situate Bagenal fully in this generation, including architects such as H.S. Goodhart-Rendel, Albert Richardson and Giles Gilbert Scott, would be a lengthy task. His writings contain many valuable opinions about his contemporaries, which help us to come closer to the core of his own beliefs. His taste, judged from the buildings he commended most strongly, was conventional, even to the point of boredom at times – an accusation against which it has been impossible even for anti-Modernists to defend certain works by Easton and Robertson (their Cambridge work included) or Holden that Bagenal championed. He was suspicious of Holden's move to reducing detail in the University of London Senate House, and of his motto, "When in doubt, leave it out."[32]

As Modernism began to occupy a substantial position in English architectural discussion in the 1930s, Bagenal put his response on record in several lectures given at the AA. Typically, he chose to place architecture in the context of the whole civilisation that was adrift, while finding it a means of reasserting the values of civilisation. The promotion of novel building products seemed to him especially threatening. For a man who refused to install a bathroom in his own house to the end of his life, it was hard to sympathise with mass consumption among the public at large. Against this, he pointed to the Danish architect and author S.E. Rasmussen's book, *Britisk Brugskunst* of 1932 – a pictorial catalogue of "timeless" design, often in the form of clothing and sporting goods shown as "an encouraging mirror of ourselves."[33] Modern methods made certain forms of building cheap, but Bagenal warned against false economies that would lower the longevity of buildings and their quality in use.

The paper "On the Philosophy of Modernism: A Criticism," 1937, similarly takes a broad view of the cultural roots of the problem of trying to achieve "freedom" in architecture, whether from style or from material substance. Bagenal believed that this

Fig. 5 Temple of Sylvanus, Elton Hall, 1957, designed by Hope Bagenal

intention was as impossible as it was undesirable, given the nature of mankind and of the physical world. Architecture was, in his view, an inappropriate vehicle for the expression of ideas better suited to painting and sculpture, and it thereby lost its grounding in "the contemplative principle." So far as Bagenal was concerned, the richness of the monumental tradition was far from exhausted, as his earlier writings had insisted. The audience at the AA who heard this paper and joined in the discussion were impressed by the magisterial quality of its thought and language, and only a few demurred over the message. Were the students, then noisily staging a revolution in favour of a social architecture of Modernism (apparent in their magazine, *Focus*),

also present to hear it? Bagenal's assertions challenged their certainties, yet he was not a simple conservative. In 1940, he claimed that "we must reform society in our capacity as citizens, not in our capacity as professional men."[34] By this he meant, and continued to claim in later years, that buildings that failed to respond to climate and made unrealistic demands on maintenance were the opposite of useful to society.

At the Building Research Station, Bagenal was involved in research into the performance of several twentieth-century buildings in London, both traditional and modern, some thirty years or more after their completion, which assessed the relative effectiveness of the much-promoted new and efficient construction and detailing.[35] This lesson was absorbed by several of the younger 1930s Modernists, such as William Allen and William Tatton-Brown, both of whom worked at the BRS under Bagenal. The rebellious students and staff at the AA also felt that the Modern architecture in the earlier 1930s neglected the potential of traditional materials such as timber and brick, and the teaching curriculum at the end of the decade began to include practical building tasks. Had the Second World War not affected the supply of materials and skilled labour so severely, it is possible that modern architecture would have avoided the frequently short-term and desperate construction measures of the post-war decades, challenging though these were to the designer's ingenuity.

In "The Architecture of Reconciliation," 1955, one of Bagenal's last substantial interventions in the architectural journals, he suggested that modern and traditional methods alike were open to the test of performance, and that personal preferences need not be decisive, provided that "fashionable romantic theories about science" were rejected in favour of "a more realistic approach."[36] This is a challenge that few architects, least of all the majority of those involved in teaching, seem ever to have risked, at a time when to question Modernism was a heresy. By this stage, Bagenal seems to have been content to confront the overwhelmingly materialist arguments in favour of Modernism with his own materialist arguments against it, avoiding most of the more poetic and philosophical aspects that had once given colour and warmth to his writings.

Sadly, some of his later lectures, such as "The Persistence of the Classic," 1955, remained unpublished, since these reveal the qualities that Erith and others most admired. In 1987, William Tatton-Brown, retired from a lifetime's career in public sector hospital architecture, offered the Prince of Wales an extract from "Architecture and the Contemplative Principle" through the pages of the *Architects' Journal* but, if the message was received, it was not enough to start a Bagenal revival.[37]

BAGENAL TODAY

It may be a hollow justification of Bagenal's importance to demonstrate how many of his ideas are current today, because it is certain that he can take no direct credit for this. However, hindsight shows how much he was able to say that is more widely accepted now than it was during the later years of his long life. The acceptance is far from universal, yet one can point to a body of (mainly) northern European and American architectural thought, emerging during the past thirty years to make the point. The concept of Critical Regionalism, promoted by Kenneth Frampton in the 1980s has many Bagenal characteristics, not only in the idea of specific geographical factors in architecture, but also in linking this to the idea of the tectonic. Writers drawing on phenomenology, such as Christian Norberg-Schultz and Karsten Harries, share Bagenal's sensitivity to place and the emotional effects of weather, and the ability of simple structures to heighten them. His ideas find many points of accord with Leon Krier, in terms of the vernacular basis of classicism, the social significance of artisanal craftsmanship, and the *amoenitas* of the small country town. The rediscovery of Nordic Classicism of the 1920s took place in the years immediately following Bagenal's death in 1979, and he would have felt that this was a good place to begin a classical revival, having written in 1955, "I would as soon go to Copenhagen and Stockholm as anywhere in Europe."[38]

On materials carrying their own will to form, Bagenal seems to speak to Louis Kahn, while his interest in the wall as a primary element, decorative as well as structural, places him in the long tradition of Gottfried Semper that has been rediscovered over many years, and borne fruit in the work of Swiss architects such as Peter Zumthor, Diener & Diener and, in Britain, in that of Caruso St John. The history of the twentieth century in Britain seems to contain many such hidden affinities, which are only coming to light in the longer view. One might conclude that Bagenal aimed to demonstrate the irreducible in classicism, almost to the point where many people would no longer be able to see it as classical at all. However, the depth of feeling evident in his writing should make it clear that the irreducible is very different from the reductionism that he stood firm against all his life, and that the conceptual stylobate he constructed is a sound platform on which to raise real buildings.

NOTES

In the 1980s, I was fortunate to meet Hope Bagenal's son, the late John Bagenal, who gave himself the retirement task of sorting his father's papers, privately publishing six volumes of edited texts and correspondence with the

title *The Best of Bagenal*. On 26 January 1984, John Bagenal spoke about his father at the Art Workers Guild, and his biographical and analytical text is held in Bagenal's Biographical File at the RIBA Library. The majority of the papers are on loan from the Bagenal family to Hertfordshire Record Office, and a handlist is available for researchers, but as yet no bibliography of published writings exists. The family retains some items, and I am grateful to Patience, Beauchamp, Elinor and Rachel Bagenal for entertaining me and providing further background information.

1. Humphrey Carver, undated letter (c. 1983) in Hope Bagenal Archive on loan to Hertfordshire County Record Office. John Brandon-Jones, "Bliss was it in that dawn to be alive," interview with Gavin Stamp in *Britain in the Thirties*, AD Profile 24, (London: Architectural Design, 1979): 98.
2. "Raymond Erith Interview," in James Gowan, ed., *The Continuing Experiment, Learning and Teaching at the Architectural Association* (London: Architectural Press, 1975): 72.
3. 'Astragal', *Architects' Journal* (3 January 1935): 5.
4. Hope Bagenal, "Review of the Neo-Georgian Period" 6, referring to Rushymead, Coleshill, Bucks. "His attempt at a new order for his loggia was not successful." Typescript in Hope Bagenal Archive.
5. Hope Bagenal, "Robert Atkinson and the Theory of Architecture," *Architectural Association Journal*, 68 (May 1953): 202.
6. Ibid., 202.
7. Atkinson and Bagenal, *Theory and Elements of Architecture* (London: Ernest Benn, 1926): 2.
8. Atkinson and Bagenal, *Theory and Elements* (1926): 269.
9. George Drysdale, review of *Theory and Elements of Architecture*, *RIBA Journal*, 34 (18 December 1926): 142.
10. Atkinson and Bagenal, *Theory and Elements* (1926): 4.
11. Ibid., 361
12. Ibid., 28
13. Ibid., 30
14. Hope Bagenal, "Some Notes on a Sicilian Tour," *RIBA Journal*, 43 (6 June 1936): 803–12.
15. Hope Bagenal, "Good Scholarship in Architecture," *RIBA Journal*, 36 (23 February 1929): 308.
16. Bagenal, "Good Scholarship" (1929): 308.
17. Bagenal, "Notes on a Sicilian Tour" (1936): 806.
18. Hope Bagenal, "Antecedents of Greek Architecture I," *Architect and Building News* 115 (18 June 1926): 579.
19. Hope Bagenal, "Amoenitas," *Architectural Association Journal*, 45 (December 1930): 205.
20. Hope Bagenal, "The Persistence of the Classic," Lecture at the Art Workers Guild, 1955: 18. Typescript in Hope Bagenal Archive.
21. Bagenal, "Robert Atkinson" (1953): 202.
22. Ibid.
23. Hope Bagenal, "The Lesson of Ostia I," *Architect and Building News* (September 20 1927): 523.
24. Hope Bagenal, "The Contemplative Principle in Architecture," *Plan, Journal of the Architectural Students Association*, No.1, 1942: 21.
25. Ibid., 22.
26. See Hope Bagenal, "Some Yorkshire Studies," *RIBA Journal* (25 April 1938): 610–16.
27. See Hope Bagenal, "Some Notes on Cottage Architecture in Ireland," *Architect and Building News*, 128 (4 December 1931): 288–89
28. Hope Bagenal, "Agricultural Buildings and the Origins of the Orders," *RIBA Journal* (13 October 1934): 1043–44.
29. Bagenal, "Agricultural Buildings" (1934): 1045.
30. Bagenal to R. C. Lambeth, 14 July 1958, quoted in John Bagenal, ed., *The Best of Bagenal* 3, privately published, 1994.
31. Raglan's ideas were published in *The Temple and the House* (London: Routledge and Kegan Paul, 1964). Erith's

letter is in the Hope Bagenal Archive. A different letter of Erith's is quoted at length Lucy Archer's *Raymond Erith: Architect* (Burford: Cygnet Press, 1985): 41–45; and the one referred to here has been quoted by her in lectures on several occasions.

32. See Bagenal's speech at the "Presentation of the Royal Gold Medal for 1955 to Mr J. Murray Easton," *RIBA Journal* (May 1955): 274, and "Robert Atkinson" (1953): 202.
33. Hope Bagenal, "The Architect's Contribution to the Thought of his Time", *Architectural Association Journal* (January 1934): 250.
34. Bagenal, "The Contemplative Principle" (1942): 23.
35. Hamilton, Bagenal, and White, *A Qualitative Survey of Some Buildings in the London Area* (London: HMSO, 1964).
36. Hope Bagenal, "The Architecture of Reconciliation: A Basis of Design," *Builder*, 138 (20 May 1955): 829.
37. William Tatton-Brown, "Hope for the Prince", *Architects' Journal*, 185 (8 April 1987): 77.
38. Bagenal "The Persistence of the Classic" (1955): 19.

David Watkin and the Classical Idea

ROGER SCRUTON

When I first met David Watkin I was beginning my second year as a Research Fellow at Peterhouse, Cambridge, and David had just been elected to the Fellowship (fig. 1). He had been described to me as an evil reactionary, an enemy of social progress and enlightenment, who would do his best to thwart the ambitions of those Fellows who were striving to meet the educational challenges of the twentieth century. This description so warmed me to the unkown Dr Watkin that I immediately went to call on him in the rooms which he had been assigned in St Peter's Terrace, on the staircase next to mine. I was astonished to discover that he had already transformed the day-quarters of the dingy don who had previously occupied them to the chambers of a Regency gentleman, with furnishings, prints and ornaments that might have been rescued from a great estate, or a great disaster (fig. 2). It had the air of someone who had fallen from the heights of inherited affluence and who was struggling to maintain himself in elegant decline.

The impression was enhanced by the presence of Monsignor Gilbey, meticulously dressed in the style of an Anglican clergyman of Jane Austen's day, crouching forward in a bergère chair as though interrupted in the course of a confessional. David himself was dressed in a three piece suit and starched collar, from which his thin neck rose like a fluted column, bearing a head of Doric severity which, however, on my explaining my identity, broke into a thin Ionic smile. I was introduced to the Monsignor who confined his adverse judgement of my bohemian dress to a rapid sweep of the eyes, and then rose to take me by the hand as though welcoming the

Fig. 1 David Watkin, Fellowship Admission Photograph, 1970 (Courtesy of the Master and Fellows of Peterhouse, Cambridge)

Fig. 2 David Watkin in his rooms in St Peter's Terrace, Cambridge, in 1971 (Photo: Gavin Stamp)

Prodigal Son. The two of them greeted me with cut-glass accents, and began to talk with a kind of Firbankian allusiveness of the appalling nature of David's new surroundings, and the distressing need to share some part of his lodgings with a Canadian hippy whose principal redeeming feature, however, was that, being married — or sort of married — he was seldom there. The dialogue between them, in which I

was included as a sympathetic audience, could have been conducted by two out-of-work actors, consoling themselves with their favourite Noel Coward roles.

And indeed, as I came to know David better, and through him Alfred Gilbey, I came to understand both of them as accomplished actors, who had chosen their roles and chosen to be meticulously faithful to them. To say this is not to make a criticism. On the contrary, it is testimony to their great strength of character that, having understood the moral and aesthetic chaos of the world into which they were born, they each of them recognized that there is only one honest response to it, which is to live your life as an example. This is what Alfred Gilbey was to David; and it is what David has been to me. As I got to know him, and as the smile with which he greeted me advanced from that original Ionic thinness to a positively Corinthian gaiety, I found myself roused first to admiration and then to wonder that a person should be able to live as David lived, his deeply romantic sensibility confined in a dramatic role entirely devoted to the classical idea. He had absorbed that idea from the Monsignor, who taught that chaos lies all around us, and that our first duty is to impose upon it whatever order — spiritual, moral, aesthetic — it can bear. The alternative to order is not freedom, which is a form of order and its highest purpose, but disorder, randomness and decay.

That was what we — David and I — as refugees from the sixties, had witnessed: the decay of everything, when law-governed freedom gave way to random self-expression. And when spiritual certainty and moral discipline find their aesthetic equivalent, the result is the classical style. That was the idea that inspired David, and it is an idea that he has exemplified in his life. Those who say (as many do) that the classical idea, transported into the modern world, is just so much dressing up, fail to realize that the choice before us is not between dressing up and a kind of primeval Lawrentian nudity, but between dressing correctly, so as to be pleasing to others, and dressing in the offensive style of the post-modernists. I would go further, and point to the sheer affectation of a Ghery, a Libeskind or a Rogers, whose buildings flaunt their metal excrescences in our cities like bejewelled old queens at a gathering of councillors. And I would contrast the polite and public-spirited demeanour of Terry, Simpson and the others whose architecture David has defended. The neo-classical movement is a movement towards order, dignity and grace — towards an architecture that does not stand out but fits in, politely taking its place in the city's shadows.

At the time of our meeting David had published his ground-breaking book on Thomas Hope. What impressed him most deeply was not the Greek revival forms

that Hope invented, but the attempt to organize a life around them. Furniture, fabrics, cutlery – all were subdued to the same delicate discipline. Words, relationships and life-style followed suit. Hope's neo-classicism was a complete *Weltanschauung*, though one which emphasized the importance of domestic ornament, since it is in intimate settings that things most hurt or soothe the eye. Hope's attention to these things was controlled by a refined taste: he was designing not for himself only but for others, with a view to creating an environment that could be shared. Of course, Greek revival furnishings have an austere and high-minded appearance, designed less to bring comfort to the ordinary life than to sit in judgement upon it. However it is true of the classical tradition generally, that its attempt to create a polite and decorous space which will be not yours or mine but everyone's, goes hand in hand with a demand – gently expressed, though as unmistakeable as that sweep of the eyes with which my shabby robes were dismissed by Monsignor Gilbey – that we should do what we can to live up to its own standard of decorum. The classical city does not require us to go around dressed in togas and making declarations of our faith in the *genius loci* – though the French Revolutionaries were, for a while, of this opinion. But it exhorts us to behave. You dress for city streets – so the Orders tell us. And in the crowds that move about them politeness is the rule. The modern city of smashed-open spaces and eyeless buildings does not make such demands. It is a place to shout in, to play in, to puke in, a place to run riot in whatever way we please. It is a city without judgement: no longer a public place, but an assembly of private spaces, all turning their backs on their neighbours.

I have expressed my protest against modernism in moralising terms. It is a matter that David and I often discussed, during the years that led to the publication of his *Morality and Architecture* in 1977. David's attack on the modernists and their apologists (and especially on that vinegary champion of the housing estate, Nikolaus Pevsner) argued forcefully against the view that the Modern Movement is the authentic expression of modern life, both historically inevitable because the *Zeitgeist* has called for it, and uniquely moral in discarding the hierachical vision of the classical idiom, and the insincere religiosity of the Gothic. The Modern Movement was announced and defended with fanfares of self-righteous applause, as an architecture that is true to our times, true to the egalitarian temperament of modern people, and freed from the falsehood and pomposity that had placed eyebrows on every window and moustaches over every door. David's book took apart the nonsense, the rhetoric and the sheer malignancy contained in those ideas, declaring, in so many words, that morality is one thing, style another, and that aesthetic values cannot be prescribed

either by the Hegelian theory of history or by the puritanical morality of the socialist establishment.

I applauded David's conclusions, but was less convinced by his argument. And he too, revisiting it in 2001, was more inclined to recognize the connection of moral and aesthetic values than to emphasize the distinction between them. He was attached to the classical idea as a way of life, and saw modernism as an iconoclastic rebuttal of the past, comparable in its motivation, as in its effect, with the socialist politics that had poisoned the culture of post-war England and against which we were both in rebellion. Modernism may have announced itself in excessively moralistic terms, but there is no doubt that it was impelled by a moral idea. And what we both found repulsive in the visual archetypes with which it had littered the towns of post-war Britain was exactly what was repulsive in its moral idea — the *ressentiment* which found nothing to admire in a high style or a decorous politeness, and which joylessly dismissed all attempts at grandeur and ornament as offences against the egalitarian order, which is not a form of order at all but a kind of regimented disintegration. Of course, David would not put it quite in that Nietzschean way. But there is no doubt that, in the end, the dispute between him and Pevsner was founded in a deep moral confrontation.

My discussions with David inspired me to write my own book on architecture. *The Aesthetics of Architecture* appeared in 1979. My hope was to show that aesthetic judgement is both essential to the architectural enterprise, and bound by rational constraints that give strong *a priori* grounds for endorsing the kind of discipline contained in the classical and Gothic traditions. I set out to justify vertical order, mouldings, shadows, repeatable proportions and disciplined apertures, of the kind familiar in our city streets at the time when the modernists set out to destroy them. I did not argue that aesthetic judgement and moral judgement are identical. But I did try to establish a deep connection between the classical styles and a way of life, and between that way of life and a vision of human fulfilment. And I thought of myself as filling in the philosophical background to David's work, understanding it less as a dismissal of modernism than as a defence of the classical idea.

In the event we were both attacked by the modernist establishment as parts of a sinister right-wing conspiracy, whose scandalous presence in our universities could be explained only by some oversight among those responsible for appointments. Reviews of our two books were unremittingly hostile, with the kind of inquisitorial malice that is directed towards anyone suspected of 'right-wing' sympathies, in the hope of opening the cupboard in which he keeps his Nazi uniform — mine stained

and crumpled, David's meticulously starched. The attacks culminated in a day-long session organized by the Bartlett School of Architecture in University College London – the leading and representative university school of architecture in Britain – devoted to lectures and seminars on our two books, all with the express purpose of showing them to be intellectually worthless, politically suspect and morally disgraceful. We were not invited and heard about the event only later. This kind of scandalous behaviour, so inimical to the ideals of academic freedom and open discussion in which we had been raised at Cambridge, could be interpreted in only one way. It was, for both of us, a clear proof that our opponents did not feel confident enough in their position to challenge us to reconsider ours, and were more concerned to affirm their beliefs by shouting them than by subjecting them to the discipline of real debate.

David turned back from his brief venture in controversy to the pursuit of architectural history, producing a magnificent textbook in the subject, and studies of Cockerell and Soane which established him as the foremost architectural historian in our country. In recent years, however, he has once again courted controversy, with a book on the architecture and thought of Quinlan Terry calculated to awaken the ghosts of former conflicts. David's closely observed analysis of Terry's buildings is also a defence of the 'radical classicism' referred to in the book's title. And the book makes clear, both through its text and through its lavish illustrations, exactly why radical classicism should be defended (fig. 3). It tells the story of Terry's quiet pilgrimage, in a country where the modernists retain tight control over all avenues to preferment. His buildings either go unmentioned in the architectural press or are subjected to dismissive polemics, focusing on their alleged nature as 'pastiche'. This epithet – which, if taken seriously, would condemn all serious architecture from the Parthenon down to the Houses of Parliament – has been elevated into an all-purpose critical tool, by people who are determined that no whisper from the past shall ever again be heard in our cities.

As David does not hesitate to point out, nobody has been more malicious in the attempt to deprive Terry of work than the great guru of modernism, Richard Rogers, the first to translate Le Corbusier's plan for Paris into partial reality, by demolishing a beautiful lived-in classical *quartier* and dumping the Centre Pompidou on the ruins. Rogers is the darling of the new establishment, heaped with honours for his achievements, which include the hideous, costly and endlessly cost-absorbing building that ought to have warned the Names of Lloyds that their money was no longer in safe hands. When at last Terry fought his way through to a public commission in London

— the new infirmary at the much-loved Royal Hospital in Chelsea — and had obtained all the necessary consents, Rogers had the impertinence to write to the Deputy Prime Minister asking him to call in the plans. For the modernists, it is a matter of life and death that the classical tradition should not be allowed to resurface. Once people begin to discover that classical buildings are not just more beautiful, less pretentious and less offensive than their modernist rivals, but also more economical, longer lasting and more adaptable to changing human needs, the modernists will be out of a job. No wonder they accept opposition with such bad grace.

Fig. 3 Quinlan Terry, The Maitland Robinson Library, Downing College, Cambridge, 1990–92 (Courtesy of Quinlan and Francis Terry Architects)

But David's defence of Terry raises in a more vivid form the question that dominated the controversy surrounding *Morality and Architecture.* What is the foundation of aesthetic judgement? And is there any hope of deciding the question how to build, and deciding it in favour of the answer that David and I believe to be the true one – the one illustrated by the radical classicism of Quinlan Terry? What could we mean by 'standards' in building and design? Here, in summary, is what I have come, partly under David's influence, to think, without the full battery of arguments for thinking it.

Judgements are objective if we are led by our nature as rational beings to agree upon them. This does not mean that those who disagree can be persuaded; nor does it mean that those who agree can find the reasons for doing so. The core principles of moral judgement are objective, even though nobody – not even Kant or Aristotle – has found the final proof of them. They are objective because rational beings, consulting only the facts, and setting aside everything that might compromise their impartiality, will come to agree on them. You will agree with your neighbour about the evil of murder, rape, enslavement, or the torture of children, so long as you and your neighbour both put self-interest aside. Those who don't agree with such judgements cannot as a rule be persuaded; but that is because they cannot and will not be impartial.

Something like this is true in aesthetic judgement. About basic matters rational beings have a spontaneous tendency to agree, provided that they set their special and distinguishing interests aside. But in this area it is extremely unlikely that they *will* disregard their own interests. Those most notorious for rejecting basic principles are those with the heaviest investment in doing so: for example, architects. There is much money to be made from lining city streets with multi-storey concrete car-parks without facades, such as disgrace the centre of Minneapolis. There is therefore a powerful vested interest in the view that there are no objectively valid standards of aesthetic judgement, or the (equally destructive) view that standards must always be changing, in obedience to social, economic and technological change.

Subtract the profit-makers and the vandals, however, and ask ordinary people how their town should be designed – not for their private good, but for the common good – and a surprising level of agreement will be reached. People will agree, for example, on scale: nothing too big for the residential quarters, nothing too broad or tall or domineering for the public parts. They will agree on the need for streets, and for doors and windows opening on to the streets. They will agree that buildings should follow the contours of streets, and not slice across them or in any way arrogate to

themselves spaces that are recognizably public and permeable. They will agree that lighting should be low, discreet and if possible mounted on permanent structures. They will agree on the humanity of some materials and the alienating quality of others; in my view they will even agree about details such as mouldings, window-frames and paving stones, as soon as they learn to think of them as chosen not for their personal benefit, but for the common good. The classical styles in architecture, in particular the pattern-book vernacular familiar from Haussmann's Paris and Georgian London, embody this kind of reflective agreement.

To say as much is not to take a stand against modernism, but only to point to matters that modernists must respect, if they are in their turn to be respected. Heidegger, not otherwise given to lucid utterance, made an important contribution in arguing that 'we attain to dwelling … only by means of building'.[1] He could have put the point the other way round with equal truth: only by learning how to build do we attain to dwelling. Building and dwelling are two parts of a single action. Architecture is the art of settlement. From this simple observation certain principles can be derived which serve to justify those spontaneous patterns of agreement to which I have referred.

The first principle is that buildings should outlast the purpose for which they are constructed. Human purposes are temporary, attached to individual people and their projects; they therefore provide no basis for a collective act of dwelling. All great buildings have the ability to survive the loss of their original purpose. Sancta Sophia, for example, has been a church, a barracks, a stable, a market and a mosque before becoming a museum. Most houses in our older towns have changed from domestic to commercial use and back again. And even when the purpose of building involves eternity — as in a temple dedicated to the immortals — the purpose will one day be changed. From this it can immediately be seen that Functionalism is profoundly mistaken. When form follows function it becomes as impermanent as function. Like the centre of Minneapolis, Functionalist buildings will never lose their disconsolate, stagnant and temporary appearance, not even if they stand for a century. In architecture function should follow form, as it does in the streets of Bath or Paris or Siena.

The second principle is that aesthetic considerations should take precedence over all others. If we abstract from the present and future functions of a building, and ask ourselves how it should nevertheless be constructed, then we have only one reliable guide. It must look right. Architecture is one of the many areas of social life in which appearance and essence coincide. We should not search behind the appearance to the hidden reality. That which is hidden is of no interest to us. Aesthetic value is the

long-term goal, utility the short-term. After all, nobody wishes to conserve a building if it does not look right.

The third principle is that most users of a building are not clients of the architect. They are the passers-by, the residents, the neighbours: those whose horizon is invaded and whose sense of home affected by this new intrusion. This is why patterns and types are so important. The old pattern-books (such as those published by Asher Benjamin in Boston in 1797 and 1806, and which are responsible for the once agreeable nature of the New England towns, Boston included) offered precedents to builders, forms which had pleased and harmonised, and which could be relied upon not to spoil or degrade the streets in which they were placed (fig. 4). The failure of Modernism, in my view, lies not in the fact that it has produced no great or beautiful buildings – the Chapel at Ronchamp, and the houses of Frank Lloyd Wright abundantly prove the opposite. It lies in the absence of any reliable patterns or types, which can be used in awkward or novel situations so as spontaneously to harmonize with the existing urban décor, and so as to retain the essence of the street as a common home. The degradation of our cities is the result of a 'modernist vernacular', whose principal device is the stack of horizontal layers, with jutting and obtrusive corners, built without consideration for the street, without a coherent facade, and without intelligible relation to its neighbours.

Architecture is a public art: whether we like it or not, we are forced to witness it. Until architects recognize that they are altering the dwelling-place of everyone, they will be unaware of the nature of their task. You can find proof of this in Boston, where people dwell happily in Beacon Hill and the North Side, in streets that have retained their public and genial character, but where whole areas of the town, senselessly redeveloped by modernist profiteers, are no longer lived in or liveable, since the mark of human dwelling has been erased from them.

The fourth principle follows from the last, namely, that architecture is a vernacular art. Although there are the great projects, and the great architects who succeed in them, both are exceptions. We build because we need to, and for a purpose. Most people who build have no special talent, and no high artistic ideals. For them, the aesthetic is important not because they have something special or entrancing to communicate, but merely because, being decent and alert to their neighbours, they want to do what is right. Hence modesty, repeatability and rule-guidedness are vital architectural resources. Style must be so defined that anyone, however uninspired, can make good use of it, and add thereby to the public dwelling space that is our common possession. That is why the most successful period of Western architecture – the

Fig. 4 Asher Benjamin, plan and elevation of a house, from *The Country Builder's Assistant* (Greenfield, Massachusetts: Thomas Dickman, 1797): plate 25

period in which real and lasting towns of great size were envisaged and developed – was the period of the classical vernacular, when pattern books guided people who had not fallen prey to the illusion of their own genius.

This does not mean that creativity and imagination have no place in architecture. On the contrary. We depend upon the stylistic break-throughs, the innovations and discoveries that create the repeatable vocabulary of forms. Palladian windows, Vignolesque cornices, the classical orders, the Gothic mouldings – these great artistic triumphs become types and patterns for lesser mortals. Our best bet in architecture is that the artistic geniuses should invest their energy as Palladio did, in patterns that can be reproduced at will by the rest of us.

This is the true reason why architects should study the classical orders: not so as to make use of them (although that would be no bad idea) but so as to understand vocabulary and detail. Measurement makes sense only if boundaries are marked. The orders should be understood not as geometrical systems, but as systems of significant boundaries — boundaries marked by shadow. In *The Classical Vernacular* I tried to give an account of boundaries which can be generalised to other styles of architecture, and which will show just what should be done by ordinary and talentless builders, in order that the rest of us should live happily with their products.[2] It is through its ability to focus our thought on boundaries, and to impart to them the felt significance of a shared life in a public space that the classical style most deserves our attention.

Once we think of architecture as a practice dominated by talentless people, we will come to see how dangerous have been the exultant manifestoes and opinionated theories of the modernists. Millenia of slowly accumulating common sense were discarded, for the sake of shallow prescriptions and totalitarian schemes. When architects began to dislike the result, they ceased to be modernists and called themselves Post-Modernists instead. But there is no evidence that they drew the right conclusion from the collapse of Modernism — namely, that Modernism was a *mistake*. Post-Modernism is not an attempt to avoid mistakes, but an attempt to build in such a way that the very concept of a mistake has no application. We are living beyond judgement, beyond value, beyond objectivity — so the Post-Modernist movement tells us. How then can we expect architecture to be different?

Such feverish ideas are, in my view, exactly what they seem — self-serving propaganda. Values are objective and permanent; what changes is our ability to believe in them, and to make the sacrifices required to live by them. Styles may change, details may come and go; but the broad demands of aesthetic judgement are permanent. By ignoring them we build cities where nobody dwells, cities from which people flee to the suburbs, there to live among leaves and illusions. The American suburb is testimony to the death of architecture — a vast expanse of privatised space, where there is no common home, and no collective dwelling. For many reasons — environmental, moral, aesthetic and even religious — it is important that the centrifugal expansion of the city be reversed: a point made tirelessly, and maybe a little tiresomely, by James Howard Kunstler.[3] People must be enticed again into the city centre, to serve as its eyes and ears, to fill it with life and work and leisure, and to make a home amid public and permeable spaces. The case for this has been unanswerably made by Jane Jacobs; but it is never listened to, so powerful are the vested interests that oppose it.[4] That is why it is important that architects understand the objective basis of aesthetic judge-

ment. For they, more than any others, need to be fortified against temptation, in a world where ugliness and destruction earn the highest fees.

Such, it seems to me, is the way in which the classical idea should be defended. As I understand it, the classical idea is grounded in our deepest intuitions regarding the life of human communities, regarding the nature of public space, and regarding the need for law-governed order if real human freedom is to be achieved. Freedom is not individual licence, but a public engagement, and such is the freedom at which the classical orders aim. Whether or not we agree with David Watkin in singling out Quinlan Terry as the representative of the classical idea, it is an idea which David has done more to impress on public opinion in our country than any other architectural historian, and an idea which – David's polemics notwithstanding – is rooted in the moral sense.

NOTES

1. Martin Heidegger, "Building Dwelling Thinking" in Martin Heidegger, *Poetry, Language, Thought*, tr. Albert Hofstadter (New York: Harper and Row, 1971): 145-61.
2. Roger Scruton, *The Classical Vernacular* (Manchester: Carcanet, 1997).
3. In *The Geography of Nowhere: The Rise and decline of America's Man-made Landscape* (New York: Simon and Schuster, 1993).
4. Jane Jacobs, *The Death and Life of Great American Cities* (New York: Random House, 1961).

PART II

NEO-CLASSICAL AND NINETEENTH-CENTURY STUDIES

Some Pages from Marie-Joseph Peyre's Roman Album

ROBIN MIDDLETON

AFTER THE FINAL dispersal of Georges de Belder's collection in 1984 the Getty Center for the Humanities in Los Angeles acquired an album of drawings by Marie-Joseph Peyre, almost all studies of architecture and fragments from Rome and its vicinity that has, surprisingly, attracted little attention. I inspected the album around 1990 and made notes then, intending to write a paper on the subject. I subsequently reported the album to Werner Oechslin. A microfilm was made available to us and we thought to write a study together, but set the matter aside. Although Janine Barrier and Eleanor Tollfree, amongst others, have since viewed the volume, or the microfilm, and have made some assessments, the drawings that interest me in particular — Peyre's original compositions — have not, as far as I know, been the subject of comment. Nor have they been illustrated. I present them here as a subject of suitable interest to David.

On the front cover of the album is a handwritten title "Recueil de morceaux d'architecture et de divers fragmens de monumens antiques faite en Italie par Marie Joseph Peyre architecte du Roy ancien pensionnaire de Sa Majesté a Rome. 1786," which indicates that the book was finalized the year after Peyre died at Choisy, from typhoid. Yet all but one of the drawings therein (69, a thirteenth-century French castle) would seem to date from the period Peyre was studying in Rome.[1]

Peyre, registered at the Académie royale d'architecture as a student of Denis Jossenay and Louis-Adam Loriot, but taught also by Jean-Laurent Legeay and Jacques-François Blondel, was awarded the Grand prix for architecture in 1751. His

Fig. 1 M.-J. Peyre, "Bâtiment qui contiendroit les Académies, et tout ce qui est necéssaire à l'éducation de la jeunesse", from *Oeuvres d'architecture*. Paris, 1765, pl. 3. Faculty of Architecture and History of Art Library, University of Cambridge.

brevet was issued only on 20 May 1753, two days after he had requested the princesse de Conti to intercede on his behalf. On 23 May he was given 300 livres to enable him to travel to Rome. The date of his arrival there is not recorded. He is first mentioned in a letter of 14 November 1753 from Charles Natoire — who had arrived in Rome two years earlier to replace Jean-François de Troy as the director of the Académie de France — addressed to Abel-François de Vandières (marquis de Marigny as of 14 September 1754), Directeur-général des bâtiments, jardins, arts, académies et manufactures du roi. Peyre was reported to be working well — "[il] vient de me faire voir un morceau d'étude bien dessiné d'un projet qui pouroit servi de palais propre à contenir les différans genre d'Académie; cet ouvrage me paroît d'un très bons goût et bien imaginé; cela fera un très bon sujet."[2] There can be little doubt that this refers to the first outline of the "Bâtiment qui contiendroit les Académies, et tout ce qui est nécessaire à l'éducation de la jeunesse," the final plan, section, and elevation of the central building for which survive at the Ecole des beaux-arts in Paris, published in 1765 in Peyre's *Oeuvres d'architecture* to stirring effect (fig. 1). The design was amongst the most celebrated of the eighteenth century.

The Académie de France was housed at that time in the Palazzo Mancini, on the Corso, almost opposite Piranesi's print shop. There were rooms for twelve *pensionnaires*, usually six painters, three sculptors and three architects, accommodated in the attic storey in rooms stiflingly hot in summer, unheated in winter, the stair accessible only through the apartment of the director. When Peyre arrived three winners of the architectural prize were in residence still: Charles-Louis Clérisseau (Grand prix 1746, a pupil of Germain Boffrand, as also, it is assumed, of Blondel) who had reached Rome late in July 1749 and remained at the Palazzo Mancini till late February 1754

(despite the notorious incident of the certificate of communion of July 1753, which almost led to Clérisseau's expulsion), thereafter serving as drawing master to William Chambers and later to Robert and James Adam, not leaving Italy for France until the summer of 1767; Julien-David Leroy (Grand prix 1750, a student of Jossenay and Loriot, as also of Legeay, Blondel and Philippe de La Guépière) who reached Rome on 28 June 1751 (like Clérisseau involved in the certificate of communion scandal) to depart for Venice and Greece in April 1754, returning to Rome in July 1755, staying no more than a month; and François-Dominique Barreau de Chefdeville (Grand prix 1749, a pupil of Boffrand) who travelled from Paris to Rome together with the sculptor Augustin Pajou (Grand prix 1748), arriving on 14 February 1752. In a letter dated 11 October 1755 from Fontainebleau, Marigny gave permission for Pajou to stay on at the Académie until the following spring.[3] However, before the letter reached Rome Pajou and Barreau had departed for Naples. Barreau left Rome finally in March 1756, Pajou on 2 June 1756.

Three other architectural *pensionnaires* arrived during Peyre's stay in Rome: Charles De Wailly (Grand prix 1752, a pupil of Legeay and Blondel), who was given permission to share his prize and pension with Pierre-Louis Moreau-Desproux (a pupil likewise of Legeay and Blondel), for four years a runner up for the Grand prix; and Louis-François Trouard (Grand prix 1753, a pupil of Loriot), who had reached Rome a few days before De Wailly and Moreau arrived together on 6 November 1754. Marigny kept De Wailly and Moreau to their agreement; they stayed only half-time and he refused to provide money for them to travel to Naples, however they stayed on for a time at their own expense. They seem to have been in Italy still – in Florence – in June 1757. Trouard had departed from Rome by 12 October 1757. Victor Louis (Grand prix 1755, a pupil of Loriot and Charles-Etienne Camus) reached Rome in late September 1756. He left in September 1759, strictly in accord with the regulations. Another resident at the Palazzo Mancini during these years requires to be mentioned, Hubert Robert, who arrived in Rome on 4 November 1754 in the train of the new ambassador, the Comte de Stainville, later the Duc de Choiseul. Though not a winner of the Grand prix, Robert was given extraordinary permission to stay at the Académie de France provided his meals were paid, and he was admitted early in 1755. He left Rome finally only on 24 July 1765.

There were, of course, other French architects and artists in Rome who might have inspired Peyre, including Jérôme-Charles Bellicard (Grand prix 1747, a pupil of Jossenay) who had replaced Jacques-Germain Soufflot as a member of Marigny's Grand tour in November 1750, and had travelled with him as far as Venice, which they

reached in June 1751. Bellicard returned to Rome at this time but how long he stayed is uncertain. Jean-Baptiste Lallemand reached Italy around 1745 and seems to have remained there, mainly in Rome, for as much as twenty-five years. There was in addition Jean Barbault, who arrived in Rome in February 1747 and was allowed – again exceptionally – in March 1750, to take up residence in the Palazzo Mancini, being expelled however at the end of 1753 when it was found that he had been secretly married on 13 January of that year (with Lallemand as a witness). Barbault lived close to the Académie, in the Trevi quarter. In 1761 he published *Les plus beaux monuments de Rome ancienne*. He died in May the year after. His second folio *Les plus beaux édifices de Rome moderne* was issued in 1765, his *Recueil de divers monumens anciens répandus en plusiers endroits d'Italie* in 1770.

There appears to have been little interaction between most of the foreign architects and the French – despite his employment of Clérisseau, Robert Adam made no mention in his letters home of Peyre and his friends. However there is one significant exception, William Chambers, who had attended Blondel's Ecole des Arts, then in the rue des Grands-Cordeliers in Paris, together with Peyre, Leroy, De Wailly and Moreau, during the school year November 1749 to April 1750. Afterwards Chambers travelled to Rome, arriving in late December 1750. During the summer of 1751 he returned to Paris to meet his future wife, Catherine More, leaving Paris in November to return to Rome. He was apparently in Paris again in 1752, in Florence in January 1753. He was married in Rome on 24 March 1753 at his lodgings in the Palazzo Tomati, 73 Strada Felice (now Via Sistina), where Piranesi was to install himself in 1761. Chambers left Rome in April 1755, travelling north to Vicenza and then Milan, which he reached in June, and thus to Livorno from where he took a boat for France. Chambers apparently travelled during these four years to Naples as well; the time he spent in Rome is thus uncertain, but there is no doubt that it served as his base.

This summary listing of some of the young architects and artists active in Rome during Peyre's stay indicates at once that only Barbault, Clérisseau, Barreau and Pajou were there through most of his tenure. Leroy was at the Palazzo Mancini during Peyre's first year and for a month in his third. De Wailly, Moreau and Trouard were there during his last year and a half, at least – as we shall see – as was Hubert Robert. Victor Louis was there during Peyre's final months. Chambers appears to have been in Rome for most of Peyre's first two years.

Very little is known of Peyre's activities during these years. Natoire informed Marigny on 5 November 1755 that Peyre had taken up painting. Giovanni Paolo Panini had long since been dismissed by de Troy as drawing master to the students, though

he seems to have instructed some still. Marigny laid much stress, however, on the need to draw well. Natoire no doubt taught the students himself. Certainly he took them on excursions to Tivoli and Frascati to sketch from nature, and they gathered together in the Forum, in the pavilion he acquired there in 1755 – known alternatively as his "villa," his "hermitage" or his "vigne" – where they sketched the ruins. Natoire recorded the site in two drawings. Marigny gave no instructions concerning the study of the monuments of antiquity; he preferred that the architects look rather at more recent buildings. Much later, on 21 September 1762, he wrote to Natoire:

> J'ay reçu, Monsieur, votre lettre du 1er de ce mois avec les dessins du Sr Le Roy et du sieur Chalegrin, ils sont assés bien; je leur sçay gré de leur attention, mais je voudrois que nos architectes s'occupassent plus qu'ils ne font des choses relatives à nos moeurs et à nos usages que des temples de la Grèce. Ils s'éloignent de leur objet en se livrant a ce genre d'architecture. Je ne juge point cette étude aussy favorable pour cultiver et augmenter leurs talents qu'ils peuvent le penser.[4]

However, the period Peyre was in Rome is notable for a new emphasis on the measuring of antique architecture. The Abbé Barthélemy reported to the Comte de Caylus on 25 January 1757 that "Moreau et Doilly" had worked closely together, measuring the Baths of Diocletian – "Ils sont entrés dans les souterrains, ont grimpé sur les toits, ont fouillé dans la terre, autant que leurs facultés ont pu le leur permettre, et ils me paroissent avoir renouvelé cette méthode sage et exacte que l'on admire en Desgodets."[5] They had prepared more than thirty drawings, enough for a book. Piranesi himself had praised the drawings. Joseph-Jérôme Le François de Lalande also reported in his *Voyage d'un françois en Italie*, of 1769, that "Peyre, Moreau et Dualli" had drawn up a general plan of Hadrian's villa – "ils y travaillerent avec une assiduité incroyable pendant plus de quinze jours."[6] Peyre showed the plan to Lalande, but it was never to be published. The three young architects, Lalande noted, had also drawn antique fragments scattered on the terrace of count Giuseppe Fede's villa set amongst the ruins of Hadrian's villa, one of which was illustrated by Leroy in *Les ruines des plus beaux monuments de la Grèce*, of 1758.[7] Peyre was to include plans of the Baths of Diocletian and the Baths of Caracalla in his *Oeuvres d'architecture*, of 1765 – "J'ai examiné scrupuleusement" he wrote then, "avec MM. Moreau et de Wailly, Architectes, alors Pensionnaires du Roi à Rome, ce qui nous reste de ces Monumens, et nous en avons assez découvert pour pouvoir lever éxactement les Plans ci-joints."[8] Piranesi, too, one might note, had offered plans of the Baths of Caracalla and Diocletian in *Le Antichità romane*, as did Barbault of the latter – less accurate – in

The friendships formed at Blondel's Ecole des Arts and reinforced after in Rome survived through life. Peyre married Moreau's sister on his return to France (to unhappy effect); he worked later in partnership with De Wailly on the greatest building of their careers, the Comédie française. Pajou worked with Moreau on the Palais Royal. Pajou worked closely also with De Wailly, first on the remodelling of the Hôtel d'Argenson (recorded by Chambers), then at the Opéra at Versailles. In 1776 De Wailly designed a house for Pajou in the rue de la Pépinière, two years later erecting his own alongside.

The links and encounters between the *pensionnaires* in Rome are of some significance when it comes to assessing their drawings. They travelled together, as noted, to the same sites, most often drawing the same views and buildings, sometimes copying one another's drawings for convenience, often trading them. But for all their activity, there are surprisingly few drawings to attest to it. Finished studies and compositions were sent regularly to Marigny and the Académie royale d'architecture, but they are, Peyre's "Académies" apart, not to be found. For Barreau, Leroy and Trouard there are no drawings from their Italian sojourn. From Peyre – the present album apart – there are just two designs for fountains in the Musée des arts décoratifs in Paris and a lively drawing of the "Illumination of the Capitol" in the Albertina in Vienna, once attributed to De Wailly, but later thought by Marianne Roland Michel to be by Peyre (though the earlier attribution might yet prove correct). There is at least one sketch of the ruins of Hadrian's Villa by De Wailly, a view of Bernini's fountain in the Piazza Navona,[11] two or three beautifully drawn fantasias of interiors based on antique and modern architecture, and about another dozen even more beautifully rendered studies of buildings or their features in Rome, once again both antique and modern. Much of this work, though, might have been done on De Wailly's return to Paris. There are, of course, innumerable drawings and paintings of ruins or compositions based on them by Clérisseau, but these were done, for the most part, for sale. They were not records of what he had seen for future use in his designs. Clérisseau showed no interest at all in modern works. There are no more than two collections of drawings of students of the period comparable – though superior by far – to Peyre's Roman album: three albums by Pajou, two at the Ecole des beaux-arts in Paris, one at Princeton, catalogued by James Draper and Guilhem Scherf, and the "Recueil de divers dessein," the so-called Franco-Italian album, and a related group of drawings by Chambers, all in the Victoria and Albert Museum in London, catalogued by Stephen Astley, Michael Snodin, Janine Barrier, and Rosemary Battles Foy. Chambers' album seems to provide a full account of his

activities in Italy. A comparison of this with the albums of Pajou and Peyre reveals at once how much the three artists shared. Peyre's, however, though a folio, is less comprehensive; it contains no more than a smattering, and a haphazard one at that, of the drawings he must have done in Italy. Many, moreover, are culled directly from his companions. But there is yet much of interest to note.

The pages of Peyre's album are numbered on the top right hand corner, recto only, from 1 to 92, but number 15 is skipped. On nineteen of the pages, whether recto or verso, drawing has been direct – 1, 3, 4, 6, 7, 8, 51v., 52v., 81v., 82v., 83v., 84v., 85v., 86v., 87v., 88v., 89v., 90v., 91, 91v., 92v.. The rest of the drawings, on thin sheets of paper, have been pasted, two, three or four, on to the page, usually recto. As the list of pages on which drawing has been direct already indicates, the album appears to have been used at first at each end. On the pages listed between 1 and 8, there are bold drawings, beginning with the three standing columns of the temple of Vespasian (then termed Jupiter the Thunderer) in the Forum, the remainder being close-up views of Roman walling and vaulting. Nine of the numbers listed as direct drawings, all verso, all at the end of the album, are original compositions. They are upside down in relation to the front of the album. Thus Peyre, when he began, put his antique studies at the beginning of the album; turning it upside down, he started a series of original compositions. The two drawings done direct in the middle of the album, 51v. and 52v., are part of a sequence of drawings, on pages 50 to 53, all given over to Bernini's baldacchino in St. Peter's – thus a recording of a modern work. One might surmise that Peyre thought at first to put antique studies in the front, modern in the middle, with his own compositions at the end. But this did not last for long; he found it more expedient to paste in his drawings – as did Chambers in his album and Pajou in his sketchbooks. When Peyre's drawings were pasted in, whether in Rome or later in Paris, is impossible to guess. One drawing, at least, probably not by Peyre (as noted), dates from long after the Italian interlude. There is no evidence of ordering other than that already indicated.

There are about 210 drawings in all, but this figure is not fixed; not all the scribbles have been counted, nor have small additional details alongside measured drawings. And though the drawings of urns, two set neatly on each sheet of paper, have been counted as two, the two large drawings of coffered ceilings, set on a grid, fifteen to a sheet, have been counted also as two.

The drawings are in various media: pencil, black and red chalk, ink and ink wash. The subjects of the drawings are often the same as those to be found in the albums

of Chambers and Pajou. About 90 of the drawings record Roman ruins and fragments – the range once again close to Chambers and Pajou, even more so to Barbault's *Recueil de divers monumens*. Nos. 3, 4, 6, 7, 8 are stark, somewhat ominous views of walls, some with arched openings. Nos. 10, 11, 12, and 71, though darkly shaded, are more engaging studies of ruins, perhaps not by Peyre, while 30, both 1 and 2, "ferry félice," and "temple de Serrapis," [Pozzuoli] 39 "Colisée de Capoue" [Capua] and the related 43 and 56, are almost certainly not by Peyre. He does not, as already noted, seem to have travelled to Naples. The views of the farmhouse (28 top) and the fountain (29) are likewise probably not by Peyre. There is an isolated plan of the port of Ostia (62 bottom), taken from a book plate (but not from Sallustio, Labacco, Ligorio, or Montfaucon), and two fairly accurate records of ceiling paintings from the Domus Aurea, known then as the Baths of Titus,[12] not derived from Pietro Santi Bartoli. One drawing (87) shows the ceiling of the hall of Hector and Andromache, then thought to be of Coriolanus. This was believed to be the room in which the Laocöon group was found, and Peyre registers this information. The other drawing (86 bottom) shows the vault of an adjoining corridor. The two drawings, with their notes, have some affinity with the archaeological method of recording evolved by Bellicard in his notebooks of 1750 and 1751. There are other items surviving from the classical past that can be readily recognized – the antique sarcophagus of Cecilia Metella then in the Palazzo Farnese (2 bottom); the Dacian captives (61 top), also in the Palazzo Farnese at the time, now in Naples; Weeping Dacia (25 left) in the Capitoline museum. There is a base (2 top), copied perhaps from the "altar of Apollo," then in Venice, illustrated in Barbault's *Monuments de Rome ancienne*.[13] There is a broad sketch (18 top) of the Temple of Antoninus and Faustina in the Campo Vaccino. There are sculptured figures (54 top and bottom, 74 top left and right, 75 top left), a herm (22 top right), a horn (60 bottom left), bas reliefs (20 bottom and 75 top right at the Villa Medici, 60 bottom right, 80 bottom left), sarcophagi and tomb chests (16 bottom left, 63 top left and right, 65 top left, 66 top, 78 top left), altars (28 bottom, 62 top, 64 bottom, 74 bottom, 86 top), a tripod (63 bottom left) and vessels and urns (64 top left and right, 65 top right, 80 bottom right). There are numerous sculptured fragments (20 top left and right, 21 bottom, 22 top left, 55 top and bottom, from Trajan's Forum, 63 bottom, from the temple of Serapis (temple of the Sun) on the Quirinal, 77 top right), cornices and entablatures (75 bottom left, from the temple of Vespasian, 76 top right and bottom right, 77 top right), capitals (13, 65 bottom, 75 bottom left, 76 top left, 78 top right), a bracket from the Palace of the Caesars (76 bottom left) and running mouldings (15 top and bottom, 77 bottom left, 78 top left).

The array was much the same as that to be seen in the Museo Capitolino and the Palazzo dei Conservatori, though hardly any of the items seem to have been drawn there. There is no evidence of any real focus of interest. They make for a messy selection. More revealing are Peyre's recordings of modern, particularly seventeenth-century architecture and sculpture.

The modern works begin, chronologically, with the Villa Madama, a plan of the loggia – drawn also by Chambers – and a perspective sketch of a window in the courtyard (84), then Vignola's Villa Giulia, a plan, a longitudinal section and two elevations (82, 83) – recorded also by Chambers. However, most of the examples date from the sixteenth and seventeenth centuries – the top of a doorframe from Giacomo della Porta's S. Paolo alle Tre Fontane (61 bottom right); one of Flaminio Ponzio's blind windows from the Palazzo Rospigliosi (85 bottom right); a bay and a window detail from Giovanni Vesanzio's portico at the Villa Mondragone (77 bottom right) finished in 1618; followed by views and details of stuccoed and painted vaults of some years later; the vault of the vestibule of St. Peter's (5) (II–1, fig. 2) and a detail of a moulding there (80 top left); a detail from the corner of Pietro da Cortona's fresco the Triumph of Divine Providence in the Palazzo Barberini, Titus Manlius/Justice (23 top) – Gabriel-François Doyen, who travelled to Rome with Chambers, was doing a painting of the ceiling for Natoire in July 1754 – as also a capital of a pilaster from there (85 bottom left). From later still in the century are A. Raggi and G.B. Baciccio's exuberant decorations on the vault of the nave of the Gesù (17). A counterproof of this same drawing is included in Pajou's album (ENSBA II 29) and a tracing in Chambers' album (V&A n. 281), but Peyre's is none the less not the original, for there is more detail in the Chambers version and yet more in Pajou's. The original was probably by De Wailly, who prepared a finished study of the whole vault.[14] There are other composite works, the monument to Innocent X under the organ loft at S. Agnese on the Piazza Navona, incorporating work by Carlo Rinaldi, Francesco Borromini and Giovanni Battista Maini (80 top left). But the greatest emphasis by far, is that on

Fig. 2 M.-J. Peyre, ink sketch of the vaulting of the portico of St. Peter's from his Italian album. The Getty Research Institute, Los Angeles. 840015* p. 5.

THE PERSISTENCE OF THE CLASSICAL

Bernini, and the focus here is on the baldacchino at St. Peter's — an overall plan (51 top), an elevation of a pedestal (52 verso), a closely measured column and detail of the fringe (52) (II–1, fig. 3), the entablature (51 verso), the scrolls on the top (51 bottom, 72 top, 72 bottom), the crowning detail (53 bottom), two of the angels (73 top left and right), the papal tiara and putti (73 bottom left). Chambers, too, drew the two angels, then thought to be by François Duquesnoy (V&A nos. 229 and 23), as did Pajou (ENSBA I 5 and 43, P. 416), but from slightly differing angles. Pajou also sketched one of the twisted columns (ENSBA II 101), and the top of the baldacchino (ENSBA II 86); this last is dated 1753. The angels and the papal tiara apart, Peyre's drawings are to scale with measurements added, which indicates that the students were able to mount the scaffolds to produce their drawings. As Werner Oechslin has noted, Niccola Zabaglia illustrated the scaffolding as plate 34 in his *Castelli, e ponti* of 1743, describing it as "Castello servito per ripulire l'ornamento della Confessione dei SS. Apostoli nel Vaticano." The ceremony most revealing of the baldacchino and thus the most likely to have prompted its cleaning was that of the illuminated cross, hung up for Lent; if so, and if the students climbed up together, it was probably soon after Peyre's arrival in Rome. De Wailly composed a brilliant, foreshortened capriccio on the basis of one of the twisted columns.[15] There is more by Bernini in Peyre: the tombs of Urban VIII and Alexander VII (26 and 27), sketched also by Chambers (V&A nos. 223, 224, and 225, 226) and by Pajou (ENSBA II 96, P. 449 and ENSBA I 117); the archway of the Scala Regia (60), sketched also by Chambers (V&A no. 242); the vault of Sant'Andrea al Quirinale (24); and the Triton fountain in the Piazza Barberini (19). There is a similar perspective of Carlo Bizzacheri and Francesco Maratti's Triton fountain on the Piazza S. Maria in Cosmedin, of some seventy five years later. Both fountains were sketched on the same sheet of paper by Pajou (ENSBA II 115). Peyre was later, in his *Oeuvres*, to draw attention to Bernini's church at Ariccia, but there are no drawings of that.

From the early eighteenth century is a sheaf of drawings (40–42, 45–50) of ten of the twelve statues of the apostles set in the niches of the nave of S. Giovanni in

Fig. 3 M.-J. Peyre, ink sketch, elevation and details of a column and part of the frieze of Bernini's baldacchino in St. Peter's, from the Italian album, The Getty Research Institute, Los Angeles, 850015* p. 52.

Laterano. The statues were commissioned in 1703 by Clement IX and executed during the fifteen years following by seven sculptors to the design of Carlo Maratta, under the supervision of Carlo Fontana. The statues of St. Matthew and St. John are missing from Peyre's series. The drawings, however, are not in his hand; and they are moreover handed. They are evidently counterproofs of drawings by Pajou, eight of whose drawings of the saints (including St. Matthew and St. John) survive in his albums (ENSBA II 62, 63, 64, 65, and P. 407, 414, 417, 429). The drawings in the Peyre and Pajou albums are identical in size. There is, however, a difficulty: Pajou's drawings are in black chalk, Peyre's in red. Janine Barrier has noted this already in *Le architectes européens à Rome, 1740–1765* and has suggested that Pajou perhaps drew two series of saints, one in black and one in red chalk. Peyre also sketched a moulding and a curule chair in S. Giovanni in Laterano (18 bottom).

Another sequence of drawings derived from Pajou is the series of 32 urns, all about the same size, set four to a page, two to a sheet of paper (31–38) many of which are antique, including the Portland vase, then in the Barberini collection, and some of which are original compositions. Janine Barrier notes in the work cited above, on the authority of Marianne Roland Michel, that 20 of these are counterproofs from an album by Pajou, now dismantled.

Yet another sequence of drawings was taken in readymade from some other student (67 and 68), making up a grid, three by five, on each page, illustrating patterns of cofferings for ceilings, both antique and modern. Four on the first sheet are marked "Pal" or "Palmire," five on the second. The French ambassador, the comte de Stainville, had presented a copy of Robert Wood's *Ruins of Palmyra*, of 1753, to the Académie de France in late December 1754, Natoire noted. The book had been intended for the pope, but he already had one.

Parallel to Peyre's drawings of architecture are several sketches of gardens, the earliest depicted being those of the Villa d'Este, the cascade fountain and details of water spouts (66 bottom left and right), the vase fountain (81 top left). From the seventeenth century is the garden of the Casino of the Farnese palace at Caprarola (79 top left, plan and elevation; 79 top right and bottom, perspective and detail sketches), and the grotto under the entrance to the Villa Sacchetti, the Pigneto, set behind St. Peter's, built in the 1630's by Pietro da Cortona, already abandoned by the eighteenth century (66 bottom left and right, elevational detail and plan. See Chambers' similar plan (V&A n. 380), and finished drawings, 561 and 562. The elevation of the villa was drawn also by Pier Leone Ghezzi; Victor Louis engraved it in dramatic perspective, cat. 2). Three drawings of gardens (14 top and bottom, 21 top),

Fig. 4 G. B. Piranesi, "Pianta di ampio magnifico collegio" from the *Opere varie*. Rome, 1750. Avery Architectural and Fine Arts Library.

perhaps all the same garden, of the sort to be seen at Frascati, are not yet identified. They could be a composite.

On three pages of the album, 57, 58, and 59, are five drawings, and evidence of a sixth having been removed. These are the originals of the five engraved fountains added to the enlarged edition of Peyre's *Oeuvres* of 1795, plates 16, 17, and 18. The sixth additional fountain included there, plate 16 bottom, no doubt corresponds to the missing drawing. This last, as also four other fountains included in the first edition of the *Oeuvres* of 1765, plate 17, signed J.-M. Moreau 1765, are in a style closer to the Roman Triton fountains than the others. As the additional six fountains were not included in the first edition of the *Oeuvres*, they might be thought to post-date it, which implies that the fountain drawings were not done in Rome. Michel Gallet notes that engravings of the later fountains were published separately by Hutin. Hutin is not listed as a print dealer in the *Dictionnaire des éditeurs d'estampes à Paris sous L'Ancien Régime* of 1987, compiled by Maxime Préaud, Pierre Casselle, Marianne Grivel and Corinne Le Bitouzé. The Hutin in question was, presumably, Jean-Baptiste, who won the Grand prix for painting in 1748, reaching Rome in 1749, where he remained until 1756, having turned by then to sculpture. He also took up engraving. He taught and was associated for the rest of his life with the Académie de Saint-Luc in Paris.

De Wailly exploited his study of Bernini's works to forceful and dramatic effect in the 1770s, after a second journey to Italy, in such designs as the salon for the Palazzo Spinola in Genoa and the Masonic lodge for Paris. Peyre was never to produce anything comparable. Yet in Rome, as his album demonstrates, he consciously explored the design of interiors of extended, colonnaded vistas, opening up to a succession of spaces, with further spaces and triumphal staircases visible off to the sides. Piranesi at once comes to mind, though the theatrical tradition of the Bibienas was perhaps more forceful an influence.

Piranesi published the first of his suites of etchings, the *Prima parte di architettura e prospettive*, in July 1743 — with a title page, a dedicatory letter to Nicola Giobbe, twelve

Fig. 5 G. B. Piranesi, ink sketch of a great hall, relating to the central part of the "Pianta di ampio magnifico collegio," British Museum, 1908.6.16.39.

plates and a list of contents. The title page and one of the plates were ruins, rich and evocative, the rest were assorted views of great palaces, halls, and a prison, composed in the manner of Giuseppe Bibiena's *Architettura e prospettive*, of 1740. In subsequent editions of the *Prima parte* it was the ruins he chose to exploit further; five plates were added, only two of them Bibienesque compositions. Forty-eight of his small views of Rome were to be included eventually in a succession of guide books, starting with G.L. Barbiellini's of 1741 (only five views by Piranesi) and culminating in Jean Bouchard's *Raccolta di varie vedute di Roma* of 1752 (fifty one plates by Piranesi, others by Legeay, Bellicard etc.). In July 1748 Piranesi completed his second independent work, the *Antichità romane de'tempi della repubblica* (known later as *Alcune vedute di archi trionfali*), twenty-five medium sized views of Rome. By then his style was established — swift, uneven strokes making up lively and dramatic compositions. By 1748 he had also begun the issue of the plates of the large *Vedute di Roma*, which was to continue to the end of his life, 133 plates in all. In 1750 Bouchard reissued the *Prima parte*, with its five extra plates, in the *Opere varie di architettura, prospettive, groteschi, antichità*, which included the first 25 plates of the *Vedute di Roma* and also the four plates of the *Grotteschi*, dating from a few years earlier, and fourteen plates of another new work, the *Invenzioni capric. di carceri*, the initial version of his celebrated prisons. In 1751 Bouchard enlarged this compilation of plates, publishing them on that occasion as *Le magnificenze di Roma*. In May 1756 Piranesi produced the most ambitious and attractive of all his undertak-

Fig. 6 M.-J. Peyre, preliminary sketch for his "Plan d'une église cathédrale pour une capitale, avec deux palais," from his Italian album, 92v., probably drawn early in 1754. The Getty Research Institute, Los Angeles, 840015*.

ings, the *Antichità romane*, two hundred plates, each two feet across, in four great volumes. Piranesi's reputation was made, not only in Italy but throughout Europe. But in Rome it was probably his drawings that most excited the students.

Peyre's celebrated design for "Un bâtiment qui contiendroit les académies," (fig. 1) on which, as we have seen, he was at work very soon after his arrival in 1753, was probably prompted by Piranesi's "Pianta di ampio magnifico collegio," (II–1, fig. 4) a plate included in the *Opere varie* of 1750, itself no doubt sparked by the Concorso Clementino programme for that year for a "Collegio per Scienza e Belle Arti." Chambers recounts in his *Treatise on Civil Architecture*, of 1759, the story of a great architectural fantasist, who was so taunted by the young students with his inability to produce a proper architectural plan that he determined to produce one of the utmost magnificence. Piranesi's plan of a magnificent college is usually thought to be the outcome of that jibe. If so – and even if not – it demonstrates that Piranesi could not, indeed, produce a satisfying plan: the routes from the entrances to the main spaces are not only indirect, but tortuous; the focal space, though undoubtedly grand (and one may judge something of it with reference to a drawing of his, now in the British Museum (II–1, fig. 5)), cannot be considered the climax to the whole – it is no more than a crossroads. There is no grasp of sequence or climax.

Piranesi's plan may be compared with Peyre's plan for a cluster of Academies; the latter demonstrates at once the coherence and fluency that a young French student could bring to the control of an architectural plan. But this is not my present concern. I am interested rather in the evidence of Peyre's slightly later attempt to prepare a plan of that kind, a sketch plan in his album, 92 verso (II–1, fig. 6) – the last or first drawing in the book, depending on which way it is opened – for his equally famous "Plan d'une église cathédrale pour une capitale, avec deux palais, l'un destiné à l'archevêque, l'autre aux chanoines." This, as noted earlier in connection with Bernard Liègeon, was the subject of the Concorso Clementino competition of 1754, though Peyre must have known only too well that, though Natoire and other French artists had been elected to the Accademia di San Luca, students were firmly discouraged from making any such submissions.

All the elements of the plan published in 1765 are present: a cathedral composed within a circle, quite symmetrically arranged, ringed by two rows of columns, interrupted by four great colonnaded porticoes, the whole set within a vast circular precinct – punctured with four fountains – ringed on this occasion by a double colonnaded gallery on the model of that of the piazza S. Pietro. This is flanked on each side by a large rectangular building organized around a court, once again with giant colonnaded entrances. But it is evident that the sketch is an initiatory attempt. The subsidiary spaces of the cathedral are not yet integrated, they do not compose well with the central space, and some are awkwardly shaped, the same wedges as used by Piranesi in his "Collegio." Peyre eventually resolved these issues (II–1, fig. 7), making his final plan stronger by far, working towards a recovery of that taste for the round and the square that Charles de Brosses in his *Lettres d'Italie* reported as lost to the French. "Les Italiens," he wrote:

Fig. 7 M.-J. Peyre, engraved version of the "Plan d'une église cathédrale pour une capitale, avec deux palais," from his *Oeuvres d'architecture*, Paris 1765, pl. 13. Avery Architectural and Fine Arts Library.

(above left) Fig. 8 M.-J. Peyre, pen and ink wash sketch for a basilical hall, from his Italian album. The Getty Research Institute, Los Angeles, 840015* p. 83v.

(above right) Fig. 9 M.-J. Peyre, pen and ink wash sketch for interrelated circular halls from his Italian album. The Getty Research Institute, Los Angeles, 840015*, 84v.

nous reprochent qu'en France, dans les choses du mode, nous redonnons dans le goût gothique, que nos cheminées, nos boîtes d'or, nos pièces de vaiselle d'argent sont contournées, et recontournées comme si nous avions perdu l'usage du rond et du carré; que nos ornements deviennent du dernier baroque: cela est vrai.[16]

In fact the two subsidiary palaces were arranged finally around square rather than rectangular courts. But here Peyre lost something, a circular colonnaded feature with four symmetrical stairs that he had sketched as a central focus and as a link across the court. Symmetrical arrangements of flights of stairs were to appear again and again in Peyre's work – the Académies project, the Hôtel de Condé project and the design for a cascade and grotto; and even more often in the work of De Wailly – the initial project (the central focus) as also the final design for the château de Montmusard (in the moats), the maison de Voltaire, the Hôtel De Wailly, the Château Enghien

proposal, as well as in the projects for the Château de Wilhelmshoe and the Théâtre des Arts. There are double flights also in Peyre's and De Wailly's Comédie Française.

Also at the end of the album are a series of related designs exploring a sequence of large, interrelated spaces, marked out by columns. The most straightforward, 83 verso (II–1, fig. 8), is of a vaulted hall flanked on either side by screens of columns interrupted in their length by an arched opening. Across the entry to the hall is a screen of columns supporting a horizontal entablature. This may be related to compositions in Piranesi's *Prima parte*, but it is not derived direct. Some of Piranesi's drawings are more suggestive of an influence, but one cannot be sure when they were done or what access Peyre might have had to them. Compositions of this sort were to be taken up by Georges-François Blondel, little enough known son of Jacques-François Blondel, who arrived in Rome in 1756 and stayed on to 1760. Notably, he included fewer mouldings than Peyre.

Fig. 10 M.-J. Peyre, pen and ink wash sketch for interrelated circular halls from his Italian album. The Getty Research Institute, Los Angeles, 840015*, 91v.

A more complex sequence of spaces is depicted on 84 verso (II–1, fig. 9): a domed circular space, broken by four arched openings, two columns *in antis* between each, continuing through a short passageway into a similar, but double-height circular space, which in turn continues through an arched opening. Once again there is far more architectural detail than one associates with Peyre's later work.

An even grander arrangement of the sort is drawn on 91 verso (II–1, fig. 10) – a double-height circular space, an arched opening, a still larger double-height circular space, domed, with arched tunnels on two levels opening up beyond. The vanishing point in the interior described previously had been moved slightly to the right, allowing the suggestion of additional space opening up to the left. On 99 verso these are made more evident, viewed through a curved screen of columns in the first vestibule, in the second including a ceremonial stair. The architecture is punctured in both halls by pedimented aedicules. There is, as before, too much going on.

There are two further compositions of such interiors, both on 85 verso, that relate to a faint plan, 91(II–1) that is made more obscure by ink grinning through from the

THE PERSISTENCE OF THE CLASSICAL

(above left) Fig. 11 M.-J. Peyre, pen and ink wash sketch for a colonnade hallway and adjacent staircase from his Italian album. The Getty Research Institute, Los Angeles, 840015* p. 85v. top.

(above right) Fig. 12 M.-J. Peyre, pen and ink wash sketch for a colonnaded hallway with an adjacent staircase from his Italian album. The Getty Research Institute, Los Angeles. 840015*, p. 85v. bottom.

page behind. The plan, marked out entirely by columns, once again suggests a processional space, punctuated by clusters of four columns, opening up in the middle to a circular space. This is the sort of arrangement for which Giovanni Niccolò (Jean-Nicolas) Servandoni was celebrated in his theatre designs. None of the views attributed to Servandoni can be accepted with any degree of certainty, but his own descriptions of his stage settings and the comments of critics indicate something of their nature. His first great success in Paris were the sets for Rebel's and Francoeur's "Pyrame et Thisbe," of September 1726. Here the triumph was considered to be the "Palais de Ninus," a succession of five clearly defined spaces – an outer vestibule, then the hall of the palace, succeeded by a gallery interrupted by two circular salons. There were columns and arches everywhere. He used a single point perspective. Nothing like it had been seen before in Paris, and even twenty-seven years later the critic of the *Mercure de France* recalled it as the most marvellous of décors, still unsurpassed. There were more of the kind. Peyre might or might not have seen such spectacles, but it scarce matters: the description alone would suffice to stir interest. De Wailly, of course, had studied with Servandoni and had worked on his sets. Peyre's sketch plan

includes not only a processional route of spaces, but a sequence of further spaces running in a parallel, to the left, once again marked out by columns, this sequence containing a great staircase. This arrangement is given form in two perspectives, 85 verso, top (II–1, fig. 11) and bottom (II–1, fig. 12), which also include a large cross-gallery. The lines of columns in these perspectives have become more relentless, particularly in the second (fig. 12), where much of the variety of features has been done away with. The columns have been changed from Ionic to Tuscan. This pattern of change hints already at Peyre's later development. The oblique views off the main axis are suggestive also of the ways in which space was to be experienced in later years – the development of the theme may be traced in illustrations of even the most symmetrically composed plans, most obviously depicted in the perspective views of Percier, Fontaine and Bernier's *Palais, maisons et autres édifices modernes dessinés à Rome*, of 1798.

Peyre's colonnaded passageway opening out to circular spaces is further explored, swiftly, on 81 verso (II–1, fig. 13), when the same plan is repeated, and two sketches, one viewed from inside, one from outside the circular hall, attempt to define it as an independent spatial unit. There is yet another rapid sketch, 89 verso (II–1, fig. 14), in

(above left) Fig. 13 M.-J. Peyre, pencil and ink sketches, plan and perspectives of a circular colonnaded hallway, from his Italian album. The Getty Research Institute, Los Angeles. 840015*, p. 81v.

(above right) Fig. 14 M.-J. Peyre, black chalk sketch of a centralized building from his Italian album. The Getty Research Institute, Los Angeles. 840015*, p. 89v

THE PERSISTENCE OF THE CLASSICAL

(above left) Fig. 15 M.-J. Peyre, pencil and ink sketch plan and elevation of an extended building from his Italian album. The Getty Research Institute, Los Angeles. 840015*, p. 90v.

(above right) Fig. 16 V. Louis, "Veduta della Villa Sacchetti," engraved view. Bibliothèque Nationale, Paris. Est. AA3 Petit in folio.

which a similar spatial configuration is expressed as a single, freestanding building, topped by a circular colonnade.

There are yet more original compositions in Peyre's album — a large wall fountain, 70, the bowl in the manner of Ennemond-Alexandre Petitot (Chambers had copies of Petitot's drawings), the upper part in the manner of Bernini, with dolphins and a giant shell, topped by a pelican with putti; a tomb in a side chapel, 88 verso, the sarcophagus surmounted with figures holding a portrait medallion and swirling drapery — but only one of portent for the future, 90 verso (II–1, fig. 15), a roughly sketched plan and elevation, and a more fully formed elevation, of an extended, symmetrically composed building, raised on a basement with interlocking staircases, the central pavilion broken in the centre by a giant apse, a grotto underneath, a colonnaded drum above, and the whole linked by colonnaded screens to small outlying pavilions. Their masses are punctured by pedimental porticoes. There is clear reference in the composition to the Villa Sacchetti (II–1, fig. 16), but if the design dates from Peyre's Roman years — and there is no reason to doubt this — it is extraordinarily precocious. The composition is redolent rather of very late eighteenth-century design, such as the "Villa per un intelligente amatore delle scienze" attributed to Mario Asprucci, illustrated in the catalogue by Angela Cipriani, Gian Paolo Consoli

and Susanna Pasquali, *Contro il barocco*.[17] This was to become Peyre's own position. Within fifty years of Peyre's stay in Rome, Bernini was to become anathema to men like A.-C. Quatremère de Quincy in France and John Flaxman in England.

NOTES

1. All references to pages in the Getty Center's Peyre album appear in the text, as do those to the albums of Augustin Pajou in the Ecole nationale supérieure des beaux-arts in Paris and to the Franco-Italian Album of William Chambers in the Victoria and Albert Museum in London.
2. Anatole de Montaiglon and Anatole Guiffrey, *Correspondance des directeurs de l'Académie de France a Rome avec les surintendants des Bâtiments* 10, 1754–63 (Paris: Charray, 1900, 1901): 477.
3. Ibid., vol. 11, 109.
4. Ibid., vol. 11, 441.
5. Jean-Jacques Barthélemy, *Voyage en Italie de M. l'abbé Barthélemy… imprimé sur les lettres originales écrits au Cte. de Caylus* (Paris: F. Buisson, 1802): 210.
6. Joseph-Jérôme Le François de Lalande, *Voyage d'un françois en Italie fait dans les années 1765 et 1766*, 5, chapter 20 (Venice, Paris: Desaint, 1769): 345–46.
7. Julien-David Leroy, *Les ruines des plus beaux monuments de la Grèce* 2 (Paris, 1758): plate 10, fig. 4.
8. Marie-Joseph Peyre, *Oeuvres d'architecture* (Paris: Prault, Jombert, 1765) revised ed. (Paris 1795).
9. Sophie Descat, *Le voyage d'Italie de Pierre-Louis Moreau: Journal intime d'un architecte des Lumières 1754–1757* (Bordeaux: Presses Universitaires, 2004): "Nottes sur mon voyage," 75.
10. Ibid., 126–27.
11. Ibid., 28 and 21 respectively.
12. Joseph-Jérôme Le François de Lalande, *Voyage d'un françois en Italie fait dans les années **1765** et 1766* 3 (Venice, Paris: Desaint, 1769): 438-41.
13. Jean Barbault, *Monuments de Rome ancienne* (Rome: Bouchard & Gravier, 1761): plate 50.
14. Monique Mosser and Daniel Rabreau, eds., *Charles De Wailly. Peintre, architecte dans l'Europe des Lumières* (Paris: caisse nationale des monuments historiques et des sites, 1979): cat. 33.
15. Ibid., cat. 48. A copy of this was held by Weinreb in 1987.
16. Charles de Brosses, *Lettres d'Italie*, 2 vols., Frédéric d'Agay. ed., (Paris: Mecure de France, 1986): Lettre XLI.
17. Angela Cipriani, Gian Paolo Consoli and Susanna Pasquali, *Contro il barocco. Apprendistato a Roma e pratica dell'architettura civile in Italia, 1780–1820* (Rome: Campisano, 2007): 101.

BIBLIOGRAPHY

Barrier, Janine, *Les architectes européens à Rome, 1740–1765. La naissance du goût à la grecque* (Paris: Monum, 2005).

Barrier, Janine, "William Chambers, Augustin Pajou and their colleagues in Rome," *Apollo* January 1998.

Barthélemy, Jean-Jacques, *Voyage en Italie de M. l'abbé Barthélemy… imprimé sur les lettres originales écrits au Cte. de Caylus* (Paris: F. Buisson, 1801).

Blunt, Anthony, *Guide to Baroque Rome* (London: Granada Publishing, 1982).

Brosses, Charles de, *Lettres d'Italie* (Frédéric d'Agay, ed., 2 vols, Paris: Mecure de France, 1986).

Chevtchenko, Valery; Cotté, Sabine and Pinault-Sørenson, Madeleine, *Charles-Louis Clérisseau (1721–1820). Dessins du musée de l'Ermitage Saint-Pétersbourg* (Paris: Editions de la Reunion des musées nationaux, 1995).

Cipriani, Angela; Consoli, Gian Paolo; and Pasquali, Susanna, *Contro il barocco. Apprendistato a Roma e pratica dell'architettura civile in Italia, 1780–1820* (Rome: Campisano, 2007).

Descat, Sophie, *Le voyage d'Italie de Pierre-Louis Moreau: Journal intime d'un architecte des Lumières (1754–1757)* (Bordeaux: Presses Universitaires, 2004).

Draper, James David and Scherf, Guilhem, *Augustin Pajou, dessinateur en Italie, 1752–1756. Archives de l'Art français n.p. vol. 33* (Paris: Jacques Laget, 1997).

Duclaux, Lise, *Charles Natoire, 1700–1777* (Paris: Galerie de Bayser, 1991).

Gallet, Michel, *Les architectes parisiens du XVIIIe siècle. Dictionnaire biographique et critique* (Paris: Mengès, 1995).

Gordon, Alden E., "Jérôme-Charles Bellicard's Italian notebook of 1750–51: The discoveries at Herculaneum and Observations on Ancient and Modern Architecture," *Metropolitan Museum Journal* 25 1990, 49–142.

Harris, John and Snodin, Michael, eds., *William Chambers. Architect to George III.* (London: Yale University Press, 1997).

Lalande, Joseph-Jérôme Le François de. *Voyage d'un françois en Italie fait dans les années* **1765** *et l* **1766** 5, chapter 20 (Venice, Paris: Desaint, 1769).

Lemonnier, Henri, ed. *Procès-verbeaux de l'Académie royale d'Architecture 1671–1793* 6, 1744–1758 (Paris: Champion, 1920).

Marconi, Paolo; Cipriani, Angela and Valeriani, Enrico, *I disegni di architettura dell'Archivio storico dell'Accademia di San Luca* (Rome: De Luca, 1974).

Montaiglon, Anatole de and Guiffrey, Anatole, *Correspondance des directeurs de l'Académie de France a Rome avec les surintendants des Bâtiments* 10, 1754–63. (Paris: Charray, 1900, 1901).

Mosser, Monique and Rabreau, Daniel, eds., *Charles De Wailly. Peintre, architecte dans l'Europe des Lumières* (Paris: caisse nationale des monuments historiques et des sites, 1979).

Michel, Olivier, "Les artistes français et les académies italiennes dans la seconde moitié du XVIIIe siècle," *Augustin Pajou et ses contemporaines*, Actes du colloque 7–8 Novembre 1997, ed. Guilhem Scherf (Paris: La documentation française, 1999): 45–74.

Pariset, François-Georges, *Victor Louis 1731–1800. Dessins et gravures.* (Bordeaux: Revue historique de Bordeaux et du Département de la Gironde, 1980).

Peyre, Marie-Joseph, *Oeuvres d'architecture* (Paris: Prault, Jombert, 1765) revised edition (Paris 1795).

Pinon, Pierre, *Pierre-Adrien Pâris (1745–1819), architecte, et les monuments antiques de Rome et de la campanie* (École Française de Rome, 2007).

Maxime Préaud, Pierre Casselle, Marianne Grivel and Corinne Le Bitouzé, *Dictionnaire des éditeurs d'estampes à Paris sous L'Ancien Régime* (1987).

Roland-Michel, Marianne, "Dessiner à Rome au temps de Pajou," *Augustin Pajou et ses contemporaires*, Actes du colloque 7–8 Novembre 1997, ed. Guilhem Scherf (Paris: La documentation française, 1999): 285–308.

Snodin, Michael, ed., *Sir William Chambers. Catalogue of architectural drawings in the Victoria and Albert Museum* (London: V & A Publications, 1996).

Fratri Optimo: The Tale of a Brotherly Gift

JOHN HARRIS

IN THE 1960s the Cambridge University Faculty of Architecture and Fine Arts became a powerhouse of art and architectural history under the professorship of Michael Jaffé. One of his innovations was to enliven the teaching with many external lecturers. I was one on a weekly schedule, supplementing lectures given by Nikolaus Pevsner. We differed as teachers in that I believed students should be taught how to use archives, family papers and drawings as the fodder of architectural history. A notable product of this powerhouse was David Watkin, whom I first met in the early 1960s when he was writing his doctoral thesis, published in 1968 as *Thomas Hope 1769–1831 and the Neo-Classical Idea*. In this book, the first of so many, David illustrated an impressionistic watercolour by William Bartlett of a Greek-style temple at The Deepdene, Surrey.[1] Neither he nor I then knew of the existence of photographs of this building dated 1907 in the Surrey Record Office (figs. 1 and 2).[2] It seems appropriate to offer these here as a Hopeian tribute to celebrate David's university career as a distinguished teacher and architectural historian.

The Deepdene was a large, rather plain, conventional house built 1769–75 for the 10th Duke of Norfolk and sold in 1790 by the 11th Duke to Sir William Burrell, whose son Sir Charles put the estate up for auction in May 1807, when it was bought by Thomas Hope.[3] Since 1799 Hope had been so heavily engaged in remodelling his Duchess Street house in London that he was not able to pay serious attention to The Deepdene until September 1818, when he began its great Picturesque transformation, no doubt after lengthy and considerable discussions with his tame executant architect

Fig. 1 Temple at the Deepdene, Surrey, south front (Photo: Surrey History Centre, Woking: SCC 8-66-1907, P 5577)

William Atkinson. In fact, his first documented architectural addition to The Deepdene was the mausoleum built in 1818, then sadly necessary to contain the ashes of Hope's younger son Charles, who had died in Florence in 1817.[4]

In contrast to the building of the house, there is sparse documentation on the remodelling and horticultural history of the gardens and park.[5] Above Deepdene was an amphitheatrical hill, upon which was what became known as the Temple or Deepdene Terrace. It gave a northerly view down towards the house. Walking along it looking down southwards, Hope coveted Sir Charles Talbot's neighbouring Chart Park, the house remodelled in Gothick for Henry Talbot around 1751 by Sanderson Miller.[6] Hope dreamt of this desirable land acquisition to add to The Deepdene. The announcement of its auction in June 1813 galvanized him into action, or rather his brother, the bachelor Henry Philip (1774–1839). For £30,000 Philip bought the entire estate for Thomas, who immediately demolished the house. So generous was this fraternal gesture that Thomas commemorated it by the building of what David rightly describes as a 'vaguely Etruscan' temple, inscribed in the pediment of the primitive aedicule on its north elevation, "Fratri Optimo H.P.H" (see Fig. 2).[7] In 1826 J.P. Neale commented: "The Hill rises with a steep acclivity behind the House, and descends on the south side, at Chart Park; a beautiful walk, amid the Alpine trees of the wood, conducts to a Temple, which commands a view of The Deepdene."[8] In 1828 G.F. Prosser provides the earliest fuller description of the temple: "It is composed of

THE PERSISTENCE OF THE CLASSICAL

a Doric frontispiece, with wings terminated by piers, crowned with antique masks: at the back of the seat is a large metal plate, containing an Arabic inscription."[9] In 1849 William Keane supplies a little more information: "[The] Temple on the summit of the hill … is of the Doric order, and entered by Seven steps, the wall embellished with Egyptian hieroglyphics."[10]

It is likely that Hope did not delay this commemoration and that it belongs with his first additions to the house as first shown in a Reptonian *Polite Repository* engraving published in May 1818, the first visual hint of its Picturesque transformation. The Temple is an extraordinary design without any precedent in England. Entirely primitive and elemental, its south portico under projecting Tuscan eaves is flanked by antae with massive piers and paterae terminated by Greek masks similar to those that originally topped Hope's semi-circular or concave screen wall to the house, dismantled due to the 1836 rebuilding.[11] However, while these two acroteria masks are original to the Temple, the single head placed on the floor of the portico between the pillars is obviously a later addition. The pair of Egyptian priests or Antinous figures is also an addition, and more of that anon. Equally primitive, according more with cemetery architecture than garden buildings, is the rear of the temple conceived as a north seat with its pedimented aedicule shown with an Isis figure standing on the seat, and four more relocated acroteria heads (see fig. 2). The aedicule is reminiscent of a garden ornament of uncertain commemoration to be seen in the foreground of one of Bartlett's views looking towards the house.[12] The similar pediment there is ornamented with a circular relief and supported, not by columns, but by splayed piers. Of equally similar character is the tunnel-vaulted arched porch with fluted ornament to the North Lodge.[13]

At first one might speculate that this 'vaguely Etruscan' building evokes something that Hope might have recorded on his travels in Turkey, Syria, Egypt, Greece, Sicily or Spain between 1797 and 1805.[14] It could have featured in Hope's novel *Anastasius or the Memoirs of a Modern Greek written at the close of the 18th Century* of 1819, or in his *An Historical Essay on Architecture*, 1835. However, Robin Middleton has perceptively suggested that the origins of this primitive design go back to a time even before Hope's acquisition of The Deepdene: to January 1805, when Joseph Michael Gandy

Fig. 2 Temple at the Deepdene, Surrey, north front (Photo: Surrey History Centre, Woking: SCC 8-66-1907, P 5577)

100

Fig. 3 Joseph Michael Gandy: *Designs for Cottages, Cottage Farms, and other Rural Buildings including Entrance Gates and Lodges* (1805): plate I

dedicated his *Designs for Cottages, Cottage Farms, and other Rural Buildings including Entrance Gates and Lodges* to Hope, for his "acknowledged taste in the Fine Arts, and particularly the judgment you have acquired, by extensive travel and research, in the principles of Architecture."[15] Gandy does not offer an ornamental vocabulary, but one of what might be called elemental framing: strip pilasters framing an opening and supporting a primitive eaves roof, or the use of flat block capitals to the strip order (fig. 3).[16] Similar parallels to The Deepdene temple may be identified in Gandy's companion volume, *The Rural Architect Consisting of Various Designs for Country Buildings* published in August 1805.

The relationship of Gandy to Hope is an intriguing one. Both Gandy and his travelling companion C.H. Tatham had been forced to return from Italy due to the advance of Napoleon's armies. By 1799 Tatham was in the employ of Hope at Duchess Street to prepare designs for the Picture Gallery and the Library.[17] There is no proof, however, that Tatham was retained for their execution. As is demonstrated by a comparison between Hope's own design for what he inscribes as "the large Picture Gallery" and Tatham's, Hope substantially altered, and indeed ornamentalised, Tatham's design, notably in the details of the organ.[18] The role of Tatham in the patronage of Hope is enigmatic. At this very time he was publishing his iconic *Etchings of Ancient Ornamental Architecture*, 1799–1800, to be followed later by *Etchings representing Fragments of Grecian and Roman Architectural Ornaments*, 1806, two books eagerly digested by Hope. It is probable that Hope preferred to have a tame executant rather than one who might be of a competitive nature and that Tatham's relationship with

such a demanding and fastidious patron may have been short–lived. The same may have been true with Gandy, even if (as David has observed) there are parallels between Gandy's designs for villas and those by Hope.[19] Before 1818 Hope had acquired two of Gandy's visionary historical compositions, the "Pandemonium" of 1805 and a "Design for a Cenotaph," the latter most likely the "Tomb of Agamemnon," exhibited at the Royal Academy in 1818. Both were placed in frames of Hope's own design. It is worth observing that the acroteria heads on the temple at The Deepdene actually appear in Gandy's "Tomb of Agamemnon" – but also in his "Sepulchral Chamber" painted much earlier, in 1800, and now in the collection of the Canadian Center for Architecture.[20] Although it may be tempting to consider The Deepdene temple a design by Gandy, therefore, this is unlikely. Gandy was notorious for falling out with his clients. He was "a 'bad-mannerd' man –& was *rude* to any *gentleman* or *nobleman* who found fault with his designs."[21]

Fig. 4 Acroteria Mask from the Deepdene (Photo: John Harris)

The William Bartlett watercolour mentioned earlier shows the south side of the temple as in one of the 1907 photographs (fig. 1), but without the two Egyptian statues and the single acroteria head at the top of the steps, proving that this head – like the four on the north side (fig. 2) – did not belong to the temple when first built. They must have been on the entrance screen wall of the house and made redundant when it was demolished by Henry Thomas Hope, Thomas's son, to make way for Alexander Roos to vastly enlarge The Deepdene from *c*.1836 (fig. 4).[22] The philanthropic and friendly Henry Thomas permitted locals to liberally enjoy his park and gardens, as can be seen in the photographic copy of a painting by John Beckett (1799–1864), a local Dorking artist. This has been dated by Doris Mercer *c*.1855 (fig. 5).[23] The photograph mount was later inscribed the "Temple Terrace," showing the beech avenue and the temple, but neither the Egyptian figure nor the four relocated acroteria masks were yet present. It is possible that the statues came to The Deepdene from Duchess Street prior to the demolition of that house in 1851. However, they could have been placed in the temple by Henrietta Adela Hope as they were not directly relevant to the core of the Hope collection of ancient sculptures sold by Christies in July 1917.[24] Indeed, their identification has been confirmed as having been sold at the auction: "The Final Portion of the Hope Heirlooms," *The Deepdene Dorking, Surrey*, by Messrs Humbert & Flint, September 12–14 and 17–19, 1917, on day 4, lot 1192, "A PAIR OF 4ft CARVED GREYSTONE FIGURES OF EGYPTIAN PRIESTS on circular bases," and lot

Fig. 5 Photographic copy of painting by John Beckett, showing the Deepdene Terrace (c. 1855) (Dorking Museum, topographical files, A/0014)

1193 "A 5ft CARVED STONE FIGURE OF THE 'GODDESS ISIS,' on square base."[25] The pair of Egyptian "priests" were purchased at the Humbert & Flint sale and later found their way to Buscot Park, Berkshire, where they remain.[26] The more recent vicissitudes of the temple began in 1938 with the threatened development of The Deepdene Terrace by the Southern Railway Company. After vociferous local protests, the Company conveyed the Terrace to the Dorking and Leith Hill District and Preservation Society in 1943. Alas, the stylistically and symbolically unique temple had been allowed to decay, and what remained of its ruin was finally cleared in 1955.[27]

NOTES

1. David Watkin, *Thomas Hope 1769–1831 and the Neo-Classical Idea* (London, John Murray, 1968): 163, 232 and pl. 56. The watercolour is in Minet Public Library, Lambeth, in an album titled *Illustrations Of The Deepdene. The Seat of T. Hope Esqre*, compiled by John Britton for an unpublished monograph.
2. The reference, in what is now called the Surrey History Centre, Woking, is: SCC 8–66–1907, P 5577. These photographs were given to me by Tim Knox.

3. In general for the historical background I have taken advantage of the restoration plan by Cazenove Architects Co-operative Design: *Deepdene Dorking Surrey Restoration and Management Plan for the Dorking and District Preservation Society*; also Doris Mercer's "The Deepdene, Rise and Decline through Six Centuries," *Surrey Archaeological Collections*, 71, 1977; and Doris Mercer and Alan Jackson, *The Deepdene, Dorking*, Dorking Local History Group, 1996. I am particularly indebted to Mary Turner, Curator of the Dorking Museum for her kind help and local knowledge. Martin and Sandra Wedgwood also gave me some local advice.
4. Now sited in Mausoleum Wood, off Chart Lane South.
5. Only J.C. Loudon attends to this, in *The Gardener's Magazine* 5, 1829: 589–93 (the gardens then being under the care of a Mr Woods).
6. For Chart Park see Doris and Edith Mercer, *Chart Park, Dorking: A Vanished Surrey Mansion*, Dorking Local History Group, 1993.
7. The words of David Watkin in *Thomas Hope* (1968): 163. The inscription translates "The Best of Brothers."
8. J.P. Neale, *Views of the Seats of Noblemen and Gentlemen*, second series, III (London: Sterwood, Gilbert and Piper, 1826): unpaginated.
9. G.F. Prosser, *Select Illustrations of the County of Surrey Comprising Picturesque Views of the Seats of the Nobility and Gentry* (London: C. and J. Rivington, 1828): unpaginated.
10. William Keane, *The Beauties of Surrey* (London: Groombridge and Son, 1849): 152–57. It is uncertain whether Prosser's "Arabic inscription" plate and Keane's wall embellished with "Egyptian hieroglyphics" are one and the same thing, or whether what appears to be some form of framed panel on fig. 1 is either. The temple is also located on a rough survey of The Deepdene dated *c*.1825 and inscribed, "Plan of the Deepdene the seat of Thomas Hope Esq," in Maps File 185, Minet Library, Lambeth. Furthermore, its site is to be found on a sale plan (SC 818 and S 238), in the Dorking Museum.
11. These masks are in an artificial stone, perhaps by James George Bubb.
12. Watkin, *Thomas Hope* (1968): pl. 43.
13. Watkin, *Thomas Hope* (1968): pl. 57. Neale, *Views of the Seats* (1826), comments, "The principal entrance to the Deep-dene, from the Reigate Road, is marked by a Lodge of peculiar design, simple yet elegant, which is represented in our vignette, and is in perfect harmony with the taste that pervades every object in this delightful domaine." A tomb of this form is shown in a view of Père Lachaise cemetery, see James Stevens Curl, *A Celebration of Death* (London, Constable, 1980): pl. 35.
14. See also David Watkin and Jill Lever, "A Sketch-book by Thomas Hope," *Architectural History*, 23, (1980): 52–59, comprising some of Hope's studies of buildings and gardens in Rome and northern Italy.
15. Robin Middleton, personal communication with the author. Joseph Michael Gandy, *Designs for Cottages, Cottage Farms and other Rural Buildings including Entrance Gates and Lodges* (London: John Harding, 1805): dedication.
16. Gandy, *Designs* (1805): pl. I (fig. 3 here) and pl. X.
17. David Watkin, "Thomas Hope's house in Duchess Street," *Apollo*, [vol?] (March 2004): 31–39
18. A drawing once in the author's collection but stolen by a foreign scholar. The difference between Tatham's organ and Hope's is telling.
19. Watkin, *Thomas Hope* (1968): 139–40.
20. See Brian Lukacher, *Joseph Gandy: An Architectural Visionary in Georgian England* (London: Thames and Hudson, 2006): 32–34, pls. 28 and 29. The Hope Gandy discussed here is surely "Agamemnon" by its subject matter. However, Lukacher regards this as a "Sepulchral Chamber."
21. Christopher Woodward, leaflet accompanying the exhibition *Soane's Magician The Tragic Genius of Joseph*

Michael Gandy (London: The Soane Gallery, 2006). This comment was made to John Constable.
22. Richard Garnier, "Alexander Roos (*c.* 1810–1881)", *The Georgian Group Journal*, 15, 2005: 11–68. They are referred to by Neale, *Views of Seats,* in their original positions: "On the right hand of the principal entrance is a handsome Screen … the pilasters of the Screen are crowned with a balustrade, the piers of which terminate in antique masks, executed in the true simplicity of the Grecian taste," and are shown in Neale's illustration of the east or carriage front. The heads found their way to the Crowthers of Syon Lodge, Isleworth, presumably at the demolition of The Deepdene in 1968, although they could have acquired them earlier. One (fig. 4) is now in the possession of this writer and three were in the possession of the late Sir Howard Colvin.
23. In the topographical files of Dorking Museum, A1/0014.
24. Henry Thomas had married Madame Anne Adela Bichet. Their illegitimate daughter Henrietta Adela Hope, Henry Thomas's testamentary heir, married Henry Pelham Alexander, who succeeded as 6th Duke of Newcastle in 1864, two years after Henry Thomas's death. Henrietta bequeathed The Deepdene in 1913 to her second son Lord Henry Francis Hope Pelham Clinton Hope. It was this Lord Francis Hope, as he was then addressed, who was forced to sell the contents of The Deepdene in 1917.
25. I am most grateful to Elizabeth Angelicoussis for tracking this sale reference down.
26. I am grateful to Philip Hewat-Jaboor who first suggested the pair of figures might be those at Buscot and to Lord Faringdon and David Freeman for confirmation. It may well be that the three figures were among the sculptures acquired from the 1917 sale by Messrs Spink & Son, who exhibited selected items in their King Street galleries in March 1919.
27. The Terrace can be reached today from a footpath off the A24 on left going south just before Chart Lane North joins on the right. Its site can be located (information from Mary Turner).

C.R. Cockerell and the Discovery of Entasis in the Columns of the Parthenon

FRANK SALMON

ONE SENSES THAT, among the many chapters in his many books, David Watkin took particular pleasure in writing the one in his 1974 monograph on Charles Robert Cockerell that deals with his subject's travels in the Mediterranean from 1810 to 1817. The young Robert must surely stand as the most Romantic English architect of the classic period of Romanticism: handsome, immensely gifted, lionised by contemporaries of all social classes and many nationalities and, to cap all this, tenacious and fortunate enough to have made major discoveries relating to classical antiquity. Cockerell's accounts of his 1811 expeditions to Aegina and the Peloponnese with John Foster, Baron Haller von Hallerstein and Jakob Linckh read with an excitement more common in the heroic phase of archaeology that began later in the nineteenth century: the sight of the helmeted warrior's face that heralded the excavation of the archaic pedimental figures of the Temple of "Jupiter Panhellenius" (Aphaia) on Aegina; or the fox hole at Bassae, barely wide enough for his head and shoulders to be lowered into, where – brushing aside the sticks and leaves of the fox's den – he glimpsed the first piece of the fallen frieze of the Temple of Apollo Epicurius, subsequently excavated and secured as a jewel in the crown of the British Museum.

Another reason why Cockerell must be placed high in the list of those British architects who, from James "Athenian" Stuart in the 1750s to Francis Cranmer Penrose a century later, were responsible for fundamental advances in our understanding of ancient Greek architectural practice lies in the fact that he appears to have

Fig. 1 C.R. Cockerell (engraved John Horsburgh) The Parthenon seen from the Propylaea c.1813–14, from *Description of the Collection of Ancient Marbles in the British Museum*, Part VI (London: G. and W. Nicol), 1830, frontispiece. (Courtesy of Cambridge University Library)

been the first person of modern times to have visually recorded and perhaps to have observed the entasis (the slight central swelling) of the columns of the Parthenon (fig. 1). Writing from Athens to his erstwhile master, Robert Smirke, on 23 December 1814, Cockerell included on the reverse of his letter a drawing on which the temple's entasis was both shown and approximately measured (fig. 2). In the 1970s, when David Watkin first saw it, Cockerell's drawing was preserved among papers that were still in the hands of his descendants.[1] Although these have since made their way into the collection of the Royal Institute of British Architects, the image has never before been published and the place of this important document in the history of the Parthenon and of what are often called the "optical refinements" of Greek architecture in general has not yet been fully recognised or contextualised. Indeed a number of myths and misunderstandings has grown up around the matter and, as it concerns both one of the most disputed – and now famous – principles of Grecian architecture in general and the monument of the Parthenon in particular, it may be thought appropriate that these should be subjected to critical scrutiny in a volume of essays dedicated to one of the great historians of the classical tradition in architecture.

Cockerell intended his drawing to be little more than a demonstration of the existence of entasis for Smirke and it is therefore not set out in a way consistent with full or entirely correct presentation of data. Indeed, the column as drawn has a slight inclination to the right (bottom to top) but this is principally because it is not

squared up on a sheet of paper that is itself not quite square.² In his letter to Smirke, Cockerell wrote:

> On the other side of this are roughly & simply shown the experiments I made on the cols: of the T. of Minerva as I promised you. By putting both the experimts on each side, the contour or profile of the col: will be as it ~~ought~~ [sic] is in execution. You will say I ought to have done it more accurately, with more precision; if you will send

me a couple of English carpenters I shall be able to do it better, with the difficulties met with here I have found no other way of ascertaining this curious point.³

Then, on the verso, written within the confines of the column itself (fig. 3), he wrote:

> Col: of the Temple of Minerva Parthenon, in which the Εντασισ or swelling is proved by two experiments. 1st: a line exactly stretched from A on the edge of the fluting begins to defract at the height of 17.7 and leaves 2" at the base at B. 2nd: a line stretched from the under edge of the last fillet of the Capital to the base touches at 11.0 & leaves ¾ of an inch at the base C. The red line expresses the profile of the column supposing it to be without the Εντασισ & in a straight line from capital to base.

Cockerell's decision to conduct two separate experiments was in line with good contemporary surveying practice. In the first experiment – illustrated on the left of the drawing – a line (perhaps of string or wire) was held at the top of one of the flutes of the column. The solid black line represents the actual profile of the column and the solid red line (just inside – that is to the right – of the solid black line) the tapering of the column assuming no entasis.⁴ Black and red lines therefore meet at both the bottom and the top of the column. The dotted line (outside both solid black and red lines) then shows the trajectory of Cockerell's string or wire, initially held taught against the top of the flute but leaving the surface of the masonry (as that begins to curve inwards) about 14 feet down (the distance is marked as 17 feet 7 inches, evidently from the base) and continuing on to arrive at the base a full 2 inches outside the masonry. For the second experiment, illustrated on the right of the drawing, Cockerell began by holding his line away from the surface of the column by placing it against the underside of the lowest fillet below the echinus (he marks this distance as 1¼ inches away from the shaft of the column). This time the string or wire touched the masonry 11 feet up from the base and parted again to leave the smaller gap of ¾ inch from the masonry at the bottom.⁵

In this letter Cockerell went on to tell Smirke that he had also noted entasis at the Erechtheion and at the Temple of Jupiter Olympius – but that the columns of the Temple of "Theseus" (the Hephaesteion) were too ruinous to detect it. Moreover, he had also taken the opportunity to sail back to Aegina where he had ascertained the entasis at the Temple of Aphaia. He reported the same information to his father, the architect Samuel Pepys Cockerell, in a separate letter dated the same day as that to Smirke, 23 December 1814:

(opposite) Fig 2 RIBA drawing CoC/Add/1/28 verso.

(opposite) Fig. 3 detail of fig. 2

I have also with a great deal of difficulty, since there are no carpenters in this country, been able to ascertain what I mentioned to you in my last viz the entasis or swelling of the Greek columns – from a straight line stretched from the capital to the base the swelling at about a third of the height in the Temple of Minerva is an inch, in that of Egina ½ an inch, thus it is the same proportion. From the ruined state of other monuments it is difficult to ascertain, but I have no doubt that it was a general rule with the Greek architects & it is a most curious fact which has hitherto escaped Stuart & our most accurate observers – indeed it is so delicate that unless one measures it the eye alone cannot perceive it.[6]

A number of questions are raised by Cockerell's drawing and the comments that accompanied it on its way back to London. In this essay it will be asked if he was indeed, along with Haller, the first person to observe the entasis of the Parthenon and, in fact, as is sometimes still suggested, of ancient Greek architecture in general.[7] Then the question of whether it was really the case that entasis in Greek architecture was discoverable only by measurement and not by the eye will be discussed and, if this was so, why it was that it had been missed by those such as James Stuart and Nicholas Revett, who had claimed to have measured Greek monuments to the hundredth and even the thousandth of an inch.

On the matter of primacy, it should quickly be stated that entasis in Greek architecture had already been published in 1784 by Paolo Antonio Paoli, President of the Noble Ecclesiastical Academy in Rome and author of a series of six dissertations on various aspects of Paestum that were based on the researches and drawings made in the 1750s under the direction of Count Felice Gazzola.[8] In the fifth dissertation Paoli noted the entasis of the pseudodipteral Temple of Hera I and illustrated a method for how it might be measured (fig. 4). In this temple the entasis is more pronounced than in any other surviving Greek example, as had been made abundantly and famously clear in the views given by Giambattista Piranesi in his *Différentes vues de Pesto,* published posthumously 1778 (fig. 5). Paoli, however, followed previous antiquaries' and architects' opinions by proclaiming that the Greeks had never used the technique and that it had been introduced by the Etruscans. Consequently he called the building at Paestum the "Etruscan Atrium."[9] Shortly afterwards, the French *pensionnaire* Claude-Mathieu Delagardette, winner of the 1791 Prix de Rome, surveyed the three temples at Paestum, publishing his results in *Les ruines de Paestum ou Posidonia* in 1798–9 (fig. 6). Delagardette reverted to identifying the pseudodipteral temple by its more familiar late eighteenth- and early nineteenth-century name of the "Basilica" but he also could not accept the entasis

Fig. 4 Paolo Antonio Paoli, *Rovine della Città di Pesto detta ancora Posidonia* (Rome: Paleariniano, 1784), plate XLI

Fig. 5 Giambattista Piranesi, *Différentes vues de quelques Restes de trois grands Edifices qui subsistent encore dans le milieu de l'ancienne Ville de Pesto* (1778), Plate 6 (Courtesy of the Faculty of Architecture and History of Art, University of Cambridge)

as a Greek feature and ascribed it to later Roman recutting of the columns.[10]

Both Paoli's and Delagardette's works were known to the English scholar-architect William Wilkins whose *Antiquities of Magna Graecia*, published in 1807 after his return to Cambridge from the Mediterranean, included the earliest English-language account of curvature — as opposed to mere tapering (that is hypotrachelion contraction) — in Grecian columns. Of the Temple of Hera I at Paestum Wilkins wrote: "The shafts diminish from their base to the top ... in a curve, which diverges more rapidly from a vertical line as it recedes from the base" (fig. 7).[11] His drawing suggests that he studied this curve in terms of a series of diameters in the lower and upper thirds of the column (rather than establishing the entasis by vertical experiments as Cockerell would do at the Parthenon), and that he did not follow Paoli and Delagardette in also attempting to account for the swell at the mid-point. Moreover, Wilkins decided that the pseudodipteral Temple of Hera I postdated the Roman conquest of Paestum. Only the Temple of Hera II he took to be Greek, and of the columns of that building he denied the existence of curvature as a designed feature, saying: "at first sight they have the appearance of swelling in the middle. This deception is caused by decay of stone in the lower parts of the shafts."[12]

The late eighteenth-century accounts have been largely overlooked by those writing on the history of the discovery of Greek entasis until relatively recently, no doubt in part because the rise in the status of the Parthenon made observation of entasis there a greater focus of attention. The notion that Cockerell discovered the

Parthenon's entasis and that he did so in the year 1810 entered the historical record thanks to Penrose's account of the history of Greek optical refinements in the 1888 (second) edition of his *Investigation of the Principles of Athenian Architecture*.[13] Two decades later, in his *Greek Refinements: Studies in Temperamental Architecture*, William Henry Goodyear converted Penrose's claim into a suggestion that Cockerell was first to observe entasis in *any* example of a Greek building, but then noted that Adolf Michaelis had credited the discovery to Wilkins (datable, therefore, to Wilkins' sojourn in Athens during the summer of 1802).[14] William Bell Dinsmoor, however, whose editions of Anderson's and Spiers' 1902 standard history of ancient Greek architecture spanned from 1927 to 1989, overlooked Wilkins, crediting the first notice of entasis jointly to Cockerell and Thomas Allason and eventually giving the date 1814 for this.[15] Wilkins' claims resurfaced in Rhodri Windsor Liscombe's 1980 monograph on the architect and have been reiterated by Lothar Haselberger in the most recent detailed study of the problem.[16] Haselberger was unaware of the Cockerell drawing published here, however, believing that the entasis of the Parthenon was first drawn out in 1820 when, as had long been recognised, William Wesley Jenkins made the studies of entasis there (as well as at nine other Greek temples) that subsequently appeared in print in the 1830 supplementary volume to Stuart's and Revett's *Antiquities of Athens*.

Fig. 6 Claude-Mathieu Delagardette, *Les ruines de Paestum ou Posidonia ... levées, mesurées, et dessinées sur les lieux, en l'an II* (Paris: Barbon, 1798–99), Plate XII, fig. C (Courtesy of The British School at Rome)

Whilst Cockerell's primacy in having measured and drawn out the entasis of the Parthenon seems beyond dispute, then, what can be said of the contending claims of Wilkins (1802) and Allason (1814) to have been first to *observe* it? The arguments in favour of Wilkins rest on a comment he made in his *Atheniensia*, published in 1816: "The columns [of the Parthenon], like those of the propylaea diminish from the bottom to the top, in a line which is slightly curved."[17] It is a problematic statement in two ways. First, placed as the last sentence at the end of a 34-page description of the Parthenon which mentions neither the word "entasis" nor Vitruvius' description of the phenomenon, it appears tacked on as an afterthought or at least as a point of no great account. Second, dealing with entasis in his coevally published *Civil Architecture of Vitruvius*, Wilkins used his illustration of the Temple of Hera I at Paestum (fig. 7), re-engraved but giving the same measurements, and argued that "the temple from which this column is taken is the production of an age, when the pure

Fig. 7 William Wilkins, *The Antiquities of Magna Graecia* (Cambridge: University Press, 1807), Chapter 6 Plate 16 detail (Courtesy of St John's College, Cambridge)

taste of the Greeks had ceased to operate, and is here given only, because an extreme case sometimes serves to illustrate a meaning imperfectly understood."[18] In other words, Wilkins still did not believe entasis to have been used by Greek architects – or, at least, certainly not during an epoch of refined taste such as that when the Parthenon was acknowledged to have been designed and built.

There is evidence (albeit not conclusive) that Wilkins' knowledge of the entasis of the Parthenon came, in fact, not from his own visit to Athens in 1802 but rather from discussion of the subject in London in 1814, based on Cockerell's observations. It may be recalled that, in his letter to his father Samuel Pepys Cockerell of 23 December 1814, Robert had written of having been "able to ascertain what I mentioned to you in my last viz the entasis or swelling of the Greek columns."[19] Robert's previous letter to his father (among those surviving at the RIBA) was that sent from Athens on 31 August 1814 in which he had written: "I have prepared the enclosed some days ago according to your hint & my promise to you from Zanti. I hope Wilkins will find it satisfactory [as] it is sufficiently explanatory of the chief part of his questions."[20] The enclosure is lost, but it must be likely that it concerned the optical refinements, perhaps including entasis, that Wilkins was struggling to accommodate as he worked at that time on his *Civil Architecture of Vitruvius*.[21] One should perhaps imagine the proud father, Samuel Pepys Cockerell, passing on information to Wilkins in London that he had missed when in Athens, and Wilkins' rival Smirke (a member with S.P. Cockerell of The Architects' Club) then writing to press Cockerell junior for a drawing as further confirmation of the discovery of entasis. The likelihood of this scenario is increased by the letter the young Cockerell wrote on the back of Figure 2 which, it may be recalled, offered Smirke the demonstration of entasis "as I promised you" – clearly a response, therefore, to a request received.

If Wilkins' claims to primacy in observation of the Parthenon's entasis can be held to be open to question, then, what can be said of the claims of Allason, published in 1819? "It deserves to be remarked," he wrote, "that Stuart and Revett have omitted to notice the εντασισ, or swelling, in the columns of the Parthenon, the Temple of Theseus, the Propyléa, etc. etc. when it is so very apparent, not only in these structures, but in all the remaining Antiquities of Greece."[22] This statement predates what seems to be the first published account of Cockerell's "discovery," which appeared the following year in the prolix travel journal of Thomas Smart Hughes:

> November 8th. This morning I ascended the citadel in company with Baron Haller and Mr. Cockerell, who kindly condescended to explain many of its architectural

beauties and impart to me a great deal of interesting information in that art of which they were themselves such illustrious ornaments. Amongst the many observations made by Mr Cockerell upon the architecture of the Parthenon I remember one which seemed very delicate and curious: it related to the entasis or swelling of its beautiful and finely-proportioned columns. With a great deal of difficulty, he measured them, and found by a straight line stretched from the capital to the base that this swell at about one third of the height, equalled one inch. That in the temple of Jupiter at Aegina equalled half an inch, which was in proportion to the other; so that he had no doubt but that there was a general rule on this point with the ancient architects: this protuberance is so delicate that it must be ascertained by measurement: the eye alone cannot perceive it. The fact had escaped Stuart and our other most accurate observers.[23]

Since it was in the autumn of 1813 that Hughes was in Athens, at first sight it appears that Haller and Cockerell were already informing interested visitors about the Parthenon's entasis on site by November of that year. An alternative reading of the passage, however, could be that Hughes' recollection of the specific discussion of entasis with Cockerell (in other words all the text from the phrase "Amongst the many observations" onwards) did not come from that occasion but rather from his memory of subsequent conversations. It is, indeed, more than likely that the discussion of this point took place very much later, once both men were back in England. Evidence for this can be found in the fact that Hughes' words at the end of the extract given here read almost verbatim as those of Cockerell in the letter, quoted above, written from Athens to his father on 23 December 1814 ("I have no doubt that it was a general rule with the Greek architects & it is a most curious fact which has hitherto escaped Stuart & our most accurate observers – indeed it is so delicate that unless one measures it the eye alone cannot perceive it"). Elsewhere in his *Travels*, Hughes quoted liberally from letters home to which Cockerell gave him access when the book was in preparation and this is surely another instance where the Cockerell letter was the source. That this conversation did not take place in Athens in November of 1813 seems to be confirmed definitively by the comparison Hughes mentioned of the Parthenon with the Temple of "Jupiter Panhellenius" on Aegina, to which Cockerell – so he informed his father, also in the December 1814 letter – had only *recently* returned to measure the entasis.[24]

Publication of Hughes' *Travels* led to a stinging letter of rebuke by Allason in *The Quarterly Journal of Science, Literature, and the Arts* in 1821. Pointing out that Hughes had left Athens well before the discovery of entasis at the Parthenon was made towards

the end of 1814, Allason suggested that the expression "the eye alone cannot perceive it" (which, as we have seen, was in fact a direct quotation from Cockerell himself) was a conscious attempt to undermine his own claims to primacy.[25] "It was myself who first noticed this peculiarity," wrote Allason, going on to say that he had told others including Haller, Cockerell and Louis Fauvel (French Consul in Athens) about it, the latter two of whom "constantly opposed my ideas on the subject." According to Allason, it was agreed that Cockerell and Haller should test out the theory by making the measurements, forwarding the results to Allason. Although he said he had written to remind Cockerell of this agreement from Naples, it was over a year later that Allason received through Robert Smirke "an admeasurement of the columns of the Parthenon, confirming my opinions in every particular." Since Figure 2 does indeed come from a letter addressed by Cockerell to Smirke, there is reason to think that Allason's account contains more than a modicum of truth. There is no way of knowing, however, whether Cockerell had merely shown initial scepticism about Allason's suggestion or had disagreed vehemently, as the latter suggested, nor whether the agreement to communicate was indeed a firm commitment, nor whether Allason's letter from Naples was ever received by Cockerell. On the other hand, Figure 2 makes it certain that Cockerell succeeded in proving the existence of the entasis by measurement whereas Allason had failed to do so. It also seems to be the case that Cockerell never himself claimed primacy in the discovery.[26] Allason, by contrast, had by his own admission been sent a copy of Cockerell's drawing by Smirke by early 1816, and had deliberately omitted to mention this when first publishing his claims in 1819 — at which time he had even sleighted Cockerell by implication: "It may however be proper to state, that this circumstance has likewise escaped the observation of more recent travellers [than Stuart and Revett], who, from a long residence at Athens, may be presumed to have had greater facilities of ascertaining every minute circumstance relating to those splendid ruins."[27]

The circumstances surrounding the events of late 1814 are likely, then, to remain no more clear than this, and we should turn finally to the broader question of the extent to which entasis was visible or measurable in Greek architecture. In the later eighteenth- and early nineteenth-century period Allason appears to have been unique in his claim that entasis was "so very apparent … in all the remaining Antiquities of Greece." It went unrecorded in the earliest detailed surveys made in Greece: by Stuart and Revett and by Julien-David Leroy in the early 1750s.[28] More surprisingly, perhaps, given the extent of the entasis at the Temple of Hera I at Paestum, it was not noticed by the Italian, French and British draftsmen whose surveys were drawn together in

Fig. 8 Thomas Major, *Ruins of Paestum* (London: J. Dixwell, 1768), Plate 23 (Courtesy of the Faculty of Architecture and History of Art, University of Cambridge)

Thomas Major's *Ruins of Paestum* of 1768 (see Fig. 8 on fig. 8).[29] Paoli's rendition of a column from the same temple (fig. 4), doubtless based on an earlier drawing by one of Gazzola's architects, shows that the entasis here was not only perceptible but also measurable. However, as has been seen above, neither Paoli nor Delagardette were able to accept this temple in its eighteenth-century state as an original work by Greek architects, whilst Wilkins had explained it as the exception proving the rule that the Greeks had simply not practised a technique ascribed to them by Vitruvius.[30] To the eighteenth- and early nineteenth-century antiquary and architect the existence of entasis, both in Roman architectural practice and in that of the Renaissance – where techniques for setting it out were included in almost every treatise from Leon Battista Alberti's *De re aedificatoria* onwards – was beyond dispute. What was at issue was the question of how prevalent the practice was among the ancient Greeks.

In the mid-eighteenth-century revisionist philosophy on the subject of architecture the very principle of entasis was already under attack. In his *Essai sur l'Architecture*, for example, Marc-Antoine-Laugier noted: "Fault: to give a swelling to the shaft at about the third of its height instead of tapering the column in the normal way. I do not believe that nature has ever produced anything that can justify this swelling," and, as a general preamble to this particular observation, it may be noted that in his preface Laugier had said "Vitruvius has in effect taught us only what was practiced in his time."[31] In the *Ammerkungen über die Baukunst der Alten* of 1762 Johann Joachim Winckelmann tied the aesthetics of a "belly giving no grace to the columns" to the statement that entasis cannot have been used in good Greek buildings.[32] Natural and aesthetic ideas were brought together in the work of "Athenian" Stuart's British disciple, Stephen Riou, writing of the Doric order in his *Grecian Orders of Architecture* of 1768:

> The diminution of the shafts of columns upwards, gives a gracefulness to their forms, which otherwise they would want. But the swelling in the middle can convey no other idea than that of the columns being oppressed by the incumbent weight. The remains of antiquity cannot furnish examples of the latter practice.[33]

Thus entasis was effectively ruled out as a Greek architectural design feature at the very inception of the Greek Revival, a cultural position from which it would have eventually to be retrieved by process of scientific observation such as that practised by Cockerell in Athens in 1814.[34] It is clear that, if the extreme and contested example of the Temple of Hera I at Paestum is set aside, Greek entasis was far more subtle than many Roman and Renaissance examples of the practice, in some of which the

shaft swells even beyond the diameter of the base of the column making it in consequence far more visible.[35] At the Paestum temple the maximum extent of the entasis is 4.8 centimetres over a height of 5.5 metres, or a ratio of 1/100. At the other extreme comes the entasis of the Ionic order inside the Athenian Propylaea, which has been measured at a maximum of 10 millimetres or even 6 millimetres over a height of about 9 metres, a ratio of 1/900 or 1/1500.[36] The entasis of the Parthenon's peristyle columns falls mid-way between these two poles, extending to a maximum of 1.6 to 1.7 centimetres over a shaft height of about 9.6 metres, or a ratio of 1/550 to 1/600.[37] When one considers that, at the time Cockerell visited the Acropolis, the temple was so tightly hemmed in by other buildings that the columns could not be viewed at full height from any distance (see fig. 1), it is no wonder that the entasis was imperceptible to the naked eye and Thomas Allason's suggestion that it was "so very apparent" has to be dismissed as a gross exaggeration.

If further evidence were required of this, it can be found in the accounts of those who succeeded Cockerell and refined the measurement of the Parthenon's entasis during the first half of the nineteenth century. Indeed, William Jenkins, writing in the 1830 supplement to *The Antiquities of Athens*, effectively exonerated Stuart and Revett for not having noted it even when themselves measuring the temple to a fine degree:

> The entasis in any instance here given is produced from the bottom of the column, but none has the entasis perceptible to the eye, and scarcely to the rule, so slight is it; from which we cannot but infer, that it never was the intention of the Grecian architects to produce any other effect to the eye of the beholder than that of a straight line; nor are we aware that there is any example now remaining which is an exception, but the columns of the pseudodipteral temple at Paestum.[38]

Following on from this came the measurements made at the Parthenon (now cleared of the encumbrances around its stylobate), the Erechtheion and the Hephaesteion by Francis Cranmer Penrose in the 1840s, of which he wrote:

> the entasis has been so delicately applied that until a comparatively recent period the columns of these temples were supposed to be perfectly straight, and are so represented by Stuart. Indeed, unless an observer, by accident or intentionally, looks exactly along the line of the flutes from the top or bottom of the shaft, the curvature is scarcely appreciable, except by its indirect effects, even to the most practised eye.[39]

Peering down the flute of one of the columns of the Parthenon whilst perched precariously upon the entablature was, of course, precisely what the young Robert

Cockerell had done in 1814, and one may only imagine his surprise and wonderment at seeing his taught string or wire line depart from the stone arris to reach the platform two inches away from the base of the column. There is no evidence that Cockerell's latter-day biographer, Professor Watkin, was quite so intrepid in investigating what he has called the "baffling optical refinements which cannot be appreciated by the unaided eye" of that great building,[40] but he is known to have assured himself of the curvature of the stylobate during his own Grand Tour by placing his hat at one end and ascertaining, no doubt from a position on his knees, that it could not readily be seen from the other!

NOTES

I am grateful to Mark Wilson Jones and to David Yeomans for their comments on a draft of this essay, and to Charles Hind of the RIBA Drawings Collection for his assistance with Figure 2.

1. David Watkin, *The Life and Work of C.R. Cockerell* (London: Zwemmer, 1974): 17, quoting the text of Cockerell's comments to Smirke on entasis. See also David Watkin, "Archaeology and the Greek Revival: A Case-Study of C.R. Cockerell," *Late Georgian Classicism: Papers Given at the Georgian Group Symposium 1987* (Roger White and Caroline Lightburn, eds.), 1988: 64–66.
2. The sheet measures 49.7 x 12.8 cm at the bottom but is 13 cm wide at the top. There is, however, also a slight variation in the height of the shaft of the column as drawn by Cockerell, which measures 15 inches and 6 tenths at the left extremity and up the centre, but 15 inches 6.5 tenths at the right edge. If Cockerell had meant by this to have also identified the inward inclination of the Parthenon's columns, he would surely have said so. It was his English successor in Athens, Thomas Leverton Donaldson, who first noticed that optical refinement five years or so later.
3. Royal Institute of British Architects [RIBA], Mss. CoC: Add./1/28, recto.
4. On this (schematic) drawing, the red lines are not, in fact, perfectly straight — as they should be (given that they assume no entasis) — whereas the left solid black line, which should be curved, is more or less or less straight. The right solid black line, however, does display the curve.
5. Francis Cranmer Penrose described the similar method he had used to measure the entasis of the northern of the two central columns on the east front of the Parthenon — and at other Athenian temples: two separate measurements were made by means of a fine harp wire weighted to the maximum. Whereas Cockerell probably had only a rule, Penrose had one with a slide joint and also a Vernier scale, thus gaining him considerably more accuracy (Francis Cranmer Penrose, *An Investigation of the Principles of Athenian Architecture* (1851): 40). It is not clear which column Cockerell measured, since he does not give the overall height (nor show the number of fillets below the echinus), but it was presumably one on the west front. Penrose gave the height of these as 31.43 feet.
6. RIBA, CoC Add./1/26. The description here of the Parthenon's entasis being at the maximum of an inch "at about a third of the height" corresponds with the touching point of Cockerell's line at 11 feet up from the base in the second of the two experiments he conducted.
7. See Howard Colvin, *A Biographical Dictionary of British Architects 1600–1840*, 4th edn. (New Haven and London: Yale University Press, 2008): 260.
8. See Suzanne Lang, "The Early Publications of the Temples at Paestum," *Journal of the Warburg and Courtauld Institutes*, 13 (1950): 48–64, giving Mario Gioffredi or Berardo Galiani as candidates for having made the meas-

urements shown in fig. 4, and Dieter Mertens, "The Paestum Temples and the Evolution of the Historiography of Architecture," in Joselita Raspi Serra (ed.), *Paestum and the Doric Revival 1750–1830: Essential Outlines of an Approach* (Florence: Centro Di, 1986): 65.

9. Paolo Antonio Paoli, *Rovine della Città di Pesto detta ancora Posidonia* (Rome: Paleariniano, 1784): 141: "Asseriscono tutti i professori così d'antichità come d'architettura, non essersi trovato mai nelle greche costruzioni un tal metodo, onde lo stabiliscono proprio de' Toscani, e da essi soltanto adoprato."

10. Claude-Mathieu Delagardette, *Les ruines de Paestum ou Posidonia … levées, mesurées, et dessinées sur les lieux, en l'an II* (Paris: Barbon, 1798–99): 70–1: "Nous pensons que ces colonnes ayant paru trop grosses ou trop courtes, les Romains les auront diminuées de diameter, en leur donnant un certain mouvement dans le galbe et c'est peut-être cette restauration qui aura fait perdre aux cannelures le caractère distinctif des ouvrages Grecs." It should be noted that Delagardette's surname is sometimes given as De Lagardette.

11. William Wilkins, *The Antiquities of Magna Graecia* (Cambridge: University Press, 1807): 64.

12. Wilkins, *Antiquities* (1807): 59. Of the hexastyle Temple of Athena (previously known as that of Ceres), which Wilkins took to be Roman as well, he also denied the existence of entasis, writing: "the shafts diminish in a straight line" (65).

13. Penrose, *Investigation*, 2nd edn. (1888): 23 and 24 note 1. That Penrose did not make this claim in the 1851 first edition on his *Investigation* suggests that knowledge of Cockerell's involvement in the recognition of Greek entasis was not common in the first half of the nineteenth century although, as will be seen later in this essay, the question of primacy in the discovery was fiercely contested in 1821.

14. William Henry Goodyear, *Greek Refinements: Studies in Temperamental Architecture* (London: Yale University Press, 1912): 22–23. See Adolf Michaelis, *A Century of Archaeological Discoveries*, trans. Bettina Kahnweiler (London: John Murray, 1908): 33.

15. William J. Anderson and Richard Phené Spiers, revised and rewritten by William Bell Dinsmoor, *The Architecture of Ancient Greece: An Account of its Historic Development being the First Part of The Architecture of Greece and Rome* (London: Batsford, 1927): 119, crediting Cockerell in 1810. The date was changed to 1814 and Allason added from the 1950 3rd edition (revised).

16. Rhodri Windsor Liscombe, *William Wilkins 1778–1839* (Cambridge: University Press, 1980): 69–70; L. Haselberger, "Old Issues, New Research, Latest Discoveries: Curvature and other Classical Refinements," in L. Haselberger, ed., *Appearance and Essence: Refinements of Classical Architecture – Curvature* (Proceedings of the Second Williams Symposium on Classical Architecture held at the University of Pennsylvania, Philadelphia, April 2–4 1993), Philadelphia: University of Pennsylvania Press, 1999: 24–25, 27.

17. William Wilkins, *Atheniensia or Remarks on the Topography and Buildings of Athens* (London: W. Bulmer & Co., 1816): 127.

18. William Wilkins, *The Civil Architecture of Vitruvius* (London: Longman, Hunt, Rees, Orme, and Browne, 1812): 39 and plate 5 of Section 1, figure 1 (not figure 2, as Wilkins has it). On the same page Wilkins advanced the tentative and – to him more palatable – theory that "if the fillet between the flutings of Ionic columns be the measure of the entasis of Virtuvius, the deviation from a straight line will be scarcely perceptible in the outline of a column." Wilkins' *Vitruvius* was published in two parts in 1813 and 1817 (see Liscombe, *Wilkins* (1980): 255–6, n. 1) and, as it is not clear which parts appeared when, the exact juxtaposition of these passages with publication of *Atheniensia* cannot be ascertained.

19. RIBA, CoC: Add./1/26.

20. RIBA, CoC: Add./1/25.

21. It is worth observing that, in the advertisement to *Atheniensia* (1816): vii, Wilkins commented of the Acropolis: "the architectural details which are wanting in Stuart … particulars so desirable to the amateurs and professionals of architecture, are, however, likely to be amply supplied through the exertions of Mr. Robert Cockerell, a gentleman every way qualified for the undertaking."

22. Thomas Allason, *Picturesque Views of the Antiquities of Pola in Istria* (London: John Murray, 1819): 3.

23. Thomas Smart Hughes, *Travels in Sicily, Greece and Albania* (London: J. Mawman), 2 vols, 1: 287.

24. It is worth noting that Hughes was not consistent with dating within his narrative. For example, on 9 November 1813 he records himself as being both in Athens (*Travels*: 266) and on an expedition to Piraeus (*Travels*: 287).

25. Thomas Allason, "On the Columns of the Athenian Temple," *The Quarterly Journal of Science, Literature, and the Arts*, 10 (1821): 204–6.

26. See Watkin, *Cockerell* (1974): 124, reporting how, in his Royal Academy lectures, Cockerell cited Penrose as the authority on entasis and noting that "he never seems to have followed up his early investigations and analysis of entasis does not form a prominent part of any of his lectures." See also C.R. Cockerell, *The Temples of Jupiter Panhellenius at Aegina, and of Apollo Epicurius at Bassae* (London: 1860): 23–24, where Cockerell merely says that entasis is found in all Doric temples except for that at Bassae, that at the Port on Aegina and at that of Corinth, making no claim for his own earlier role in establishing this understanding.

27. Allason, *Picturesque Views* (1819): 3.

28. See, however, Jacob Landy, "Stuart and Revett: Pioneer Archaeologists," *Archaeology*, 9 (1956): 258: "A brief reference to entasis seems to be made in the second volume of the *Antiquities of Athens*, where it is mentioned that the columns of the Theseum diminish from the bottom by 'a beautiful curved line'." In this context it is worth noting that Stuart recognised that traces of colour on the Ionic Temple on the Ilissus in Athens were original to the building, yet chose not to pursue the question of polychromy in Greek architecture any further (see David Watkin, "Stuart and Revett: The Myth of Greece and its Afterlife," in Susan Weber Soros, ed., *James "Athenian" Stuart 1713–1788: The Rediscovery of Antiquity* (New Haven and London: Yale University Press, 2006): 39).

29. The drawing on which the engraving of Figure 8 on fig. 8 is based was originally made by Jacques-Germain Soufflot and further refined by Robert Mylne after his visit to Paestum in 1756 (see Michael McCarthy, "New Light on Thomas Major's 'Paestum' and later English Drawings of Paestum," in Serra, ed., *Paestum and the Doric Revival* (1986): 47).

30. See Ingrid Rowland (trans.), *Vitruvius: Ten Books on Architecture* (Cambridge: University Press, 1999): 50 (*De architectura libri decem*, Book III Chapter 3 Section 13: "At the end of the present book I shall record the illustration and method for the addition made to the middles of columns, which is called *entasis* (bowing) by the Greeks, and how to execute this refinement in a subtle and pleasing way.")

31. Marc-Antoine Laugier, *Essai sur l'Architecture* (trans. and ed. Wolfgang Herrmann), (Los Angeles: Hennessey and Ingalls, 1977): 18 and 2.

32. See Haselberger, "Old Issues, New Research" (1999): 25.

33. Stephen Riou, *The Grecian Orders of Architecture* (London: J. Dixwell, 1768): 22. Riou continues: "To begin the diminution from the bottom of the shaft, is the most natural and most approved, especially for the Doric." It is ironic, therefore, that figure A on Plate 1 of Part I of Riou's treatise does show a slight curve a third of the way up on the left side (only) of the Doric shaft.

34. A remarkable exception to this, however, is to be found inside Joseph Bonomi's church at Great Packington, Warwickshire, of 1789–92, where the four corner Doric columns appear to be modelled on those of the Temple of Hera II (Neptune) at Paestum (see Marcus Binney, "A Pioneer Work of Neo-Classicism," *Country Life* 150 (8 July 1971): 110). Binney notes, however, that Thomas Major's rendition of the order of that temple "failed to convey the entasis, or swelling, that gives the columns their distinctive character. At Packington this swelling is very predominant and one is forced to conclude that the designer knew enough to correct the mistaken impression given by Major." Indeed, Bonomi had returned from England to his native Italy in 1783 and in 1784 visited Paestum with the owner of Packington, the Earl of Aylesford, who is known to have been interested in and to have sketched Greek columns. His knowledge of entasis could, therefore, derive from personal observation or conversation, or from Paoli's book (see Peter Meadows, *Joseph Bonomi, Architect, 1739–1808* (London: RIBA, 1988): 7, and David Watkin, "Bonomi at Packington", *The Georgian Group Report & Journal* (1989): 105).

35. See Penrose, *Investigation* (1888): 39, n. 3: "The entasis of the Parthenon, Theseum and Erechtheum is so much more delicate than it is in the Roman and Revived Classical examples, with which only the earliest travellers in Greece were acquainted, that they seem to have overlooked it altogether."
36. Haselberger, "Old Issues, New Research" (1999): 28. The 6-millimetre claim is an unsubstantiated one by Dinsmoor, whereas the 10-millimetre figure has been firmly established by Manolis Korres.
37. 1.6 to 1.7 centimetres is, of course, somewhat less than the 1 inch measured by Cockerell, equating to about $^{10}/_{16}$ of an inch.
38. William Jenkins, "Further Elucidations of Stuart and Revett's Antiquities of Athens," *The Antiquities of Athens* (London: Priestley and Weale, 1830): 5.
39. Penrose, *Investigation* (1888): 39.
40. David Watkin, "Sacred Cows: The Parthenon," *Perspectives on Architecture*, 23 (June–July 1996): 96.

The Design and Construction of the National Gallery

CHARLES SAUMAREZ SMITH

As an undergraduate studying Neo-Classical architecture under David Watkin, I knew, as did others, that David had been an undergraduate under the late Michael Jaffé and that he had written his BA dissertation on the architecture of the National Gallery, before embarking on his PhD thesis on Thomas Hope under Nikolaus Pevsner, subsequently published by John Murray under the title *Thomas Hope and the Neo-Classical Idea*. But whereas the majority of undergraduate dissertations were readily available for consultation in the library in Scroope Terrace, David's was nowhere to be found. I have occasionally quizzed him as to what happened to it and he has always claimed that it no longer exists. So, when, much later in my life, I came to want to know more about the origins of the National Gallery and its place in Trafalgar Square, I found that I had to do so sadly without David's help and guidance.

What follows is my own attempt to reconstruct the narrative of the design and construction of the National Gallery's original building in the form in which it first opened to the public as a relatively small public building in 1838. I have, so far as possible, followed the precepts which I learned from David: that architectural history should pay close attention to the visual sources for any building; that buildings in England should be viewed within a European context; and that architectural history should be written in a way which is intelligible and not arcane.[1] But I have added, too, an interest which I developed during my time as an undergraduate in the detailed process of building and the ways in which it is possible to unravel the appearance of

a building from a close attention to its building history. My account does not pretend to be based on original research. It is intended instead to demonstrate the ways in which David's historical teaching has continued (I hope) to be a benign influence as I sought to understand the layout of the current National Gallery, how it was originally used, how its character was determined by the original Board of Trustees, and how the building developed out of the constraints of the budget and the brief. These were the aspects of my training in architectural history which I found useful when acting as a client for new building projects at the National Gallery and, before that, at the National Portrait Gallery.

As is well known, the National Gallery began life in a domestic house on the north side of Pall Mall, not far from where the Athenaeum was built to designs by Decimus Burton in the late 1820s, and the more elegant and less self-important Traveller's Club shortly afterwards by Charles Barry. The house had belonged to John Julius Angerstein, the German financier (but of Russian extraction) and founder of Lloyd's insurance exchange, whose collection was bought by the nation in 1824 in order to establish a National Gallery. It was immediately obvious that Angerstein's house was hopelessly inadequate as a long-term home for a national

Fig. 1 Charles Joseph Hullmandel, *The Louvre as compared to 100, Pall Mall*

collection of paintings and particularly pathetic if compared to the Louvre in Paris (fig. 1).

So, when John Nash produced designs in 1825 (published in 1826) for the development of the space then occupied by William Kent's Royal Mews, now Trafalgar Square, he included a suggestion that the National Gallery should be placed on the north side of the square in a long, low building with domes and a Corinthian portico.[2] In the middle of the square, he suggested a building designed in the form of a Greek or Roman temple to house the Royal Academy. He was perhaps inspired by the great drawings of the Roman Forum done by his nephew and pupil, James Pennethorne, in Rome and which were sent to Nash on 17 April 1825 or, alternatively, by the model of the Parthenon which he kept on the landing of the grand staircase of his house in Regent Street.[3] On the east side of Trafalgar Square, Nash proposed a building for the Athenaeum Club and the Royal Academy of Literature. The west side was already earmarked for a building to house the College of Physicians and the Union Club, now Canada House, which was designed by Robert Smirke, the architect of the British Museum. In other words, Nash imagined the new Trafalgar Square as a central forum in the city for scholarly and public institutions, comparable in style and character to the designs which Hawksmoor had made, but not executed, more than a century earlier for Oxford and Cambridge.

Fig. 2 Edward Hodges Baily, *William Wilkins*, Fitzwilliam Museum (by permission of the Master and Fellows, Trinity College, Cambridge)

As with so many of the schemes for the design of the National Gallery, some of these ideas had already been suggested at least twenty years before by James Wyatt who realised that the space occupied by the Royal Mews might provide an opportunity for a building which could house the national archives and the Royal Academy, as well as a National Gallery.[4] In June 1828, a Select Committee suggested that the existing Mews building could be adapted "at a very small expense," a proposal which was endorsed by the Board of Trustees at a meeting held in the Royal Mews on 15 July 1828 (it was only in 1828 that the Board began to meet at all regularly). In August, Nash was asked to produce a design for a new building. The *Literary Gazette* reported that Nash was "to be entrusted with the erection of a National Gallery and a Royal Academy," and the *Gentleman's Magazine* that Nash's plans had obtained the necessary approval. Neither report was true. Instead, the Trustees began to investigate the possibility buying the house immediately next door to Angerstein's house in Pall Mall in order to create a long frontage on Pall Mall, with space behind the two houses to allow for expansion. The British Institution advanced £4,000 towards the cost of this

proposal, but the Duke of Wellington as Prime Minister "would not listen to it."[5]

In 1830, when it was proposed that Angerstein's house should be demolished to make space for a road into St. James's Square, the Board of Trustees investigated an idea of constructing a new building on a vacant site immediately alongside St. James's Palace, which had been available since a fire in 1809. In December 1830 Trustees agreed the brief for a building which was to have consisted of three, large, sky-lit galleries and rooms beneath for offices – in other words, nothing tremendously ambitious and without much room for future growth. But this idea also came to nothing.

In June 1831, Agar Ellis, one of the original proponents of a National Gallery in the House of Commons, now Lord Dover and recently appointed First Commissioner of Woods and Forests, inspected Dysart House in Pall Mall as a possible site. It had the obvious attraction of relatively low costs of conversion. But, in August 1831, William Wilkins, probably acting in his role as Treasurer of the Royal Academy, returned to the previous suggestion that the King's Mews should be adapted in such a way that it might house both the Royal Academy, which was then still in Somerset House, and the National Gallery as well (fig. 2). He must have intuited that the government was unlikely to be willing to pay for a free-standing, new building on the model of University College or St. George's Hospital, his two most recent London projects.

On 16 September 1831, the Trustees met at Lord Dover's house to consider Wilkins' proposals. They agreed that Angerstein's house was manifestly inadequate and that Wilkins' ideas provided the best possible, as well as the cheapest, solution. They wrote to the new Prime Minister, Earl Grey, that the proposal was "the most practicable that has hitherto been offered to them, and well adapted to that purpose" and, the following month, they showed Lord Grey the plans. According to Lord Dover, the Prime Minister "seemed to like the plan – and promised to consider it favourably."

Not long afterwards, on 20 November 1831, Wilkins published a short pamphlet entitled *A Letter to Lord Viscount Goderich on the Patronage of the Arts by the English Government* (as Frederick Robinson, Viscount Goderich had been the Chancellor of the Exchequer who had approved the funding of a National Gallery in February 1824). Wilkins compared the condition of the National Gallery in London to its equivalents on the continent and, in particular, noted the extreme inadequacy of Angerstein's house as a safe place in which to house a national collection:

It is painful to witness the half measures adopted by the government in all its

Fig. 3 William Kent, *Royal Mews, Charing Cross, London* (1731–33)

proceedings relating to the arts. The purchase of the Angerstein collection took place at a very favourable period, when public distress had not yet cramped their resources; still these fine and invaluable works have been suffered to remain in a mansion ill calculated for their display, and where they are subject at all times to the ravages of the elements. The principal room is above the Offices of the Keeper, where the accidental ignition of a chimney flue would subject the whole to immediate perdition.[6]

He concluded that:

Whilst every nation on the continent, whether free or despotic, is engaged in the formation of galleries truly national, our own, the freest amongst the free, and ... the most liberal in rewarding the production of native talent, have as yet pursued no such patriotic example.[7]

In May 1832, a "Committee of Gentlemen" was established under Lord Duncannon (who had replaced Lord Dover as First Commissioner of Woods and Forests) including Lord Goderich, Lord Farnborough, Lord Dover, Sir Robert Peel, Ridley Colborne, Samuel Rogers and Joseph Hume, to consider the whole question as to how best to house the National Gallery, the Royal Academy, and the public records. Following the requirement that all public projects should be subject to competition, three architects were then invited to submit proposals: John Nash, no doubt invited as having been responsible for so many of the major town planning projects in London in the previous twenty years but at this point in his career well past his prime, settled in the Isle of Wight and leaving his son-in-law, James Pennethorne, in charge of the office;[8] C.R. Cockerell, who had travelled widely in Italy and Greece and been responsible for a number of country house commissions during the 1820s; and William Wilkins, a Greek Revival architect, but whose recent work included a number of Gothic designs for Cambridge colleges as well as a Romanised temple front for the non-denominational University College, London.

Nash put forward a proposal for a long, colonnaded building, akin in character to his terraces round Regent's Park and to the terraces along the Mall which had replaced the demolished Carlton House. But by now his ideas were probably regarded as too scenographic – grand façades which looked effective as part of a more general

composition, but which often left much to be desired in terms of their detailed planning and were felt to be lacking in intellectual, as well as physical, substance. Cockerell's magnificent proposals for a gallery 400 feet long over an arcade of shops were regarded as too expensive. Wilkins' initial idea, on the other hand, was, as before, a matter of adapting the old Royal Mews building, originally designed by William Kent (fig. 3). It was on this basis that he was selected — as an architect who was prepared to be responsible for a relatively economical makeover of an existing building. It probably also helped that he was a close friend of Lord Aberdeen, one of the Trustees of the National Gallery, and, like Wilkins, a student of archaeological remains.

However, by June 1832, the committee had become slightly more ambitious in its ideas and Wilkins was asked, instead, to put forward proposals for a free-standing building which would re-use the columns and entablature of Carlton House, the palace of the Prince Regent which had recently been demolished. Wilkins designed a building which was long and low, in some ways quite utilitarian and combining the functions of both gallery and academy into a single façade, facing south towards Whitehall and incorporating the National Gallery on its west side and the Royal Academy on its east. Many people both then and since have lamented the absence in his design of a proper sense of monumentality. It was as if he was trying to preserve some of the character and qualities of the previous Royal Mews, the shape of which, and, indeed, some of the aspects of its style, hover like a ghost behind Wilkins' design. But it is hard to reconstruct now the hostility which faced the building of every major project during this period of public works after the Napoleonic Wars: the determination to save public money at all costs, and the distaste for anything which might smack of *folie de grandeur*. Wilkins judged his clients correctly. There was just enough of a hint of grandeur in the central section of the façade, including the small, ultimately too insubstantial, dome. There was a certain amount of celebratory sculpture on the pediments, which was not executed in order to save money. And probably one of the reasons why the design was judged acceptable in the political circumstances of the early 1830s is precisely the reason why it has been regarded with affection, if not admiration, ever since. It lacks pomposity. It was not much different in style and character, nor, indeed, in cost to a moderately grand Greek Revival country house. It was planned to cost £41,000 if built of brick and £10,000 more if stone.

Sir Robert Peel was an enthusiastic supporter of the scheme. He spoke in the House of Commons on 23 July 1832, advocating its broader social implications:

> In the present times of political excitement, the exacerbation of angry and unsocial feelings might be much softened by the effects which the fine arts had ever produced on the minds of men. Of all expenditure, that, like the present expenditure on a national gallery, is the most adequate to confer advantage on those classes which have but little leisure to enjoy the most refined species of pleasure. The rich may have their own pictures, but those who obtain their bread by their labour cannot hope for such enjoyment. The erection of the national gallery would not only contribute to the cultivation of the arts, but also to the cementing of the bonds of union between the richer and the poorer orders of the state.[9]

This was the Tory view of the public benefits of a National Gallery, slightly *de haut en bas* (Peel had been an opponent of the Great Reform Bill), but not without idealism as to its potential benefits in social amelioration. The following evening, the President of the Royal Academy, Sir Martin Archer Shee, raised his glass to Wilkins at the Academy's annual dinner and Wilkins responded by praising the Prime Minister for "the stimulus given to the dormant state of the Fine Arts by the construction of a Royal Academy in conjunction with a National Gallery."

By January 1833, Wilkins' design for the National Gallery was nearly complete. In order to protect the view of the façade of St. Martin-in-the-Fields, the front had been set back 50 feet further north than Wilkins had originally planned. There had been a number of other changes. The subsidiary porticoes which led through to the barracks and workhouse behind (and which were to allow the passage of soldiers through to quell the mob in Trafalgar Square) had been moved forwards in order to try and give some sense of animation to what was otherwise always going to be an exceedingly long and slightly featureless façade. A semi-circular gallery had been added at the back. It was no longer felt necessary for the ground floor of the west wing to house the public records. And, as always seems to be the case with public projects, the costs had gone up, from £50,000 to £66,000, less £4,000 for the value of old materials from Carlton House, which could be sold.

The following month, Wilkins' scheme was leaked to the *Literary Gazette*. It was instantly the subject of intense public ridicule. What people realised right from the beginning was that the building was much too low for its setting, unable to dominate the space to the south. This was partly a consequence of its being designed to house not just one, but two great public institutions, the Royal Academy as well as the National Gallery: in other words, the portico was the only common element which united institutions whose rooms stretched out to either side. Moreover, public taste was already turning towards the idea of a richer and more monumental surface for

public buildings and was much less in sympathy with the relative austerity of the Greek Revival, which had been pioneered and promoted by William Wilkins from Downing College onwards.

Colonel Sir Edward Cust, a vocal Member of Parliament with a particular interest in public projects (he was the person who had insisted that any major public building project should be the subject of a competition), showed the engraving of Wilkins' building in the House of Commons alongside a Neo-Renaissance scheme which he had had drawn up by Charles Barry, who tended to prefer a more Italianate style to the neo-Greek, evident in the design of the Manchester Institution (now the Manchester City Art Gallery), and the Travellers' Club, which had opened in 1829. Cust's purpose was to encourage the government to require Wilkins to make the design higher and more monumental.

On 25 April 1833, Wilkins wrote to Lord Duncannon, perhaps in response to public pressure, suggesting that the façade should indeed be raised by 5 feet, bringing it to the level of St. Martin's and, at the same time, masking the roof of the Barracks behind. But, three days later, he argued against an increase of more than 5 feet on the grounds that it would interfere with the internal plan and diminish the quality of light in the top-lit picture galleries. Then, in May 1833, *The Times* suggested that the project should be moved altogether to Regent's Park in order to allow space for future extensions. And, in August, Lord Duncannon was forced to admit in the House of Commons that the costs had now risen to £70,000 and suggested that the whole scheme should be scrapped, Wilkins paid off, and the National Gallery moved to the Banqueting House in Whitehall.

Wilkins was, not surprisingly, devastated by the suggestion that his last great public project might be scrapped and wrote to Lord Duncannon: "Your Lordship cannot be expected to be fully aware of this change of plans on my professional practice but I know it *must be* such as will leave me no option but that of retiring altogether from practice."[10] For whatever reason, this was a temporary glitch and, on 30 August 1833, the Treasury approved the scheme.

Wilkins' problems and difficulties were certainly not at an end. Many public projects have suffered from being designed by committee, and because the Treasury has always wanted to save money and politicians to interfere. Nor was the design of the building exempt from changes during the course of construction. In particular, in June 1834, Wilkins was taken by Duncannon to see the sculptures which Nash had intended to use on Marble Arch. He was delighted to re-use them on the façade of the National Gallery. As he wrote to Duncannon, "I am no advocate for the intro-

duction of sculpture into buildings unless it be of excellent design and good execution," but he felt that these sculptures "[were] of this description and may be made not only conducive to a certain degree of richness in the exterior but by breaking the horizontal sky-line greatly improve the general effect."[11] This is why you find over the front entrance of the National Gallery symbolic sculptures of Europe and Asia and an empty lunette which was originally intended to be filled with a commemorative bust of the Duke of Wellington, which is now in the lobby of the staff entrance.

In July 1834, Wilkins realised that the idea of re-using the columns of Carlton House for the entrance portico was not going to work. To begin with, he thought that they could at least be used to embellish the side entrances; but, here too, he decided that, in the end, it was better to build new ones. He reported to Duncannon that he had

> engaged to erect both [gateways] of entirely new materials except the capitals of the columns, which have been wrought anew and have been made, by the removal of some of their ornamental foliage, to correspond with the greater simplicity of those intended to be introduced in the center portico of the buildings. By this arrangement I have been enabled to give a greater substance, as well as height, to the columns insomuch that the difference in bulk between them and the columns for the center portico will be imperceptible.[12]

Although the workmen engaged on the project went on strike between August and October 1834 (strikes were not only a phenomenon of the twentieth century), the Royal Academy side of the building (that is the east side) was sufficiently complete for it to be used in 1836 for the display of the designs for the new Houses of Parliament. But already the public mood was beginning to turn against the project. In his *Contrasts* published in that year, Pugin used the new National Gallery, not yet open, as an example of all that was wrong with contemporary British architecture – too mean and utilitarian and lacking a proper historical sense of the Gothic. And at the hearings of the Select Committee on Arts and Manufactures, held in 1836, the numbers of pictures it could show was compared very unfavourably to Klenze's grand, purpose-built Alte Pinakothek in Munich, which had the capacity for showing 1,600 pictures, mostly in large, top-lit galleries, but with cabinet rooms to the side, and, even more, the new Hermitage in St. Petersburg, which could show at least 4,000.

By 1837, Wilkins was beginning to be worn out by the stresses and strains of the project. He urged the Office of Works to proceed with the levelling of Trafalgar Square and to allow for the construction of a terrace immediately in front of the new

Fig. 4 York and Son, *View of the National Gallery c.1870*, NMRDD97/00316

building. But he was convinced, probably rightly, that the Treasury had decided to torpedo this idea, and, on 26 May 1837, he informed the Commissioners of Woods and Forests, slightly tragically, that he must let things take their course, for he had "already suffered [him]self to be agitated to a degree prejudicial to [his] health if further prolonged."[13]

The building was finally available for inspection by Queen Victoria on 7 April 1838 and the National Gallery opened to the general public two days later. The *Times* greeted its opening as follows:

> It is generally known that the rooms in which the pictures are hung are but badly calculated for the purpose, and that the interior of the place is more than commensurate in defects with the absurdities and bad taste of the outside. Those who have seen the pictures in the Louvre, at Paris, though the place in which they are hung is not particularly well adapted for the occasion, will readily admit that they have a better chance of being seen to advantage, even in that building, than those of the English National Gallery, in the contemptible closets of the pie-crust edifice on the north side of Charing-cross.[14]

Thackeray, meanwhile, described it as "a little gin-shop" while King William IV is said to have described it just before his death, in his last recorded utterance, as "a nasty little pokey hole."[15] From that point onwards, most of the efforts of all subse-

quent building projects at the National Gallery have been intended to correct, as far as possible, the defects of William Wilkins' original design.

What becomes clear from a detailed narrative of the circumstances of the National Gallery's design is that it was a pragmatic response to the circumstances of official building in the early 1830s: constrained by the frugality of the public purse, constantly open to question in the House of Commons, dominated by the bureaucratic mentality of public committees. These were hardly the circumstances in which to produce an intellectually coherent or profound vision of classicism of the sort which C.R. Cockerell was able to achieve at the Ashmolean, or Schinkel in Berlin, or Klenze in his Glyptothek in Munich. The circumstances of its construction were very different from the autocratic town-planning which was possible in Berlin, Munich and Paris. Wilkins was not designing on a new site. There was not very much of a sense of civic ambition. And he had to create a building which would accommodate not just one major national institution, but two.

On the other hand, if one regards the National Gallery as a form of loose-fit, polite classicism, a set of galleries for the display of paintings masked by an economical, but polite façade, then the National Gallery can be viewed as an effective solution to a complicated brief (fig. 4). It has grown organically behind its original façade, and Wilkins' original five galleries stretching west from the main entrance have been much more consistently admired and imitated than the grander and more ostentatious galleries designed in the late 1860s by E.M. Barry, although not opened until 1876. One of the reasons why people like visiting the National Gallery more than, say, the Louvre or the National Gallery in Washington is precisely because the galleries retain a sense of human scale.

Wilkins' National Gallery can be viewed as a monument to an era when classicism was axiomatically part of the vocabulary of official culture before the Battle of the Styles. It has frequently received a bad press, not least from John Summerson who described it memorably in *Georgian London* as having "a dome over the portico and turrets over the terminal pavilions, like the clock and vases on a mantelpiece, only less useful."[16] But now that the area in front of the façade has been cleared of traffic, if the building is viewed from below Norman Foster's new steps, or from across the full expanse of Trafalgar Square, or when it is seen sideways looking towards St. Martin's-in-the-Fields (perhaps the most memorable view of the way the building is massed) it can be seen as it was intended: an important example of England's dignified and not too pretentious public institutions.

NOTES

1. The first person besides David Watkin to study the building history of the National Gallery was Gregory Martin, then an Assistant Keeper at the Gallery, who published "Wilkins and the National Gallery", *Burlington Magazine*, 113 (June 1971): 318–29 and a series of articles on "The Founding of the National Gallery in London", in *Connoisseur* (1974). Not long afterwards, there was a chapter by Michael Port on the National Gallery in J. Mordaunt Crook and M.H. Port, eds., *The History of the King's Works* 6, 1782–1851 (London: HMSO, 1973): 461–70. Since then, Rhodri Liscombe has been the main writer on Wilkins, publishing his monograph (now hard to obtain) on *William Wilkins 1778–1839* (Cambridge: University Press, 1980). More recently, there has been an exhibition *The Age of Wilkins: The Architecture of Improvement* at the Fitzwilliam Museum from 20 June to 15 August 2000, with an accompanying catalogue by David Watkin and Rhodri Liscombe; a long entry in Simon Bradley and Nikolaus Pevsner, *The Buildings of England: London 6: Westminster* (New Haven and London: Yale University Press, 2003): 305–10; and a great deal of relevant material has been produced by Jonathan Conlin in "The Origins and History of the National Gallery, 1753–1860" (unpublished Ph.D. Thesis, University of Cambridge, 2002) and in his monograph, *The Nation's Mantelpiece: A History of the National Gallery* (London: Pallas Athene, 2006): 372–80. I am extremely grateful to Jonathan Conlin for much of the information and research material on which this essay is based. I am also grateful for detailed comments on the text from Gregory Martin, Rhodri Liscombe and, most especially, from Chris Whitehead, whose monograph *The Public Art Museum in Nineteenth Century Britain: The Development of the National Gallery* (Aldershot: Ashgate, 2005) covers the later history; and to Mark Pomeroy who helped source the photographs and quotations.
2. These plans are discussed by John Summerson, *John Nash: Architect to King George IV*, 2nd ed. (London: Allen and Unwin, 1949): 178.
3. British Architectural Library, PeJ/1/4, discussed and illustrated in Frank Salmon, *Building on Ruins: The Rediscovery of Rome and English Architecture* (Aldershot: Ashgate, 2000): 102–3 (and see page 75).
4. Wyatt had discussed his plans for a National Gallery with Joseph Farington on 31 March 1798. See *The Diary of Joseph Farington*, Kenneth Garlick and Angus Macintyre, eds., (New Haven and London: Yale University Press), III: 995.
5. These proposals are discussed by Gregory Martin, "The Founding of the National Gallery in London", *Connoisseur*, 4 (1974): 202–4.
6. William Wilkins, *A Letter to Lord Viscount Goderich on the Patronage of the Arts by the British Government* (London: R. Rodwell, 1832): 42.
7. Wilkins, *Letter to Lord Viscount Goderich* (1832): 71.
8. According to James Pennethorne's diary, he was asked by Nash on 1 June 1832 to "go to the island (i.e. the Isle of Wight) about National Gallery" (see Summerson, *John Nash* (1949): 270).
9. *Hansard*, 3rd series, 14, c.605.
10. PRO, Works 17/10/1 cit. Liscombe, *Wilkins* (1980): 200.
11. Wilkins to Alex Milne, 16 June 1834, PRO, Works 17/13/6, fol.1. This episode is discussed in Martin, "The Founding of the National Gallery": 50–51 and Conlin, *Nation's Mantelpiece* (2006): 375.
12. PRO, Works 17/10/1, fols. 143–44.
13. PRO, Works 17/10/1, fols. 256–58, 267–68.
14. *The Times* (Tuesday 10 April, 1838): 5.
15. I have been unable to find the original source for this quotation, but it appears in W.T. Whitley, *Art in England, 1821–37* (Cambridge: University Press, 1930): 334.
16. John Summerson, *Georgian London* (London: Pleiades, 1945): 192.

Charles Barry's Designs for Northumberland House

MANOLO GUERCI

THIS ESSAY IS concerned with three remarkable sets of designs made in 1852–4 by Sir Charles Barry for Northumberland House in London, the greatest representative of the old aristocratic palaces on the Strand. Presented and analysed here for the first time, they can be reckoned amongst the most accomplished achievements of England's leading interpreter of the Italian Renaissance palace, whose work has received no attention in recent years.[1]

Built by one of the most powerful Jacobean courtiers, Lord Henry Howard, 1st Earl of Northampton, between 1605 and c.1611, as a massive four-towered square block around a central courtyard with a large garden extending to the Thames (fig. 1), Northampton (later Northumberland) House remained in the family of his heirs, the Earls of Suffolk, until 1642.[2] Through the marriage in that year of Algernon Percy, 10th Earl of Northumberland, into the Suffolk family, the house became a property of the Percys, who used it as their primary London residence for the following 234 years, until its tragic demolition in 1874. A new street called Northumberland Avenue was built instead, to connect Trafalgar Square with the newly-created Victoria Embankment.

By the time of Barry's involvement, Northumberland House epitomised some 150 years of architectural practice. Architects called in for advice, or directly involved with alterations, included Edward Carter, John Webb, Daniel Garrett, James Paine, Robert Adam, C.R. Cockerell, Thomas Hardwick and Thomas Cundy. Edward Carter had completely rebuilt the south front of the house for the 10th Earl of Northumberland

Fig. 1 John Smythson, [1609]: survey of the ground floor of Northampton (later Northumberland) House at Charing Cross, London

between 1642–9, initiating a process of continuous alterations which gradually transformed it into a secluded riverside palace with its public side moved away from the Strand. A few years later, in 1655–7, John Webb designed the great external staircase erected by Edward Marshall in the middle of the south front to provide a direct connection to the garden, and remodelled Carter's interiors.[3] Daniel Garrett was responsible for updating the Strand front "in order to make it appear less like a prison," and for adding two wings in the garden.[4] The east one contained service rooms, while that on the west included a Library, Bed Chamber and a Waiting Room.[5] Commissioned by the 7th Duke of Somerset, the 10th Earl's grandson, in 1748, works were carried on under Sir Hugh Smithson, who took the name of Percy through marriage and in 1766 became 1st Duke of Northumberland of the third creation. It was he who transformed the newly-created west wing into an enormous two-storey Picture Gallery or Ball Room 106 feet long, to be completed in c.1754–7 by Garrett's successor, James Paine (fig. 2). Lavishly decorated, the Gallery had nine great windows alternated with oval and pier glasses on the garden side, while on the opposite one there were two identical chimney pieces supported by Barbarian captives and surmounted by elaborate overmantels which framed the full-length portraits of the Duke and Duchess of Northumberland.[6]

The updating of the Strand front was followed by that of the courtyard elevations, which were finished "in the Roman style of architecture,"[7] that is Palladianised, and faced with Portland stone. In the 1770s, Robert Adam created the famous Glass Drawing Room in the state apartments on the south side for the new Lord and Lady Northumberland, together with some magnificent new interiors for Syon House and Alnwick Castle, the family's suburban and ancestral seats.[8] A Neo-Classical version of the Baroque Mirror Room which had Italian prototypes such as the rooms by Filippo

Fig. 2 Charles Barry, 1853: Survey of the ground floor of Northumberland House as altered by Thomas Cundy in 1818–24

Juvarra at the Palazzo Reale in Turin, the Gallery at the Palazzo Doria-Pamphilj in Rome, or the Porcelain Room at the Palazzo Reale at Portici, Naples, this was "a splendid chamber for 'the parade of life'," with eight large pier glasses and walls sheathed with red and green spangled-glass panels overlaid with gilt-metal ornaments.[9] Lit by a central chandelier and a number of candelabra, it featured an inlaid-scagliola chimneypiece of a sober Neo-Classical design.

By the early nineteenth century, constant alterations to the south front had apparently caused some structural problems. The outer wall was leaning outward, while many of the state rooms still maintained their original character of being too narrow in proportion to their length.[10] Called in for advice by the 3rd Duke of Northumberland in 1819,[11] C.R. Cockerell remarked that they had "the appearance rather of galleries than salons,"[12] and judged the great staircase, essentially unaltered since its first erection, "dark, and unpleasant in its sudden approach from the Hall door." He thus proposed a "magnificent disposition," that is a new saloon in the courtyard, which would have made an immense room some ninety feet square, probably unmatched within the context of a private residence.

Cockerell's involvement at Northumberland House was to be limited to hasty observations; the 3rd Duke therefore commissioned Thomas Hardwick, a pupil of Sir William Chambers who had previously worked at Syon, to remodel the interior.[13] But it was Thomas Cundy who, between 1818 and 1824, eventually carried out what was the fifth alteration of the south front, giving Northumberland House that characteristic nineteenth-century appearance documented in several photographs of the early 1870s.[14] Perhaps the grandest aspect of Cundy's alterations was the reconstruction of the main internal staircase as three large flights of veined marble steps, particularly praised during the Great Exhibition of 1851, when the 4th Duke, another important Algernon in the history of Northumberland House, opened it to the public for the first time (together with Syon House).[15]

A philanthropist, art collector and patron of the arts immersed in travel and archaeological exploration, Algernon "the Good" was one of the first Englishmen to journey in Upper Egypt to record Pharoanic remains there.[16] In Rome in 1853 the Duke met the architect and archaeologist Luigi Canina, who had restored the gardens of the Villa Borghese in 1822, to discuss the scheme for the interior restoration of

Alnwick Castle. Carried out between 1854 and 1863, this included a new set of state apartments designed by Anthony Salvin, one of the finest Victorian exponents of the castle style who had already worked for the Percys.[17]

By September 1851, the 4th Duke had also commissioned Charles Barry to inspect the interiors of Northumberland House, with the view of a grand scheme of reconstruction of the south front.[18] Had it been realised, this would have been the sixth as well as the last alteration of the public side of the house.

Given the Duke's penchant for sixteenth-century Roman palaces, the choice of Barry must have been an almost inevitable one: his club houses in Pall Mall, The Travellers' (1830–2) and The Reform (1838–41); the British Embassy at Constantinople (1845–7); and the much grander Bridgewater House in London (1846–51), had made him the undisputed interpreter of Italian Renaissance palaces on British soil.[19] In addition, Barry led the way in the alteration of pre-existing buildings, which he would almost invariably rework in a highly Italianate fashion. Amongst these were notable country houses such as Trentham Hall, Staffordshire, reconstructed for the 2nd Duke of Sutherland between 1834 and 1849;[20] Highclere Castle, Hampshire, remodelled for the 3rd Earl of Carnarvon in 1842–9;[21] and Cliveden House, Buckinghamshire, rebuilt for the 2nd Duke of Sutherland in 1850–1.[22] Barry's unexecuted schemes of this type included alterations for Petworth House, the seat of the Dukes of Egremont, the other branch of the Percy family.[23]

From the architect's point of view, notwithstanding his full-time engagement with the Houses of Parliament since 1836, Northumberland House represented a unique chance to work on the greatest and only surviving example of the Strand palaces. Appropriately enough, it faced the newly-created Trafalgar Square (1840s), Barry's only urban project to be realised.[24]

The first series of plans for Northumberland House is dated 25 May 1852.[25] It consists of a single sheet showing the existing layout with proposed alterations of the ground floor, and, at either side of it, part of the basement wings of the house (fig. 3). The purpose was the improvement of the state apartments on the garden side, to remedy, as it has been suggested, both the constriction of the seventeenth-century quadrangular plan as well as the narrowness of its interiors. Furthermore, given the considerable social changes going on in the area, the Strand entrance into the house no longer afforded a dignified and safe route.[26] Hence, Barry's proposal to link the outer wings in the garden by a continuous arcade providing the house with an imposing new entrance from the south through Scotland Yard and Whitehall, an idea which would be further elaborated in the second and third series of designs (see

Fig. 3 Charles Barry, 1852: preliminary design for basement and ground-floor plans with proposed alterations at Northumberland House, detail

fig. 4).[27] At this stage, however, the architect was still trying to improve access from the Strand by opening two "occasional Gateways" either side of the main one, to ease the passage of carriages. This was clearly an issue in a house where entertainment had traditionally been on a very large scale. The *London Chronicle* of 5 June 1764 recorded that there were on one occasion "1,500 persons of distinction ... at Northumberland House," while an almost contemporary account of Count Kielmansegge's attempt to leave a party there of "a mere six hundred guests" to celebrate the coronation of George III stated that "Nothing is perfect, not even in this house; the inconvenience of getting away is a very great drawback, the courtyard being too small for the quantity of carriages and sedan chairs, and everybody has to come in and go out by the one gateway, which is very narrow."[28]

In this preliminary design (fig. 3), Barry moved the main entrance to the house – that is through the courtyard on the Strand side – from the south to the east wing, while the room previously occupied by the great staircase became a large entrance hall leading into the state apartments on the garden side. He also added an extra wing to the east, which included a new monumental staircase of three parallel flights devised "upon the Italian principle, each flight being between walls and vaulted,"[29] followed by a new set of rooms for dining in state opposite the Ball Room. At basement level,

Fig. 4 Charles Barry, 1853: first design for the layout of the property with proposed alterations

a new kitchen and related services were provided, while a private entrance hall and passage leading from the garden to the state rooms above gave further access to the house.

The two plans of 1852 were only the first stage in Barry's grand scheme of reconstruction. They were soon followed on 6 April 1853 by a set of fifteen survey drawings of Northumberland House,[30] together with the first complete series of designs including a block plan of the house and grounds (fig. 4), three floor plans, elevations and sections for a total of nine drawings.[31] The former shows the house as Thomas Cundy had altered it in 1818–24 (fig. 2), while the latter offers a first glimpse at Barry's crescendo.[32] Through the quadrangle on the Strand side, where the number of "occasional Gateways" was reduced to one, the house would have been entered from the east wing through a new Entrance Hall followed by an Inner Hall leading to the main staircase (fig. 5). This was no longer three flights of steps, but a simpler staircase of two flights within walls, more in accordance with Barry's ideal of Roman gravitas.[33] The great state rooms in the south-west sides of the house, that is the Drawing Room, Glass Drawing Room, Tapestry Room, and Ball Room, were left undisturbed, with the exception of a central enfilade of new doors as well as further access into the Ball Room. It was, in fact, on the east wing, formerly devoted to

THE PERSISTENCE OF THE CLASSICAL

services (see fig. 2), that Barry concentrated his improvements, with the creation of a new set of dining rooms for private and public functions. As the section shows (fig. 6), the State Dining Room, which equalled the size of the opposite Ball Room, would have been a full-height coffered barrel-vaulted room reminiscent of grand Roman interiors such as those of the Temple of Venus and Rome.

The state apartments were to be conjoined by a continuous terrace, that is a loggia on its south range, which provided a direct and sheltered link between the Ball Room and the opposite State Dining Room (fig. 5). At basement level, that is the garden, the colonnade supporting the terraces created a cloister-like enclosure (fig. 4), providing a magnificent new background for the Scotland Yard entrance, as well as further ground for receptions. This may be seen as an *al fresco* version of Barry's great central halls surrounded by arcaded corridors, such as those at the Reform Club and Bridgewater House.[34] In effect, as the architect specified, "The Colonnade connecting the two wings, which on ordinary occasions would be open, might during great receptions be closed on the north side by blue and white Blinds, drawn down to the pavement to exclude all draughts, so that the colonnade would be available in its entire length for the setting down, and taking up, of Company in large numbers simultaneously."[35] The south arcade, on the other hand, led to a series of grand new halls in the east wing, connected to the state rooms on the ground floor by the principal staircase.

Fig. 5 Charles Barry, 1853: first design for plan of the ground floor with proposed alterations

The impact of Barry's improvements becomes clearer once we compare his designs for the new façades of the garden wings with their respective survey drawings. While the original mid-1750s side ranges were architecturally featureless in their exteriors (fig. 7), they now had a distinctive *piano nobile* characterised by tall framed windows with triangular pediments, which rested upon a base with channelled rustication (fig. 8). All but those at the extremes opened onto the balustraded terrace supported by Doric columns, which provided some depth in an essentially plain design, while the attic was marked with a series of square relief panels blocking off the original windows. The whole, framed by rusticated quoins and cornices, and

surmounted by hipped roofs, epitomised some of Barry's most successful designs of the astylar sort, such as the façades for the Travellers' and Reform Clubs in London, inspired by the Palazzo Pandolfini (1516–20) and the Palazzo Farnese respectively (begun c.1513–4).[36]

The elevations for the south fronts, both of the centre and of the wings, were less successful (fig. 9). The side wings, characterised by two orders of tripartite loggias surmounted by three panels and an exceedingly tall pediment, were ill-proportioned, as was the low arcade which linked them. The decoration of the central façade, on the other hand, was essentially left to the three orders of loggias with no clear distinction as to the hierarchy of floors, which, together with the roof balustrade and statues, made too vertical and undistinguished an elevation in relation to its length.

It is unlikely that Barry would not himself have realised the problems highlighted above. In effect, these were due mainly to the limits imposed by the previous façade, which largely mirrored the seventeenth-century structure of the house (fig. 10).[37] In any case, neither the Duke nor the architect seemed happy with the designs initially proposed. In a letter of 8 June 1854, Barry was giving Northumberland "a general explanation of the Second Design which I have had the honour to prepare in compliance with your Grace's interest for alterations & additions at Northumberland House; which, it has occurred to me you might be glad to look at ... & I think you will find that it embraces the whole of your Graces [sic] requirements, with some additions which I propose as improvements."[38] In what appears as an almost apologetic discourse, he concluded by stressing that "the plans elevations & sections of this second designs,

(top) Fig. 6 Charles Barry, 1853: first design for section of the east wing with proposed alterations, detail

(bottom) Fig. 7 Charles Barry, 1853: survey elevation and sections of the west wings, north and south fronts, detail

THE PERSISTENCE OF THE CLASSICAL

have been long since prepared, but I have thought it useless to [send] them in your Grace's absence."[39]

The second series of designs for Northumberland House shows Charles Barry at his best. Dated 1 May 1854, and accompanied by a detailed specification, it comprises plans, elevations and sections – ten elaborate drawings in all.[40] As far as the internal arrangement is concerned, the difference from the previous plans is marginal, and it is clearly in both the interior and exterior elevations that the improvements are most apparent. As the sections show, the height of the state rooms was considerably raised, giving the right prominence to the *piano nobile* (fig. 11).[41] The staircase, a grander version of Barry's very first design, faced a large Saloon with a central dome, decorated with an elaborate ensemble of niches with statues. The Saloon opened onto a suite of two dining rooms for family and public functions, which could be turned into a single great room on state occasions. They were both heavily decorated with coved ceilings resting upon a cornice supported by Corinthian semi-columns in between the windows and panels, presumably for large paintings, on either side. The whole, completed by elaborate chimney-pieces featuring full-size statues and mirrors, was in stark contrast to the gravitas of the previous design, and was reminiscent of great Italian interiors such as the Galleria Doria-Phamphilj in Rome (1731–3).

(top) Fig. 8 Charles Barry, 1853: first design for elevation and section of the west wing and south front with proposed alterations, detail

(bottom) Fig. 9 Charles Barry, 1853: first design for the elevation of the garden fronts

As far as the interior decorations are concerned, the difference between the two designs may be accounted for by the choice of a different style, each with its own implications and costs. Externally, however, the improvements of the second design

144

would seem to surpass the limits of its predecessors. The façades of the side wings, whilst presenting a similar language, were lowered and better proportioned than their predecessor (fig. 12 – and see fig. 8). The heavy rustication of the base and quoins was then reflected in the columns of the loggia in a typical Mannerist mould, while the architrave and balustrade of the terrace became altogether more prominent. Larger windows, still crowned by triangular pediments but no longer surmounted by panels, became the focal point of the composition, while the presence of an elaborate frieze and cornice, together with a tall balustrade with urns which hid the roof, enhanced the horizontality of the buildings. This was skilfully picked up in the south fronts of the two wings (fig. 13 – lower image), each a heavily-rusticated composition with a large door and a window opening onto a balcony supported by caryatides. No longer arcaded, but composed of a series of rusticated columns in pairs, the colonnade linking the two wings was also much more slender than its predecessor (see fig. 9).

While the elevations of the side wings maintained a closer relation with their astylar Renaissance models, embodied, as we have seen, in Barry's designs for the Club houses, the façade of the south front itself afforded an original, if eclectic composition typical of his mature repertoire, employed at great country houses such as Clumber Park. Made for the Duke of Newcastle's Nottinghamshire mansion in 1857 and left unexecuted, the latter designs bore particular similarity to those of Northumberland House.[42] Here, the ground floor, characterised by the rusticated

Fig. 10 Charles Barry, 1853: survey elevation of the garden front as rearranged by Thomas Cundy in 1818–24

Fig. 11 Charles Barry, 1854: second design for sections of the garden front (top first) and east wings (central, below) with proposed alterations

Fig. 12 Charles Barry, 1854: second design for the elevation of the side wings with sections of the new south front and east wing

loggia embracing the whole court, was surmounted by a prominent *piano nobile*, with tall slender arcades in the mould of Brunelleschi's Ospedale degli Innocenti in Florence of 1419–24. They framed large windows, and terminated with *serliane* at either end emphasising the two taller parts of the buildings. Conveniently reduced in height, the top floor provided some relief to the eye, with lesser decorations and windows opening onto a balustraded terrace over the loggia. At either end, the windows were tripartite and more elaborate, with large arcaded tops and medallions on both sides. The composition was crowned by a balustrade with urns which again prevented the view of the roof.

These grand ideas of Charles Barry for reconstruction, despite the considerable achievements of the second scheme, sadly remained on paper. On 30 October 1854, the architect sent a bill of £910 for his professional service,[43] that is £145 for "survey and measurements," £330 for the first designs, and £390 for the second, paid in November of the same year.[44] This is the last relevant record at our disposal, though an invitation from the Duchess of Northumberland "at home," registered in Barry's diary for Wednesday 14 May 1856, would seem to suggest some further links, if short-lived, between the architect and the house.[45]

Since first turning his attention to Northumberland House in September 1851, however, the 4th Duke of Northumberland had become increasingly engaged with the restoration of Alnwick Castle, which became an extraordinary and full-time commitment to bringing Rome to the North. The Duke may also have been discouraged by the forthcoming changes which would soon affect the amenities of his London house, that is the building of Charing Cross Station of 1864, as well as the

Fig. 13 Charles Barry, 1854: second design for the elevations of the garden fronts

urban redevelopment occasioned by the creation of the Victoria Embankment. In 1865, the Metropolitan Board of Works made the first of a series of controversial attempts at the compulsory purchase of the house, to make space for the new Northumberland Avenue running from Trafalgar Square to the Embankment.[46] Nine years later, despite the resistance of the family, and various "alternatives routes," Northumberland House was demolished. Viewed in this context, Barry's designs represented the last grandiose act of a Victorian architectural tragedy.

NOTES

I first met David Watkin in the winter of 2002, when, after discussion on several (then rather unshaped) ideas for a Ph.D., he agreed to be my supervisor. These ideas resulted in a dissertation entitled "The Strand Palaces of the early seventeenth century: Salisbury House and Northumberland House", whence the topic of this essay originates. It is a nice coincidence that I should write on Charles Barry for David's *festschrift*, since Barry's Reform Club was one the first buildings to catch my attention (as well as "reassuring" me) when, a visiting student at University College London in 1998, I first plunged myself into the study of eighteenth- and nineteenth-century London. I have acknowledged elsewhere those who have helped me with my study of Northumberland House. Here I should like to thank the late Sir Howard Colvin, Dr Mark Girouard, John Harris, Dr Gordon Higgott, and Dr Frank Salmon for their help and advice; the Duke of Northumberland for access to the archives at Alnwick Castle and for permission to publish the plans reproduced here, together with Clare Buxter and Lisa Little for their assistance; Dr Charles Hind and his team at the Royal Institute of British Architects for coping with my requests during the examination of Barry's substantial corpus of papers and drawings; and Ian Leith at English Heritage for information on the photographs of Northumberland House.

1. Barry's biography, *The Life and Works of Sir Charles Barry*, was published by his son Alfred Barry in 1867 (London: J. Murray), while a number of articles and essays, to which research on this architect has been confined, are all fairly dated (see below). In addition, a thorough investigation of Barry's vast corpus of drawings remains to be done.
2. See Manolo Guerci, "The Strand Palaces of the early seventeenth century: Salisbury House and Northumberland House", 2 vols. (Ph.D. dissertation, University of Cambridge: 2007), vol. 1, Part 2: 87–137; vol. 2, app. 18: 227–31.
3. See Jeremy Wood, "The architectural Patronage of Algernon Percy, 10th Earl of Northumberland" in *English Architecture Public and Private: Essays for Kerry Downes*, John Bold and Edward Chaney, eds., (London and Rio Grande: The Hambledon Press, 1993): 55–80.
4. The Duchess of Somerset to Lady Luxborough, June 1749. The letter is quoted in the *Survey of London: The Strand* (London: London County Council, 1937), vol. 38, 13–14. For Garrett's new façade see Peter Leach, "A Pioneer of Rococo Decoration. The Architecture of Daniel Garrett II," *Country Life* 156 (19 Sept. 1974): plate 1.
5. This is evident from a plan of the ground floor of c.1750 (Duke of Northumberland, Alnwick Castle, hereafter A.C., B.XV.2K) published in David Owsley and William Rieder, "The Glass Drawing Room from Northumberland House," *Victoria and Albert Museum Yearbook* 2, (1970): plate 29.
6. See Jeremy Wood, "Raphael Copies and Exemplary Picture Galleries in Mid Eighteenth-Century London," *Zeitschrift fur Künstgeschichte* (1999): 401–e5. Barry's survey drawings of 1853 included a detailed plan of this room.
7. See Robert and James Dodsley, *London and its Environs Described*, 6 vols. (London: Robert and James Dodsley, 1761), vol. 5: 53.
8. See: Owsley and Rieder, "The Glass Drawing Room" (1970): 101–24; Eileen Harris, *The Genius of Robert Adam. His Interiors* (New Haven and London: Yale University Press, 2001): 93–103.
9. Owsley and Rieder, "The Glass Drawing Room" (1970): 103.
10. This is recalled in Howard Colvin, "Northumberland House" (unpublished draft of a paper delivered at the annual lecture of the Society of Architectural Historian of Great Britain, London, 1993), who kindly provided me with a copy of it.
11. See: A.C., MS 94, f. 6–; Howard Colvin, *A Biographical Dictionary of British Architects 1600–1840* (3rd ed. New Haven and London: Yale University Press, 1995): 260.
12. Quoted in Colvin, "Northumberland House" (1993): 6–7.
13. See A.C., B.XV.2, folios 3–4. Drawings by him were produced between June 1818 and May 1819.
14. These dates are provided by Colvin, *A Biographical Dictionary* (1995): 286; the plan for a new south front is dated

April 1821 (see A.C., B.XV.2g). Cundy also rebuilt the garden staircase. For the photographs see *Survey of London* (1937), plates 3, 4, 7.

15. See *Northumberland House: Its Saloons and Picture Gallery, with a Description of its Magnificent Staircase* (London: H.G. Clarke and Co, 1851). Over a period of three days in mid September, 14,567 visitors were allowed into the house, including 155 artisans and labourers visiting from Northumberland with the Duke's bailiff. I owe this information to Lisa Little.

16. See F.M.L. Thomson, "Percy Algernon, 4th Duke of Northumberland," *Oxford Dictionary of National Biography* (hereafter *ODNB*), H.G.C. Matthew and Brian Harrison, eds., 60 vols. (Oxford: Oxford University Press, 2004) vol. 43: 678–86.

17. See: Richard Hodler, "Salvin Anthony," *ODNB* (2004), vol. 48: 784–86; Colin Shrimpton, *Alnwick Castle*, official castle guide compiled by Clare E. Baxter (Derby: Heritage House Group Ltd, 2004). Salvin worked for the Dukes of Northumberland from about 1844 when St. Paul's Church, Alnwick, was built, and then proceeded to erect schools and churches in the local villages on the estate and at Tynemouth. While actual works at the castle begun in 1854 with the foundation stone of the new Prudhoe Tower, Salvin had produced plans since 1853. I am grateful to Lisa Little for this information.

18. A contemporary note in the diary of Charles Barry junior (Royal Institute of British Architects, hereafter RIBA, 6(c)6 Notebook 1851, D.C./BaFam), who at the time worked with his father, reads thus: "Northumberland House / Levels Three Stables & garden & / Destination of rooms by steps / Section of [yard] house / Do [ditto] to windows & [?] window Ball Room / Kitchen lights / Staircase Left hand side of [?] / Rooms by Carpenters yard skylight / Gas light of [?] staircase / Principal Stairs upper flights."

19. See M. Digby Wyatt, "On the architectural career of the late Sir Charles Barry," *Sessional Papers of the Royal Institute of British Architects (1859–60)* (21 May 1860): 118–37; Barry, *The Life and Works* (1867); Marcus Whiffen, "The Education of an Eclectic – Some notes on the travel diaries of Sir Charles Barry," *Architectural Review* 105 (May 1949): 211–16; Henry Russell Hitchcock, *Early Victorian Architecture in Britain* (1954), 2 vols., (2nd ed., New Haven and London: Yale University Press, 1972): 162–219; Mark Girouard, "Charles Barry: A Centenary Assessment," *Country Life* (13 Oct. 1960): 796–97; Marcus Binney, "The Making of an Architect – The Travels of Sir Charles Barry – I," *Country Life* (Aug. 28 1969): 494–98; Binney, "A Lion in Rome – The Travels of Sir Charles Barry – II," *Country Life* (4 Sept. 1969): 550–52; Binney, "An End and a Beginning – The Travels of Sir Charles Barry – III," *Country Life* (11 Sept.1969): 622–24; Peter Fleetwood-Hesketh, "Sir Charles Barry," in *Victorian Architecture*, Peter Ferriday, ed. (London: J. Cape, 1963): 123–30.

20. RIBA, C. Barry's drawings collection: SA 22/4; SB 89; SC 33/4 (1–8). See: John Cornforth, "Trentham, Staffordshire – I. Formerly a seat of the Dukes of Sutherland," *Country Life* (25 Jan.,1968): 176–80; Cornforth, "Trentham, Staffordshire – III. Formerly a seat of the Dukes of Sutherland," *Country Life* (8 Feb. 1968): 282–85.

21. See Girouard, *The Victorian Country Life* (Oxford: Clarendon Press, 1971): 68–70.

22. RIBA, C. Barry's drawing collection: SC 33/6 (1); PB 202. See Russell Hitchcock, *Early Victorian Architecture* (2nd ed. 1972), vol. 1: 166; 205–6; 218; 244; vol. 2: plate 6, 21.

23. RIBA, C. Barry's drawings collection: SA 46 5R. Barry had made alterations to the church there for the 3rd Earl of Egremont, between 1827–30.

24. RIBA, C. Barry's drawings collection: SA 46–7. See *Survey of London* (London: London County Council, 1940), vol. 20, part 3: 15–18.

25. A.C., Library: 03454.

26. This had been noticed since the first proper account of Northumberland House in Dodsley, *London and its Environments* (1761). By the 1850s, Charing Cross was largely a commercial area, while the Strand had long lost its character of prime residential estate. During the turbulent years preceding the Reform Bill of 1830–2, which, incidentally, led to the construction of Barry's Reform Club, iron shutters had to be erected to protect

the house against the "demonstrations of the mobility." See Ian Dunlop, "Northumberland House, London" (30 July 1953): 347.

27. The carriage entrance on the south-west side of the garden had been opened in 1823 by the 3rd Duke of Northumberland. See *Survey of London* (1937): 16.
28. Friedrich Von Kielmansegge, *Diary of a Journey to England, 1761–62* (London, New York and Bombay: Longmans, Greens and Co, 1902): 145–46. Quoted in Christopher S. Sykes, *Private Palaces. Life in the Great London Houses* (London: Chatto and Windus, 1985): 152.
29. Extract from the annotations in the plan.
30. A.C., Library: brown leather folder, 100 x 75 cm. Inscribed: "Northumberland House 1853 as now existing."
31. A.C., Library: brown leather folder, 100 x 75 cm. Inscribed: "Northumberland House 1853 with proposed alterations." As the bill (A.C., Syon Miscellanea: D/3/6) specifies, the drawings were accompanied by a general specification, as in the case of the second design, which has not been found. Photographs of the plans of the ground and first floors are preserved in the Conway Library, Courtauld Institute of Art, University of London.
32. As a note in Barry's diary of 28 May 1853 testifies (RIBA, Barry's collection, sketchbook 403/24: "Duke of Northumberland at 11"), the architect met with the Duke shortly after completion of these designs.
33. See Barry, *Life and Works* (1867): 52–53.
34. Barry may have been acquainted with Cockerell's idea of creating a new saloon in the courtyard, which, apart from Northumberland House where such a project was hardly realisable, may have influenced his own earlier solutions for these houses. See Russell Hitchcock, *Early Victorian Architecture* (1972): 169.
35. A.C., Syon Miscellanea D/3/4: Extracts from Barry's specification of the second design for alterations at Northumberland House, also applicable, to a large extent, to the first design.
36. RIBA, C. Barry's drawings collection: (Traveller's) SB 47; SC 31; SD 54; (Reform) SB 46, 49, 89; SC 29–30, 59–60. See: Stanley C. Ramsey, "London Clubs – I. The Reform Club," *Architectural Review* 33 (1913), part 1: 87–90; Ramsey, "London Clubs – III. The Travellers' Club", *Architectural Review* 34 (1913), part 2: 29–32; Whiffen, "The Reform Club: A Barry Triumph," *Country Life* (Nov. 3 1950): 1498–1501; Whiffen, "The Travellers' Club – Its Building History and the Evolution of its Design," *RIBA Journal* (Sept. 1952): 417–19.
37. Notwithstanding the amount of alterations to this side of the house, the height of the *piano nobile*, that is first floor from the garden, had remained unchanged since the works of the 10th Earl of Northumberland in the 1640s and 50s. Cundy had raised the height of the second floor, which was occupied by the private apartments.
38. A.C., Syon Miscellanea D/3/4.
39. A.C., Syon Miscellanea D/3/4.
40. A.C., Library: brown leather folder, 96 x 72 cm. Inscribed: "Northumberland House Additions & Alterations Second Design."
41. Barry also provided the plan for the new ceilings. This change would not have affected the Glass Drawing Room, which had been partially altered by Cundy when the number of windows was reduced from four to three.
42. RIBA, C. Barry's drawings collection: SA 23, SA 66. See Barry, *Life and Works* (1867): 269–72.
43. A.C., Syon Miscellanea: D/3/5–6.
44. RIBA, Sketchbook 403/25: "Duke of Northumberland £910."
45. RIBA, Sketchbook 403/27: "Duchess of Northumberland at home", "Duchess of Northumberland at home architects Invit."
46. See A.C. Northumberland Additional: B/20, "House of Commons – Minutes of Debate (26 Feb. 1866);" B/134/2, "The Charing Cross and Victoria Embankment Approach Bill, 1873." I am grateful to Lisa Little for a discussion on the matter.

PART III

CLASSICISM AND THE PICTURESQUE
IN THE TWENTIETH CENTURY

Neo-Georgian: The De-Gothicizing of Wilton House

JOHN MARTIN ROBINSON

AN IMPORTANT FEATURE of David Watkin's work has been the publications he has produced about later twentieth-century architects working in the classical style. This essay concerns an episode rather earlier in the century and a building – Wilton House – not normally noted as an important location for consideration of the qualities of Neo-Georgian design. In fact, the ambitious remodelling of James Wyatt's early nineteenth-century ranges at Wilton that took place between 1913 and 1930, with further extensive redecoration in the 1960s, epitomises English architectural taste of the time in its Neo-Georgian phases. These works at Wilton, though generally overlooked, add a significant twentieth-century architectural element to the art history of the house, which is one of the most important in England. As well as a new North entrance front, the twentieth-century phase created two especially impressive interiors which complement the Inigo Jones/John Webb state rooms in the South range. The work begun in 1913 is also of interest as the major achievement of a young Edwardian architect of promise, Edmond Launcelot Warre, whose career was blighted by the First World War, not because he was killed himself, but because few of his particular circle of clients had the inclination for new projects of this kind afterwards. He was, however, to go on to extend Glyndebourne for the Christie family in the 1920s and 30s, including the first Opera House there.[1]

Embarking on the major reconstruction of an historic house in 1913 seems rather odd in retrospect, but to those living at the time, the future looked rosy: the Lloyd George threat had been averted; the economy was booming. Many other great houses

THE PERSISTENCE OF THE CLASSICAL

Fig. 1 Colen Campbell, Plans of Wilton House from *Vitruvius Britannicus* (London: 1717), 2, plates 61–62, showing the internal layout before Wyatt's reconstruction, especially the way the rooms in the old North and West ranges were lit from windows to the inner courtyard.

saw similar ambitious architectural schemes initiated in the same years, notably Chatsworth and Knowsley – where Romaine Walker was responsible for pre-First World War campaigns of "restoration to what never existed," to quote Lord Derby.[2] The parts chosen for reconstruction at Wilton were James Wyatt's two Gothic wings of 1800–10, carried out for the 11th Earl of Pembroke, work that was almost universally despised at the beginning of the twentieth century. "Dull," "unimpressive," "bathos," were terms applied.[3] Critics thought that "Wyatt the Destroyer" had demolished Tudor-Renaissance and Inigo Jones elevations and interiors to make way for "hideous sham Gothic" unworthy of the seventeenth-century South front and state rooms, and the mid-sixteenth-century gatehouse on the East side.[4]

It was determined, therefore, to return Wyatt's North front and interiors to the condition in which they might have been before they succumbed to 'misguided' Regency meddling. The Edwardian remodelling was in fact based on a mistaken premise. The quadrangular house at Wilton had never had North and West façades prior to Wyatt. The former rooms in those wings were piecemeal Georgian remodellings of Tudor spaces and were lit mainly by windows facing into the inner courtyard (fig. 1). The old North and West exteriors were largely unfenestrated and irregular, with the projecting Chapel (of unknown character) on the West side and a plethora of 'out-offices', backyards and the semi-detached kitchen impinging directly on to the town to the North. Historic Wilton pre-Wyatt had only had two fronts, South (Garden) and East (Entrance).[5]

Wyatt's achievement had been to re-organize and re-plan the building to make a spacious North forecourt and symmetrical North entrance front for the first time,

154

comfortable family rooms including a large new dining room and an informal west-facing library-living room (the *sine qua non* of Regency house-planning) as well as dozens of new bedrooms, and the Gothic Cloisters round the central quadrangle which transformed the internal communications. Wyatt's Cloisters, "stately and very light" with plaster vaults by Francis Bernasconi, were on the whole admired and were therefore retained in 1913.[6] Most of his other Gothic work at Wilton, however, was to be re-dressed according to twentieth-century taste, though keeping his well-considered plan which has enabled the place to function properly as a comfortable country house down to the present day.

The twentieth-century reconstruction of Wilton was initiated by Reginald, 15th Earl of Pembroke and his wife Beatrice (Paget), sister of the 6th Marquess of Anglesey, as soon as he inherited in 1913. The Angleseys were part of the circle of cultivated Edwardians keen on old houses known as 'the Souls', and Lady Pembroke took as strong an interest in the improvements as her husband. The Pembrokes chose as their architect Edmond Launcelot "Bear" Warre (1877–1959), fourth son of the Provost of Eton, a keen oar, and later a Balliol friend of Hilaire Belloc's. Warre had been a school contemporary of Lord Pembroke, and his architectural career working mainly for Etonian clients started auspiciously.

After Oxford, Warre had trained as an architect in the office of Sir Thomas Graham Jackson, which he entered in 1898 and whose eclectic classical/Tudor style and interest in restoration he adopted.[7] In 1906, he succeeded Jackson as consultant architect to Eton College, a role he filled until his father's retirement as Provost in 1918. He restored the fifteenth-century Cloisters at Eton, being responsible for the large brick buttress supporting Lupton's Tower, and the removal of the Georgian iron railings on the West side. He also remodelled the Provost's Lodge, installing central heating, building a new back stairs, generally de-Victorianizing, and opening up Tudor doors and fireplaces, at a cost of £2000 in 1910–4. He advised on the electric lighting in College Chapel and restored the East end. He also carried out work in various School Houses, including new sick rooms and bathrooms at Godolphin (Goodhart's) and The Hop Garden (Churchill's); designed the Baldwin and Austen-Leigh Institute in 1911, and refenestrated the museum in Queen's Schools, replacing an oriel with a large mullion and transom window in 1913.

After the First World War, in which he served as a captain in the King's Royal Rifles, Warre repaired the Upper Schools, restoring stonework with the advice of SPAB, creating the Choir Room next to the Chapel as a war memorial, and designing a house called "Babylon" for E.L. "Jelly" Churchill. As late as 1937, he designed the

fountain pool in Cloister Court. Apart from this work at Eton, Warre had been involved at various country houses, including the restoration of Askerton in Cumberland for the Carlisle family and Beaudesert in Staffordshire for the 6th Marquess of Anglesey (Lord Pembroke's brother-in-law). He also built a church, St. Martin, Edmonton, in North London, which was paid for by a school friend's mother, Mrs. Elizabeth Mason in 1909.[8] He therefore seemed a very suitable architect for Wilton in 1913.

The first priority for reconstruction there was Wyatt's symmetrical North front with its squat centre tower and austere projecting Gothic *porte cochère,* flanked by three-bay crenellated links with tall pointed windows, squashed between taller corner towers (fig. 2). The old flanking towers were kept but the *porte cochère* and battlements were demolished, and the whole façade refenestrated and newly detailed in an idiosyncratic Italo-Tudor style somewhat reminiscent of Warre's old master, T.G. Jackson, in Oxford (fig. 3). It adds a new but harmonious dimension to the architecture of the house. The most original part of Warre's remodelling is the new entrance porch with a stone balcony and a large twelve-light mullion and transom window overhead, which replaced Wyatt's *porte cochère* and surmounting coat of arms. The new composition is both more welcoming and much grander than the previous incarnation. At first glance, all seems Tudorbethan, thanks

Fig. 2 (above)

Fig. 3 (below)

Fig. 2 The north front of Wilton House in a Victorian photograph, with Wyatt's Gothic porte-cochère, pointed windows and crenellations, before their replacement by E.L.Warre for the 15th Earl of Pembroke in 1913.

Fig. 3 The north front of Wilton House as redesigned by E. L. Warre in an idiosyncratic Italo-Jacobethan style reminiscent of Warre's old master, Sir Thomas Graham Jackson, in buildings like The Schools at Oxford. It forms an overture to the historic architecture of Wilton.

to the mullions and leaded panes, but the central balustraded balcony, supported on strong paired consoles carved with eagles and lions, is more Italianate. The Roman Doric columns framing the entrance pick up the scale and form of the subsidiary order of Sir William Chambers's triumphal arch opposite, which with one of Wyatt's dramatic strokes had been brought down from a southern parkland ridge to form the gateway into the forecourt (fig. 4). This order creates a degree of architectural rapport — otherwise not obvious — between Chambers's academic Neo-classicism and Warre's Edwardian bravura.

The mullion and transom windows were derived from those in the mid-sixteenth-century East gatehouse, then thought to be authentic but now believed to be at least partly Wyatt (fig. 5). The retained flanking towers, once deemed the work of Inigo Jones, are in fact Tudor remodelled with pedimented tops *circa* 1705.[9] They nevertheless hint at the seventeenth-century glories of Wilton's famous South front (see fig. 1). The new top balustrade is also copied from that on the South front. Like an operatic overture, therefore, Warre's elevation incorporates and foreshadows themes of the main score. That makes it a subtle and appropriate entrance statement, scholarly enough but also imaginative and appropriate to its situation. This sort of architecture has long been out of fashion. Even Christopher Hussey opined: "While more attractive [than Wyatt], and providing a stately background to the forecourt … [it] cannot be said to have risen completely to the opportunity, nor to the comparisons presented."[10] This seems unduly harsh. Warre's front is rather a good

Fig. 4 (above)

Fig. 5H (below)

Fig. 4 The Triumphal Arch at Wilton, designed by Sir William Chambers and re-sited by James Wyatt as the entrance to the North Forecourt. The Roman Doric columns used by Warre to frame his new front door are a subtle tribute to the sub-order of the Chambers-Wyatt gateway opposite.

Fig. 5 Wilton House East gateway, dating from the mid-sixteenth century and "restored" by Wyatt. The mullion and transom windows were copied by Warre in the new North front. The clock turret was designed by the 16th Earl of Pembroke in 1963.

THE PERSISTENCE OF THE CLASSICAL

effort and a clever introduction to the complex architectural glory of Wilton. It is sensitive to and subtly reflective of established elements of the place, but certainly not a bland clone.

Inside the house a similar architectural approach was adopted. Wyatt's entrance hall of 1809 was simplified, mainly by the loss of the display of armour for which it had been designed. The armour was sent off to auction, and the wall brackets and shelves which supported it removed. This was partly to pay for the continuing construction work. War had broken out in 1914 and Lord Pembroke and Warre had joined their respective regiments in Flanders and Northern France, while Lady Pembroke ran a military hospital in the rest of the house. Most of the builders and craftsmen, however, were too old to fight and so carried on with their work, despite the suddenly changed and more stringent circumstances. Wiring for electricity had been begun in 1913, but could not be brought into use as the turbine ordered to power it was diverted by the war effort and never delivered, so that the hospital in the South front state rooms had to make do with gas and oil lamps.[11] Warre designed the very smart brass heraldic light switches throughout the house, and possibly was advised on this detail by Lord Pembroke's brother-in-law, Sir Neville Wilkinson, Ulster King of Arms.

Work during the war years concentrated on remodelling Wyatt's dining room, a two-storeyed great-hall-type space which filled the whole North wing west of the Entrance Hall. Wyatt's design had a cambered beamed ceiling, and Gothic wall panelling, all of plaster grained to look like oak. The tall narrow North-facing windows were swathed in crimson curtains. The room was thought to be gloomy as well as hideous.[12] It was decided to bring it into harmony with the Inigo Jones-Webb rooms, a decision reinforced by the discovery in the Saw Mill loft of a cache of displaced fittings, including joinery, chimneypieces and two magnificent pairs of carved caryatids (see fig. 8). These were all assumed to be Inigo Jones, thrown out by Wyatt. Though of splendid quality, they are more likely to be eighteenth-century Jones Revival, carefully saved when the 8th Earl's North Hall and Vestibule were replaced by Wyatt, and the 9th Earl's South front ground floor interiors converted to a row of Bachelor Bedrooms by the 11th Earl. The caryatids are most likely to have come from the 8th Earl's Vestibule whose design has been attributed to John James of Greenwich.[13] A pair of these and an heraldic pediment were used for the entrance doorway which was moved from the West corner to the centre of the South side of the dining room.

Fig. 6 Wilton House, marble chimneypiece in the style of Inigo Jones in Warre's Dining Room. It probably comes from the 8th Earl's Great Hall and may have been designed by John James of Greenwich. It is one of a number of authentic fittings incorporated in Warre's work.

In the dining room, too, a large pedimented, cartouched marble chimneypiece, possibly also from the 8th Earl's Hall, replaced Wyatt's simpler Gothic job (fig. 6). The proportions of the room were improved by lowering the ceiling and inserting a floor of bedrooms above. These were part of a general modernization which also included the installation of twenty new bathrooms.[14] The new dining room ceiling was coved and embellished with moulded plaster, and the walls articulated with plaster panels to frame a set of three seventeenth-century tapestries found rolled up under the library sun blind boxes.[15] The dining room decoration could not be completed until after 1918. Warre had intended plentiful gilding and wanted to design an elaborate overmantel to frame the portrait of Lord Pembroke. But this had to be abandoned because of war-time price inflation and tax rises. Warre explained the increased expense in reply to what had obviously been the anguished reaction of Lady Pembroke to news of escalating costs: "I was afraid the estimates of nearly £3000 for the Dining Room would be a shock. I had no idea what your limit was so I simply aimed at a treatment that would knit up the existing features and produce a room of similar calibre to those designed by Inigo Jones. It is the gold that runs the price up …"[16] The room was more cheaply finished in 1920 in dark 'Georgian green' and white with no additional mouldings or gilding.[17] Despite these final economies, Warre's dining room is nevertheless a splendid achievement and was given additional authenticity by the incorporation of the caryatid doorcase, marble chimneypiece and old tapestries. It is not even mentioned, however, in Nikolaus Pevsner's description of Wilton in the *Buildings of England* series.

Between the Wars, attention turned to taming Wyatt's Gothic library which filled nearly the whole of the West wing facing the garden. This was an ugly duckling twin to the old dining room with a plaster coffered ceiling grained to look like wood. There were ante-rooms at either end. That at the North was divided off by a large moulded plaster arch, and that to the South by tall double doors with Gothic panels. The walls were lined with oak-grained crenellated timber bookcases with wire doors. The West wing at Wilton had originally been the Tudor Long Gallery, providing the link between the Great Hall on the North side and the State apartment in the South range. In the eighteenth century it had been divided into an enfilade of three spaces used for showing sculpture and paintings: the White Marble Table Room, the Passage Room and the Chapel Room, the latter giving access to the Chapel Tribune and Single Cube Room (see fig. 1).[18] The 10th Earl had commissioned a plan from Sir William Chambers to knock these rooms together to create a library and dining room in the 1760s, but this proposal does not seem to have been fully carried out.[19] When

THE PERSISTENCE OF THE CLASSICAL

Fig. 7 Wilton House Library, remodelled in 1933 to a design by Rex Whistler who was responsible for the cornice, giant pilasters and the doorcases. Only Wyatt's bookcases survived, but much simplified and painted white.

the 11th Earl embarked on remodelling the house in 1800, his father's ideas were a formative influence and a big living room-library in this area was among the improvements which Wyatt was expected to bring about. The new West Cloister, providing by-pass visitor access to the State Rooms, meant the new library could be completely private for the family with views over the west garden which was redesigned as part of the project.

Wyatt's work at Wilton had been bedevilled by lack of proper management, for which he blamed Mr. Chantry, the clerk of works, though he himself failed to visit the site for four years after his initial flurry of activity. The 11th Earl, too, was busy elsewhere, including a special embassy to Vienna in 1807.[20] The result was terrible defects and failures in the new building, and sudden changes while work was in progress. The library was a victim of these; while under construction, it was decided the space was too narrow and the West wall was moved outwards a few feet. This was made possible by tacking a few bits of wooden batten on to the ends of the existing roof beams. After a hundred years, these began to buckle and give way, cracking the ceiling and requiring the roof to be rebuilt with a steel structure.[21]

It was partial collapse of Wyatt's ceiling, then, that provided the opportunity for remodelling the room in 1933. A family 'committee of taste' comprising Lady Pembroke, her brother Lord Anglesey, and her sons Sidney and David Herbert, with their artist friend Rex Whistler, oversaw the proposals. The room was redesigned in the Neo-Georgian manner with a plain plaster ceiling and giant Tuscan wall pilasters and cornice (fig. 7). The entrances to the ante-rooms at either end were replaced with magnificent new doorcases using two pairs of carved wooden caryatids from the Saw Mill, including that from the Dining Room which was replaced (fig. 8). At the same time, the crenellations and wire doors were removed from the bookcases which were painted cream. Whistler, with his pronounced architectural tastes, advised on all this, chose the cream and gold colour scheme and designed the new wall pilasters himself.[22] Whistler's library at Wilton is a rare three-dimensional Neo-Georgian exercise by him

and ranks alongside his *trompe l'oeil* painted dining room at Plas Newydd, executed for Lord Anglesey at the same date.

At Wilton, as at so many English houses, the Second World War caused huge upheaval. Most of the house was requisitioned by the army in 1940 and the contents removed and stored. Sidney, later 16th Earl, wrote: "All this was heart-breaking. The empty rooms were used as offices … All these horrors had to be seen to be believed. The old house withdrew into itself, and lost its charm, tho' outside not its beauty."[23] Much of the effort in the decade after 1945 was directed at repairing war damage, such as eradicating dry rot in the Cube Rooms caused by the army blocking a vital internal downpipe with telephone wires and replacing Wyatt's ceiling over the Gothic Stairs with a plain coved affair after the original was brought down with a crash caused by stamping of military feet and slamming of doors.[24]

As soon as he inherited in 1960, the 16th Earl embarked on a complete redecoration and re-arrangement of most of the interior, spending the large sum of £33,000 in four years. This was done with the advice of John Fowler and Nancy Lancaster, and Wilton was one of their major 1960s jobs. Wyatt's Cloisters were repainted in shades of warm ochre stippled over a yellow ground; and eighteenth-century pictures were hung on the walls in place of the Regency arrangement of Roman sculpture which had been dismantled during the War. Some of the displaced statuary in store was sold by Christie's in 1961 and 1964.[25] The Library was also completed at this time by sashing the windows, richly gilding the cornice and doorcases, marbling the pilasters, reducing the bookcases and covering the walls with a specially printed Coles paper (see fig. 8). A large marble Jonesian chimneypiece, from the Stewards' Room, was brought upstairs and installed here to complete the ensemble.[26]

The Chinese Breakfast Room on the ground floor, designed by Jeffry Wyatville in 1814, was made into the dining room, close to the new kitchen, when the whole of the service side was re-organized and concentrated on the lower floor of the West wing. The original blue-ground Chinese wallpaper (wrecked by the army) was copied by hand in Hong Kong in 1960 at a cost of £550. Lady Pembroke's sitting room on the first floor of the East Gatehouse was also transformed; Victorian bookshelves and Tudorbethan overmantle were removed and a plain plaster ceiling with coved cornice installed, the walls lined with white painted panelling from the old Housekeeper's Room, "to which Wyatt had banished it," and another of the 9th Earl's Jonesian

Fig. 8 Caryatids incorporated in a doorcase in the Library at Wilton House. They are one of two pairs discovered with other displaced fittings in the Saw Mill Yard in 1913, all of which were re-fitted in the house in the different phases of twentieth-century work. They were probably part of the 8th and 9th Earls' work, displaced by Wyatt in the early nineteenth century.

marble chimneypieces inserted here.[27] It is similar to that still *in situ* in the Large Smoking room below, a room designed by the 9th "Architect Earl" for his own use in the 1730s.

Much of the 16th Earl's work at Wilton was in the nature of decoration, though it involved the rebuilding of the central bay window of the West elevation, but he also made one significant alteration to the external architecture. This was the replacement of Wyatt's decaying slate-hung Gothic clock turret on the East Gatehouse (see fig. 2) with a classical cupola of his own design, helped by C.A. Austen, the Clerk of the Works, and a "man from the Ministry" (see fig. 5).[28] Lord Pembroke was inspired by the form of the original cupola shown in an ink sketch on an estate survey of 1565. That, however, had a standard Tudor half onion profile, while Lord Pembroke's new cupola of 1963 is an octagonal *tempietto* with Tuscan columns, classical cornice and elegantly curved dome, more akin to Georgian stable clocks. It is a perfect addition to the house and completes the Wilton skyline with a triumphant 1960s classical flourish. It incorporates the clock made by Davis of Windsor in 1745, the faces painted blue and gold.[29]

The twentieth-century alterations and improvements at Wilton are symptomatic of the romantic enthusiasm for English country houses that developed at the end of the Victorian age and through the Edwardian years. This was an enthusiasm especially prevalent among 'the Souls', that brilliant circle of friends who included Lady Pembroke's family, the Angleseys and their relations – the Wemysses, Mannerses and Lindsays. Their love of ancient houses and Tudor England – Haddon, Stanway, Beaudesert – is exemplified at Wilton in Warre's elevation of 1913. As the century progressed, the rediscovery of the Georgian and classicism increasingly coloured developments at the house. "Rex Whistler's art epitomizes the romantic thread of that generation," an attitude which continued to shape architectural taste in Britain long after the birth of Modernism.[30] It is appropriate, therefore, that Whistler's classical re-casting of the library at Wilton should be one of the few real architectural *jeu d'esprits* of a genius chiefly expressed in painting and *trompe l'oeil*. Finally, the whole 1960s phase when the 16th Earl, aided by John Fowler and Nancy Lancaster, tied all the disparate threads together by decoration and deft alterations, reflects the strong traditionalist strand in English twentieth-century architecture. It completed the de-gothicization project which had been initiated in 1913. Despite being twice disrupted by World Wars, it is a remarkably consistent architectural story.

NOTES

1. E.L. Warre's designs for the Music Hall and Opera House of 1923–33 are preserved at Glyndebourne.
2. Christopher Hussey, "Knowsley Hall Lancashire", *Country Life*, 81 (13 March 1937): 276.
3. Christopher Hussey, "James Wyatt and Wilton House", *Country Life*, 134 (8 August 1963): 314.
4. Lord Pembroke, "Notes on Building Alterations" (MS), Wilton Estate Office. (Description by Sidney 16th Earl of Pembroke of the twentieth-century alterations at Wilton House.)
5. See John Bold, *Wilton House and English Palladianism* (London: RCHM, 1988): 25–76.
6. Gustav Waagen, *Art Treasures of Great Britain* (London: J. Murray, 1854) III: 143.
7. Basil Jackson, ed., *The Recollections of Thomas Graham Jackson* (Oxford: University Press, 1950): 257. (Jackson had been an Oxford contemporary of Dr. Warre, E.L. W's father, in the 1850s.)
8. Eton College Archives. Coll/06/4/58, p91/35; p518/758; p518/785. I am grateful to Michael Meredith for help with Warre at Eton.
9. Bold, *Wilton House* (1988): 67.
10. Hussey, "James Wyatt and Wilton House" (1963): 314.
11. Pembroke, "Notes".
12. Ibid.
13. Bold, *Wilton House* (1988): 67.
14. Pembroke, "Notes". The first guest bathroom at Wilton had been installed for Edward VII in 1908.
15. Pembroke, "Notes".
16. Wiltshire County Record Office, Herbert of Wilton MSS: 2057/H6/15: E.L. Warre to Lady Pembroke, December 1919.
17. The gilding was finally carried out as part of the revival of the dining room in 2008. It had been disused for over fifty years.
18. Colen Campbell, *Vitruvius Britannicus* (London 1717) II: plates 61–62.
19. John Harris, *Sir William Chambers: Knight of the Polar Star* (London: Zwemmer, 1970): 251–52.
20. Wiltshire Record Office, 2057/H1/6: Correspondence between James Wyatt and Earl of Pembroke.
21. Pembroke, "Notes".
22. Ibid.
23. Ibid.
24. Wiltshire Record Office 2057/H6/27.
25. Christie's Sale Catalogues 3 July 1961, 28 April 1964, 2 June 1964. The sculpture display was reinstated on lines inspired by the original Wyatt-Westmacott plans in 2007 under the direction of the author.
26. Pembroke, "Notes".
27. Ibid.
28. Ibid.
29. Ibid.
30. John Cornforth, "The Backward Look", in Gervase Jackson-Stops, ed., *The Treasure Houses of Britain* (Washington: National Gallery of Art, 1985): 69.

"A Vindication of Classical Principles"
Sir Albert Richardson (1880–1964)

JOHN WILTON-ELY

WHEN IT appeared in 1914, Albert Richardson's *Monumental Classic Architecture in Great Britain and Ireland during the Eighteenth and Nineteenth Centuries* represented a landmark not only in the historiography of British architectural history but in the attitude towards the inspiration of the past for contemporary designers. Had it not been for the social and economic changes following the First World War, the general impact of this seminal publication would probably have been more profound, but its prime concerns were to have a lasting consequence on Richardson's work as an inspiring teacher, designer and restorer. As David Watkin observed, referring to this magisterial book:

> The whole picture of English architecture so carefully built up by Blomfield and his contemporaries was now reversed as a mirror-image, so that the period they had most despised, the later eighteenth and early nineteenth centuries, was seen as the triumphant climax of the movement begun by Inigo Jones. According to this new assessment, the grand tradition of buildings represented by the work of C.R. Cockerell, H.L. Elmes, James Pennethorne and Alexander Thomson had been wantonly destroyed by the nationalism of the Gothic Revival and of the Arts and Crafts Movement, so that it was left to Richardson and his generation to pick up the pieces and build a new and glorious classical future. Where his immediate predecessors and, indeed, many of his contemporaries, had been nationalist, Richardson was cosmopolitan so that he was able to refer with knowledgeable enthusiasm to the torch of classicism as kept alight by Joseph Louis Duc, Jacques Ignace Hittorff and Henri

Labrouste in France, by Karl Friedrich Schinkel in Germany, and in his own day, by McKim, Mead and White in North America.[1]

Although never a revivalist, as he has frequently been portrayed, Richardson followed Sir Joshua Reynolds in the conviction that regular contact with the achievements of the classical past was an enlivening and inspirational source for contemporary expression.[2] Now that the achievements of the Modern Movement can be viewed more dispassionately, this has been found to be equally true, if less explicit, of such radical designers as Le Corbusier, Walter Gropius and Ludwig Mies van der Rohe. Throughout Richardson's writings, lectures and public statements over some fifty years, this belief in the fundamental principles and humanism of classicism never deserted him. Moreover, those students of the Georgian achievement, such as the present writer, who greatly benefitted from personal contact with him during his later years, have seen his ideals recognised and vindicated within the past decades as an overt expression of classicism has re-entered the field of contemporary design, even if occasionally lacking the discriminating and scholarly principles on which Richardson founded his work. Moreover, many of the British classical architects and designers of the late eighteenth and nineteenth centuries whom he championed almost single-handed in the early decades of the last century are now universally admired and are subjects of substantial monographs, exhibitions and continuing research.[3]

Richardson's training and work in the offices of Evelyn Hellicar, Leonard Stokes and Frank T. Verity gave him an unusual combination of formal attitudes towards design which appeared early in his scholarly writings and publications.[4] From the Arts and Crafts preoccupations of the first two masters, he learnt the value of traditional materials and qualities of craftsmanship within the vernacular and regional traditions in British architecture, without being affected by the associational and sentimental which often typified that late nineteenth-century world. From Verity, on the other hand, he rapidly enlarged his formal horizons in terms of an international classicism represented by the Ecole des Beaux-Arts, which employed the new steel and concrete technology, even if he was not entirely won over by the latter as a direct means of expression. The facade of the Central London Polytechnic in Upper Regent Street, which he designed in 1907, shows a remarkable assimilation of the formal system and vocabulary of the Beaux-Arts school in marked contrast to the banal classicism of surrounding buildings in Upper Regent Street.

Predictably, Richardson was a leading figure among the circle of architects, led by S.D. Adshead, who set up the short-lived Classical Society in 1908. While the English

Renaissance and Wren had been imaginatively interpreted by Shaw and his contemporaries during the last decades of the previous century, later designers in the classical tradition, British as well as Continental, had largely been ignored by the architectural profession as well as by scholarship in general. The Society, which included Charles Reilly, Edwin Cooper, Vincent Harris, John Anderson and Edwin Lutyens, among others, saw classicism as offering a coherent and challenging system of design principles. By reacting against the romanticism and individualism of Shaw's generation, they sought to return to the historic tradition of western architecture which Britain was thought to have discarded with the nineteenth-century Gothic Revival.[5] French classical discipline in design, enshrined in the Ecole des Beaux-Arts, was regarded as providing a model for the reform of architectural education while the contemporary work of McKim, Mead and White in America was seen as confirming the vital modernity of classicism and the compatibility of its aesthetic principles with steel-framed structures. As the member of the Classical Society who published extensively, Richardson's personal commitment to late eighteenth- and nineteenth-century continental classicism was manifested by a series of pioneering articles in *The Architectural Review* from 1911 onwards which included articles on the Neo-Grec and Empire styles, on classic architecture in Russia, on Jean Charles Krafft, Schinkel and Hittorff, and on Duc's remodelling of the Palais de Justice in Paris.[6]

Ever the teacher, Richardson demonstrated his belief in the continuing relevance of classical exemplars in his first book, *London Houses from 1660 to 1820: A Consideration of their Architecture and Detail*, which was jointly produced with his partner Charles Lovett Gill and published by Herbert Batsford in 1911. It is typical of the man that he could swiftly move from the monumental international classicism of France, Germany and Russia, as well as the sophisticated Regency interiors of Thomas Hope, to the intimate scale and mundane brick architecture of late Stuart and Georgian speculators in squares and terrace housing. His main objective was to reveal the same classic principles operating in the living tradition traced from the periods of Jones and Wren to those of Adam and Soane. The didactic function of this elegantly produced book is clearly stated in the Preface as "primarily intended for the study of architects either practising in, or visiting the Metropolis; and not only will its purpose appeal to English or Colonial Architects, but also to those of all other nationalities; because the London House contains features, which as *motifs* for transposition, are universally applauded."[7] At this time the London squares in particular, which were still largely intact and unaffected by unsympathetic development, were barely regarded as serious subjects of study, and the fine plate photographs specially taken by A.E.

Walsham (apart from a few interiors by Bedford, Lemere & Co.) which augment the eighteenth-century views of the urban spaces, make nostalgic viewing today. The short introductory text ranges from a discussion of planning, room proportions and interior decoration to the discussion of the handling of materials and fittings, such as fanlights, glazing bars and door-cases, as well as the treatment of ironwork in balustrades, railings and balconies. The setting of the individual buildings within the urban space concerned is also given emphasis in a commentary taking the form of detailed notes which accompany each illustration.

Fig. 1 Richardson and Gill, with Horace Farquhason, New Theatre (later Opera House), Manchester (1912), drawn by Hanslip Fletcher

During Richardson's early travels throughout Britain and the Continent, especially in France, he was tirelessly accumulating a large quantity of sketches and analytical studies of architecture which enabled him to judge the distinctive character of the British classical achievement within a wider context. He was increasingly convinced of the lessons to be learnt from the eclectic and finely-enriched system of design found in architects as diverse as Schinkel, Klenze, Duc, Hittorff and Labrouste. This system was characterised by its combination of the formal astringency of Greek classicism with the experimental tradition and ornamental richness of late Roman and Italian Renaissance design – a creative synthesis which, for him, was to be the essence of the Neo-Grec style and absorbed into his own designs. In terms of the British achievement, this was to lead him towards an unqualified admiration for the neglected architects of Victorian classicism, notably C.R. Cockerell and Harvey Lonsdale Elmes. Such sources provided the inspiration for Richardson's first major design – the New Theatre (later Opera House) at Manchester, completed in 1912, with a composition showing an exceptionally accomplished command of ornamental forms within a finely proportioned structure of marked restraint (fig. 1). In the preliminary designs for the principal facade, which reveal the marked influence of his admired continental exemplars in nineteenth-century French classicism, it is the final act of inserting the arched feature within the tympanum in the executed building which reveals Richardson's clear understanding of Cockerell's distinctive application of the classical canon, particularly as

Fig. 2 Charles Robert Cockerell, Branch Bank of England, Liverpool (1844–7) (Photograph: Frank Salmon)

found in his Bank of England, Liverpool (fig. 2). As Charles Reilly observed, when writing about Richardson's theatre in a survey of Manchester's buildings in 1924, "what makes this exterior so striking and so different to that of any other theatre or cinema I know is the simplicity and strength of its main lines. The building is sufficiently rhetorical for its purpose yet remains in essence dignified and simple."[8]

In 1913 Richardson delivered a series of lectures at University College, London, on "The Work of the English Architects of the Eighteenth Century and Neo-Classic School of the Nineteenth Century," sponsored by the Carpenters Company, which were subsequently published in the *Architects' and Builders' Journal*. This material was expanded to form the text of the exceptionally lavish treatise *Monumental Classic Architecture*, commissioned by Batsford and published the following year with a dedication to the Prince of Wales. As with his book on London houses, he was concerned to encourage creative reform by a survey of striking examples and in this case Richardson aimed to promote a greater concern for academic discipline in urban design, strongly inspired by the French tradition. Here he broke new ground by drawing attention to the great and largely neglected achievement of public architecture in Britain and Ireland from its genesis under Inigo Jones to its triumphant climax in the middle of the nineteenth Century. As he expressed it in the Preface:

> An academic style is necessary to the architecture of great civic centres: without its benign and uplifting influence the correct tone of the capital can never be attained. All building partakes somewhat of this character which prevails at such culminating points of interest. Where else is it to obtain its impression? What else exists to be mirrored? When the tone at the centre of the city is decadent there concurs a corresponding depression on the outskirts.[9]

As with many of his later books, Richardson took considerable care over the design and presentation of this folio volume, from the finely embossed cover and spine down to the careful juxtaposition of images on the page openings. His visual

material was carefully selected to reinforce his views, and the sheer wealth of outstanding plate photographs (many of them in exceptionally impressive collotype images) accompanied by measured plans, sections and elevations by colleagues and students, gave this work a formidable sense of authority.[10] While the argument was thus presented in a strongly visual manner, somewhat reminiscent of Richardson's flamboyant lecturing manner, the circuitous text is couched in an appropriately sonorous style which, as often in his later writings, is inclined to digress and occasionally to fall into lists of works. There are, however, a number of memorable passages possessing an almost Johnsonian rhetoric, as appropriate to such a manifesto. For instance, referring to George Dance's Newgate Prison, he writes: "Real architecture requires to be molten in the imagination of the designer; to be ready as it were to emerge from such a crucible in one instantaneous gush. Then it attains to such power and significance as to leave an impression, on the mind of all beholders, of a prefect coherent and indivisible whole."[11]

The book divides the rise of monumental design into four phases, beginning with Roman Palladianism (1730–80) in which the unrivalled range of surviving public buildings by James Gandon and Thomas Cooley in Dublin were celebrated, together with William Chambers's Somerset House and Dance's Newgate. This was followed by the Greco-Roman phase (1780–1820) where the Greek Revival, pioneered by James "Athenian" Stuart and the scholarly circle of the Society of Dilettanti, was shown to combine with Roman classicism in John Soane – the ideal professional academic architect – particularly in the creation of the Bank of England. Here, as if forming an architectural elegy, are photographs of Soane's masterpiece, together with John Nash's Regent Street and John Rennie's Blackfriars' Bridge – all to be swept away within the next thirty years.[12] If an evaluation of Soane and Nash was a work of pioneering scholarship at the time, even more so was Richardson's treatment of the designers of his "Greek" phase (1820–40); in particular William Wilkins, Robert Smirke, William Henry Playfair and Thomas Hamilton. Finally the culmination of the monumental tradition, as he saw it, in two parallel if interrelated movements – the Neo-Grec and the Italian phase – was all the more remarkable at a time when the last of the major architects examined, Alexander "Greek" Thomson, had died only five years before Richardson's birth and the last work illustrated (the Harris Library, Preston, by James Hibbert) was finished in 1896 as Richardson was beginning his tutelage under Frank Page. Characterising this final phase, Richardson discerned "something of the Homeric age, something eloquent of the idyllic Italian Renaissance, and moreover, something essentially modern."[13] For him the heroes of

this triumphant synthesis of the Greek and Roman legacies of achievement were to be C.R. Cockerell, Harvey Lonsdale Elmes and Charles Barry who, "while they demonstrated the suitability of the Hellenic motif, avoided the pedantic reproduction of its forms. They viewed the architectural problems of their day with the eyes of the Greeks, full of appreciation for the purest sensuous beauty, never overstepping the limits of the academic, and thoroughly understanding the impartation of correct architectural character."[14]

This value of the academic was of central concern throughout Richardson's thought and writings during these years, particularly since he had worked in two offices where the benefits of a coherent system of institutional training, offsetting the individualistic tradition of British architecture at the turn of the century, were fully recognised. Stokes, as a former president of the Architectural Association (1888–91), had been involved in the movement away from articled pupilage towards systematic instruction in full-time schools of architecture, while Verity's career and outlook embodied the values of the structured training within a core philosophy of design at the Ecole des Beaux-Arts. Richardson had already presented these views in a paper, "The Academic in Architecture," delivered at the RIBA in 1912, in which he said: "Contrary to prevalent opinion, originality and individuality do play a part in the development of the academic; as component attributes their presence is inevitable and welcome. The inventive faculty is strengthened by contact with tradition; the old truths and beauties are brought out again in stronger relief and are displayed in the garb of modernity."[15] It was to be a natural move in his career, therefore, when he was appointed to succeed F.M. Simpson in the Chair of Architecture at the Bartlett School of London University in 1919.

Apart from a growing number of new professional responsibilities, the demanding tasks of teaching and running an institution such as the Bartlett School absorbed a great deal of Richardson's creative energies over these years. His views continued to be as effective in conditioning the development of architectural history as much as that of the creative discipline. For example, the impact and idiosyncratic style of his methods of communicating the relevance of the classical past to students made a lasting impression on Sir John Summerson who was among the new intake of 1922. As he recalled some 58 years later, Richardson

> was the first architect and architectural historian I had ever met, also the first enthusiast, and I found him kind and alarming. Then in his early forties, he seemed in a state of perpetual motion, bowling through the studios, lecturing against the clock with prophetic urgency, exhorting us to attend, before it was too late, to the massive

power of hypostyle halls, the structural grandeur of aqueducts or what he liked to call the "nervous artistry" of antique ornament ... We mocked him a little but we were impressed and the reason for that was that whether he was talking about Assyrian or Egyptian or Greek or Roman or Georgian or his beloved Cockerell, he was talking about one thing; just simply architecture, ageless and sublime.[16]

Throughout his career Richardson's professional commissions tended to divide broadly between urban and sophisticated monumental designs on the one hand and modest regional works, reflecting local vernacular traditions and materials, on the other. As already shown, quite early on his enthusiasms and scholarship also represented this range in treatment from his discussion of major complexes, such as Somerset House or the Bank of England, to his analysis of modest but well designed anonymous terraces and villas in Georgian London. Although introduced in his London book, his first really extensive treatment of classicism at work in this latter field appeared in 1924 with *Regional Architecture in the West of England*, produced in collaboration with Gill (whose main contribution consisted of the photographs) and dedicated to Edward, Duke of Cornwall. Again, the resulting book was intended to have a practical purpose for contemporary designers. As the preface states:

> At this present attempts are being made throughout the country to re-establish a form of building expression which has the merit of being traditional; it is essential, therefore, in this study to take into account conditions that formerly pertained, such as local trading interests, available materials, the proximity of large towns, the existence of trunk roads, the navigable rivers and canals and other factors, all of which played a part in determining contemporary prosperity.[17]

Similar in approach to their first book on the London house, the authors applied a chronological approach in three phases, concentrating on the expression of vernacular as well as sophisticated classicism from 1730 to 1850. Separate chapters on specific areas, including Exeter, Plymouth and the Isles of Scilly, served to demonstrate classicism at work in particular locations applied to a hierarchy of building types from farms to villas and banks to custom houses. No detail was too small to make the point as a plate of comparative door-knockers demonstrates.

For the first time in one of Richardson's books, in addition to a plentiful quantity of prints and photographs, he included a number of his own vivid thumb-nail drawings selected from his sketch books. These brisk studies summed up with a masterly economy the essence of what he wished to communicate, rather in the fashion of his large-scale virtuoso sketches, dashed off in the heat of lecturing to his

Bartlett students, or the ink drawings on glass lantern slides used for the same purpose. Demonstrating his instinctive feel for the life of classical forms, he was to retain this facility to the last years of his life when engaged in animated conversations, whether in his study, at the dinner table or autographing books. When schooling the present author in the hierarchy of the classical orders, Richardson at the drawing board in his early 80s was still capable of executing fine free-hand profiles of mouldings and details of ornamental vocabulary, with an instinctive and unhesitating manner, invariably accompanied by a ceaseless commentary punctuated by emphatic gestures.

In the same year that Richardson took over the Bartlett, he had finally acquired a much-desired house at Ampthill. Avenue House was to become in itself a source of inspiration, not only through the rapidly accumulating collections of art, furniture, books and drawings, but because it epitomised the kind of relatively modest late eighteenth-century house which he keenly admired in terms of its reticent, well proportioned spaces, lean classical mouldings and total fitness for purpose. Indeed on various occasions he referred to his new home as his "yard-stick and measuring scale."[18] Some six years later, in 1925, this scale of building was to be the subject of a new book, *The Smaller English House of the Later Renaissance, 1660–1830: An Account of its Design, Plan and Details*. This was written in collaboration with the American writer H. Donaldson Eberlein, who had made an extensive study of classical colonial architecture in his own country and had been greatly inspired by Richardson's articles in the *Architects' and Builders' Journal*.[19] It was to be another handsomely-produced book by Batsford and, like *Monumental Classic Architecture*, was also published in the United States. *The Smaller English House* covered another aspect of the English classical tradition, one which had largely been neglected it favour of the grander houses featured in Edward Hudson's *Country Life* and H. Avray Tipping's *English Homes*. Similar in approach and chronological limits to the London book of 1911, the intention was to make available a wealth of classical concepts and details for the inspiration of contemporary designers. As also with the earlier surveys of London and the West Country, there was no intention to promote pastiche or "Neo-Georgian." (Indeed, the latter was a term of opprobrium which Richardson regularly used to dismiss the illiterate and ubiquitous "Georgian" public buildings and modern speculative homes which emerged between the Wars.) In their Preface the authors took pains to stress that "it is not their desire to dogmatise on the merits of the style they describe, or to expect the examples to be used as motifs" but that they "view the humane pleasantries of the features of the houses and the originality of the detail, apart from its classical

tendencies, as offering ideas to architects and the public, which, besides having an historical interest, will form a standard of good taste and proportion."[20] Apart from photographs (including three of Avenue House), many of them taken by Eberlein, and a wealth of Richardson's vivid sketches and summary plans, the illustrations also included a number of detailed measured drawings, made in 1911 by the architect Grey Wornum, serving to stress the careful attention to detail that characterised the Georgian achievement, even found among modest and "anonymous" buildings throughout England. After a chronological sketch outlining domestic development from the Queen Anne House to the works of S.P. Cockerell, J.B. Papworth, John Nash and Decimus Burton, the remaining chapters were devoted to practical aspects of design: namely the "Evolution of Plan"; "Materials and Craftsmanship"; and "Varieties in Composition". In the last chapter, "Conclusion and Modern Uses", while accepting the value of the classical concepts and proportions demonstrated from facade to glazing bar, Richardson's belief in the importance of learning from a detailed study of case histories over a period of development is summarised in the final phrase, "intelligent evolution is the true meaning of modernity."[21]

Fig. 3 Richardson, St Margaret's House, (for Sandersons), Well Street, London (1930–2)

During these years, although disagreeing with many of the more radical concepts of the Modern Movement, Richardson was still willing to see positive applications of the classical discipline within avant-garde contemporary design as strikingly manifested in his own award-winning design for the Sanderson's wallpaper building at St Margaret's House, Wells Street, London, of 1930–2, with its restrained classical formula across a steel frame. (fig. 3) As he put it during a RIBA discussion on "Modernism in Architecture" in 1928:

> We have learned to simplify, to invent, to economise. We have learned to meet new conditions. Planning has shown us the lines on which the art is likely to develop. Concrete has demonstrated new structural possibilities. The copy-book has been relegated to the architectural nursery. But we architects nevertheless still have a just pride in the past, a reasonable view of the present, and a keen desire to invent. In the works

of Sullivan, Otto Wagner, Tony Garnier, etc., you will find a vindication of classical principles ... These men have advanced the art.[22]

Throughout the 1920s and 1930s Richardson was rapidly acquiring an outstanding collection of architectural drawings, particularly by designers within the Golden Age of classicism, as he regarded the period between 1760 and the mid-nineteenth century. In this collecting activity, as with his writings, he was a considerable pioneer and benefited from the low prices. Sadly, however, very little documentation exists of sources or dates of acquisition for these drawings since he was primarily concerned with their practical value to him as a committed classical architect and teacher operating within a living tradition where ideas and concepts mattered far more than the niceties of art-historical significance.[23] In this respect it is particularly significant that these historic works were purchased from money from the practice and Richardson's vigorous use of them as a daily source of inspiration was indicative of his wish to empathise with his predecessors. It is also symptomatic of his approach that few of the historic drawings were framed but kept in folios, both in London as well as Ampthill, where he was able to refer to them swiftly while designing as well as teaching. While there was a quantity of unidentified designs, predictably the roll-call of identified architects in the collection represented a continuity of classical experiment over a period of some 150 years which included Samuel Angell, Lancelot Brown (a group of designs for Peper Harrow), John Carr, William Chambers, C.R. Cockerell, J.M. Gandy, John Gibson, J.A. Hansom, Philip Hardwick, Thomas Harrison, David Laing, Robert Mylne, C.J. Richardson, Thomas Sandby, George Saunders, John Soane, Robert Taylor, John Vardy, Lewis Vulliamy, and James and Samuel Wyatt.

This collection, which was largely dispersed in 1983, featured among its highlights an album containing well over one hundred designs by Robert Mylne bought prior to 1925.[24] This exceptional group of designs, many of them executed in coloured washes with highly detailed technical information on roofing and drainage, indicated the deep respect with which Richardson regarded an architect whose instinctive feel for fine proportions and formal astringency, joined to sound construction and meticulous planning, characterised his own practice and teaching. In fact, Richardson's last book was to be *Robert Mylne, Architect and Engineer, 1733 to 1811*, published by Batsford in 1955. This latter publication noticeably suffered from having to be produced in the extremely demanding years as President of the Royal Academy and in the midst of a highly active post-war practice.[25] It nevertheless

showed the insights that Richardson's own experience (which had included engineering training at the London Polytechnic and during the Great War) could throw on working procedures and practical concerns, as revealed in this transcription of Mylne's professional diary which covered almost his entire career between 1762 and 1810.

In addition to an important collection of Chambers's business letters, a particularly seminal work in the collection was John Eastry Goodchild's scrap-book entitled *Reminiscences of my Twenty-Six years Association with Professor C.R. Cockerell*.[26] This latter covered virtually all of his commissions and projects from 1833 to 1859 and represented a major source of highly detailed information on Cockerell's activities as well as his artistic and intellectual development.[27] The 188—page album included drawings by the architect, engravings and photographs of buildings as well as autograph letters by the architect and his father, Samuel Pepys Cockerell. Like Chambers, Cockerell was to remain one of the leading exemplars to Richardson of a scholarly designer who engaged in an active professional life and showed the discerning and inventive application of classical principles from modest commissions to the highest expression of monumental buildings.

Reflecting his writings, the collection at Ampthill (as well as in his successive London offices) was also representative of Richardson's international range and wide terms of reference. Like Soane he firmly believed in the value of living within an environment where he was constantly surrounded by inspirational material, in terms both of drawings and folios, engravings, models, casts and works of decorative arts as well as his own sketches, framed or accumulated in countless albums. Among his finest foreign drawings were works by Charles-Louis Clérisseau, Victor Louis and an exceptional group of highly finished designs by Giacomo Quarenghi which included the English Palace and landscape lay-out at Peterhof, the Alexander Palace at Tsarskoe Selo, and St George's Hall in the Winter Palace, St Petersburg. An impressive design for an illusionistic ceiling, attributed to Andrea Pozzo, hung in his London office, while at Ampthill Giuseppe Vasi's vast engraved panorama of eighteenth-century Rome, as seen from the Janiculum, was accompanied on the walls by etchings from Piranesi's *Vedute di Roma*, together with prints of St Petersburg and Napoleon's Paris.

Richardson's extensive libraries of architectural folios and pattern books, both in Ampthill and London, were used in as thorough, vigorous and robust a manner as by his eighteenth-century predecessors. In conversations during his later years, he repeatedly testified to the creative importance for him of engraved designs by Marot, Neufforge, Thomas Hope, as well as Percier and Fontaine, and would think nothing

of taking a taxi, in mid-conversation with the present writer, to demonstrate an application from Neufforge on the facade of one of his London buildings.[28] A reference to these particular designers also underlines Richardson's lively response and comprehensive concern with interior design; Hope, Percier and Fontaine providing the same inspiration through their highly imaginative application of classical forms as found in Cockerell's works. In fact Richardson's early recognition of Hope's interior designs for his Duchess Street house in London through his 1911 articles on "The Empire Style in England" and subsequent acquisition of pendant wall-lights by this designer (now in the Royal Pavilion Brighton), was to play an important part in the Regency Revival in interior design and collecting after the First World war.[29] Apart from furniture by Hope and Holland, he acquired drawings for decorative designs as wide ranging as a sketch for the staircase ceiling painting at Grimsthorpe Castle by Sir James Thornhill and an exceptionally fine Chambers design for the Library ceiling at Woburn of 1767 to Alfred Stevens's lavish ornamental programme for Dorchester House, London, of 1856 and Edward Bell's opulent proposals for wall and ceiling decorations in the Octagon Room and Ball Room of the Bath Assembly Rooms of 1879 (the latter being restored by Richardson after the Second World War).[30]

The inter-war years marked a new phase in Richardson's literary and professional career as the brave promise of the new classicism began to fade and the more radical standpoint of the International Modern Movement became increasingly assertive in architectural thinking and education. New commercial pressures in development and urban expansion also began to threaten the classical heritage. In 1925 a second book was produced with Eberlein which examined another aspect of regional and provincial architecture where social history was reflected in vernacular as well as more sophisticated buildings, but subject to greater pressures for change. *The English Inn: Past and Present* recorded a remarkable range of buildings which were to be swiftly altered or drastically changed with the rapid advance of motor transport, although it is fair to say that Richardson himself was an enthusiastic user of the car and fully exploited the advantages it provided for rapid and exhaustive study tours as well as for his professional duties. Since this book went quickly out of print and more material was accumulated, Richardson published a further work on the same theme alone, *The Old Inns of England*, in 1934 with a cautionary Foreword by Lutyens referring to the "regrettable exceptions, such as the adjectival 'olde worlde' creations, which are as objectionable and as needless as are the ultra-modern, in that both deface our countryside."[31] While the classical tradition was indicated in sophisticated examples, such as the Stamford Hotel, the White Hart at Salisbury and the Swan at Bedford, there are signs

in both books of a growing nostalgia and retreat from the contemporary world which increasingly characterised Richardson's viewpoint and uses of the past as the inter-war years advanced. Gradually scholarship and practice were beginning to drift apart although moments of that creative synthesis which he deeply valued in Neo-Classicism continued to occur in his later work when provided with an exceptional challenge to relate new structures to an historic environment.

As a kind of valediction to the age which he most revered, Richardson's *Georgian England: A Survey of Social Life, Trades, Industries & Art from 1700 to 1820*, published in 1931, was to be the last of his copiously illustrated "de luxe" books produced by Batsford. In this work, based on lectures originally delivered to the University of Bristol, Richardson covered a wide range of subjects extending from the armed services, religion, trade and industry to recreation, sport, drama, music, literature, painting and sculpture. In certain respects this formed a kind of gloss to the impressive collection he had developed at Ampthill which covered all these areas with the same pioneering discernment and enthusiasm. His crusading zeal was undiminished and the book drew attention in particular to the decorative and building crafts at a time when the appreciation of the Georgian achievement was reaching an all-time low. In 1932 he was to play a leading role in the opposition to the Crown Commissioners' stated intention of demolishing Nash's Carlton House Terrace and again, in 1937, over the wanton destruction of the Adam Brothers' Adelphi, which brought about the formation of the Georgian Group with his active support.

In the years following the Second World War, Richardson's committed scholarship, deep understanding of the British tradition and much of his creative energy were devoted to an extensive programme of restoration where he was able to draw on an almost unrivalled familiarity with the practical application of classicism. Prominent among these commissions were Wren's St James, Piccadilly; Hawksmoor's St Alfege, Greenwich; Gibbs's Senate House, Cambridge; John Wood the Elder's Assembly Rooms, Bath; Samuel Wyatt's Trinity House, and The Merchant Taylors' Hall, both in the City of London. After retiring from the Chair at the Bartlett in 1946, the following year he became Professor of Architecture at the Royal Academy (the first since 1911) and continued in that position until 1960 with an opportunity to expound views which were no longer to be found in other schools. Within that period he became President of the Academy (1954–6), during which time he consciously promoted the classical principles of his revered predecessors, Chambers, Soane and Cockerell, as well as actively promoting an ambitious pioneering exhibition at Burlington House which reassessed the applied and decora-

tive as well as fine arts of his favourite period, *English Taste in the Eighteenth Century* (fig. 4).[32]

In 1951 he had edited and contributed to a collection of essays on Henry Holland's finest surviving house and furnished interiors at Southill, Bedfordshire, where he had long enjoyed a close relationship with the Whitbread family as friend and adviser.[33] Perhaps nowhere else in Britain does one come closer to Richardson's ideal of classicism as the basis of good practical and rational design than in the formal reticence and application of fine detail throughout this house. Its custom-built fittings and furniture similarly represent a unique fusion of late eighteenth-century French and English classicism within a building and a series of interior spaces which are perennially fresh and enlivening. Two years earlier he had produced a brief volume which, despite its modest scale, may be regarded as Richardson's testament of design. In *An Introduction to Georgian Architecture*, illustrated by a wealth of his vivid sketches, he attempted to identify those elusive qualities at Southill. In his words:

Fig. 4 Sir Albert Richardson in his London office, c. 1950 (Simon Houfe Collection)

the secret of Holland's remarkable and exquisite taste rests on his own power of selecting proven motifs. There is shown that zest for inquiry and common sense which lies at the root of all the finest classic architecture. Holland was a realist in absolute fidelity to the facts and qualities of antique masterpieces. This love of detail for its own sake – of minor effects subtly ordered, precisely finished, richly simple and irresistible – points its own moral. In his work all the influences of his time meet and attain perfect balance. The most exacting realism is adorned and enriched by all the resources of artistic skill; at the same time there is a complete suppression of meretricious pomposity.[34]

Some ten years later, the completed design for Bracken House – one of his last major buildings and now listed – was to demonstrate all the formal resources and artistic skills which came from a lifetime of studying, expounding and practicing those classical principles (fig. 5). The sequence of the facades not only combined the qual-

ities of formal coherence and classic restraint in composition advocated in *Monumental Classic Architecture*, within a particularly sensitive urban space close to Wren's St Paul's, but displayed a mastery of detail which stemmed from years of close study of classical ornament and appropriate material finish. As he had expressed it in his *Introduction to Georgian Architecture*:

> if we would capture the spirit of Georgian architecture, how should we set about our task? Not by the blind imitation of form, nor by the mere revival of the phases of the style; for continuity does not flourish in this way. On the contrary we should try to understand its realism, its refined austerity, its clarity and its logic. All these attributes form part of the general make-up; but welding them all, there is another force which animates and determines the rest. This is the classic spirit which for more than two centuries has shone like a beacon to guide the architects of England. It was the unfailing principle and the definite goal of art.[35]

Fig. 5 Richardson, Bracken House (for the Financial Times), Cannon Street, London (1954–7)

NOTES

The substance of this essay formed the basis of a contribution to the exhibition catalogue, *Sir Albert Richardson(1880–1964)*, edited by Alan Powers, with Simon Houfe and the present writer, at the Royal Institute of British Architects Heinz Gallery, London, 1999. In addition to the benefit of several years of conversations with Sir Albert Richardson himself, the author is greatly indebted to Sir Albert's daughter, the late Mrs Kathleen Houfe, his son-in-law and partner the late Mr Eric Houfe, and more recently and even more extensively to his grandson, Mr Simon Houfe as well as to Professor Powers.

1. D. Watkin, *The Rise of Architectural History* (London: Architectural Press, 1980): 120.
2. In Richardson's annotated copy of Reynolds's *Discourses on Art* presented to the present author, bracketing and heavy underlining are given to all the passages expressing this fundamental belief. A characteristic passage is: "we must have recourse to the Ancients as instructors. It is from a careful study of their works that you will be enabled to attain to the real simplicity of nature; they will suggest many observations that would prob-

ably escape you, if your study were confined to nature alone. And, indeed, I cannot help suspecting, that, in this instance, the ancients had an easier task than the Moderns. They had, probably, little or nothing to unlearn, as their manners were nearly approaching to this desirable <u>simplicity</u> [AER's underlining]; while the modern artist, before he can see the truth of things, is obliged to remove a veil, with which the fashion of the times has thought proper to cover her." (*Third Discourse*)

3. For a discussion of the subsequent development of eighteenth- and nineteenth-century historiography, see Watkin, *Rise of Architectural History* (1980). A list of Richardson's extensive writings from 1908 onwards, based on a bibliography, initially compiled by Simon Houfe and still being extended, appears in Powers, *Sir Albert Richardson* (1999): 84–92.

4. N. Taylor, 'Sir Albert Richardson: A Classic Case of Edwardianism, *Architectural Review*, 140 (1966); reprinted in A. Service (ed.), *Edwardian Architecture and its Origins* (London: Architectural Press, 1975): 444–59.

5. For Richardson's early career and writings within the context of the revived interest in classical design and the formation of the Classical Society, see A. Powers, "Architectural Education in Britain, 1880–1914," PhD thesis (University of Cambridge, 1982): 168– .

6. Key articles by Richardson in the *Architectural Review* include "The Style Neo-Grec," 30 (July 1911): 25–29; "The Empire Style in England: I and II," 31 (November 1911): 255–63; (December 1911): 315–25; "Karl Friedrich Schinkel," 33 (February 1912): 61–79; "The Palais de Justice, Paris and its Remodelling by Joseph Louis Duc," 34 (November 1913): 93–94, and 35 (January 1914): 7–10; "Jean Charles Krafft, Architecte-Dessinateur," 36 (September 1914): 52–58; "Jacques Ignace Hittorff," 36 (December 1914): 102–10; "Classic Architecture in Russia: I", 38 (November 1915): 87–99; "Classic Architecture in Russia: II, III & IV," 39 (January 1916): 19–24; (March 1916): 50–55;(May 1916): 95–103.

7. A.E. Richardson and C. Lovett Gill, *London Houses from 1660 to 1820* (London: B.T. Batsford, 1911): vii.

8. C. Reilly, *Some Manchester Streets and their Buildings* (Liverpool: University Press, 1924): 119.

9. A.E. Richardson, *Monumental Classic Architecture in Great Britain and Ireland during the Eighteenth and Nineteenth Centuries* (London: B.T. Batsford, 1914): vi. His concern with the monumental treatment of urban centres continued late into his life as witnessed by a rapid sketch done by Richardson in April 1960 for the present author inside the flyleaf of his book *Georgian England* showing the treatment of the Thames river frontage immediately to the south of the transept portico of St Paul's, remarkably anticipating the current axial approach to the Millennium Bridge. This was also the subject of an earlier perspective design exhibited at the Royal Academy.

10. Richardson took an active role in producing this impressive book and clearly influenced the design by Percy Delf Smith of the ornate gilt embossed cover which featured a motif based on a Neo-Grec girandole, with a Greek fret border. The spine has a mask of Medusa. The superb photographs were specially taken by E. Dockree. See A Crawford, "In praise of collotype: Architectural Illustration at the Turn of the Century," *Architectural History* 25 (1982): 62–63, plate G. The book's international distribution was handled by Charles Scribner's Sons, New York, for the United States, and C.F. Schulz & Co., Plauen, for Germany, Austria and Switzerland. John Betjeman recalled the impact of the book and its illustrations on him when at Oxford in the mid-1920s: "With its large sepia photographs, measured drawings, and informed text, it opened to me a world more exciting even than that of Hawksmoor and Vanbrugh. I had never before heard of anyone admiring the British Museum for its architecture, or Somerset House or St George's Hall, Liverpool, or Waterloo Bridge, which was then still standing to Rennie's design. I started to look at the Romano-Greek and banks by C.R. Cockerell and Euston Great Hall and Portico by P.C. Hardwick. The Professor became my hero, and has always remained so." ("Introduction: an Aesthete's Apologia", *Ghastly Good Taste*, revised edition (London: Anthony Blond, 1970): xxii.)

11. Richardson, *Monumental Classic Architecture* (1914): 28. The phrase "real architecture requires to be moulten in the imagination of the designer" is strikingly similar to Lutyens's image in a famous letter to Herbert Baker in 1903 where the former, referring to the handling of architecture observed that: "to the average man [it] is dry bones, but under the hand of Wren it glows and the stiff materials become as plastic clay" (see C. Hussey, *The Life of Sir Edwin Lutyens* (London: Country Life): 121).

12. Among the major buildings alone, which were discussed and illustrated in *Monumental Classic Architecture*, the following were demolished: Dance's Newgate Prison (1902); Cockerell's Westminster Insurance Office, The Strand (1908); virtually all of Taylor's and Soane's Bank of England, apart from the screen walls and the Princes Street Vestibule (1921–37); Gibson's National Provincial Bank, Threadneedle Street (1922); Nash's Quadrant, Regent Street (1923–28); almost the whole of the Adam brothers' Adelphi (1937); and Rennie's Waterloo Bridge (1937). Far later casualties were Hardwick's Euston Station Arch and Great Hall (1961) although Richardson did not live to see Cockerell's outstanding Sun Life Assurance Office, Threadneedle Street, destroyed in 1970.

13. Richardson, *Monumental Classic Architecture* (1914): 75.

14. Ibid. Reilly, as head of the School of Architecture at Liverpool, also promoted Cockerell's buildings as a subject for study at the this time and had attempted to set up a "Cockerell Prize" in 1910 (see Powers, "Architectural Education in Britain, 1880–1914": 178).

15. "The Academic in Architecture," *Journal of the Royal Institute of British Architects*, 3 ser., 19 (31 August 1912): 683.

16. John Summerson, "Address on receiving the Royal Gold Medal in Architecture", *Journal of the Royal Institute of British Architects*, 12 (1976): 494. Extremely similar initial reactions were experienced by the current author as a Cambridge student some 38 years later when first meeting the "Professor" in retirement at Ampthill in 1960, while nervously pocketing a copy of J. M Richards' *An Introduction to Modern Architecture* – train reading on the journey to Bedfordshire.

17. A.E. Richardson and C. Lovett Gill, *Regional Architecture of the West of England* (London: Ernest Benn, 1924): ix.

18. S. Houfe, Sir A. E. Richardson Archive, "An Assessment" (typescript): 35. For a vivid portrait of Richardson's attitude towards collecting and the display of his historic possessions, see *S. Houfe, Sir Albert Richardson. The Professor*, (Luton: White Crescent Press Ltd., 1980) especially Chapter 5, "A Lifetime of Collecting."

19. An early publication of this theme by Richardson was "The Classic Tradition in America," *Architects' & Builders' Journal*, 40 (21 January 1914): 46–8.

20. A.E. Richardson and H. Donaldson Eberlein, *The Smaller English House of the Later Renaissance 1660–1830* (London: B.T. Batsford, 1925); viii.

21. Richardson and Eberlein, *Smaller English House* (1925): 185.

22. "Modernism in Architecture," *Journal of the Royal Institute of British Architects*, 35 (June 1928): 518.

23. According to a communication from Simon Houfe, Richardson probably began collecting these drawings from about 1919, purchasing them from Batsford's antiquarian section. He is known to have acquired the album of C.J. Shopee, a minor architect/collector, in that year and inscribed in pencil on the cover "many drawings added 1919–1926." When the collection was divided at the close of the partnership with Gill in 1945 (having been purchased for the firm), many of the works were transferred to Ampthill. Gill's share appears to have included drawings of church interiors of the 1830s but is unlikely to have included any major works. A selection of Richardson's finest drawings was shown in two exhibitions in the 1960s, covered by the publications *Compositions in Perspective: Designs by Noted Architects of the Past lent by Mrs Eric Houfe from the Collection of Sir Albert Richardson*, S. Houfe, ed. (Cecil Higgins Gallery: Bedford, 1967) and *Architectural Drawings from the Collection of Sir Albert Richardson*, J. Wilton-Ely, ed. (University Galleries, Nottingham, and Newark-on-Trent- Museum and Art Gallery, 1968). Certain key drawings also appeared in the later exhibition, *18th and 19th century British and Continental Drawings*, (entries by B. Bergdoll, C. Garcon and T. Landau, with introduction by H.M. Colvin) (London: Clarendon Gallery, in association with Fischer Fine Art, 1984).

24. See sale catalogue, *Important Architectural Drawings and Watercolours: I. The Sir Albert Richardson Collection* (Christie's, 30 November 1983). The Mylne album was probably acquired prior to 1925 since the street elevation and ground-floor plan of The Wick, Richmond, is illustrated in *The Smaller English House* (fig. 62), published that year.

25. A definitive monograph on Mylne is currently in preparation by Roger Woodley, based on his doctoral thesis, University of London, 1999. See also Robert Ward, *The Man who Buried Nelson: The Surprising Life of Robert Mylne* (Stroud: Tempus, 2007).

26. Both the Chambers letters and the Goodchild Album are now in the collection of the RIBA.
27. D. Watkin, *The Life and Work of C.R. Cockerell* (London: A. Zwemmer, 1974), especially 252–53 and plates 80, 134 and 144.
28. In 1948 Richardson edited an abridged reprint for Alec Tiranti of engravings from the *Edifices de Rome Moderne* by Percier's student Paul-Marie Letarouilly (1795–1855), based on the latter's meticulous survey of Renaissance classicism in Rome, made in 1821.
29. Richardson's articles of 1911 on "The Empire Style in England," which extensively illustrated engravings of the Duchess street interiors and furniture from Hope's *Household Furniture and Interior Decoration*, are referred to above in note 6. For his early acquisition of the pendant wall-lights by Hope, probably from the Christie's 1917 sale, and the Regency Revival, see D. Watkin, *Thomas Hope and the Neo-Classical Idea, 1769–1831* (London: John Murray, 1968): 110, 191–92, 256–58. Richardson's writings and his furnished house with collections at Ampthill were also to have a considerable impact on the remarkable and evocative series of interiors created in his Rome apartment by Mario Praz who visited Avenue House and shared the same taste for the later Neo-Classical style, discussed in Praz's books, *La Casa della Vita* (Milan: Mondadori, 1958); translated by Angus Davidson as *The House of Life* (New York: Oxford University Press, 1964) and *La filosofia dell'arredamento* (Milan: Longanesi, 1964, translated by Angus Davidson, as *An Illustrated History of Interior Decoration* (London: Thames & Hudson, 1964).
30. Stevens was included among the neglected Victorian classicists in *Monumental Classic Architecture* with an illustration of his design for his first major commission, the bronze doors of Pennethorne's Geological Museum, Piccadilly, of 1846 (fig. 122).
31. A.E. Richardson, *The Old Inns of England* (London: Batsford, 1934): v.
32. *English Taste in the Eighteenth Century from Baroque to Neo-classic* (Royal Academy of Arts: London, 1955–6). Ever ready to promote an awareness of the lessons to be learnt from his favoured era, Richardson wrote in the Preface: "It was an age of quality and elegance in which artists and craftsmen pursued a common ideal. The merit of the period was the intrinsic value of its artistic contributions to the word at large. Small wonder then that the Eighteenth Century has impressed modern life so completely with its tenets of good sense."
33. A.E. Richardson, ed., *Southill. A Regency House* (London: Faber & Faber, 1951).
34. A.E. Richardson, *An Introduction to Georgian Architecture* (London: Art & Technics, 1949): 96.
35. Richardson, *Introduction to Georgian Architecture* (1949): 127–28.

Classicism without Columns

GAVIN STAMP

> ... *peristyles and porticoes which contribute so essentially to the beauty and convenience of architectural compositions in warm climates, round our houses would be more disadvantageous than useful.*
>
> Sir John Soane, LECTURE X [David Watkin, *Sir John Soane: Enlightenment Thought and the Royal Academy Lectures* (Cambridge: University Press, 1996): 634]

IN THE LATE 1940s, the Royal Fine Art Commission considered the design for the proposed two new blocks of government offices in Theobald's Road in London to be built under the Lessor Scheme. The eventual result, known as Adastral House (for the Royal Air Force) and Lacon House, exhibited no trace of the progressive influence of the Modern Movement and were therefore criticised by Nikolaus Pevsner in the first London volume of his *Buildings of England*. He described them as "deplorable, crushingly utilitarian ... built ... without any consideration, it seems, of aesthetic qualities."[1] But this was unfair, for their designer certainly had aesthetic ambitions as his buildings not only have cornices but were originally to be ennobled with large classical porticoes. When, however, the design was presented to the Commissioners it was severely criticised and Sir John Summerson later told me how the architect had then angrily removed the portico from his model, exclaiming that he supposed they would prefer it like that.

In the course of the twentieth century, the committed classically-trained architect began to find his calling more and more of a challenge. New building types were

emerging, while the advent of the steel and concrete frame allowed structures to rise higher and the architect had to apply his stylistic language to these without it becoming pathetically etiolated – or redundant. Meanwhile, the advent of the rhetoric of the Modern Movement combined with the anti-traditional, progressive spirit engendered by the catastrophe of the Great War made many younger architects regard the classical approach as irrelevant. The "moral revulsion" felt by the young Maxwell Fry when he saw the stone classical veneer hoisted up onto the steel frame of the new Devonshire House in the 1920s was surely typical (if exaggerated in retrospect). "The steel framework had been standing there for some time in sufficient elegance, and what I saw now was a crust of stonework, heavy in intention but bared to its essentials, being hung and bolted and jointed on to the framework like so much scenery. Broad but flat-cut Florentine rustications had topped the Guinness advertisements and were joining in an elaborate cornice, with over it a frieze of fat cherubs carrying swags of fruit."[2]

For the architect who was anxious to find a modern but classical form of expression and who was unhappy at applying classical detail merely as a veneer over a framed skeleton there were several possible approaches. One was to employ a language of trabeation, expressing the structural grid in classical terms. This was the solution adopted by J.J. Burnet on Kodak House in Kingsway, where he employed the American method of covering the recessed floor ends in metal, leaving the stone-clad vertical stanchions to read as a giant abstracted order of columns. And this was the solution pursued by A.E. Richardson and his partner C. Lovett Gill in a series of carefully designed commercial buildings in London. In all of them, Richardson made good use of his knowledge of Neo-Classical precedents, of the work of Schinkel, Cockerell and "Greek" Thomson. In Moorgate Hall, designed in 1914 (now demolished), a low-relief façade incorporated three floors between rusticated pilaster strips and two more floors in attics. In Leith House of 1925–6 (alas, also now gone), the partly curved façade consisted of a grid of verticals and horizontals below a cornice in which the hierarchy of the classical order was still evident (fig. 1). The abstraction in this brilliant, subtle design was perhaps analogous to the "diagrammatic classicism" evolved by Auguste Perret to civilize reinforced concrete structures.[3] In St Margaret's House of 1930–1 (winner of the RIBA London Architecture Medal in 1932 and happily still standing), broad brick pilaster strips are elided with an abstracted flat entablature in a manner which recalls Schinkel's long-lost barracks and military prison in Berlin. All three buildings belong on that trajectory of rationalist classical simplification which leads from the nineteenth-century Prussian master to Mies van der Rohe, via Thomson.

A second approach was to eliminate, to abstract the classical language so as to leave buildings defined by flat facades or simple masses, without an expressed order but with openings arranged on classical principles. This was certainly a justification for Neo-Georgian as it was precisely what the eighteenth-century urban house builder had done. Many indeed — not least foreign observers like Adolf Loos and Steen Eiler Rasmussen — saw London's plain brick terraced houses as a model for a modern domestic architecture. "The tendency of these houses which remind us so much of modernistic experiments of our days," wrote Rasmussen, "this modernism from about 1800, was by the contemporaries hardly recognised as a style."[4] Ernö Goldfinger claimed, with reason, that his three brick and concrete houses in Willow Road, Hampstead, was a modern version of the Georgian terrace. Most Neo-Georgian by English architects was rather more conventional, but it exemplified the virtues of careful proportions, restrained detailing and fine brickwork and, as applied for instance to countless Post Offices by Office of Works architects, came close to becoming a national modern style. Easy, conventional denigration of Neo-Georgian ignores the considerable merits of this type of architecture.

Fig. 1 Leith House, Gresham Street, City of London, by Richardson & Gill 1925–26 (demolished) with Wren's St Lawrence Jewry in the distance [photo: Gavin Stamp, 1987].

Much Neo-Georgian could be dull and repetitive, however, and one way of making it more interesting was to reflect the influence of Soane, especially as he could be seen as a conscious moderniser. Soane was, Raymond Erith claimed in 1949, "a very rare bird, and unique among the great architects, in being a progressive classicist. Now the idea of a progressive classicist is, to contemporary architects, practically incomprehensible. To them, the abandonment of classicism, and indeed of all tradition, is the prerequisite of progress." But, argued Erith — ignoring the evident contradictions between Soane's own writings and his built work — "unlike so many people who believe in progress, he didn't believe that progress always meant destruction first in order to progress afterwards. Soane's aim was to make classical architecture progress and absorb in itself the new needs of a new age. He thought it could be made to absorb the expanding means of construction."[5]

Soane's nervous, planar work was, however, scarcely a model for larger urban structures. For these, for monumental public buildings for which a giant order or portico was considered appropriate, a simplification of forms was employed which has come to be known as "stripped classicism." It is a style frequently but wrongly associated

with totalitarian regimes, for many examples can be found in Washington D.C. as well as in London. It was a style satirised by Osbert Lancaster in 1938 by drawing two near-identical examples of monumental stripped classical colonnades, one labelled "Third Empire," the other "Marxist Non-Aryan." Both exhibited "The same emphasis on size, the same tendency to imagine that beauty is to be achieved by merely abolishing ornament, regardless of the fact that it is dependent on the proportions of what is then revealed, the same declamatory and didactic idiom."[6] And this was surely true of the many examples erected in the 1930s by organisations with no connection with the Nazi or Soviet regimes, such as E. Berry Webber's Dagenham Town Hall or Percy Thomas's Temple of Peace in Cardiff — both of which were included in "a representative selection of English architecture produced between the wars" made by the Architecture Club in 1946.[7] Such buildings would soon give porticoes — stripped or not — a bad name.

Rather more interesting and intelligent was the abstraction pursued by Charles Holden in his lifelong "search for the elemental."[8] In his stations on the Northern Line Extension and in his work for the Imperial War Graves Commission, he achieved a monumental simplicity reminiscent of ancient temples, in which interest and power was given to severe cubic masses of stone by a subtle batter and set-backs. A similar process of simplification was used on his multi-storey public buildings in London, that is, the London Transport headquarters and Senate House for London University, but by the time he came to design the English Electric headquarters in the Aldwych in the 1950s — replacing the exuberant Edwardian Baroque of the Gaiety Theatre — his architecture had been so abstracted that very little of interest was left. Well did Pevsner describe the result as "a dull, lifeless building, stone-faced and with nothing to recommend it."[9] "The time-honoured and creative conspiracy to 'believe' in the Five Orders has at last been dissolved," Summerson concluded in 1963. "Might some useful and splendid discipline called "classicism" survive without the Orders and their inexorable ratios? Many architects have believed so and the world of the 'twenties and 'thirties of this century was well supplied with buildings, classical in thought, but stripped down to diagrammatic nullity. The League of Nations Headquarters in Geneva ... is such a building. The Senate House of the University of London is another."[10]

There was, however, another alternative, which was to follow the example set by the one, great, architect who was able to invigorate and expand the classical language in the twentieth century: Edwin Lutyens. Here was an architect who also sought the elemental, particularly in his war memorials, in which simple masses were given vigour

by alternate set-backs and recessions as well as by the application of *entasis*. But the classical sense of form was never lost, and Lutyens added to the vocabulary, just as the ancient Greeks had done with triglyphs and guttae, by freezing in stone forms made of timber, cloth or leaves: the stone flags on his war memorials at Leicester or Villers-Bretonneaux; the garlands on the Cenotaph. In his urban buildings, however, Lutyens avoided pedantry or irrelevance by playing his Mannerist games to enliven whole facades – even if sometimes this bore little relation to interior arrangements. His "disappearing pilasters" was an early trick, but he had many others at his disposal. Perhaps his most inventive adaptation of the classical language appeared on the exterior of the Midland Bank headquarters in the City of London, where banks of windows are separated by tall pilaster strips which have the character of buttresses, made of minutely diminishing courses of rustication (fig. 2). And the usual oversailing cornice was omitted. Even Maxwell Fry was impressed by this highly original response to the "Grand Cañon" character of City streets, comparing it favourably to the nearby new Lloyd's Bank: "Mr Tait's cornices and colonnade are a retrogression, where in the Midland Bank the lack of a cornice is a logical concession ... The whole effect is one of the exultant piling up of fine masonry. It is alive and expansive, and looks as though it were built stone upon stone, upward from the ground" – when, of course, all those precisely cut pieces of masonry were in fact fixed to structural steelwork.[11]

Fig. 2 Detail of the Poultry façade of the Midland Bank headquarters in the City of London by Sir Edwin Lutyens, 1924–30 [photo: Gavin Stamp, 1987]

It was Lutyens's unique ability to expand and adapt the classical language, combined with his extraordinary comprehension of the possibilities of three-dimensional form reinforced by his use of a personal geometrical system, which made him an inspiration to a younger generation of architects – not least E. Vincent Harris, the *doyen* of town hall builders. Many felt that Lutyens's example ensured that the classical tradition could live on. In his biography which formed part of the Lutyens Memorial published in 1950, Christopher Hussey concluded by claiming that "We can now ... recognise that the Thiepval Memorial, the Poultry Bank, and the designs for Liverpool Cathedral ... constitute forward bases, of great cogency, established by Lutyens's genius as starting points for the advance of the Humanist tradition into the questionable future."[12] But this was over-optimistic. In the changed post-war climate, with the proponents of the Modern Movement in the ascendant, not only was the

Fig. 3 The entrance range and library at Lady Margaret Hall, Oxford, by Raymond Erith, 1959–61 [photo: Gavin Stamp, 1999].

design for Liverpool Cathedral abandoned, but Lutyens's example was increasingly regarded as a tiresome irrelevance.

Lutyens died in 1944; other distinguished classicists who were a little younger continued in practice but were increasingly marginalised. Some, notably Vincent Harris and Albert Richardson, found that their latest buildings were subject to demonstrations in 1959 organised by Anti-Ugly Action, a pressure group emanating from the Royal College of Art which was as much anti-traditionalist as it was in favour of the Modern Movement.[13] Nevertheless, the classical tradition was far from dead, even if new classical buildings were either ignored or disparaged in the architectural press (thus making it difficult to form an objective assessment of British architecture in the 1950s and 60s). And a few architects succeeded in demonstrating that a classical approach could be both modern and practical, fulfilling a contemporary brief as well – and possibly better – than a Modernist solution. Such work deserves to be better known and ought to be an inspiration to architects today.

Classical country houses continued to be built, of course, just as they are today. But the country house as a building type scarcely presented a challenge, except in terms of integrating services and a modern superfluity of bathrooms, as the precedents were well-tried and usually demanded by the client. For there has never been any shortage of rich men with conventional taste in Britain who desire nothing more and nothing less than a Neo-Palladian house, in which a radical approach is not required. And so many of these houses have a grand portico attached, ignoring the sensible junction made by Alberti that, "The pediment to a private house should not emulate the majesty of a temple in any way."[14] In consequence, many dull if well-mannered and well-proportioned boxes with the obligatory portico have been built since the Second World War, to receive far more praise than they deserve in the pages of *Country Life* when, in a time of Modernist orthodoxy, they surely had mere curiosity value. Some of the better and more restrained examples were designed by the Yorkshire architect, Francis Johnson. The pity is that Raymond Erith, in his domestic work, moved from the Soanian simplicity he advocated to a more literal Palladianism, culminating in the overwrought King's Walden Bury, Herts, of 1969–71 in which any architectural inspiration was overwhelmed by pedantic classical detailing.[15]

Far more interesting, because more challenging, were Erith's non-domestic designs. Sadly, his 1947 design for a warehouse and offices in Ipswich and his entry for the Trades Union Congress Memorial Building competition the following year remained unbuilt, for both drew upon Late Georgian and Soanian precedents and, in their references to industrial structures, attempted to "to make classical architecture progress and absorb in itself the new needs of a new age."[16] And neither would have had pediments or porticoes. Happily, Erith's scheme for a new entrance range and library at Lady Margaret Hall, Oxford, was built, in 1959–61 (fig. 3). In this he aimed at "simplicity and repose," which was achieved by the use of a Late Georgian manner of industrial or military character, while the plain pediment over the modest entrance could never be mistaken for that on a temple.

Some of the most thoughtful and inventive classical buildings of the 1950s were commercial. A.E. Richardson, despite by now being Sir Albert, P.R.A., and posturing as "the last of the Georgians," produced the last and most sophisticated of his trabeated Neo-Classical designs in Bracken House in the City of London (see fig. 5 on p. 179 above). With its pilaster strips in a dark pink brick – for the client was the *Financial Times* – and its most elegant fenestration, and managing to turn corners with consummate ease and purpose, it is full of resonances of Schinkel and Cockerell, as well as of Guarini's Palazzo Carignano in Turin. Yet it could only be a building of its time – although Pevsner thought it "a self-conscious revival of a forty-year-old 'Modern'"[17] – and Richardson felt no need to apply a fully developed order, let alone a portico. Much denigrated by contemporary critics and the target of an Anti-Ugly demonstration, Bracken House later enjoyed the curious distinction of being the first post-war building in England to be listed.

A little to the north is the contemporary New Change building by Victor Heal, initially occupied by the Bank of England. Much larger, but less original and certainly more stodgy than Bracken House, it nevertheless had considerable merit. Occupying a large bombed site, it was arranged around a courtyard and interest was given to the long Cheapside front by fine sculptured detail as well as by recessions from the

Fig. 4 New Change Buildings, City of London, for the Bank of England by Victor Heal, 1953–60 (demolished) [photo: Gavin Stamp, 2006].

THE PERSISTENCE OF THE CLASSICAL

building line. Engaged columns occasionally appeared, but the architect felt no need to apply pretentious porticoes. Built of red brick with Portland stone dressings, the curved front along New Change was an appropriate and respectful neighbour to St Paul's Cathedral (fig. 4). Pevsner, however, found it "regrettable" and "almost beyond comprehension how a design that would have been reactionary twenty years before could have been put into execution in the 1950s."[18] In consequence of such easy dismissals and a general prejudice against post-war classical architecture, it was not considered eligible for listing. Even so, the demolition in 2007 of so large and well-built a masonry structure, which could easily have been modernised and extended upwards by a competent architect, was a scandal and a loss which will be regretted when the glass-clad replacement, designed by a fashionable French architect, is completed. Fortress House in Savile Row, built in the late 1940s, like Adastral House, under the Lessor scheme and once the home of the National Monuments Record and English Heritage, was also a recent victim of the same prejudice. Designed by Curtis Green, Son & Lloyd, its classicism was far from pedantic and the internal reinforced concrete construction was not denied by its precisely detailed thin skin of Portland stone.

Fig. 5 No.100 Pall Mall, London, by Donald McMorran, 1956–58 [photo: Gavin Stamp, 1986].

More distinguished and more architecturally satisfying than either of these buildings is the block in Pall Mall between the Reform and Royal Automobile Clubs (fig. 5). Designed by Donald McMorran for, of all people, Rudolf Palumbo, the shadowy developer who had destroyed nearby Norfolk House less than two decades before, it relies for effect on symmetry, proportion and the apparent weight and depth of its travertine elevations, penetrated by a regular rhythm of segment-headed windows. In other words, it relies for effect on its general classical treatment (enhanced by rooftop pavilions) rather than on detail, of which there is little. Pevsner seems to have been both disconcerted by it and yet generous, for it could not be simply dismissed as reactionary. Instead, he referred to its "curious, flat, smooth front in a traditional style, yet not in period imitation. The shallow segmental arches of some openings are the hallmark. The whole seems to keep a strange ghostly silence."[19]

This, surely, was an intelligent answer to the problem of designing a modern classical building. Its simplicity was in accord with the spirit of the age, but its visual

appeal lies in its apparent masonry construction, governed by classical principles. Expressed columns would be superfluous. "Excitement and sensation are the qualities most looked for and praised," wrote McMorran in 1960, soon after the Pall Mall building was completed, "but what is up-to-date today is doomed to be *vieux jeu* tomorrow, and the "mistress art" of architecture is reduced to a feverish succession of "-isms." The worst buildings of today may be judged the worst in human history. Hope lies in a patient discovery of the humanist values, expressed in compressive structures, as they always have been and must always be."[20] With hindsight, McMorran's assertion seems justified, but his approach was censored in his time. Five years later, John Betjeman was moved to write to *The Times* because of the prejudice shown by McMorran's obituarist. "I would like to defend the late Mr. Donald McMorran's design of the office building on the site of the Carlton Club. It is a solid, three-dimensional composition of stone in a stone street of Renaissance character. It depends for effect on proportion rather than detail. It knows how to turn a prominent corner far more effectively than the more recent building on the site of the Army and Navy Club opposite. It seems more in keeping in scale and texture with Pall Mall than New Zealand House."[21]

The editor chose not to run Betjeman's letter, but he did publish one from W.A. Eden, who wrote that, "Nobody was more aware than [McMorran] of the need to come to terms with the demands of the modern world. He believed that an architect is the servant of his clients, and so in most of his work he strove, first and foremost, to achieve efficient planning and good building; but he believed also that these were not enough to make a building worthy of the name of architecture which, for him, was predominantly a matter of humane proportions."[22] More than any other British working in the second half of the twentieth century, McMorran, together with his later partner George Whitby, despite working in an increasingly hostile professional climate, succeeded in demonstrating that the classical tradition could indeed progress and absorb the needs of a new age, and that it was not necessary to sport columns and porticoes to sustain the humane qualities of true classical architecture. Yet although their buildings have lasted well, vindicating this approach, and have attracted a small but select group of admirers, their work is still not well known and little has been written about them.[23]

It would be wrong to dismiss either McMorran or Whitby for being blinkered and reactionary traditionalists, although McMorran provoked opposition from the modernist professionals by criticising trends in architectural education.[24] Both were open minded and prepared to experiment. McMorran happily used and expressed

pre-cast concrete trusses in his Phoenix School and Whitby used *in-situ* concrete construction as well as pre-cast concrete elements in his own Plashet School, again in East London. But both remained convinced that a humane and well-made architecture could only come though the intelligent development of tradition and the use of good building craftsmanship. The honest expression of structure – whether or not that structure was designed to last – was not enough, for they were also concerned with wider architectural values and the visual impact of their work in the public realm. And they concluded that it was only traditional masonry construction which could create the necessary effect on both the eye and understanding to give a satisfactory impression of stability, permanence – and beauty. "All the great architecture of the past was based solely on the principle of *compression*," McMorran argued in 1960, and that the eye and mind could gain no satisfaction from the expression of tensile structures.

> Reinforced concrete containing concrete in compression and steel in tension must be unintelligible, and therefore confusing and unpleasing ... This may be why Le Corbusier in his later work has confounded his followers by turning from 'bony' structures to 'fat' ones like the chapel at Ronchamp which has the visual character of the old compressive architecture ... If tensile elements are unavoidable (as in normal floor construction) they must not be allowed to affect *what is seen* if they are not to destroy the aesthetic significance of the building. This idea is considered heretical today, but it was accepted as common sense in the eighteenth century. It leaves us (surprisingly) with no more material resources than our forerunners. We can, of course, use steel as a compressive material, but its impermanence does not recommend it. There are no other 'modern' materials of any consequence. Stone, brick and mass concrete remain. We are left facing a purely aesthetic problem, and it is only to the humanist tradition that we can look for guidance.[25]

As for tackling modern building types, McMorran accepted there were limits to the adaptability of the classical language. "Up to a height of 80 or 100 ft. it is possible to design a commercial building in the Renaissance tradition, that is, with some windows emphasized, and some suppressed, in the interest of composition and unity. Lutyens and others adopted this convention with varying skill and success, and, extravagant and illogical as they may be in some respects, the results are acceptably humane and capable of being related to the work of Wren and later masters. The City feels at home with them. But above these heights, and within the limits imposed on floor-to-floor spacing my modern economy, this kind of expression becomes impossible, or, if attempted, grotesque."[26] This, however, did not prevent McMorran &

Whitby later attempting to design – with remarkable success – a miniature stone classical skyscraper at the Wood Street Police Station in the City of London (see fig. 10).

In their search for an appropriate aesthetic solution, both McMorran and Whitby were strongly influenced by Lutyens and his ability to abstract classical forms to create his "Elemental mode." "What would Lut have done?" Whitby would ask when faced with a particular problem.[27] McMorran, indeed, was in a direct line of succession from Lutyens, having been a pupil and then a partner of the great man's former assistant, Horace Farquharson. In between, he had worked for Vincent Harris, whose own work shows a considerable debt to Lutyens. When in 1947 the RIBA gave the London Architecture Medal for the best building of the period 1937–46 to the Police section house in Greenwich by Farquharson & McMorran, he acknowledged "the debt which we all owe to our masters, and I should like to refer to Mr. Vincent Harris, without whose example and precepts the job would not have had the character which you have been good enough to admire."[28]

Much of the early work of Farquharson & McMorran was for the Metropolitan Police. A notably handsome example is the Hammersmith police station in the Shepherd's Bush Road, completed in 1940 (fig. 6). Well made in brick and stone, its symmetrical elevation is pared down to essentials while losing nothing of classical elegance and proportion, nor attention to detail. It pointed to the way McMorran's work would develop after the Second World War. Later, in 1955, the *Builder* noted that "There are many who think [this police station] is the finest small building put up in London in the past 20 years."[29] Significantly, perhaps, McMorran's work – both before and after he was joined by Whitby in 1958 – never included a country house.[30] He did, however, tackle the much more demanding area of public housing. The Lammas Green Estate on Sydenham Hill has a village character achieved by placing

(top) Fig. 6 Police Station, Shepherds Bush Road, Hammersmith, London, by Farquharson & McMorran, 1938–40 [photo: Gavin Stamp].

(bottom) Fig. 7 Holloway Estate, Parkhurst Road, London, for the City Corporation, by McMorran & Whitby, 1955–71 [photo: Gavin Stamp, 1989].

Fig. 8 Devon County Hall, Exeter, by McMorran & Whitby, 1957–64, and, to the left, 'Belair' of c.1700 [photo: Gavin Stamp, 1986].

low buildings around a green while more monumental Neo-Georgian blocks of flats were placed along the street, defining and protecting the space behind. Not that McMorran's Neo-Georgian was conventional. At the Holloway Estate the windows on the long brick elevations are sashed but not strictly Georgian, and they are omitted where not required (fig. 7). But there is a discipline about the fenestration which, combined with the round open arcades and the pediment on the end elevations reflecting the shape of the low-pitched roofs, indicates a subtle classical sensibility. Unlike so many contemporary public housing schemes, both these developments appear to be popular and in good order today; both benefited from having the City Corporation as client, so there was no pressure to use cheap materials or prefabrication.

Some of the partnership's finest works were in the sphere of local government, in which they established a reputation for sound and commonsense building. The Devon County Hall (1957–64) on the edge of Exeter takes its cue from "Belair," a handsome red-brick house of c.1700 which is incorporated into the composition (fig. 8). But the new buildings cannot be described with any precision as Neo-Georgian; they have a powerful quality of their own, which has echoes of twentieth-century Scandinavia as well as of the eighteenth century. A range over a low segmental open arcade is dominated by three tall rectangular windows and above the low-pitched roof rise a pair of monumental chimney-stacks. Asymmetry is introduced with a sturdy brick tower, given a distinctive character with more of the arch forms that govern the overall design. As usual, there are digested reminiscences of Lutyens and thus, perhaps, of Vanbrugh, while arched recessions in the brickwork recall Soane. At the later Shire Hall in Bury St Edmunds, the Soanian influence is stronger – particularly in the detached County Record Office. But the County Buildings themselves are distinguished by a regular but undogmatic fenestration, with windows occasionally of different sizes. McMorran & Whitby's windows, some rectangular, some segment-headed, are conspicuous for being traditional, in that they are sliding sashes with glazing bars, but not conventionally Neo-Georgian.

Some of McMorran's best work is to be found at the University of Nottingham where, in the 1950s, halls of residence were built in an open rolling landscape. These buildings were by several different architects who all worked in a semi-traditional

manner (and therefore attracted the attention of the Anti-Uglies). Two were by McMorran, assisted by Whitby. The best of all of them is Cripps Hall, where a powerful brick bell-cote, reminiscent of Vanbrugh, rises above the Refectory (fig. 9). And the entrance to Cripps Hall is framed by pairs of giant stone Ionic columns supporting the roof which runs continuously over a brick domestic range. It is an unusual and unexpected apparition, as if to make the point that the classical system underpins the architecture but, in the worthy attempt to make it both practical and modern, there is usually no need to give literal expression to that governing order. The Department of Education at Nottingham was also by McMorran & Whitby, in which an abstracted and attenuated Tower of the Winds rises above elegant brick arcaded elevations, whose unpretentious, practical character is given by the typical segment-headed windows. Yet the revised "Pevsner" for *Nottinghamshire* could describe these buildings as "weak neo-Georgian" when they are evidently neither.[31]

McMorran & Whitby's last and most impressive creations are in the City of London. Both were built in Portland stone rather than brick. The Wood Street Police Station (1962–6) is firmly classical in its symmetry and organisation (see fig. 10). Tall segment-headed windows dominate the principal elevation and a pair of magnificent, powerful chimneys rises above the pitched roof. But ostensible classical detail is kept to a minimum. There are few mouldings and the rustication at the lower level simply consists of bands of flat projecting stones. Adjacent stands the residential "section house," a miniature classical skyscraper with simple segment-headed windows piercing the stone walls which rise to a pitched roof placed over pediment-gables. In both buildings what is particularly impressive is the way that services and ducts were integrated into the formal language rather than be left as brutal appendages or insertions.

When this Police Station was completed in 1966, "Astragal" in *The Architects' Journal* was merely condescending. "In younger, angrier days Astragal would have attacked such pretentious phoney design, with anachronistic rusticated chimneys and much load-bearing stonework. But McMorran was a sincere and devoted architect who cared passionately about what he was doing. So, crazy though it is, this police station is in another class from commercial trash nearby."[32] Indeed it was. And today, this late classical masterpiece, a triumph of civilized, rational design and modest scale, makes

Fig. 9 Cripps Hall, University of Nottingham, by McMorran & Whitby, 1957–59 [photo: Gavin Stamp, 1986].

Fig. 10 a & b Wood Street Police Station, City of London, by McMorran & Whitby, 1963–66 [photos: Gavin Stamp, 1987].

a telling contrast with the arrogant slickness of the High Tec buildings and the illiterate vulgarity of the Post-Modern blocks which stand around – mostly designed by established architects who have acquired knighthoods and even peerages. As Simon Bradley wrote in the latest *Buildings of England* volume on the City, "The classical allusions seem now most solid and serious by comparison with the archness of 1980s Postmodernism."[33]

"Astragal" used the past tense about McMorran as he had died the previous year. A second City job, an extension to the Central Criminal Court in the Old Bailey, was already on the drawing board but it was left to George Whitby completely to redesign it and carry it to completion in 1972. The particular problem here was sympathetically to add to the original Edwardian Baroque building by E.W. Mountford while giving the extension a modern and complete character of its own. Whitby's solution was a triumphant success. His powerfully modelled Portland stone façade follows the scale and lines of the old Old Bailey but, in its austerity, could only be of its own time (fig. 11). As ever, openings were segment headed, but sculptural vigour was given by expressing the internal services in wide, flat bays between the windows which are corbelled out from the building line (fig. 12). Again there are echoes of the abstracted monumental classicism of Lutyens, as well as of the powerful English Baroque of Vanbrugh and Hawksmoor.[34] The Old Bailey Extension is a recognisably

(left) Fig. 11 Extension to the Central Criminal Court, Old Bailey, City of London, by George Whitby, 1966–72, with E.W. Mountford's original building of 1900–07 behind [photo: Gavin Stamp, 1987].

(right) Fig. 12 The Old Bailey elevation of the Extension to the Central Criminal Court [photo: Gavin Stamp, 1982].

classical design, yet there are no mouldings, no columns and certainly no porticoes.

The virtues of the building were well described by John Betjeman in the address, or poem, he read out at Whitby's memorial service in 1973 – for the architect had died just a year after it was opened at the age of only 56. "... *Si monumentum requiris* ..." Betjeman announced to those gathered in Hawksmoor's church of St Mary Woolnoth,

> ... at the western gate of the City
> Behold the Law's new fortress, ramparting over the Bailey
> In cream-coloured clear-cut ashlar on grim granitic foundations –
> But, like all good citizens, paying regard to its neighbours,
> Florid baroque on one side, plain commercial the other.
> This is your work, George Whitby, whose name we remember:
> From Donald McMorran and Dance to Wren and Nicholas Hawksmoor,
> You stand in a long tradition; and we who are left salute you.[35]

The Old Bailey Extension was completed at a time when, at long last, the assumptions and orthodoxies of the Modern Movement were beginning to be questioned. The powerful, intelligent abstraction of its design, with no literal classical details but full of references to history and tradition for those with eyes to see, could surely have been an inspiration and a model for the Post-Modern classicism that would

emerge by the end of the decade. In the event, however, it was largely ignored.

Whitby's building was a major public work, and a highly sophisticated response to a challenging, complex brief, yet such was the prejudice against any deviation from the Modern (or was it just blinkered incomprehension?) that it was hardly noticed in the professional press. *Building Design* referred to it, but only after its strengths were demonstrated when an IRA bomb exploded outside the year after completion. As the building suffered little damage while every window on the modern commercial office block opposite was blown out, the journal wondered if its "reactionary architecture" might be a model for resisting terrorism: "Its job as a temporary prison and the likelihood of it being first target for insurgents makes it a very typical example of the architecture of a more pessimistic future."[36] Earlier, "Astragal" had sneered in the *Architects' Journal* that, "'The walls of the Old Bailey Extension are built not clad', says George Whitby, the architect. Perhaps he wanted it to look like a penitentiary – he has certainly succeeded, particularly with the round-headed [sic] mullioned windows which vividly recall cell openings. The imagery of the building says: abandon hope all ye who enter here. Whitby was … in the 2000 Group, which believes that 'architecture should be an Art, free from pseudo-scientific dogma of political, economic and sociological theory'. 'Nuff said."[37]

But not enough was, or has been said. After Whitby's death in 1973, John Brandon-Jones wrote to complain that his obituary in *The Times* "failed to draw attention to the unusual character of their work. McMorran and Whitby were among the leaders of the small band of architects who have demonstrated the possibility of applying classical principles in the design of large modern buildings. Over and over again they were able to show that the traditional formulae were capable of infinite variety and also that for many purposes, traditional materials and craftsmanship could still compete successfully with system building from the economic as well as from the aesthetic point of view. Their buildings have qualities of austere elegance and dignity that will be very hard to match …"[38]

That proved to be the case. The assuredness and restrained grandeur of the work of McMorran & Whitby has not been emulated since their deaths. It was a tragedy for the cause of classical architecture in Britain that McMorran's death in 1965 was followed by that of both Whitby and Raymond Erith in 1973, leaving no practising architect with either the intention or the ability to continue their vital struggle to adapt the "long tradition" for modern conditions. Architects there were, of course, and a younger generation of classical architects would emerge, but the focus was – perhaps of necessity – on country house work, and all too often the results were

literal in their attention to correct classical detail. Only those prepared to learn from the work of Soane or Schinkel have demonstrated any promise.[39] But the architect who was most lauded for picking up the classical torch in 1973 has proudly eschewed radical thought and never demonstrated any desire, or ability, to develop or abstract the classical language as suggested by Soane or Lutyens or McMorran. He has made, instead, a successful career from faithfully and pedantically applying Palladian detail to unremarkable structures.[40] All this has simply made the task of the enemies of tradition easier.

Quinlan Terry has nevertheless been the subject of several monographs as well as endless laudatory articles. It is, perhaps, as if just to attempt a classical design in a generally hostile climate was sufficiently remarkable in itself, regardless of whether the result — as architecture — was good or bad, pedestrian or imaginative. Dr Johnson's observation on a woman's preaching being like a dog walking on its hind legs comes to mind: "It is not done well; but you are surprised to find it done at all." In contrast, precious little has been written about the work of McMorran and Whitby (although a proper study is now at last promised).[41] When the present writer tried to publish an article about their work twenty years ago, both the *Architectural Review* and *The Architects' Journal* rejected it while other journals, not least *Country Life*, treated the idea with indifference.[42] Yet this was at a time when Soane was being elevated into a cult figure and many modern architects responded to and claimed to be inspired by his more abstract work. As John Summerson had written about the Dulwich Picture Gallery some two decades earlier in his analysis of *The Classical Language of Architecture*, "There is not a single conventional column or even a conventional moulding in sight. Everything has been abstracted and then rendered back in Soane's own personal interpretation. It is all very original and seems to point to a new freedom for architecture. It seems so to us, but it did not to the generation that followed."[43]

Donald McMorran and George Whitby did not find it necessary to apply conventional columns to their buildings and they made sparing use of conventional mouldings. Details were thought through and modified in response to practical considerations and architectural effects were achieved through elimination and abstraction to leave austere, direct compositions and sometimes powerful sculptural forms all carried out in fine masonry. Yet their work was recognisably classical in its proportions and in its governing sensibility. Their buildings have weathered well and continue to function well, and thereby proclaim, now more than ever, that it is possible, as Soane had earlier demonstrated, to have a modern progressive classicism, a classicism without columns.

NOTES

1. Nikolaus Pevsner, *The Buildings of England: London (Except the Cities of London and Westminster)* (Harmondsworth, 1952) 220; according to the revised *London 4: North* edition (1998), the architect was Arthur S. Ash. The buildings survive but were modernised and altered in 1999 by Sidell Gibson.
2. Maxwell Fry, *Autobiographical Sketches* (London, 1975): 136; Fry was somewhat misleading in dating his conversion to modernism and omitted to mention that he himself was designing classical buildings for the Southern Railway for longer than he wished posterity to think.
3. John Summerson, *The Classical Language of Architecture* (London, 1964): 45.
4. Steen Eiler Rasmussen, *London: The Unique City* (London, 1937): 229.
5. Lecture on Soane quoted in Lucy Archer, *Raymond Erith, Architect* (Burford, 1985): 31, 34.
6. Osbert Lancaster, *Pillar to Post* (London, 1938): 78.
7. *Recent English Architecture 1920–1940 selected by the Architecture Club* (London, 1947).
8. Eitan Karol, *Charles Holden Architect* (Donington, 2007): 4.
9. Nikolaus Pevsner, *London I: The Cities of London and Westminster* (Harmondsworth, 1962): 340.
10. John Summerson, *The Classical Language of Architecture* (London, 1963): 13–14.
11. E. Maxwell Fry, "New Banks at 'The Bank'" in *The Architects' Journal* 69, 9 January 1929, 63. Lloyd's Bank in Cornhill was designed by Sir John Burnet & Partners and Campbell, Jones & Smithers, i.e. by Thomas Tait.
12. Christopher Hussey, *The Life of Sir Edwin Lutyens* (London & New York, 1950): 589.
13. See Gavin Stamp, "Anti-Ugly" in *Apollo*, January 2005, 88–89, & Gavin Stamp, "Anti-Ugly Action" in *Blueprint*, January 2007, 60–63.
14. Leon Battista Alberti, *On the Art of Building in Ten Books*, translated by Joseph Rykwert, Neil Leach & Robert Tavernor (Cambridge, Mass., & London, 1988), Book Nine: Ornament to Private Buildings, 301.
15. The building was completed by Erith's partner and successor, Quinlan Terry.
16. See note 5 above.
17. Pevsner (1962), 204.
18. Ibid., 205.
19. Ibid., 559.
20. Donald McMorran, "Architecture in 1960:" typescript for lecture or article dated October 1960 (the late Mrs Margaret McMorran).
21. John Betjeman, copy of letter to The Times, 10th August 1965, sent with letter to McMorran's widow in which he wrote "I admired him as a person and as an architect. I don't expect the Times will publish the enclosed letter I've sent to it, but it will be shown to whoever it was wrote Donald's obituary" (the late Mrs Margaret McMorran). McMorran's obituary had appeared in *The Times* for 10 August 1965.
22. W.A.E., letter to *The Times*, 14 August 1965, 8.
23. In fact, the only article would seem to be my own, "McMorran and Whitby: A Progressive Classicism" in *Modern Painters* 4, no. 4, Winter 1991, 56–60. But Elain Harwood has extolled the partnership's work in her *England: A Guide to Post-War Listed Buildings* (London, 2003), writing that "Devon County Hall confirms McMorran as an underrated master of an undervalued genre." It is also noteworthy that the cartoonist Posy Simmonds chose the Wood Street Police Station for her programme in the 'Building Sights' series for BBC2 television in 1996.
24. McMorran was strongly and volubly opposed to the (successful) campaign led by Leslie Martin to make architecture an academically respectable subject within universities. At the 1956 Conference on Building Training it was reported that "He could not help associating the poor design of so much of our building today with the purely modern notion that architecture could be taught in schools, as a kind of abstraction without tradition, and apart from its practice as an essential part of the building industry" (biographical note by A.B. Waters in the McMorran biographical file in the RIBA Library).
25. Donald McMorran, lecture, 1960.

26. Donald H. McMorran, letter to *The Times*, 27 January 1954, 7.
27. *Ex info* Mark Whitby.
28. *The Builder* 173, 14 November 1947, 541.
29. *The Builder*, 29 April 1955, 698.
30. The wing in the Tudor style added to 'Frenden' at Highworth, Wiltshire, was probably Farquharson's work (*Builder* 19 December 1941, 551) and the house at Camilla Lacy near Dorking was a small brick 3-bedroom house and certainly not Neo-Palladian (*Builder* 15 August 1952).
31. Nikolaus Pevsner & Elizabeth Williamson, *The Buildings of England: Nottinghamshire* (Harmondsworth, 1979), 258. The McMorran & Whitby buildings are discussed and illustrated in A. Peter Fawcett & Neil Jackson, *Campus Critique: The Architecture of the University of Nottingham* (Nottingham, 1998).
32. *The Architects' Journal*, 144, 6 July 1966, 6.
33. Simon Bradley & Nikolaus Pevsner, *London 1: The City of London* (London, 1997), 325.
34. A likely additional influence on McMorran's and Whitby's urban buildings was the abstracted, mannered classicism of architects like Muzio and Del Debbio in Fascist Italy, but this cannot be documented: certainly there are affinities.
35. John Betjeman, *A Nip in the Air* (London, 1974); the poem was read at St Mary Woolnoth on 29 March 1973.
36. *Building Design*, 23 March 1973, 15.
37. *The Architects' Journal* 156, 6 September 1972, 516.
38. *The Times*, 3 March 1972, 16. The offending obituary (27 February 1973), like that for McMorran seven years earlier, was presumably written by J.M. Richards who, by this date, was at last beginning to question the assumptions of the Modern Movement himself.
39. i.e. Dimitry Porphyrios and John Simpson, the latter having shown remarkable ingenuity in creating exquisitely and practically detailed Neo-Classical interiors around and within existing structures. There is also Robert Adam, who has shown a willingness to adapt and experiment with the classical language, and Craig Hamilton.
40. See Gavin Stamp, John Summerson & Leon Krier, "Classics Debate" on the Howard Building at Downing College, Cambridge, in *The Architects' Journal* 187, 16 March 1988, 34–51, and the David Watkin-Gavin Stamp debate provoked by the new library at Downing College also designed by Quinlan Terry in *The Spectator* for 11 December 1993, 26–27, 22 January 1994, 33–34, & 19 February 1994, 34–36, together with *Private Eye* 836, 31 December 1993, 7. However, it is worth remarking, as David Watkin wrote in *The Spectator* for 22 January 1994, that "it is wonderful that Terry has put up a building that allows such a learned debate to be carried on at all, regardless of which side they eventually take. One of the most lamentable features of modern architecture was that its deliberately offensive rejection of the grammar of traditional architectural language, in detail as well as in proportion, removed it from the language of civilised critical debate."
41. Edward Denison, McMorran's grandson, is preparing a monograph, sponsored by Whitby's engineer son Mark Whitby.
42. The article was eventually published in 1991: see note 23 above.
43. John Summerson, *The Classical Language of Architecture* (London, 1964), 40. This praise for Soane would seem to contradict Summerson's answer to the question he posed at the beginning of the book (p. 8) as to whether it is possible "for a building to display absolutely none of the trappings associated with classical architecture and still, by virtue of proportion alone, to qualify as a 'classical' building? The answer must, I think, be 'no'."

Complexities and Contradictions of
Post-Modernist Classicism:
Notes on the
Museum of Modern Art's 1975 Exhibition
The Architecture of the Ecole des Beaux-Arts

BARRY BERGDOLL

BY THE mid-1970s the founding claims of the Modern Movement in architecture and the instrumental histories of its chief defenders were subjected to ever more intense critical scrutiny from the most diverse quarters. By the time David Watkin emerged from the unexpected platform of Peterhouse to the front ranks of the critique of the underlying assumptions of Modernist architectural practices that many felt had lost their way, the debate was already underway in the architectural press, in architectural schools, and even in museum exhibitions on both sides of the Atlantic. The debates between Modernists and traditionalists emerging in British architecture, just as the period's spirited debates between the "Whites" and the "Grays" in American practice in the mid-1970s, was soon held afloat by a rising tide of polemical books which set out to dismantle the gospel according to Sir Nikolaus Pevsner, Sigfried Giedion, Henry-Russell Hitchcock, and more recently Reyner Banham.[1] Although it was scarcely the first sweeping critique, Brent Brolin's *The Failure of Modern Architecture* of 1976 was unambiguous in its title. The period of "complexity and contradiction," opened a decade earlier when the Museum of Modern Art published Robert Venturi's "gentle manifesto," *Complexity and Contradiction in Architecture*, now entered a new phase in which old certainties were to be dismantled and replaced by new ones, in which the critique of Modernism moved consciously towards the preparation of an architectural style of historical reference, symbolism, ornament. The following year Brolin's book was joined by an unholy trinity: Peter Blake's *Form Follows Fiasco: Why Modern Architecture hasn't Worked*, David Watkin's *Morality and Architecture:*

The Development of a Theme in Architectural History and Theory from the Gothic Revival to the Modern Movement and, in a reconstructive mode, Charles Jencks's *The Language of Post-Modern Architecture*, this last confirming the connection between the rising critical tide and the complex contours of emerging Post-Modernism in architecture.[2] Jencks stood out for his optimism, seeking gleefully to categorize the very strains of the new pluralism emerging in wake of Modernism's ardent belief in unity of expression and doctrine. Paradoxically, Watkin's painstaking dismantling of the operations of the Modernist belief in the Zeitgeist, was, in hindsight, equally a product of this complex moment, the coming of age of post-modernism.

To this trilogy must be added another book – whose polemical setting has only rarely been discussed, Arthur Drexler's monumental *The Architecture of the Ecole des Beaux-Arts*, conceived to accompany the eponymous exhibition at the Museum of Modern Art in 1975 but published only two years later (fig. 1).[3] Although the book would largely have a critical reception in a reinvigoration of the scholarly study and interpretation of nineteenth-century French architecture, the exhibition had been received, as I hope to show in studying it here, as a thinly veiled and sustained critique of the modern movement, even though its subject was ostensibly the academic tradition in nineteenth-century French architecture and in French and American civic architecture of the late nineteenth and early twentieth century (fig. 2). That, of course, was the very architectural tradition that the Museum of Modern Art had set out to curtail from the founding of its Department of Architecture in 1932 with a clear mandate to transform architectural taste and ideology in America (fig. 3). Forty-five years later, the controversial and puzzling exhibition at MoMA of the dazzling watercolours of the student competitions that had been the mainstay of architectural training in France from the late eighteenth century until 1968, was seen as an equally seminal event, by some even as a bookend that bracketed even a certain history of Modernism opened in 1932. At the same time, Drexler's exhibition and book helped usher in a type of Post-Modernism far from his conscious intent, even as Watkin's work would, within a few short years, serve as one of the foundation manifestos of a revived Post-Modern classicism.

With all the appearance of a nineteenth-century Salon, the dramatically installed exhibition at the Museum of Modern Art brought enfilades to a museum that had trained two generations of Americans to understand the free plan (fig. 4), and proved

Fig. 1 Dust jacket, Arthur Drexler, *Architecture of the Ecole des Beaux-Arts*, which appeared in 1977, two years after the exhibition, illustrating part of Louis Duc's restoration project of the Roman Coliseum.

THE PERSISTENCE OF THE CLASSICAL

to be one of the most catalytic architectural events of the decade. On display were one hundred and fifty five drawings and photographs, dominated by the large-scale student competition drawings from the archives of the Ecole des Beaux-Arts in Paris, plus drawings for two later realized buildings: Henri Labrouste's sensuously austere renderings of his great Bibliothèque Sainte-Geneviève (1838–50), and both Viollet-le-Duc's and Charles Garnier's designs for the Paris Opera. The latter was represented not only in drawings but in the chromolithographic plates which the Museum bought for the purpose, a rare moment then of the previously disdained architecture of ornament and pomp and circumstance seeping past the carefully controlled gates of the permanent collection (figs. 5 & 6). For the final section of the exhibition Drexler assembled a panorama of black and white photographs of Beaux-Arts style buildings in both France and America largely in the form of reproductions from commercial photography archives, with the exception of the stunning suite of photographs by Charles Dudley Arnold of the World's Columbian Exposition in Chicago of 1893, the first great manifesto of the American synthesis of Beaux-Arts architectural composition with the principles of the City Beautiful Movement in town planning (fig. 7). Arnold's vintage prints were loaned by

(top) Fig. 2 Entrance gallery, "The Architecture of the Ecole des Beaux-Arts" at the Museum of Modern Art, with elements of the Grand Prix of A.L.T. Vaudoyer (1784).

(bottom) Fig. 3 View of Le Corbusier installation, with model of the Villa Savoye, "Modern Architecture – International Exhibition," 1932, The Museum of Modern Art, New York.

Columbia University's Avery Library and by the Chicago Historical Society. The aesthetic of photographs mounted in thin section frames or simply clipped to Plexiglas panels on the wall to lessen the relief of traditional frames, along with the preference for black backgrounds and dramatic lighting (which had already emerged as Drexler's characteristic exhibition aesthetic) was deployed to great effect, the central axis of the show itself evocative of the exhibitions of student competition drawings staged after the professors at the Ecole judged the coveted Grand Prix (see fig. 4).

Had the exhibition been hosted by another museum, even another New York museum – the Metropolitan Museum of Art or the newly reorganizing Cooper Hewitt Museum, both in Beaux-Arts style buildings, for instance – the reading of

this display of student competition drawings would, no doubt, have failed to take on its startling resonance, and the exhibition might have been received *prima facie* as a scholarly exercise. But staged in the galleries of Philip Goodwin and Edward Durell Stone's modernist Museum of Modern Art (1939), the very institution which had inaugurated its architecture department in 1932 with the polemical and decisive exhibition defining the tenets of the International Style (see fig. 3) and arguing for its unique appropriateness to contemporary America, the "Beaux-Arts show", as it quickly came to be known in short hand, took on the character of a manifesto even before it was opened to the public on 29 October 1975. It was scrutinized and analyzed as a gesture even before the curatorial details of the check list and installation were known. Indeed to a certain extent they might be argued to have been irrelevant. After forty-five years of missionary zeal, it seemed as if MoMA, the flagship of Modernism, was changing the colours on its mast, a position confirmed two years later when the monumental publication belatedly appeared, with Drexler's polemical forward and three major historical essays – polemical in their own right, but for largely divergent reasons – by the young historians Neil Levine, David Van Zanten, and Richard Chaffee. Each of them had, quite independently, devoted their doctoral research to what they saw as the catch-up-work of bringing the re-evaluation long underway of nineteenth-century English and American architecture into the study of the French nineteenth century. Their collective historical focus would not be the great Gothic Revivalist architect and theoretician Eugène Emmanuel Viollet-le-Duc, who had long established laurels as a proto-Modernist – even though this view had been challenged in two doctorates in the late 1950s, one by Robin Middleton at Cambridge University, the other by John Jacobus at Yale.[4] Instead it was the Ecole des Beaux-Arts itself, that bastion of the classical tradition and for many decades the *nec plus ultra* of credentials in the American architectural profession, at least until the late 1930s when Walter Gropius arrived with the legacy of the Bauhaus at Harvard.

Fig. 4 Central axis of "The Architecture of the Ecole des Beaux-Arts" with the axis closed by a blow up photograph of students delivering their competition entries below the state of Melpomene at the Ecole des Beaux-Arts.

Even though an international tour of the exhibition was planned, in the end the event was to play itself in a very American discursive field, one only briefly extended to Britain when Robin Middleton organized, in 1978, a follow up event at the Architectural Association.[5] Mystery still veils the cancellation of the planned

mounting of the exhibition at Paris's Musée des Arts Décoratifs, and even more so the decision not to print the translated catalogue in 1980, for which the pioneer historian of nineteenth-century French architecture Bruno Foucart had penned a – now lost – preface. It would have been a very significant prelude to the debate over Modernism and Post-Modernism staged two years later in competing exhibitions during that autumn's Biennale de Paris: "La modernité ou l'esprit du temps," which introduced a wide range of emerging Post-Modern practices worldwide; and "La modernité: un projet inachevé," a tight exhibition of forty practices considered to be expanding the project of Modernism curated by Paul Chemetov with a title evocative of Jürgen Habermas.[6] The only other presentation of the exhibition at the National Gallery of Canada in Ottawa from 24 September to 7 November 1976 seems, however, to have gone largely unnoticed and to have had little effect on the Post-Modern turn in those years in Canadian architecture. But for the moment in North America it seemed as if the project of Modernism was indeed completed and depleted. And Drexler's show would continue to be debated long after it was dismounted in New York, even if Drexler himself seemed to retrench in his last great survey exhibition *Transformations in Modern Architecture*, staged in 1979 and largely devoted to projects whose continuity with the International Style were evident.

(top) Fig. 5 "The Architecture of the Ecole des Beaux-Arts" gallery with drawing by Charles Garnier of the Opera (left) and Henri Labrouste of the Bibliothèque Sainte-Geneviève (right).

(bottom) Fig. 6 "The Architecture of the Ecole des Beaux-Arts" gallery with photographs, lithographs, and drawings of Charles Garnier's Opera and Henri Labrouste's Bibliothèque Sainte-Geneviève

If the show was to have only very belated and second-hand effect on architecture and architectural history in France (where the gesture of celebrating the Ecole des Beaux-Arts less than a decade after the events of 1968 had belatedly ended the classical tradition) it seemed at first a non-starter. In the English-speaking world MoMA's show was experienced as a seismic shift in architecture, in architectural history, and in the relationship between the two – or some would say a confirmation of a seismic shift already underway – to such an extent that many appeared at the opening night on 29 October 1975 wearing lapel pins with the slogan "Bring Back the Bauhaus," an ironic comment conceived by the architectural critic Suzanne Stephens

206

and the architect Susana Torre, both recent alumnae of Drexler's Department of Architecture and Design (fig. 8).[7] More than simply allowing the very academy against which the Modern Movement had most emphatically rebelled (only seven years after the 1968 student riots in Paris) into the very museum that had modelled itself on the Bauhaus and thought of its departments as missionaries in the avant-garde struggle for Modernism, the show was seen clearly as a complex, even perplexing, critique of architectural Modernism, the *lingua franca* of American corporate and public architecture. The show — in preparation, ironically enough, since the late 1960s — and its accompanying book wove together Drexler's growing doubts about the Modern Movement and the very American corporate Modernism he had done so much to champion in some of the first exhibitions he staged in MoMA's architecture department in the early 1950s. One should cite "Built in USA: Postwar Architecture" and "Architecture for the State Department" both 1953, and "Buildings for Business and Government" of 1957, all of which paid particular attention to Skidmore, Owings & Merrill, the most Miesian of the period's large corporate firms. These exhibitions in many ways set the tone for Drexler's first decade at the Department, which he would dominate for nearly thirty years.[8]

Fig. 7 "The Architecture of the Ecole des Beaux-Arts" gallery with photographs of French (left) and American (right) Beaux-Arts structures.

By the 1960s Drexler had begun to pay as much attention to the work of engineers as architects — a theme that was to return in his framing of the issue of reconsidering the nineteenth-century in the introductory essay to the Beaux-Arts book. But a real change began only in the early 1970s when he sought to align the department more closely with the critiques of Modernist urban assumptions that were emerging in the schools and in the increasingly frequent public protests to post-war urban redevelopment schemes, as well as with the rise of the historic preservation movement. Most significantly Drexler had helped sponsor that maverick school and think tank The Institute for Architecture and Urban studies and its quest for an architecture related to deeper meaning structures — characterized in particular by the interest in structural linguistics of Peter Eisenman and in the revival of Le Corbusier's notion of collage by Michael Graves and Richard Meier. In unexpected ways — today not immediately clear from the mere evidence of the installation photographs of the exhibition and the lavish book that ultimately served as its catalogue — the show was intended as a sweeping condemnation of the Modernist city. It came in the wake of

Fig. 8 Lapel button produced as an ironic protest for the vernissage of the exhibition "The Architecture of the Ecole des Beaux-Arts" (courtesy Suzanne Stephens), 1975.

two decades of American urban redevelopment which had led to massive destruction of the legacy of the nineteenth century and of American Beaux-Arts monuments, notably the demolition of New York's Pennsylvania Station in 1963 and the repeated threats to Grand Central Station in the 1970s. As Drexler explained it, the Beaux-Arts show was intended — among other things — to serve the same role that the preservation of Beaux-Arts monuments had brought in the cacophony of architectural positions that had emerged in the wake of 1968 in the US and in France. "It is scarcely surprising," he wrote in April 1974, "that once again architects agree about very little concerning the nature of their art. Indeed, if there is one thing about which they do agree, at least enough to sign manifestos and march on picket lines, it is the necessity of preserving what is left of Beaux-Arts architecture, wherever it might be found."[9] Critics immediately understood. Robert Campbell in the *Boston Globe* noted that "Only a fool would believe that the exhibition is really about the Architecture of the Ecole des Beaux-Arts,"[10] and the *Wall Street Journal* asked "Is this supposed to reflect a major shift in contemporary architecture or is this merely revivalism? After all," they continued, with reference to a recent show on nineteenth-century French academic art at the Metropolitan Museum, "technology and futuristic ideas aren't very popular at the moment, but delving into the 19th century certainly is."[11] But it was *New York Times* critic Ada Louise Huxtable — herself a former assistant in the MoMA Department of Architecture — who, as so often, had the most pertinent take in an article in the *New York Times Magazine* entitled "Beaux-Arts: The Latest Avant Garde." Huxtable noted:

> The exhibition is obviously about to break a taboo. It is going to make the architectural Academy respectable again, as is already happening with the Academy in painting and sculpture. At its deepest level, it urges us to examine the "moral imperative" of utility and sociology, the modernist doctrine that is the basis of today's building. That is attacking a very sacred cow. But the show has brought a lot of beautiful drawings and hidden history out of the closet ... The Museum of Modern Art is still performing its charter job of questioning the established order. This time, it is the order that it helped establish. And if it is making waves by looking backward, that is the nature of our times.[12]

While Drexler was keen to indicate that he was not endorsing any literal revival of the monumental classicism of the Beaux-Arts tradition — something which would gain more and more adherents in the coming years particularly as the show was adopted by John Barrington Bayley and his friends at "Classical America"[13] — he was eager to use the French Beaux-Arts to stimulate a debate over Modernism's lack of interest in context and historical precedent, and in particular its place in the period's large scale urban redevelopment. This was something that Jane Jacobs had already criticized in her seminal and popular *Death and Life of Great American Cities* of 1961. Drexler also wished to address the growing cleavage between social purpose and architectural education. If his ideas were only partially formed in 1974, by the time of the publication in 1977, on the other side of a storm of debate and controversy sparked by the event, his ideas were firm. In 1974 Drexler wavered between using the Beaux-Arts to suggest that the Modern Movement itself had become, on the one hand, a new academy — rigid and unquestioned — and, on the other, suggesting that one might, as Robert Venturi would soon put it, actually learn "the right lessons" from the Beaux-Arts.[14] Drexler had sold the idea to his fellow curators at a meeting in January 1974 with the following argument:

> The modern movement in architecture and design is usually described as the first conscious effort in the Western World to break with the inherited Greco-Roman tradition ... What is not yet a subject for coherent discussion is the body of ideas and buildings against which the modern movement rebelled: the Beaux-Arts. What the Beaux Arts and modern movement had in common were the convictions that architecture can be taught; that good teaching leads to good practice; that architects must sit in judgment on the societies for which they build; and that architects must be given the opportunity to build at ever larger scale, even if this requires modification of the social order.[15]

And he goes on: "The success of the modern movement in creating individual masterpieces of architectural form has not cancelled out its disastrous failures in urban planning — the area in which it most sought to justify its forms concepts. It is in urban planning that Beaux-Arts principles were most effective, not only in sustaining the character of the urban environment but in handling individual buildings at any scale. A Beaux-Arts architect was not so much interested in urbanism as in being urbane."[16] As a result Drexler organized two events, staged within weeks of the opening. First was a panel bringing together the young historians who were writing for the as-yet-unpublished book, to present their ideas under the guidance

of the two father figures of the American reconsideration of the nineteenth century: Henry-Russell Hitchcock and Vincent Scully. A week later a second panel of architects and critics, including Colin Rowe, Anthony Vidler, George Baird, and the historian of Viennese urbanism Carl Schorske was convened to debate the urbanism of the Beaux-Arts city as a critique of orthodox modernism.[17] As Drexler concluded his précis of the future exhibition, taken up again in the press release:

> A more detached view of architecture as it was understood in the Nineteenth century might also provoke a more rigorous critique of philosophical assumptions underlying the architecture of our own time. Now that modern experience so often contradicts modern faith, we would be well advised to re-examine our architectural pieties ... Two central concerns which merit reexamination today, according to the Museum, are the recognition of the importance of a building's system of internal circulation in determining it's architectural form, and the use of drawing as a flexible means of visualizing architectural form.[18]

The critique was at least two-fold. Modern architecture had become diagrammatic and at the same time students were taught to think of architecture models as ends in themselves. The lost art of Beaux-Arts rendering would reveal the extent to which students in the French academic tradition had been taught to understand the refinements of details and surface treatment, making the very construction of a building into an act of both civic responsibility and artistic investment. What Drexler shared at this point with two of his young authors, David Van Zanten and, in particular, Neil Levine, was a sense that Louis Kahn, and along with him the whole so-called Yale-Philadelphia axis that was recalibrating American architecture around geometric formality, processional progressions, and a material articulation of masonry walls, represented at once a new primitivism in Modernism, and a synthesis of the old Beaux-Arts/Modernist rift that was particularly American. "That our architecture is not all we might wish for, and that its efforts are not universally admired, are issues by now familiar to the layman as well as the professional," Drexler concluded his essay introducing the book. "To confront these problems is neither to lament the loss of innocence nor to betray a historic mission; rather it is to suggest a perspective that might free energy for a different kind of integration ... Drawing as scenography is an art that would have to be learned again, bringing with it the desire to design again something that can in fact be drawn."[19] Not surprisingly, under Drexler in the 1970s MoMA would devote itself to the collection and display of architectural drawings as never before.[20] But for our purposes it is interesting to note that the dénouement of

the essay comes with a discussion of Louis Kahn, whose desire "to enrich form involved history."[21] Drexler related Kahn's Roman-inspired plans not only to the archaeology of the 1950s and 1960s, but to his awareness of "nineteenth-century Beaux Arts interpretations … his work opens the post-modern (and this is perhaps the first, albeit lower case, use of the word at the Museum of Modern Art) because it refuses to accept reductionism as its measure of value."[22]

The young scholars whose work found its way into Drexler's volume as part of this larger historiographical enterprise were no less directly connected to the recalibration of American architecture away from the Miesian heritage of Skidmore, Owings and Merrill towards the work of Kahn and the latest experiments in meaning and symbolism represented by his Philadelphia colleague Robert Venturi, the single most important American figure in American architecture's linguistic turn around 1970. David Van Zanten had been an undergraduate in the early 1960s at Princeton – Venturi's own alma mater – where the architecture school was one of the last great hold-outs of Beaux-Arts education through the presence of the French émigré architect Jean Labatut, and alongside him the socially engaged art historian Donald Drew Egbert, who had long been engaged in a study of the French academic tradition as a kind of slow path to Modernism. Egbert had published extensively on the origins of modern architectural theory in the culture of Romanticism, notably in books on *Social Radicalism in the Arts,* and had taught a course in the history of the French academic tradition, recorded in a partial manuscript left unpublished at his death. Even after he enrolled as a doctoral student at Harvard in the late 1960s, Van Zanten remained so moved intellectually by Egbert's point of view that he was determined to publish the unfinished book, a project he completed after he developed his one-time mentor's own work in a major essay on the history of Beaux-Arts composition.[23] Van Zanten's approach to the French nineteenth century – recorded in a wide ranging and masterful description of the evolution of planning techniques in the training of the Beaux-Arts from the late eighteenth to the early twentieth century – came from a sense of the survival of Beaux-Arts ideology in American academia, in such unreformed centres as Princeton and the University of Pennsylvania, where Kahn taught for many years and where Van Zanten joined the faculty in 1971.[24] This was a point of view moreover which was celebrated in early 1977 – in conjunction with the publication of Drexler's delayed catalogue – with an exhibition at New York's Institute of Architecture and Urban Studies on "Princeton's Beaux-Arts and Its New Academicism: From Labatut to the Program of Geddes", Robert Geddes being the current Dean of the School, having moved in 1965 from the University of Pennsylvania.

Fig. 9 Robert Venturi, Denise Scott Brown, and Steven Izenour, The Duck vs. The Decorated Shed, from *Learning from Las Vegas* 1972.

By contrast, Neil Levine's work grew directly from the inspirational teaching of one of Kahn's greatest supporters, the Yale architectural historian Vincent Scully. Levine, following Scully's lead — and to a lesser extent that of another member of the Yale faculty, George Hersey — engaged with a wholly different set of issues more aligned with the period's interest in the semiotics of architecture and in Scully's dual interests in Kahn's powerful space-making and Venturi's re-evaluation of surface, ornament, and legibility. Scully was not only the spokesman behind what emerged in those years as the so-called Yale-Philadelphia axis, but also an early supporter of Venturi, whose 1966 *Complexity and Contradiction* had been published by MoMA with an introductory essay by Scully declaring it the most important utterance since Le Corbusier's *Vers une Architecture*.[25]

Levine's essay "The Romantic Idea of Architectural Legibility: Henri Labrouste and the Néo-Grec," was the tour de force intellectual exercise of Drexler's book. Self-consciously struggling to deconstruct Giedion's take on that seminal building (in *Bauen in Frankreich*), in which the rational cast iron structure was divorced from a consideration of its masonry envelope rich with historical references and a complex programme of inscriptions, Levine at once resituated Labrouste's undertaking in the complex cultural moment of French Romanticism of the 1830s — taking up a theme that Scully had developed in his earlier work on the evolution of American architecture of the same period, notably in the *The Shingle Style and the Stick Style: Architectural Theory and Design from Richardson to the Origins of Wright* (1971) — and made a case for "legibility" as the chief characteristic of that romanticism. Legibility was of course the preoccupation of the Yale-Philadelpia axis's search for meaning in architecture, and nowhere more than at the Yale's Department of the History of Art where a local brand of the period's fascination with semiology and the meaning of structures was conjugated in relationship to Vincent Scully's championing of Robert Venturi, Denise Scott Brown, and Stephen Izenour, whose *Learning from Las Vegas*, published in 1972, had been first taught as a Yale architectural studio during Levine's years in residence in New Haven. Venturi's idea of the deco-

rated shed (fig. 9) as a building that embraces a disjunctive separation of a working structure from a great sign professing its meaning is not hard to detect in Levine's insistence that precisely such a cleavage was pioneered by Labrouste's Bibliothèque Sainte-Geneviève (see fig. 6). This, he says, "can only be understood if one accepts the fact (sic) that the néo-Grec meant the replacement of classicism by a new way of thinking about architectural form and content," since "Néo-Grec architects were the first to make the radical distinction between structural principle and decorative form."[26] This rather willful reading of the envelope of Labrouste's library which is everywhere detailed in relation to static forces and interior programme was meant to underscore an elaborate "literary expression" in the building, something that Levine went on – in Middleton's follow up conference at London's Architectural Association in 1978 – to develop in a breath-taking reading of the building in relationship to Victor Hugo's prescription that the book had killed the building.[27]

Nowhere was this connection with emerging Post-Modern theory and practice more overtly underscored than in an article David Van Zanten wrote towards the end of the exhibition's run, hoping to counter what he thought were false appraisals of the whole undertaking. "The more we – like the show itself – concentrate on these French ideas, the more we realize that we are doing so in order to understand the architecture being produced around us … the Modern show is retrospective, not because the subject matter was 19th century drawings, but because it was really about Kahn, Venturi and Moore, Mies and Johnson."[28] The theme was returned to by the recently appointed architecture critic of the *New York Times*, Scully protégé Paul Goldberger, who noted that "Labrouste's work is subtle, rich in meaning and invention, and in a certain sense can be said to have paved the way for the work of such current architects of historical allusion as Charles Moore and Venturi & Rauch."[29]

From the earliest draft of the press release Drexler hoped that the event would go beyond a change in values in the design of individual buildings to catalyze a critical appraisal of the Modernist city: "Although the modern movement succeeded in creating individual masterpieces, it has failed disastrously in urban planning. In this area Beaux-Arts principles functioned more effectively by sustaining the character of the urban environment while simultaneously handling the design of individual buildings at any scale."[30] With its focus on the competition drawings for the Grand Prix, in which – with one notable exception – a specific site was never given for the students's projects, the display scarcely carried this message. Some overall urban views of Charles Garnier's Opera did to an extent for the French nineteenth century. But the message, in the last gallery of photographs, was centred primarily on the larger

context of the monument in the urban fabric. Celebrating late nineteenth- and early twentieth-century American civic structures from the New York Public Library and Pennsylvania and Grand Central Stations — long the antitheses of MoMA's view of an appropriate modern architecture — to the Detroit Public Library and the Pan American Union in Washington, D.C., buildings all photographed in larger urban contexts, the message of the lost values of the American City Beautiful Movement came to the fore as the show concluded. Most prominent here was that spectacular early testing ground of City Beautiful ideals, the fairgrounds of the 1893 World's Columbian Exposition in Chicago.

This content was given equal billing in the two round table events, held on the evenings of 11 and 18 November 1975. In these two round table discussions the larger critique of the city, hard to discern in the display in the galleries, was made clear. The second evening was devoted loosely to the theme of the modern city, with the modern city now understood to be a flexible concept that might include things which some felt compatible, others contradictory — namely the city of Haussmann as well as that of Le Corbusier and Hilbersheimer. And the question was posed implicitly if the nineteenth-century city ("The Academic City" as it was called in a series of papers published in *Oppositions*, the magazine of the Institute of Architecture and Urban Studies shortly thereafter) was anti-modern or proto-modern. George Baird, whose own credentials would soon include editing a volume on *Meaning in Western Architecture*, announced to the audience "My understanding was that part of the polemical intent of this exhibition was to use the Beaux-Arts as a challenge to the Modern Movement, certainly as we know it today in its anti-urban tendencies. That's a fight I am certainly anxious to see fought. I was somewhat doubtful," he continued, "of whether or not the Beaux-Arts was the weapon I would have picked up to do it."[31] Although the discussion rarely moved to specifics it encapsulated the period's re-engagement with the appreciation of the historical city, even its massive transformation in the mid-nineteenth century in response to the pressures of modernization. Paris and Vienna, the latter particularly in the comments of historian Carl Schorske, were cited as exemplars, even if, of the great nineteenth-century cities, Barcelona might have held more lessons for gridded Manhattan. Colin Rowe showed a few slides contrasting the figure-ground relationships in the nineteenth century with those of the neighbourhoods of German Modernist *Siedlungen* and the great expansion project of Amsterdam South where, he quipped, "there is no street left at all" — a synopsis in short of the position he had been preaching for some years and which would soon be encapsulated in his seminal *Collage City*, edited with Fred Koeter and

published a year after Drexler's *Architecture of the Ecole des Beaux-Arts* appeared. Anthony Vidler moderated and tried to push the group to see the city in a larger historical perspective going back to the Enlightenment, Rowe spoke of the Saint-Simonians and utopian socialists, and all of them focused on the relationship between the individual monument and the larger shape of the city in what they agreed was the capitalist or bourgeois city of the nineteenth century. Over and over the suggestion was made that rediscovery of this city, that Le Corbusier had set out to critique, held lessons for the present, as faith in the Modernist project was clearly everywhere greatly diminished.

Alongside the discussion of the monument, the city of streets and boulevards, and the role of historical reference and ornament, was the question of morality. Drexler admitted that history was still held in suspicion: "I think it is an interesting habit of mind of our own time to equate a refusal to be cut off from history as a reactionary moment."[32] But it was Rowe who concluded on the topic of Modernism and morality: "In the Modern Movement the messianic drive has been really rather spectacular. It is not possible to write a history of modern architecture without having a considerable background in theology and it is really a subject I believe increasingly for a theologian if not an anthropologist. It is a mission either to bring history to an end … or to bring paradise to earth."[33] Within two years of course David Watkin would make the same point in a vastly different context, to vastly different conclusions, and with vastly different influence on the subsequent development of classicism and Post-Modernism.

NOTES

1. There is a growing body of historiographical literature on these four figures. On Pevsner see Fulvio Irace, *Nikolaus Pevsner, la trama della storia* (Milan: Guerini Studio, 1992); Timothy Mowl, *Stylistic Cold Wars: Betjeman versus Pevsner* (London: John Murray, 2000); and Peter Draper, ed., *Reassessing Nikolaus Pevsner* (Aldershot: Ashgate, 2004). On Giedion see Sokratis Georgiadis, *Sigfried Giedion: eine intellektuelle Biographie* (Zürich: Eidgenössische Technische Hochschule, Institut für Geschichte und Theorie der Architektur/Ammann, 1989) and Detlef Mertins, "Transparencies Yet to Come: Sigfried Giedion and the Prehistory of Architectural Modernity" (Ph.D. Dissertation, Princeton University, 1996); on Hitchcock see Frank Salmon, ed., *Summerson and Hitchcock: Centenary Essays on Architectural Historiography* (New Haven and London: Yale University Press, 2006). And on Reyner Banham, see Nigel Whiteley, *Reyner Banham, Historian of the Immediate Future* (Cambridge, Mass.: MIT Press, 2002).
2. Brent C. Brolin, *The Failure of Modern Architecture* (New York: Van Nostrand Co., 1976); Peter Blake, *Form follows Fiasco: Why Modern Architecture hasn't Worked* (Boston: Little Brown, 1977) (an Italian edition appeared in 1987); David Watkin, *Morality and Architecture, The Development of a Theme in Architectural History and Theory from The Gothic Revival to the Modern Movement*. Oxford: Clarendon Press, 1977; Charles Jencks, *The Language of Post-Modern Architecture* (New York: Rizzoli, 1977).

3. Reviewed by David Watkin, "Conservative Principle," *Apollo* 103, no. 193 (March 1978): 229-30.
4. Robin Middleton, "Viollet-le-Duc and the Rational Gothic Tradition" (Ph.D. Thesis, Cambridge University, 1958) and John Jacobus, "The Architecture of Viollet-le-Duc," (Ph.D. Thesis, Yale University, 1956). On Middleton see Barry Bergdoll, "Introduction: The Matter of Fragmentation: a Homage to Robin Middleton," in Barry Bergdoll and Werner Oechslin, eds., *Fragments, Architecture and the Unfinished: Essays Presented to Robin Middleton* (London: Thames & Hudson, 2006): 11-19.
5. Robin Middleton, guest editor, *AD Profile 17: The Beaux-Arts, Architectural Design* 48, nos. 11-12 (1978).
6. *La Modernité ou l'esprit du temps.* Paris: Editions L'Equerre, 1982; and Paul Chemetov, ed., *La Modernité un projet inachevé, 40 architectes* (Paris: Editions du Moniteur, 1982).
7. I am grateful to Suzanne Stephens for lending her remaining talisman, photographed here. She recalled in an email to the present author that "it was done as an ironic comment, an idea that eluded some historian [Felicity Scott] ... writing about it in *Perspecta*. Arthur [Drexler] was at first exasperated and then had to have a button. We gave it to him."
8. On Arthur Drexler see Felicity Scott, "When Systems Fail: Arthur Drexler and the Postmodern Turn," *Perspecta 35: Building Codes* (2004): 152-71, reprinted in revised form as Chapter 3 of Felicity Scott, *Architecture or Techno-Utopia, Politics after Modernism* (Cambridge, Mass: MIT Press, 2007): 59ff.
9. Memo No. 34, preparatory notes for MoMA press release, April 30, 1975. MoMA archives.
10. Robert Campbell, "This show is a statement," *Boston Evening Globe* (10 November 1975). Copy in The Museum of Modern Art Archives CUR 1110.
11. Manuela Hoelterhoff, "Escape from a World of Glass Boxes," *The Wall Street Journal* (2 December 1975). Copy in the Museum of Modern Art Archives CUR 1110.
12. Ada Louise Huxtable, "Beaux Arts - the latest avant-garde," *The New York Times Magazine* (Sunday 26 October 1975). Copy in The Museum of Modern Art Archives CUR 1110.
13. Letter from John Barrington Bayley to Arthur Drexler, 2 December 1977, MoMA Archives, Box 315. "Dear Arthur, First the magisterial work on the Ecole which I glanced at with extreme pleasure, looked in the index, found my name, and then found myself on two pages – the médallion d'honneur. I felt wonderful."
14. Robert Venturi, "Learning the right lessons from the Beaux-Arts," *Architectural Design* 49, no. 1 (1979): 23-31.
15. Arthur Drexler, "Beaux-Arts," memorandum, 31 January 1974. Museum of Modern Arts Archives Reg. 1110.
16. Drexler, memorandum, 31 January 1974.
17. Tapes of both evenings are held in the archives of the Museum of Modern Art and deserve to be transcribed as fascinating historical documents, invaluable to the historiography of nineteenth-century architecture.
18. Drexler, Memo. No. 34, Draft Press Release, 30 April 1975, Museum of Modern Art Archives.
19. Drexler, "Engineer's Architecture: Truth and its Consequences," in Drexler, ed., *The Architecture of the Ecole des Beaux-Arts*. New York: The Museum of Modern Art (distributed by MIT Press, Cambridge, Mass.), 1977.
20. See Barry Bergdoll, "The Museum of Modern Art," *A + U (Architecture and Urbanism)* Tokyo 2008:04, no. 451: 66-73.
21. Drexler, *Beaux-Arts* (1977): 56.
22. Ibid., 58.
23. Donald Drew Egbert, *The Beaux-Arts Tradition in French Architecture*, with an introduction by David Van Zanten (Princeton: Princeton University Press, 1980).
24. David Van Zanten, "Architectural Composition at the Ecole des Beaux-Arts from Charles Percier to Charles Garnier," in Drexler, *Beaux-Arts* (1977): 111-324.
25. Vincent Scully, introduction to Robert Venturi, *Complexity and Contradiction in Architecture* (New York: The Museum of Modern Art, 1966).
26. Neil Levine, "The Romantic Idea of Architectural Legibility: Henri Labrouste and the néo-Grec," in Drexler, *Beaux-Arts* (1977): 325-416, here cited p. 332.
27. Neil Levine, "The book and the building: Hugo's theory of architecture and Labrouste's Bibliothèque Ste.-Geneviève," in Robin D. Middleton (ed.), *The Beaux-Arts and Nineteent-Century French Architecture* (London:

Thames and Hudson, 1982): 138-73.
28. David Van Zanten, "Remarks on the Museum of Modern Art Exhibition: "The Architecture of the Ecole des Beaux-Arts", *Journal of the Los Angeles Institute of Contemporary Art* (May, 1976).
29. Paul Goldberger, "Beaux-Arts Architecture at the Modern," *The New York Times* (29 October 1975): 46. See also Goldberger's follow up article "Debate Lingers after Beaux-Arts Show," *The New York Times* (6 January 1976): 30.
30. Drexler, Memo. No. 34.
31. Reel-to-Reel tape recording of the symposium, MoMA archives.
32. Ibid.
33. Ibid.

The English Vision: The Picturesque Revisited

CHRISTOPHER WOODWARD

The English Vision: The Picturesque in Architecture, Landscape and Garden Design of 1982 is, for me, the most suggestive of David Watkin's books. I read the book as a Cambridge student of eighteen; on the first day of holiday between the Lent and summer Terms I borrowed a Ford Escort from my father and Youth-Hostelled from garden to garden. At Stowe I puzzled at my first ha-ha; at Stourhead I was not sure what was real; at Rousham it seemed impossible that a countryside of furrows, tractors and cattle could imperceptibly change into a grey-skied Arcadia guarded by a bronze nymph. The book was a revelation: the first to show that the raw materials of landscape could be transformed by an artist's eye.

The English Vision studied how in the early eighteenth century writers, artists and architects created a Picturesque way of seeing and composing architecture and landscape. It argued that "the theory and practice of the Picturesque constitute the major English contribution to European aesthetics."[1] It is also a personal interpretation of Englishness — although Watkin would never use the "I" word — and continues its themes into the present day. One theme is that "make believe" is an English characteristic, whether in our preservation of the façades of ancient institutions such as the Church or the monarchy, or "the romantic chain of sham castles" from Herstmonceaux in the fifteenth century to Castle Drogo in the twentieth. "In the meantime, with the death of the Modern Movement, stylistic pluralism has been established as the architectural fashion of the 1980s," the book concludes, in a note of expectant triumph. "Presumably [Uvedale] Price and [Richard Payne] Knight

would have approved."[2] Later that decade Quinlan Terry designed Richmond Riverside as a Picturesque composition, a single block of offices and retail broken up into facades varied in style and composed as a painterly silhouette. Modernist critics showed photographs of how the sash windows did not align with the strip-lit open-plan interiors. But the offices were let, and on any fine day hundreds of people sit below the windows to eat their lunch.

The English Vision can be seen as one of the many breaches Watkin has made in the enceinte of Modernism: a flanking attack, perhaps. It argues that the English enjoyment of architecture is visual, not moral or functional. Indeed – think of Richmond Riverside or, say, Tower Bridge – the less a building expresses its function or structure the more popular it tends to be. Modernism mistrusted such purely visual pleasure as superficial, although a critic might argue the "Modernist Picturesque" deserves its story told. Dame Sylvia Crowe, for example, translated Capability Brown into the landscapes of power stations and the grass humps of traffic roundabouts. To Watkin, however, the "Townscape" movement of the 1940s – an approach still taught in architecture schools in the 1980s – was in itself superficial in its understanding of the Picturesque. It appropriated the Picturesque innovation of presenting an un-built design as an existing landscape, in order to disguise its concrete brutality: new estates were "extensively illustrated in *The Architectural Review* in crudely impressionistic sketches by Gordon Cullen which always included windswept patios and outdoor cafes enlivened with metal furniture and shallow concrete tubs."[3]

The book might also be understood as a romantic reaction to the "political" approach to the landscape begun by left-wing historians in the 1970s, exemplified, of course, by John Berger's interpretation of Gainsborough's Mr and Mrs Andrews as a celebration of landownership and wealth. In 1980 *The Dark Side of the Landscape* by John Barrell – also teaching at Cambridge – had presented a Marxist view of the meanings implicit in the countryside. *The English Vision*, however, presents the realities of economics and society as metamorphosed into poetic illusion; it is happiest at the magical moment when a well-fed cow nibbles the grass at the base of an Ionic temple.

The 1970s and 80s were coincidentally the heroic age of garden history and the beginning of garden conservation. The Garden History Society was founded in the late 1960s, when Mavis Batey recalls being asked: "Garden history – what's that?"[4] the Museum of Garden History was founded in 1977, The National Council for the Conservation of Plants and Gardens in 1978, and in 1979 Sir Roy Strong organised at the V&A the first ever exhibition about garden design. Gardens were restored: the

Fig. 1 Heveningham Hall, Suffolk: in a project begun in 1995 Kim Wilkie implemented Capability Brown's unexecuted design for the lake and surrounding landscape. (Kim Wilkie Associates)

amphitheatre at Claremont was uncovered and shifted back into shape by a JCB. Period reconstructions began: as I write, I can see out of the window the knot garden designed at the Museum of Garden History by the Marchioness of Salisbury. The summit of this approach came at Heveningham Hall in Suffolk where, in 1995, Kim Wilkie was commissioned to create new gardens to complement the house designed by Robert Taylor and James Wyatt. In the foreground it was decided to implement the unexecuted Brown design for a lake two kilometres in length (fig. 1). It is an epic achievement in its own right, but the approach taken is also a recognition that Brown was unsurpassed at creating a landscape on this scale.

A strength of garden history was — and still is — how it attracted scholars from other disciplines. The appreciation of eighteenth-century gardens was inseparable from the cult of the English topographical view, initiated by the scholarship of John Harris and the purse of Paul Mellon. Paintings such as Balthazar Nebot's views of the avenues at Hartwell or Thomas Robbins' delineation of the Rococo follies at Painswick became iconic. The anonymous artist who painted Claremont was dubbed by Harris "The Master of the Tumbled Chairs;" mischievous, of course, but — as in saleroom values — expressive of the new recognition given to this school of art. Plant history also became a narrative, with writers such as Penelope Hobhouse showing

how the choice of plants available to a gardener was transformed by a century of trade, empire, and exploration. In 1973 George Clarke wrote the first article on the political allusions at Stowe; it re-introduced the idea that a garden could be a political statement.[5] Clarke was a history master at the school and he had become curious at how the temples and sculpture corresponded to the battles, Parliamentary Acts and Whig politics he taught in the classroom. Above all, garden history has attracted literary historians. In his 1985 biography of Pope, Maynard Mack placed gardening as central to our understanding of the man.[6]

In this context the distinctive contribution of David Watkin was to introduce intellectual and philosophical history. Together with John Dixon Hunt – whose *Figure in the Landscape* was published in 1978 – he showed that the history of gardens could be read as the history of ideas. In particular, *The English Vision* showed that we cannot understand the innovation of the Picturesque unless we go beyond Brown, Kent and Bridgeman and read Kames, Addison and Locke; the new aesthetic of the Picturesque does not begin with a spade or a sketchbook but with Locke's argument in his *Essay Concerning Human Understanding* (1690) that the mind works by the association of accumulated memories. It is this aspect of *The English Vision* which makes it a timely book to re-read today. Two of the strongest themes in debate about contemporary design are the desire, firstly, that garden design should be recognised as an art form and, secondly, that it should have a higher intellectual credibility. And it is eighteenth-century Britain which – time and time again – is cited to support each case.

In the autumn of 2007 the designer and writer Dan Pearson spoke at the first Symposium of Thinkingardens [sic], an online forum sponsored by the Royal Horticultural Society.[7] Its ambition is "to get gardens out of the ghetto of gardening [and for] gardens to be seen as a serious education and provocation, not just a wonderful pastime." In Japan, Pearson described, it is understood that it takes twenty-five years to become a true gardener: a knowledge of plants must be supported by an education in philosophy and art. And such seriousness is expected of the garden visitor: at the moss garden Saiho-Ji forty minutes of spiritual preparation is required before being permitted to enter. In Britain, he suggested, it is necessary to go back to the eighteenth century to discover such expectations.

In *The Arcadian Friends* – published at exactly the same moment – the historian and critic Tim Richardson writes: "It probably sounds absurd to twenty-first century ears, attuned to the concept of garden and gardening as a simple-minded outdoor version of DIY, but for four decades from this point [that is the first half of the eighteenth

century] garden design constituted the cutting edge of international avant-garde art, with Britain leading the way."[8] Is there a villain? Who de-intellectualised gardens? To Richardson, it is "Capability" Brown, his lawns denuded of symbols or challenges. To others it is the Victorians: bedding plants, botanical novelty, and competitive masses of colour. Or is it Gertrude Jekyll, whose muddy old boots have become the icon of twentieth-century gardening? And what does that tell us about changing attitudes to the relationship between intellect and activity (fig. 2)?

Fig. 2 In the twentieth century Gertrude Jekyll's boots became gardening's most iconic artefact. Here they are seen placed on the tomb of John Tradescant at the Museum of Garden History, in preparation for the Jekyll retrospective of 1993 (*The Independent*)

Richardson continues with talk of "the garden's suppression as an art form by the mainstream art world. [...] As I write this I have in mind a recent diktat from the Arts Council of England to the effect that gardens are not eligible for grants because they do not count as art."[9] A myth, I assumed, and emailed the Council. "The ACE supports projects for funding including land and environment art, landscape art and design, and projects for art in the public realm in garden or landscape settings, so arguably there is significant support for contemporary development in the art of the garden," came the reply.[10] What this means is that the Arts Council does not consider a garden designer as an artist.

In 2005 Richardson co-founded VISTA together with Noel Kingsbury, aspiring to introduce cultural criticism to the discussion of gardens: a Marxist wrote about "Capability" Brown, and a feminist about women in the cut flower industry. It sold 1,000 copies, an exceptional number for a garden book without a single picture. VISTA has become a programme of debates at the Museum of Garden History. They are podcast to readers of *Gardens Illustrated*, an early indication – perhaps? – of a widening interest. There is, undeniably, a zeitgeist.

Last summer Germaine Greer chewed up the Chelsea Flower Show in *The Guardian*: "Having fled Chelsea after a mere 20 minutes at the flower show, I find myself puzzled by the degree of revulsion I felt…"[11] Her criticism was the absence of ideas or intellect, and the enervating competitiveness of colour, expense and "trophy" plants. As one contrast she chose the Veddw in Monmouthshire, created by Anne Wareham and her husband Charles Hawes (fig. 3). A unique feature of this new and evolving garden is that Wareham and Hawes invite criticism from journalists and ordinary visitors, in a deliberate contrast to what they perceive as a culture of polite

compliments. Why, Wareham asks, are gardens not reviewed in the same way as films, books or new plays? Again, the eighteenth century is cited as a precedent: a garden such as Stowe or West Wycombe was a talking point, an arena for a fencing game of wit, patronage and satire. Wareham was one founder of Thinkingardens; a second was Stephen Anderton, one of the country's leading gardens journalists. His particular ambition is to have the subject elevated from the weekend gardening supplements to the arts pages — and he, too, cites Stowe as one precedent for the prominence of gardens in cultural debate.[12]

Fig. 3 The Veddw, Monmouthshire, a 'thinking garden' created by Anne Wareham and her husband Charles Hawes

However, the most substantive connection between the eighteenth century and the present day is *The New Arcadian Journal*, the periodical begun in 1981 — the year before *An English Vision* was published. It was begun by Dr Patrick Eyres and a circle of colleagues at the Bradford College of Art, united by an enthusiasm for the eighteenth-century landscape garden. Begun at Eyres's kitchen table — and today a handsome collaboration between writers and print-makers — each year the *NAJ* studies a garden or a theme of political, literary or sexual symbolism. In its study of Wentworth Castle, for example, it discussed the construction of Stainborough Castle, a mock-Gothic eyecatcher, by the Earl of Strafford. Strafford was a Jacobite, *NAJ* revealed, and the juxtaposition of the "castle" with the new house of Wentworth Woodhouse — built by an upstart Whig — explained as a political dispute.[13]

Perhaps the most characteristic *NAJ* hero is Thomas Hollis (1720–74), the heir to a mercantile fortune who in 1741 bought 3,000 acres of land in West Dorset.[14] Hollis did not build a big house, or make an ornamental garden. He learned to farm, built schools and chapels, but also created what the *NAJ* dubbed "The Invisible Pantheon." He renamed the fields, farms and woods after his heroes and ideal virtues as a patriot, anti-Catholic and radical Whig. To the modern visitor it is a disconcerting contrast: it is archetypal rolling countryside but directions instruct him to drive past Republic, Plutarch and Cicero on the left, before passing through Common Wealth, Free State and Revolution. Each is a field; there is Marvell's Farm; "Locke's" has become a B&B, and a modern bungalow continues the name of "Coligny," the Protestant martyr of St Bartholomew's.

Fig. 4 Overview of Stockwood Park, Luton, by Chris Broughton, commissioned for the *New Arcadian Journal*, 2006

The *NAJ* has dedicated its 2008 issue to Ian Hamilton Finlay (1925–2006). It has been an advocate of the poet, artist and garden maker ever since its first issue, in which it printed The Monteviot Proposal for a contemporary sculpture garden. It is Finlay who is the most eloquent connection between the two periods. Little Sparta, the garden he began with his wife Sue at an old farm called Stoneypath in the Pentland Hills forty years ago, has recently been voted the most significant twentieth-century work of art in Scotland.[15] However, it was a conscious reinterpretation of an eighteenth-century garden, as is evident not only in its composition and scenes but in the placement of temples and symbolic sculpture and inscriptions. Each reinvents eighteenth-century precedents in order to express Finlay's uneasiness at modern civilisation: "Apollo: His Muses / His Missiles / His Music" is inscribed over the architrave of the Garden Temple. In the Woodland Garden lines of mossy corrugated concrete blocks suggest fallen columns at first sight; in fact, they signify tank tracks. A second Arcadia he created is Stockwood Park at Luton, commissioned by the local authority in 1986 and reopened in 2008 after a restoration funded by a major grant from the Heritage Lottery Fund (fig. 4).[16] Indeed, he presented his designs as prints in the manner of Claude Lorraine, whose drawings of landscape – engraved in the *Liber Veritatis* – were so influential on designers of the generation of William Kent.

Little Sparta is one of three contemporary works which are name-checked in every single debate about the artistic or intellectual status of gardens. The second is The Garden of Cosmic Speculation made by Charles Jencks at Portrack House near Dumfries. The third is the garden begun by Derek Jarman at Prospect Cottage, Dungeness, in 1986. It is this third garden which, I think, takes us closest to the crux of the debate: the gardener's unique relationship between conceptual thought and practical activity. It was begun in 1986. "The garden started accidentally" remembers "HB," Jarman's amanuensis: "… a sea-worn driftwood staff topped with a knuckle of beachcombed bone was used to stake a transplanted dog-rose, and an elongated lowtide flint protected a seedling seakale from careless feet."[17] It became a single visual composition; it also became symbolic and rhetorical. In his poems Jarman presented the rusted metal coils, tilting but upright stakes and resilient plants as

expressions of mortality and hope in the time of HIV. It is recognised as a work of art, and has in turn inspired music, photography, and film. But what is also apparent is the physicality of the garden: it is a garden of texture and smell, of hard work in a windy landscape, of bending down to shelter plants in cold, shifting pebbles.

In 2008 Jarman's work is being celebrated in a retrospective at the Serpentine Gallery and Prospect Cottage has an international reputation.[18] Little Sparta, as previously mentioned, has been voted Scotland's most significant work of modern art. Why, then, is there a perception of inferiority? Who is resisting the argument that gardens are works of art and intellectual engagement? It is possible to criticise the media or the Arts Council but the greater challenge is, perhaps, in the nature of gardening itself. Garden design is unique in the visual arts in its relationship between thought and activity, mind and body: it is the only medium in which the rhythms and textures of the physical process take over from thought. "Your brain goes into your fingers," says Victoria Glendinning, author and gardener.[19] Gardens have always been created by writers, philosophers and painters. Nevertheless, a garden created by an intellectual is not necessarily an "intellectual garden." Indeed, it can be the very opposite: a deliberate escape from the weight and throb of the mind. Think of Pope at Twickenham, Colette's erotic musings on roses, or in more recent times the poet James Fenton's proud delight in dahlias in his column for *The Guardian*. Gardening occupies a unique place, somewhere between poetry and cookery. And it is a good place to be.

This relationship has been most sensitively explored in the contributions to *Hortus*, the literary journal begun by David Wheeler which celebrates its twenty-first birthday this year. When you visit a garden described in *Hortus* – say, Katherine Swift's at Moreville Hall in Shropshire – it is a physical and visual experience. But it also has a second existence, invisible to that visitor: as an experience lived and remembered by the maker. "Is 'garden' a noun or a verb?" asks Niall Hobhouse. Both, he suggests. In 2007 Hobhouse caused a stir in the gardens world with "The Hadspen Parabola."[20] He invited designs for the walled garden on his estate in Somerset, Hadspen, a space built on the plan of a Parabola in the early nineteenth century. It was the first open

Fig. 5 Coombe Farm, Devon, showing the courtyard dedicated to Hermes in the garden created by Alasdair Forbes. The ground plan is a labyrinth, and the buttresses on the old barn are to be read as herms to the primitive, chthonic, apotropaic Hermes. (Alasdair Forbes)

competition to design a garden for a country estate; the on-line forum became a debate about the relationship between design and planting. What struck Hobhouse was a paradox at the centre of our obsession with gardening: "Gardening is like a challenge in Greek mythology. Like the curse of Sisyphus. Gardeners are condemned for ever to make these wonderful things which always escape from them."[21] It is a medium uniquely transient, and uniquely subservient to Nature. But Nature is, of course, its strength – Nature, and the fourth dimension of Time.

In February 2008 Noel Kingsbury published the first article on Plaz Metaxù, a garden in a valley in North Devon.[22] Its maker is Alasdair Forbes, who acquired the 32-acre Coombe Farm in 1992. Plaz Metaxù – its name means "the space between" – was immediately recognised as the most significant garden of thought to be made in Britain since Portrack and Little Sparta; like Jencks and Finlay, Forbes is not a professional garden designer. The garden is dedicated to the Gods of Greek mythology. The old farmyard has become a courtyard of Hermes (fig. 4); in a second courtyard a mimosa flowers into a yellow burst of gold, representing Zeus's rape of Danae. An apple orchard is the journey of Eros, and Hades is a high hedged enclosure, approached by a winding path of spring flowers which represents the escape of Persephone. It is one of the most poetic reinventions of classical antiquity created since the eighteenth century. It is also a highly contemporary garden: the sculpture is abstract, Hermes is represented as the God of modern communications and Rilke and Emily Dickinson are potent influences. Most significantly, his view of Greek myth is mediated by the archetypal psychology of James Hillman (born 1926). In books such as *The Myth of Analysis* (1998) Hillman argued for a polytheistic understanding of the soul in contrast to the monotheism of Christianity. The Greeks understood, he wrote, that we are each a tussle of fantasies, and each is personified by a God. Plaz Metaxù presents what Hillman called "divine discontent." It is a landscape alive with the Gods.

 Forbes believes, one realises, that a landscape garden is the ideal medium by which abstract ideas of philosophy or psychology can be translated into visible and tactile form. Put another way, a painting or a work of architecture could not express the profundity and nuance of his ideas of humanity, divinity and the soul. Other arts have space, colour and form; the garden maker can add to these the extra dimensions of Time and Nature, the weather and the seasons, of physique and sensuality. We are reminded of what the eighteenth century understood so well: the landscape garden is the most poetic of the visual arts.

NOTES

1. David Watkin, *The English Vision: The Picturesque in Architecture, Landscape and Garden Design* (London: John Murray, 1982): viii.
2. Watkin, *English Vision* (1982): 199.
3. Watkin, *English Vision* (1982): 199.
4. See the inaugural issue of *Hortus* (No.1, 1987) for her description of the formative years of garden history and conservation.
5. George Clarke, "Grecian Taste and Gothic Virtue: Lord Cobham's Gardening Programme and its Iconography,", *Apollo*, 97 (June 1973): 566–71.
6. Maynard Mack, *Alexander Pope: A Life* (New Haven and London: Yale University Press, 1985).
7. For a report see www.thinkingardens.co.uk/Symposium.
8. Tim Richardson, *The Arcadian Friends: Inventing the English Landscape Garden* (London: Bantam, 2007): 176.
9. Richardson, *Arcadian Friends* (2007): 256.
10. Email from Eve Sullivan (Arts Council England) to the author (27 July 2007).
11. *The Guardian* (4 June 2007).
12. Conversation with the author (26 February 2008).
13. Patrick Eyres, ed., *Wentworth Woodhouse: A Landscape of Georgian Monuments*, *NAJ* no. 59/60 (2006).
14. Patrick Eyres, ed., *The Invisible Pantheon: The Plan of Thomas Hollis as inscribed at Stowe and Dorset*, *NAJ* no. 55 / 56 (2003).
15. See *Scotland on Sunday* (5 December 2004). The newspaper polled fifty gallery directors, art historians and artists.
16. See "Three English Gardens by Patrick Eyres", in Ian Hamilton Finlay *Selected Landscapes* (ed., Patrick Eyres), *NAJ* no. 61 / 62 (2008): 106–107.
17. Preface by "HB" in Derek Jarman, *Derek Jarman's Garden* (London: Thames & Hudson, 1995): 5.
18. *Derek Jarman Curated by Isaac Julien* (2008).
19. Conversation with the author (5 April 2008).
20. www.thehadspenparabola.com.
21. Conversation with the author (5 February 2008).
22. Noel Kingsbury, "Symbolic Intention", in *House and Garden* (February 2008).

Bibliography of David John Watkin, 1961–2008

1961
"Lamp-Posts: Decline and Fall in Cambridge," *Architectural Review*, June, 423–26

1964
"'The Hope Family' by Benjamin West," *Burlington Magazine* 106, December, 571–72

1966
"Charles Kelsall: The Quintessence of Neo-Classicism," *Architectural Review*, August, 109–12

1967
"Letheringsett Hall, Norfolk," *Country Life* 141, 5 January, 18–21
"Some Dufour Wallpapers: A Neo-Classical Venture into the Picturesque," *Apollo*, June, 432–35
"Shotesham Park, Norfolk," *Country Life* 142, 10 August, 312–16

1968
BOOK
Thomas Hope (1769–1831) and the Neo-Classical Idea, London: John Murray. 316 pp. 101 illus.
REVIEW
Review of Hugh Honour, *Neo-Classicism*, in *The Observer*, 15 December, 29

1969
"The Virtue of Magnificence: Spanish Sources for the Heraldic Sculpture at King's College Chapel," *Architectural Review* 145, February, 139–40
"Childerley Hall, Cambridgeshire," *Country Life* 146, 6 November, 1170–73

1970
"Buckland Filleigh, Devon," in *The Country Seat: Studies in the History of the British*
Country House presented to Sir John Summerson, John Harris and H.M. Colvin, eds., London: The Penguin Press. 229–33

1971
Household Furniture and Interior Decoration by Thomas Hope, with a new Introduction by David Watkin, New York: Dover Publications, Inc.. v–xiii. Illus.
Review of John Harris, *Sir William Chambers, Knight of the Polar Star*, in *The Spectator*, January, 20
Review of Robert Macleod, *Style and Society: Architectural Ideology in Britain, 1835–1914*, in *The Spectator*, 10 July, 61
Review of Paul Thompson, *William Butterfield*, and Phoebe Stanton, *Pugin*, in *The Spectator*, 11 December, 854–55

1972
BOOK
Ed., *Sale Catalogues of Libraries of Eminent Persons*, vol. 4, *Architects*, London: Sotheby with Parke-Bernet. 283 pp.
ARTICLES
"Warburg and Gombrich," *Encounter*, April, 76–80
"A Pioneer of English Neo-Classicism: C.H. Tatham" (with Christopher Proudfoot), *Country Life*, 13/20 April, 918–21
"The Furniture of C.H. Tatham" (with Christopher Proudfoot), *Country Life*, 8 June, 1481–86
Review of J. Mordaunt Crook, *The British Museum*, in *Apollo*, November, 459–60

Review of Isobel Rae, *Charles Cameron, Architect to the Court of Russia*, and Anthony Cross, ed., *Russia under Western Eyes, 1517–1825*, in *Apollo*, December, 567–69

1973

ARTICLE

"The Country Houses of C.R. Cockerell (1788–1863)," *NeoClassicismo*, Atti del convegno internazionale promosso dal Comité International d'Histoire de l'Art, Università degli Studi di Genova, 118–22

REVIEWS

Review of J.M. Richards and Nikolaus Pevsner, eds., in *The Anti-Rationalists, New Statesman*, 23 February, 274–75

Review of Nikolaus Pevsner, *Some Architectural Writers of the Nineteenth Century*, and Marcel Franciscino, *Walter Gropius and the Creation of the Bauhaus*, in *Apollo*, July, 70

Review of J. Mordaunt Crook, *The Greek Revival*, and Derek Linstrum, *Sir Jeffry Wyatville*, in *Architectural Review*, July, 73–74

Review of *Marble Halls* [Exhibition, Victoria and Albert Museum], in *New Statesman*, 28 September, 443–44

Review of J.M. Richards, *The Castles on the Ground*, and Alan Jackson, *Semi-Detached London*, in *New Statesman*, 3 November, 777–78

1974

BOOK

The Life and Work of C.R. Cockerell, London: Zwemmer. 272 pp. 170 illus.

ARTICLES

"The Making of the Ashmolean Museum," *Country Life*, 7 February, 242–45

"The Work of William Walcot," *Country Life*, 10 October, 1032–33

REVIEWS

Review of Johann Steingruber, *Architectural Alphabet 1773*, in *Apollo*, March, 210

Review of Alec Clifton-Taylor, *English Parish Churches as Works of Art*, in *Apollo*, December, 533

1975

ARTICLES

"Architecture and Morality," *The Cambridge Review*, 24 October, 8–12

"Architecture and Morality II," *The Cambridge Review*, 21 November, 38–41

Review of A. Charles Sewter, *The Stained Glass of William Morris and his Circle*, in *Architectural Design*, April, 253

REVIEWS

Review of Rudolf Wittkower, *Studies in the Italian Baroque*, in *Architectural Review*, September, 181

Review of John Cornforth and John Fowler, *English 18th century Interior Decoration*, in *Antique Collector*, September, 51

1976

Review of James Macaulay, *The Gothic Revival 1745–1845*, in *Architectural Review*, March, 182

Review of Gillian Darley, *Villages of Vision*, in *Times Literary Supplement*, 12 March, 281

Review of Helen Rosenau, *Boullée and Visionary Architecture*, in *Apollo* 104, October, 321–22.

1977

BOOKS

Morality and Architecture, Oxford: The Clarendon Press. 126pp., reprinted 1978. 126 pp. Reprinted 1984: Chicago University Press
 Spanish edition: *Moral y Arquitectura*, Barcelona, Tusquets Editores, 1981
 Japanese edition: Kajima Institute Publishing Co., Ltd., 1981
 Italian edition: *Architettura e Moralità*, Milan: Jaca, 1982
 French edition: *Morale et architecture aux 19e et 20e siècles*, Brussels and
 Liège: Mardaga, 1979

The Triumph of the Classical: Cambridge Architecture 1804–1834, Cambridge University Press. 86 pp. 26 illus.

Charles-Louis Clérisseau (1721–1820), Cambridge, Fitzwilliam Museum. 10 pp.

Architettura Moderna (with Robin Middleton), Milan: Electa Editrice. 489 pp. 664 illus.
 German edition: *Architektur der Neuzeit*: Stuttgart: Belser Verlag, 1977
 English edition: *Neo-Classical and 19th century Architecture*, New York: Harry Abrams, 1980 (two-volume paperback edition, New York: Rizzoli, 1987)
 French edition: *Architecture moderne: Du néo classicisme au néo-gothique*,
 Paris: Berger-Levrault, 1983

ARTICLE

"Cities of Silence: The Cemeteries and Memorials of the Great War," *Country Life*, 10 November, 1399–1400

REVIEWS

Review of Mary Banham and Bevis Hillier, eds., *A Tonic to the Nation, the Festival of Britain 1951*, in *The Cambridge Review*, 25 November, 123–24

Review of Andrew Saint, *Richard Norman Shaw*, and Jane Fawcett, ed., *Seven Victorian Architects*, in *Apollo*, April, 310–12

Review of Arnaldo Bruschi, *Bramante*, and Peter Murray, *Architecture of the Renaissance*, in *Apollo*, November, 424–25

1978

"Architecture of the Empire's Capital: The London 1900 Exhibition at the Heinz Gallery," *Country Life*, 29 June, 1916–17

Review of Arthur Drexler, ed., *The Architecture of the Ecole des Beaux-Arts*, and Mark Girouard, *Sweetness and Light, the 'Queen Anne' Movement, 1860–1900*, in *Apollo*, March, 229–30

Review of John Wilton-Ely, *The Mind and Art of Piranesi*, in *Apollo*, September, 209–10

1979

BOOKS

English Architecture, a Concise History, London: Thames and Hudson. 216 pp. Illus. reprinted 1979; 1996; rev. ed., 2001. 224 pp.

A History of Chorlton Hall, near Chester (with John Hess), privately printed, Cambridge. 19 pp. Rev. and enlarged edition, 1995. 21 pp. Illus.

ARTICLES

"Karl Friedrich Schinkel: Royal Patronage and the Picturesque," *Architectural Design* 49, nos. 8–9, pp. 56–71

"Architectural Writing in the Thirties," *Architectural Design* 49, nos. 10–11, pp. 84–89

REVIEWS

Review of Henry Millon and Lind Nochlin, eds, *Art and Architecture in the Service of Politics*, in *Architectural Review*, October, 204–5

Review of Frank Bottomley, *The Church Explorer's Guide*, in *The Universe*, February

1980

BOOKS

The Rise of Architectural History, London: Architectural Press, and New Jersey: Eastview Editions. 104 pp. Reprinted, Chicago University Press, 1983

The London Ritz: A Social and Architectural History (with Hugh Montgomery-Massingberd), London: Aurum Press. 192 pp. Illus.

Burke's and Savills Guide to Country Houses 3, East Anglia, "Cambridgeshire," London: Burke's Publications, 1–32

ARTICLES

"The House of Joy," in *Quinlan Terry*, Frank Russell, ed., London: Academy Editions, viii–xi

Foreword and bibliography to new edition of Geoffrey Scott, *The Architecture of Humanism*, London: Architectural Press, ix–xxix & 266

"A Sketch-book by Thomas Hope" (with Jill Lever), *Architectural History* 23, 52–59

"The Rise of Architectural History," *RIBA Journal*, April, 67–69

"Architecture Sees the Light," *Daily Telegraph*, 24 April, 16

REVIEWS

Review of Anthony Quiney, *John Loughborough Pearson*, in *Apollo* 111, January, 75

Review of Priscilla Metcalf, *James Knowles, Victorian Editor and Architect*, in *Times Literary Supplement*, 1 February, 106

Review of Roger Scruton, *The Aesthetics of Architecture*, in *Architectural Review* 167, February, 68–69

Review of Philip Steadman, *The Evolution of Designs: The Biological Analogy in Architecture and the Applied Arts*, in *Architectural Review* 167, April, 259–60

Review of John Martin Robinson, *The Wyatts, An Architectural Dynasty*, in *Daily Telegraph*, 24 January, 259

Review of David Cole, *The Work of Sir Gilbert Scott*, in *Times Literary Supplement*, 20 June, 698

Review of Philip Johnson, *Writings*, in *Architectural Review*, June, 388

Review of Edward G.W. Bill, *The Queen Anne Churches: A Catalogue of the Papers in Lambeth Palace Library*, in *Journal of Ecclesiastical History* 31, no. 3, July, 367–69

Review of Robert Harbison, *Deliberate Regression*, in *The Guardian*, 18 September

Review of John Summerson, *The Life and Work of John Nash, Architect*, in *Daily Telegraph*, 18 September

1981

"The Waterloo Palace," *Sothebys Art at Auction*, 46–49

Review of *The Journals of Benjamin Latrobe 1764–1820*, vols 1–2, in *International Architecture*, no. 4, vol. 1, issue 4, 41

Review of Richard Carrott, *The Egyptian Revival*, in *Apollo*, April, 275

Review of Alec Crook, *From the Foundation to Gilbert Scott: A History of the Buildings of St John's College, Cambridge*, in *Times Literary Supplement*, 3 April, 386

Review of Rhodri Liscombe, *William Wilkins 1778–1839*, in *Burlington Magazine*, May, 316–17

Review of Joseph Rykwert, *The First Moderns: The Architects of the 18th century*, in *Journal of the Society of Architectural Historians* 40, no. 1, March, 79–80

Review of Jill Franklin, *The Gentleman's Country House and its Plan 1835–1914*, in *Times Literary Supplement*, 12 June, 677

Review of J. Mordaunt Crook, *William Burges and the High Victorian Dream*, in *Times Literary Supplement*, 17 July, 815

1982

BOOKS

The English Vision: The Picturesque in Architecture, Landscape and Garden Design, London: John Murray, and New York: Harper. 227 pp. Illus.

The Buildings of Britain: Regency, a Guide and Gazetteer, London: Barrie and Jenkins, 1982. 192 pp. Illus.

Athenian Stuart: Pioneer of the Greek Revival, London: George Allen and Unwin. 70 pp. 80 illus.

ARTICLES

Entries on C.R. Cockerell, Thomas Hope, and Charles Heathcote Tatham, in the *Macmillan Encyclopedia of Architects*, 4 vols, New

York: The Free Press

REVIEWS

Review of Robin Middleton, ed., *The Beaux Arts and 19th–century French Architecture*, in *AA Files* 1, no. 2, July, 90

Review of Mark Bence–Jones, *Burke's Guide to Country Houses* 1, *Ireland*, and Colin McWilliam, *The Buildings of Scotland, Lothian Except Edinburgh*, in *Apollo*, July, 128

Review of James Stevens Curl, *The Egyptian Revival*, Architectural Review, in November, 80

Review of John Physick, *The Victoria and Albert Museum*, in *Times Literary Supplement*, 10 December, 1379

1983

BOOK

John Soane (with John Summerson and G.-Tilman Mellinghoff), London: Academy Editions; New York: St Martin's Press. 123 pp. Illus.

ARTICLES

"Newly discovered drawings by C.R. Cockerell for Cambridge University Library," *Architectural History* 26, 87–91

"The Carpenter of Karlsruhe," review of *Friedrich Weinbrenner (1766–1826)*, [Exhibition, Architectural Association], in *AA Files* 3, January, 84–87

REVIEWS

Review of Pierre du Prey, *John Soane: The Making of an Architect*, in *Society of Architectural Historians Newsletter* 29, Winter, 6

Review of Robert Fishman, *Urban Utopias in the 20th century*, in *Apollo* 117, February, 144–45

Review of Charles Dellheim, *The Face of the Past*, in *Times Literary Supplement*, 29 April, 427

Review of Helen Searing, ed., *In Search of Modern Architecture: A Tribute to Henry-Russell Hitchcock*, in *Journal of the Society of Architectural Historians* 42, no. 3, October, 304–5

Review of Clive Aslet, *The Last Country Houses*, in *Monuments Historiques de la France* 129, October-November, 89–90

Review of H.M. Colvin, *Unbuilt Oxford*, in *Times Literary Supplement*, 4 November, 1221

1984

BOOKS

The Royal Interiors of Regency England, London: Dent; New York: Vendome Press. 128 pp. Illus.

Peterhouse 1284–1984, privately printed, Cambridge. n.p. Illus.

ARTICLES

"The Grand Hotel Style," in *Grand Hotel: The Golden Age of Palace Hotels, an Architectural and Social History*, Jean D'Ormesson et al., eds., London: Dent; New York: Vendome Press, 13–27

"William Kent," in *A House in Town, 33 Arlington Street, Its Owners and Builders*, London: Batsford, Antony Ratcliff, et al., eds., London: Batsford, 11–32

"The Lost Palace" [Carlton House], *Illustrated London News*, Christmas, 69–72

REVIEWS

Review of Dorothy Stroud, *Sir John Soane, Architect*, in *Apollo*, July, 78

Review of Mark Binney, *Sir Robert Taylor*, and Anthony Barrett and Rhodri Liscombe, *Francis Rattenbury and British Columbia, Architecture and Challenge in the Imperial Age*, in *Apollo*, September, 215–16

1985

ARTICLES

"Soane's Museum, un labyrinthe pittoresque," *Beaux-Arts Magazine*, Paris, January, 60–67

"Modernism and Morality," in *Classical Tradition and the Modern Movement*, 2nd International Alvar Aalto Symposium, Asko Salokorpi, ed., Helsinki, 138–57

"Holford, Vulliamy, and the sources for Dorchester House," in *Influences in Victorian Art and Architecture*, London: Society of Antiquaries, 81–92

REVIEWS

Review of Lionel Esher, *Our Selves Unknown: An Autobiography*, in *Daily Telegraph*, 1 February, 16

Review of *Design and Practice in British Architecture: Studies Presented to Howard Colvin*, John Newman, ed., in *Times Literary Supplement*, 5 April, 372

1986

BOOKS

A History of Western Architecture, London: Barrie and Jenkins; New York: Thames and Hudson. 591 pp. Illus. Reprinted 1992. 2nd ed., rev. and expanded, London: Laurence King, 1996, 607 pp., 767 illus.; 3rd ed., Laurence King, 2000, 704 pp., Illus; 4th ed., rev. and expanded, New York: Watson-Guptill, 2005, 720 pp., 981 Illus.

Italian edition: *Storia dell'Architettura Occidentale*, Bologna: Zanichelli, 1990, 717 pp. Illus.

German edition, *Geschichte der Abendländischen Architektur*, Cologne 1999, 423 pp. Illus.

Dutch edition: *Die Westerse Architectur: Een Geschiedenis*, Nijmegen: Sun, 1994

Polish edition: *Historia architektury zachodniej*, Warsaw: Arkady, 2001, 661 pp., Illus., and 8 vols, Edipresse Olska SA, 2007

Greek edition: Athens 2005, 741 pp., Illus.

ARTICLE

"Willis and Clark, 1886–1986," *Cambridge Review* 107, May, 68–69

REVIEWS

Review of Lucy Archer, *Raymond Erith, Architect*, in *Country Life*, 30 January, 283

Review of John Dixon Hunt, *Garden and Grove: The Italian Renaissance Garden in the English Imagination 1600–1750*, in *History Today* 36, September, 56–57

Review of Gwyn Headley and Wim Meulenkamp, *Follies: A National Trust Guide*, in *Times Literary Supplement*, 8 August, 872

Review of Derek Olsen, *The City as a Work of Art*, in *New York Times Book Review*, 19 October, 36

1987

BOOKS

German Architecture and the Classical Ideal 1740–1840 (with Tilman Mellinghoff), London: Thames and Hudson; Cambridge, Mass: MIT Press. 296 pp. 254 Illus.
German Edition: *Deutscher Klassizismus. Architektur 1750–1840*, Stuttgart 1989
Italian Edition: *Architettura neoclassica tedesca, 1740–1840*, Milan: Electa, 1990

ARTICLE

"New Light on the Hope Mansion in Duchess Street" (with Peter Thornton), *Apollo*, September, 162–77

REVIEWS

Review of Clive Aslet, *Quinlan Terry: The Revival of Architecture*, in *The Salisbury Review* 5, April, 63–65

Review of Alexander Tzonis and Liane Lefaivre, *Classical Architecture: The Poetics of Order*, in *Times Literary Supplement*, 5 June, 617

1988

ARTICLES

"La permanence du classicisme dans l'architecture contemporaine," *Monuments Historiques de la France*, February-March, 87–91

"Merks Hall, Essex," *Country Life*, 7 July, 142–45

Preface to new edition of Willis and Clark, *An Architectural History of the University of Cambridge*, Cambridge University Press, 3 vols., vol. 1, vii–xx

"Napoleon's Furniture Empire," *Antique*, Summer, 46–49

"Louis XIV: The Design Machine," *Antique*, Winter, 53–56

REVIEWS

Review of Michael Port, *The Commission for Building Fifty New Churches: The Minute-books*, in *Journal of Ecclesiastical History* 39, i, January, 52

Review of J. Mordaunt Crook, *The Dilemma of Style: Architectural Ideas from the Picturesque to the Post-Modern*, in *Landscape*, February, 87–89

Review of Hilde de Haan and Ids Haagsma, *Architects in Competition*, in *Times Literary Supplement*, 20 May, 1559

Review of Peter Leach, *James Paine*, in *Architects' Journal*, 13 July, 71

Review of John Ruskin, *Modern Painters*, in *Modern Painters* 1, no. 2, Summer, 101

Review of John Summerson, *Georgian London*, in *Architectural Review*, September, 12

Review of Harold Meek, *Guarino Guarini and his Architecture*, in *Times Literary Supplement*, 16 September, 1026

Review of Brendan Gill, *Many Masks: A Life of Frank Lloyd Wright*, in *Modern Painters* 1, no. 4, Winter, 109

1989

BOOK

The Architecture of Basil Champneys, Cambridge: Newnham College. 47 pp. 37 illus.

ARTICLES

"Archaeology and the Greek Revival: A Case-Study of C.R. Cockerell," in *Late Georgian Classicism*, Roger White and Carol Lightburn, eds., London: The Georgian Group, 58–72

"Léon Krier: Classicism Today and Tomorrow," *Country Life*, 8 April, 128–30

"Georgian Furniture Design: Life before Adam," *Antique*, Summer, 42–46

"Eaton Hall", *Antique*, Winter, 30–34

"Bonomi at Packington," *The Georgian Group Report and Journal*, 103–05

REVIEWS

Review of *Paris, City of Revolution* [Exhibition, Fitzwilliam Museum], in *Architects' Journal*, 19 April, 96–97

Review of Kerry Downes, *Sir Christopher Wren: The Design of St Paul's Cathedral*, and *The Architecture of Sir Christopher Wren*, in *Times Literary Supplement*, 26 May–June, 590

Review of Maurice Barley, *Houses and History*, in *English Historical Review* 104, July, 725–26

1990

ARTICLES

"The Migration of the Palm: A Case-Study of Architectural Ornament as a Vehicle of Meaning," *Apollo*, February, 78–84

"The Walhalla," *Arquitectonica*, February, 63–92

"The Hope Family and Neo-classicism," *Documentatieblad Verkgroep 19e Eeuw* 22, Holland University Press, 1–7

"On Classic Ground," *Modern Painters*, Summer, 75–77

"Classical Berlin," *Antique*, Summer, ii–v

"Robert Adam: A Critical Review," *Classical Design in the Late Twentieth Century: Recent Work of Robert Adam*, The Bath Press, 9–12

"Living Architecture," *Kensington Green*, Autumn, 28–30

REVIEWS

Review of James Stevens Curl, *The Londonderry Plantations 1609–1914*, in *The Salisbury Review*, March, 58

Review of *Churches of South-East Wiltshire*, Royal Commission on Historical Monuments, in *English Historical Review* 105, July,

748–49

Review of Eileen Harris assisted by Nicholas Savage, *British Architectural Books and Writers 1556–1785*, in *Times Literary Supplement*, 28 December, 1396

1991

ARTICLES

"*Iungit Amor*: Royal Marriage Imagery in France, 1550–1750," *Journal of the Warburg and Courtauld Institutes* 54, 256–61

"Château de Barbentane," *Country Life*, 7 February, 62–67

"Frank Lloyd Wright and the Guggenheim Museum," in *AA Files* 21, Spring, 40–48

"The Fruits of Unification," *Country Life*, 22 August, 54–55

"Scottish Adam," *Antique*, Autumn, 274–76

REVIEWS

Review of James Stevens Curl, *Victorian Architecture*, Peter Howell, *The Faber Guide to Victorian Churches*, and Elizabeth Williamson, *The Buildings of Scotland, Glasgow*, in *Apollo*, February, 137

Review of Andreas Papadakis, ed., *New Classicism*, Michael Greenhalgh, *What is Classicism?*, and Robert Adam, *Classical Architecture*, in *Modern Painters* 4, Spring, 100–1

Review of Hakan Groth, *Neo-classicism in the North: Swedish Furniture and Interiors 1770–1850*, in *Antique*, Spring, 206–7

Review of Allan Braham, *The Architecture of the French Enlightenment*, in *British Journal for Eighteenth-century Studies*, Spring, 107

Review of Spiro Kostof, *The City Shaped: Urban Patterns and Meanings Through History*, in *Country Life*, 10 October, 134

Review of Thomas McCormick, *Charles-Louis Clérisseau and the Genesis of Neo-Classicism*, in *Architectural Review*, November, 12

Review of James Stevens Curl, *The Art and Architecture of Freemasonry*, in *Apollo*, December, 431

Review of James Ackerman, *Distance Points: Essays in Renaissance Art and Architecture*, in *Times Literary Supplement*, 27 December, 14

1992

ARTICLES

"Architecture," in *The Legacy of Rome: A New Appraisal*, Richard Jenkyns, ed., Oxford
University Press, 329–65

"Pevsner: un studio sullo 'storicismo'," in *Nikolaus Pevsner: La trama della storia*, Fulvio Irace, ed., Milan: Guarini Studio, 57–70

"Craftsmanship Alive and Well: Quinlan Terry's Villas in Regent's Park," *Country Life*, 4 June, 82–85

"Sir Nikolaus Pevsner: A Study in *Historicism*," *Apollo*, September, 169–72

"Architectural Education, Practice and Patronage in Ancien Regime France," in *Georgian Architectural Practice*, Giles Worsley, ed., The Georgian Group, London, pp. 18–23

"The Recovery of Reverence," in *A Vision of Europe*, Exhibition Catalogue, University of Bologna, September 1992, 25–40

"Léon Krier," in *Léon Krier: Architecture and Urban Design 1967–1992*, London: Academy Editions, 12–13

"Women as Patrons," *Antique*, New Year, 334–36

"The Architectural Patronage of George IV and Louis-Philippe, Duc d'Orléans," *Antique*, Summer, 376–78

REVIEWS

Review of H.M. Colvin, *Architecture and the After-Life*, in *Architectural Review*, January, 8

Review of James Leith, *Space and Revolution: Projects for Monuments, Squares and Public Buildings in France 1789–99*, in *Architectural Review*, May, 13

Review of Mark Swenarton, *Artisans and Architects: The Ruskinian Tradition in Architectural Thought*, in *English Historical Review* 107, July, 752

Review of Hilary Ballon, *The Paris of Henry IV: Architecture and Urbanism*, in *RIBA Journal*, September, 23

Review of Karl Friedrich Schinkel, *Die Reise nach Frankreich und England im Jahre 1826*, in *Zeitschrift für Kunstgeschichte* 61, Heft 1, 158

Review of Alex Scobie, *Hitler's State Architecture: The Impact of Classical Antiquity*, in *The Journal of Roman Studies*, 82, 310–11

1993

ARTICLES

"George Gilbert Scott junior (1839–1897): 'the history of a narrow mind'," in *Private and Public Doctrine* [Festschrift for Maurice Cowling], Michael Bentley, ed., Cambridge University Press, 168–80

Entries on Charles Kelsall and Geoffrey Scott in *Dictionary of National Biography: Missing Persons*, Oxford University Press, 371–72 & 588–89

"Cockerell Redivivus," in *The Golden City: Essays on The Architecture and Imagination of Beresford Pite*, Brian Hanson, ed., RIBA Heinz Gallery, and Prince of Wales's Institute of Architecture, 1–12

"Putting a Human Head on a Horse's Neck," in *Interventions in Historic Centres*, London: Academy Editions, 38–41

"The Anglesey Desk," *Christie's International Magazine*, July–August, 18–20

"George Dance and Character in Architecture," in *The Contemporaries of Robert Adam*, Giles Worsley, ed., London: The Georgian Group, 50–54

"Forget the Will to Shock," *The Spectator*, 11 December, 26–27

"The Recovery of Reverence," in *Building Classical: A Vision of Europe and America*, Richard Economakis, ed., London: Academy Editions, 20–25

"A Case of Regency Exoticism: Thomas Hope and the Benaki drawings" (with Fani Maria Tsigakou), *Cornucopia* 5, vol. 1, 52–59

Afterword to *The Commonplace Book of Monsignor A.N. Gilbey*, London: Bellew Publishing, 189–92

REVIEWS

Review of Sylvia Lavin, *Quatremère de Quincy and the Invention of a Modern Language of Architecture*, in *Architectural Review*, January, 15

Review of James Stevens Curl, *Classical Architecture*, in *Architectural Review*, April, 96–7

Review of *The Architectural Historian in America*, Elizabeth Blair MacDougall, ed., in *Journal of the Society of Architectural Historians* 52, no. 2, June, 246–47

Review of Terence Russell, *Architecture in the Encyclopédie of Diderot and D'Alembert*, in *Country Life*, 1 July, 115

Review of John Morley, in *Regency Design*, *Antique* 8, no.1, 562

Review of Charles Saumarez Smith, *Eighteenth-century Decoration: Design and the Domestic Interior in England*, in *Evening Standard*, 15 July, 45

Review of *Boughton House, The English Versailles*, Tessa Murdoch, ed., in *Times Literary Supplement*, 6 August, 16

Review of Joseph Friedman, *Spencer House*, in *Evening Standard*, 4 November, 55

Review of Margit Bendtsen, *Sketches and Measurings: Danish Architects in Greece 1818*, in *Society of Architectural Historians Newsletter* 50, Autumn, 13

Review of David Thomson, *Renaissance Architecture: Critics, Patrons, Luxury*, in *Architectural Review*, December, 96

1994

ARTICLES

"The German Connection," in *Alexander Thomson*, Gavin Stamp and Sam McKinstry, eds., Edinburgh University Press, 189–98

"Was the Amateur Architect a British Phenomenon?" in *The Role of the Amateur Architect*, Giles Worsley, ed., London: The Georgian Group, 27–32

Introduction to David Clarke, *The Architecture of Alienation: The Political Economy of Professional Education*, New Brunswick and London, xxv–xxvii

"Poetry Amid Graceless Prose," *The Spectator*, 22 January, 33–34

"Pugin: A Gothic Passion," *Modern Painters*, Summer, 95–96

"Restoring Symbolism," in *Acropolis Restoration: The CCAM Intervention*, Richard Economakis, ed., London: Academy Editions, 210–11

REVIEWS

Review of Claude Perrault, *Ordonnance for the Five Kinds of Columns after the Method of the Ancients* (with intro by A. Pérez-Gómez), in *French History* 8, 90–91

Review of John Wilton-Ely, *Piranesi as Architect and Designer*, in *Architectural Review*, January, 96

Review of Claude-Nicolas, Ledoux, *Unpublished Projects*, in *Architectural Review*, February, 96

Review of Charles Saumarez Smith, *The Building of Castle Howard*, in *English Historical Review* 109, February, 193

Review of Howard Saalman, *Filippo Brunelleschi: The Buildings*, in *Architectural Review*, March, 97

Review of Alex Potts, *Flesh and the Ideal: Winckelmann and the Origins of Art History*, in *Antique* 9, no. 1, 676

Review of Steven Parissien, *Palladian Style*, in *Evening Standard*, 27 June, 53

Review of Paul Atterbury and Clive Wainwright, eds., *Pugin: A Gothic Passion*, and Megan Aldrich, *Gothic Revival*, in *Evening Standard*, 11 July

Review of Peter Adam, *The Arts of the Third Reich*, and Alexei Tarkhanov and Sergei Kavtaradze, *Stalinist Architecture*, in *Society of Architectural Historians Newsletter* 52, Autumn

Review of Nicholas Ray, *Cambridge Architecture: A Concise Guide*, in *Times Literary Supplement*, 16 December, 28

1995

ARTICLES

"Cavogallo, Southern Peloponnese," *Country Life*, 9 February, 40–45

"Pavilion at Barn Elms," [anon], *Country Life*, 31 March, 89

"Chorlton Hall, Chester," *Country Life*, 14 September, 88–91

"Soane and the Picturesque: The Philosophy of Association," in *The Picturesque in Late Georgian England*, Dana Arnold, ed., symposium proceedings, 1994, London: The Georgian Group, 45–50 & 73–74

"Freemasonry and Sir John Soane," *Journal of the Society of Architectural Historians* 54, December, 278–93

"C.R. Cockerell and the Role of Archaeology in Modern Classical Architecture," *The Classicist* 2, 16–24

"Stile e politica nell'architettura britannica degli anni trenta," *Classicismo - Classicismi: Architettura Europa/America 1920–1940*, Centro Internazionale di Studi di Architettura Andrea Palladio di Vicenza, Milan: Electa, 185–95

"Northern Fantasy," *Antique International* 9, no. 2, 16–35

"Gathering Acorns," review article on Raphael Samuel, *Theatres of Memory*, Jennifer Jenkins and Patrick James, *From Acorn to Oak Tree: The Growth of the National Trust*, Paula Weideger, *Gilding the Acorn: Behind the Façade of the National Trust*, and Merlin Waterson, *The National Trust: The First Hundred Years*, in *Art Quarterly*, no. 22, Summer, 50–51

REVIEWS

Review of Michael Hall, *The English Country House: From the Archives of Country Life 1897–1939*, in *Evening Standard*, 6 February, 25

Review of Friedrich Gilly, *Essays in Architecture 1796–1799*, in *Society of Architectural Historians Newsletter* 54, Spring, 11–12

Review of Pierre du Prey, *The Villas of Pliny from Antiquity to Posterity*, in *Country Life*, 16 February, 60

Review of Panayotis Tournikiotis, ed., *The Parthenon and its Impact in Modern Times*, and Manolis Korres, *From Pentelicon to the Parthenon*, in *Evening Standard*, 27 February, 25

Review of Bernd Dams and Andrew Zega, *Follies and Pleasure Pavilions in the Gardens of the Ancien Régime*, in *Antique International*, April-June, 70–71

Review of Jules Lubbock, *The Tyranny of Taste*, in *Evening Standard*, 5 June, 28

Review of John Martin Robinson, *Treasures of the English Church*, in *Evening Standard*, 26 June, 26

Review of Barry Bergdoll, *Karl Friedrich Schinkel*, in *Architectural Review*, July, 96

Review of Giles Worsley, *Classical Architecture in Britain: The Heroic Age*, in *Evening Standard*, 17 July, 23

Review of William MacDonald and John Pinto, *Hadrian's Villa and its Legacy*, in *Country Life*, 20 July, 76

Review of Nigel Everett, *The Tory View of Landscape*, in *Albion* 27, no. 2, Summer, pp. 323–25

Review of H.M. Colvin, *A Biographical Dictionary of British Architects 1600–1840*, 3rd edn., in *Country Life*, 19 October, 88–89

Review of Priscilla Roosevelt, *Life on the Russian Cultural Estate: A Social and Cultural History*, in *Evening Standard*, 30 October, 27

Review of David McKitterick, ed., *The Making of the Wren Library*, in *Country Life*, 2 November, 72

"Unsuitable home for the Trust," *Daily Telegraph*, 25 November, 18 [letter on the purchase by the National Trust of the home of the Beatles]

1996

BOOK

Sir John Soane: Enlightenment Thought and the Royal Academy Lectures, Cambridge University Press. 763 pp. 24 colour plates, 125 black and white. Reprinted 1997

ARTICLES

"Alec Cobbe: 'Creations and Recreations'," in *Creations and Recreations: Alec Cobbe, Thirty Years of Design and Painting*, London: Prince of Wales's Institute of Architecture, 11–29

"Paternoster Square," *City Journal*, New York, vol. 6, no. 1, Winter, 14–27

"18th-century French Architects and Cabinet-makers," *Antique International*, New Year, 25–27

"Monuments and Mausolea in the Age of Enlightenment," in *Soane and Death*, Giles Waterfield, ed., Dulwich Picture Gallery, 9–25

"Soane's Lecture Illustrations," in *Soane and Death*, Giles Waterfield, ed., Dulwich Picture Gallery, 75

"The Complete Cobbe," *Christie's International Magazine*, May, 40–41

"'A Local Habitation and a Name'," *A Vision of Europe: Urban Renaissance*, Gabriele Tagliaventi, ed., Bologna: Grafis Edizioni, 35–49

"Richmond Riverside," *City Journal*, New York, vol. 6, no. 2, Spring, 104–19

"Soane's Concept of the Villa," in *The Georgian Villa*, Dana Arnold, ed., Stroud: Alan Sutton, 94–104 & 167–69

"Morris at Peterhouse", *Peterhouse Annual Record 1995–96*, 32–41

"Fitzwilliam Museum Extension must not be Allowed," letter, *Country Life*, 4 April

"Sacred Cows: The Parthenon," *Perspectives on Architecture* 23, June–July, 96

"The Lost Treasures of Houghton," *Christie's International Magazine*, September

Entries on the Greek Revival, Laugier, Sir John Soane, James Stuart, James Elmes, Thomas Hope, and Decimus Burton, in the *Dictionary of Art*, 34 vols, London

REVIEWS

Review of *Soane and Death* [Exhibition, Dulwich Picture Gallery], in *Modern Painters* 9, no. 1, Spring, 101–2

Review of Katie Scott, *The Rococo Interior: Decoration and Space in Early 18th-century Paris*, in *Antique*, May

Review of Dimitri Shvidkovsky, *The Empress and the Architect: British Architecture and Gardens at the Court of Catherine the Great*, in *Evening Standard*, August

Review of Timothy Mowl, *Horace Walpole: The Great Outsider*, in *Evening Standard*, 2 September, 28

Review of the *Dictionary of Art* (34 vols, London), in *Architectural Review*, November, 96

Review of Derek Blyth, *Flemish Cities Explored*, in *Times Literary Supplement*, 1 November, 31

Review of Eleanor DeLorme, *Garden Pavilions and the 18th-century French Court*, in *Architectural Review* 200, December, 88

1997

ARTICLES

"Preserve the Temple from the Bridge," *Counsel: Journal of the Bar of England and Wales*, January/February, 12–14

"C.R. Cockerell and the Cockerell Building," *Caius and Cockerell: The Transformation of a Library*, Gonville and Caius College, Cambridge, 11–17

"The Master's Lodge, Peterhouse," *Country Life*, 28 August, 34–37

"Stirling's No. 1, Poultry," *RIBA Journal*, October, 30

Sir John Soane and Enlightenment Thought, [first Annual Soane Lecture], Sir John Soane's Museum, 25pp, 10 illus.

REVIEWS

Review of Paul Jeffery, *The City Churches of Sir Christopher Wren*, in *Times Literary Supplement*, 17 January, 36

Review of John Harris and Michael Snodin, eds., *Sir William Chambers: Architect to George III*, in *The Court Historian* 2, no. 1, February, 37–39

Review of David Schuyler, *Apostle of Taste: Andrew Jackson Downing, 1815–1852*, and Thomas Gordon Smith, ed., *John Hall and the Grecian Style*, in *Society of Architectural Historians Newsletter* 60, Spring, 13

Review of Michael Snodin and Maurice Howard, *Ornament: A Social History since 1450*, in *Antique International*, Spring, 90–91

Review of Peter Mandler, *The Fall and Rise of the Stately Home*, in *Country Life*, 17 April, 84

Review of Andrew Ballantyne, *Architecture, Landscape and Liberty: Richard Payne Knight and the Picturesque*, in *Architectural Review*, August, 88

Review of Andrea Palladio, *The Four Books on Architecture*, transl. by Robert Tavernor and Richard Schofield, in *Times Literary Supplement*, 22 August, 21

Review of Jane Roberts, *Royal Landscape: the Gardens and Parks of Windsor*, in *Country Life*, 4 September, 88

Review of *Lord Burlington: Art, Architecture, Gardening*, Toby Barnard and Jane Brown, eds., in *English Historical Review* 102, September, 987–88

Review of Ian Gow, *Scottish Country Houses and Gardens: From the Archives of Country Life*, in *Country Life*, 23 October, 100

1998

ARTICLES

"Soane and Simpson," *The Caian*, Gonville and Caius College, Cambridge, November, 55–64

"Rooms that Speak of Memory: Gonville and Caius College, Cambridge," *Country Life*, 2 April, 48–53

"Beckside House, Lancashire," *Country Life*, 10 September, 148–53

"The Master's Lodge, Gonville and Caius College, Cambridge," *Country Life*, 24 September, 22–27

"An Eloquent Sermon in Stone," *City Journal*, New York, Summer, 94–107

"Monsignor Alfred Gilbey: An Appreciation," *Daily Telegraph*, 27 March, 31

"Splendor in Stone: Regency Sensibility," *House and Garden* (USA) 167, September, 272–77

"John Soane: Architettura e illuminismo," *Casabella* 62, October, 72–83

REVIEWS

Review of Paul Turner, *Joseph Ramée: International Architect of the Revolutionary Era*, in *Architectural Review*, March, 80

Review of Janet Gleeson, *The Arcanum: The Extraordinary True Story of the Invention of European Porcelain*, in *Times Literary Supplement*, 3 April, 10

Review of Léon Krier, *Architecture: Choice or Fate*, in *Country Life*, 16 April, 88

Review of Edward Chaney, *The Evolution of the Grand Tour*, in *Country Life*, 21 May, 89

Review of John Harris, *No Voice from the Hall*, in *Art Quarterly*, Summer, 49–50

Review of James Lees-Milne, *Through Wood and Vale*, in *Country Life*, 20 October, 121

1999

ARTICLES

"Greek and Gothic Country Houses: The Impact of Napoleon," *The Regency Great House*, Malcolm Airs, ed., Oxford, 14–24

"Built Ruins: The Hermitage as Retreat," in *Visions of Ruin: Architectural Fantasies*, exhibition catalogue, Sir John Soane's Museum, 4–14

"Soane: The Royal Academician and the Public Realm," in *John Soane Architect: Master of Space and Light*, Royal Academy of Arts, London, 38–47

"Freemasons Hall," in *John Soane Architect: Master of Space and Light*, Royal Academy of Arts, London, 264–67

"Monsignor Alfred Gilbey," *Daily Telegraph Fifth Book of Obituaries: 20th-century Lives*, Hugh Massingberd, ed., 433–35

"Sculpture as Propaganda," *Antique Interiors International* 34, 64–70

"The Queen's Gallery, Buckingham Palace," *Country Life*, 28 January, 48–51

"Royal Opera House Development," *RIBA Journal*, February, 20–21

"Soane: The Power of the Primitive," *Country Life*, 2 September, 56–63

"Painters Yard, Chelsea," *Country Life*, 16 September, 120–24

"Living for 1000 Years," *Aspects of Property*, Autumn, 7–9

"The Travellers' Club and the Grand Tour: Raphael Corrected," *The British Art Journal*, 1, Autumn, 56–62

"The Grove Buildings Quadrangle, Magdalen College, Oxford," *Country Life*, 21 October, 92–95

"The Master's Lodge, Gonville and Caius College, Cambridge" (with Christopher Brooke and Hugh Richmond), *The Caian*, Gonville and Caius College, November, 110–25

"Chartres Cathedral," *Sunday Times*, 28 November

"The Greek Revival," *Dictionary of American Arts*

REVIEWS

Review of Robert Tavernor, *Alberti and the Art of Building*, in *Architectural Review*, February, 88

Review of Todd Marder, *Bernini, the Art of Architecture*, in *Country Life*, 18 February, 97

Review of Ingrid Rowland, *The Culture of the High Renaissance: Ancients and Moderns in 16th-century Rome*, in *Architectural Review*, March, 89

Review of Cynthia Wall, *The Literary and Cultural Spaces of Restoration London*, in *Architectural Review*, April, 89

Review of James Stevens Curl, *Dictionary of Architecture*, in *Country Life*, 15 April, 109

Review of John T. Cliffe, *The World of the Country House in*

17th–century England, in *Country Life*, 22 April, 125

Review of Lydia Soo, *Wren's 'Tracts' on Architecture and Other Writings*, in *Georgian Group Bulletin*, May, 15

Review of James Ayres, *Building the Georgian City*, in *Antique Interiors International*, 35, 122–27

2000

BOOKS

Sir John Soane: The Royal Academy Lectures, ed., Cambridge University Press, 328 pp. 35 Illus.

The Age of Wilkins: The Architecture of Improvement, exhibition catalogue, Cambridge: Fitzwilliam Museum, 58 pp., 22 illus.

ARTICLES

"The Architectural Context of the Grand Tour: The British as Honorary Italians," *The Impact of Italy: The Grand Tour and Beyond*, Clare Hornsby, ed., British School at Rome, London, 49–62

"Sir John Soane's Grand Tour: Its Impact on his Architecture and his Collections," *The Impact of Italy: The Grand Tour and Beyond*, Clare Hornsby, ed., British School at Rome, 101–19

"Il Rinascimento Urbano: Un'Opinione da Cambridge," in *Rinascimento Urbano: La Città nel Terzo Millennio*, Gabriele Tagliaventi, ed., Milan, Teleura, 35–51

Introduction and catalogue entries to *Inside Out: Historic Watercolour Drawings of Interiors and Exteriors, 1770–1870*, London: Stair & Co.

"St Peter's, Rome," *Sunday Times*, 2 January, 18–19

"Munich Glass in the Chapel at Peterhouse, Cambridge," *Apollo*, February, 3–7

"The President's Lodgings, Magdalen College, Oxford," *Country Life*, 17 February, 44–47

"Bolesworth Castle, Cheshire I," *Country Life*, 23 March, 112–17

"Bolesworth Castle, Cheshire II," *Country Life*, 30 March, 76–79

"Il Classicismo Oggi: La Questione Etica," *L'Altra Modernità: 1900–2000*, Savona, 65–80

Review article on *Inside Out: Historic Watercolour Drawings of Interiors and Exteriors,*

1770–1870, *Country Life*, 14 December, 56

REVIEWS

Review of Tim Mowl and Brian Earnshaw, *An Insular Rococo*, in *Architectural Review*, January, 96–7

Review of Klaus Merten, *German Castles and Palaces*, in *Country Life*, 6 January, 64

Review of Lucy Archer, *Architecture in Britain and Ireland, 600–1500*, in *Architectural Review*, 97

Review of Timothy Mowl, *Stylistic Cold Wars: Betjeman versus Pevsner*, in *Country Life*, 9 March, 138

Review of Gavin Stamp, ed., *The Light of Truth and Beauty: The Lectures of Alexander 'Greek' Thomson Architect (1817–1875)*, in *Society of Architectural Historians of Great Britain Newsletter*, 69, Spring, 16

Review of Ian Sutton, *Western Architecture*, in *Country Life*, 23 March, 149

Review of Pierre du Prey, *Hawksmoor's London Churches: Architecture and Theology*, in *Country Life*, 10 August, 69

Review of Giles Waterfield, *The Long Afternoon*, in *Country Life*, 17 August, 68.

Review of Christopher Ridgway, ed., *Sir John Vanbrugh and Landscape Architecture in Baroque England 1690–1730*, in *Architectural Review*, October, 104

Review of James Lees-Milne, *Deep Romantic Chasm: Diaries, 1979–1981*, in *Country Life*, 19 October, 114

Review of John Wilton-Ely, ed., *Giovanni Battista Piranesi: The Complete Etchings*, in *Journal of the Society of Antiquaries*, Winter, 23

Review of Robert Harbison, *Reflections on Baroque*, in *Architectural Review*, December, 96

2001

BOOKS

Morality and Architecture Revisited, London: John Murray; and Chicago University, Press. 158 pp.

Alfred Gilbey: A Memoir by Some Friends (ed. and contrib.), London: Michael Russell. 144 pp. Introduction, 7–8 and "A Personal Reminiscence," 116–44

ARTICLES

"George III and the Shift to Gothic: An Essay in Nationalism," *New Offerings, Ancient Treasures: Essays in Medieval Art for George Henderson*, Paul Binski and William Noel, eds., Stroud: Sutton Publishing, 519–36

"Beckford, Soane, and Hope: The Psychology of the Collector," in *William Beckford, 1760–1844: An Eye for the Magnificent*, Exhibition Catalogue, Bard Institute for the Study of the Decorative Arts, New Haven and London: Yale University Press, 33–48

"Classical Architecture and a New Lincoln Center," *City Journal*, New York, vol. 11, Summer, 90–101

"The Solar House, Wakeham, Sussex: an essay in energy-efficient design," *Country Life*, 21 June, 174–77

"A Pair of Berlin Hard-Paste Porcelain Vases with Topographical Scenes: Some Architectural Notes," *French and Continental Works of Art*, Partridge Fine Arts, London, 148–52

"The Taste of the Prince Regent," *French and Continental Works of Art*, Partridge Fine Arts, London, 162–67

REVIEWS

Review of Georgia Clarke and Paul Crossley, eds., *Architecture and Language: Constructing Identity in European Architecture, c.1000–c.1650*, in *Architectural Review*, January, 89

Review of Alex Potts, *Flesh and the Ideal: Winckelmann and the Origins of Art History*, in *Times Literary Supplement*, 26 January, 32

Review of Anthony Grafton, *L.B. Alberti: Master Builder of the Italian Renaissance*, in *Country Life*, 1 March, 96

Review of Stephen Parissien, *George IV: The Grand Entertainment*, in *Country Life*, 15 March, 97

Review of John Bold, *Greenwich: An Architectural History of the Royal Hospital for Seamen and the Queen's House*, in *Times Literary Supplement*, 8 June, 18

Review of Richard Wilson and Alan Mackley, *Creating Paradise: The Building of the English Country House, 1660–1880*, in *Architectural Review*, July, 96

Review of John Martin Robinson and David Neave, *Francis Johnson Architect: A Classical Statement*, in *Country Life*, 5 July, 140

Review of James Yorke, *Lancaster House*, in *Country Life*, 9 August, 92

Review of Christopher Woodward, *In Ruins*, in *Country Life*, 13 September, 207

Review of Eileen Harris, *The Genius of Robert Adam: His Interiors*, in *Country Life*, 20 September, 196

Review of Paul Frankl, *Gothic Architecture*, rev. ed. by Paul Crossley, in *Architectural Review*, November, 96

2002

BOOK

John Simpson: The Queen's Gallery, Buckingham Palace, and Other Works (with Richard John), London: Andreas Papadakis Publisher. 136 pp. Illus.

ARTICLES

"The Queen's Gallery Rebuilt," in *Royal Treasures: A Golden Jubilee Celebration*, Jane Roberts, ed., The Royal Collection, 63–66

"The Queen's Gallery, Buckingham Palace," *Country Life*, 23 May, 108–15

"Città Nuova, Alessandria, Italy," *Country Life*, 21 November, 78–79

"Building: Ancient and Modern: The Queen's Gallery," *Architecture Today* 130, July, 20–30

"Classical Revival: The Queen's Gallery," *The Georgian*, Autumn/Winter, 10–11

REVIEWS

Review of James Stevens Curl, *Classical Architecture*, in *Architectural Review*, June, 104

Review of James Stevens Curl, *Georgian Architecture*, in *The Georgian*, Autumn/Winter, 28–29

2003

ARTICLES

"The Gothic Revival, the Arts and Crafts Movement, and the Contemporary Restoration of the City," *Architectural Culture Around 1900: Critical Reappraisal and Heritage Preservation*, Fabio Grementieri, ed., Universidad Torcuato di Tella University, 66–71

"Poundbury: A Commission from the Prince," *The Richard H. Driehaus Prize: Inaugural Recipient: Léon Krier*, in Michael Lykoudis, ed., University of Notre Dame, Indiana, 37–44

Foreword to *Harold Falkner: More than an Arts & Crafts Architect*, by Sam Osmond, Chichester: Phillimore, xi–xiv.

"Albany, Piccadilly," *Country Life*, 12 June, 102–07

"Two Hundred Years of Albany, 1803–2003," *The Georgian*, Spring/Summer, 17–18

"Ionic Villa, Regent's Park," *Country Life*, 28 August, 54–57

REVIEWS

Review of Vaughan Hart, *Nicholas Hawksmoor: Rebuilding Ancient Wonders*, in *Architectural Review*, January, 80

Review of Herbert Rott, *Palazzi di Genova: Architectural Drawings and Engravings*, 2 vols, in *Times Literary Supplement*, 2 May, 7–8

Review of Colin Rowe, *Italian Architecture of the 16th century*, in *Architectural Review*, August, 88–89

Review of James Stevens Curl, *Classical Architecture*, and John Wilton-Ely, *Piranesi, Paestum, and Soane*, in *The Georgian*, Spring/Summer, 34–35

Review of Tracy Ehrlich, *Landscape and Identity in Early Modern Rome: Villa Culture at Frascati in the Borghese Era*, in *Architectural Review*, May, 96–97

2004

BOOK

The Architect King: George III and Culture of the Enlightenment, The Royal Collection. 204 pp. 118 Illus.

ARTICLES

"Thomas Hope's House in Duchess Street: Drawings by Robert Adam and C.H. Tatham," *Apollo*, March, 31–39

"Enlightened Farmer George," *Country Life*, 18 March, 82–85

"HSBC new building, St James's Street," *Building Design*, 9 July, 12–15

"Five Novels Starring Buildings," *Country Life*, 23 September

Entries on James Burrough, C.R. Cockerell, F.P. Cockerell, Arthur Davis, Harvey Lonsdale Elmes, Henry Holland, Sir John Soane, and James Stuart, in the *New Dictionary of National Biography*

REVIEWS

Review of Jill Lever, *Catalogue of the Drawings of George Dance the Younger (1741–1825) and of George Dance the Elder (1695–1768)*, in *Apollo*, April, 60–61

Review of *Raymond Erith 1904–1973 Progressive Architect*, exhib., Sir John Soane's Museum, in *British Art Journal* 5, no. 3, Winter, 85–86

2005

ARTICLES

"The Lure of Egypt" in Christopher Hartop, ed., *Royal Goldsmiths: The Art of Rundell & Bridge 1797–1830*, Cambridge, 54–59

"George III: Enlightened Monarch?" in Jonathan Marsden, ed.,

The Wisdom of George III, London: Royal Collection Publications, 331–46

REVIEWS

Review of Alan Powers, *The Twentieth Century House in Britain from the Archives of Country Life*, in *Apollo*, January, 68–69

Review of Sandra Berresford, *Italian Memorial Sculpture 1820–1940*, in *Country Life*, 11 February, 82

2006

BOOK

Radical Classicism: The Architecture of Quinlan Terry, New York: Rizzoli. 256 pp. Illus.

ARTICLES

"The Deepdene: 'grotesque and confused'," in *Fragments: Architecture and the Unfinished: Essays Presented to Robert Middleton*, Barry Bergdoll and Werner Oeschlin, eds., London: Thames and Hudson, 139–46

"La Grèce et le Sublime: La Psychologie de Ledoux et Soane," in *Claude Nicolas Ledoux et le Livre d'Architecture Français; Etienne Louis Boullée, L'Utopie et la Poésie de l'Art*, ed. Daniel Rabreau and Dominique Massounie, Centre des Monuments Nationaux, Paris, 120–28

Chapter 1, "Stuart and Revett: The Myth of Greece and its Afterlife," and Chapter 19, "Epilogue: The Impact of Stuart over two Centuries," in *James Athenian Stuart (1713–1788): The Rediscovery of Antiquity*, Susan Soros, ed. (exhib. cat., Victoria and Albert Museum, London, and Bard Institute, New York), New Haven and London: Yale University Press, 19–57 & 515–48

"The Transformation of Munich by King Maximilian I Joseph and Ludwig I," *The Court Historian* 11, 1, 1–14

"The Rise of the House of Adam: New Houses by Robert Adam Architects," *Country Life*, 23 February, 76–81

"A Classical Fantasia: 'A Tribute to C.R. Cockerell' by Carl Laubin," *Apollo*, March, 94–97

REVIEWS

Review of John Martin Robinson, *The Regency Country House*, in *Apollo*, January, 69

Review of James Stevens Curl, *The Egyptian Revival*, in *Apollo*, April, 71

Review of Alain de Botton, *The Architecture of Happiness*, in *Literary Review*, May, 43–44

Review of Ptolemy Dean, *Sir John Soane and London*, in *Literary Review*, June, 37–38

Review of Manfredo Tafuri, *Interpreting the Renaissance: Princes, Cities, Architects*, in *Literary Review*, August, 39–40

Review of James Stevens Curl, *A Dictionary of Architecture and Landscape Architecture*, in *The Georgian* 2, 34

2007

BOOKS

Carl Laubin: Paintings (with John Russell Taylor), London: Philip Wilson

Visions of World Architecture: John Soane's Royal Academy Lecture Illustrations, London: Sir John Soane's Museum, 16 pp. Illus.

ARTICLES

"Deepdene, Surrey," *Country Life*, 1 November, 92–5

"Mount Temple, Co. Wicklow, Ireland," *Country Life*, 8 November, 80–83

"Wren and St Mary-le-Bow," in Michael Byrne and G. R. Bush, eds., *A History of St Mary-le-Bow*, Barnsley: Wharncliffe Press, 90–103

REVIEWS

Review of Vaughan Hart and Peter Hicks, *Palladio's Rome: Translation of Andrea Palladio's Two Guidebooks to Rome*, and Tracy Cooper, *Palladio's Venice; Architecture and Society in a Renaissance Republic*, in *Apollo*, February, 93–94

Review of John Martin Robinson, *Grass Seed in June*, in *Literary Review*, February, 38–39.

Review of Giles Worsley, *Inigo Jones and the European Classicist Tradition*, and Christy Anderson, *Inigo Jones and the Classical Tradition*, in *Literary Review*, March, 24–25.

Review of John Harris, *Moving Rooms*, in *Literary Review*, November

Review of Hermann Muthesius, *The English House*, 3 vols, in *Literary Review*, December

2008

BOOKS

Ed., with Philip Hewat-Jabor, and contrib., *Thomas Hope, Patron and Designer in Regency London* (exhib. cat., Victoria and Albert Museum, London, and Bard Institute, New York), New Haven and London: Yale University Press, and contrib.: Introduction, xiii–xvii; Chapter 2, "The Reform of Taste in London: Hope's House in Duchess Street," 23–43; Chapter 3, "The Reform of Taste in the Country: Deepdene," 44–55; Chapter 12, "Critic and Historian: Hope's Writings on Architecture, Furniture, and Interior Decoration," 219–235; and Chapter 15 (with Frances Collard), "The Afterlife of Hope: Designers, Collectors, Historians," 249–263

The Roman Forum, London: Profile Books